What Every Museum Director Should Know about Working with Boards

What Every Museum Director Should Know about Working with Boards

Edward M. Luby

ROWMAN & LITTLEFIELD
Lanham • Boulder • New York • London

Published by Rowman & Littlefield
An imprint of The Rowman & Littlefield Publishing Group, Inc.
4501 Forbes Boulevard, Suite 200, Lanham, Maryland 20706
www.rowman.com

86-90 Paul Street, London EC2A 4NE

British Library Cataloguing in Publication Information Available

Library of Congress Cataloging-in-Publication Data

Names: Luby, Edward M., 1959- author.
Title: What every museum director should know about working with boards / Edward M. Luby.
Description: Lanham : Rowman & Littlefield, [2024] | Includes bibliographical references and index. | Summary: "What Every Museum Director Should Know about Working with Boards outlines the key areas museum directors need to appreciate in order to successfully work with boards"—Provided by publisher.
Identifiers: LCCN 2024030879 (print) | LCCN 2024030880 (ebook) | ISBN 9781538188064 (cloth) | ISBN 9781538188071 (paperback) | ISBN 9781538188088 (ebook)
Subjects: LCSH: Museums—Management—Moral and ethical aspects. | Museum directors—Professional relationships. | Advisory committees.
Classification: LCC AM121 .L84 2024 (print) | LCC AM121 (ebook) | DDC 068/.0684—dc23/eng/20240705
LC record available at https://lccn.loc.gov/2024030879
LC ebook record available at https://lccn.loc.gov/2024030880

Dedication

To Pam, for being everything.

"No man, one sees, can understand and estimate the entire structure or its parts—what are its frailties and what its repairs, without knowing the nature of the materials."—George Eliot, *Middlemarch*

I would like to thank Charles Harmon, Senior Executive Editor at Rowman & Littlefield Publishers, for his thoughtful guidance, continual support, and great expertise and adroitness in helping to shape this book. I am also grateful to Lauren Moynihan, Assistant Acquisitions Editor, Rowman & Littlefield, for her deftness in managing the submission and production process and for always ensuring that my work met editorial guidelines. I would like to thank the many friends, family members, and colleagues who patiently listened to updates about the writing process, who believed that the topic of the book was important, and who urged me to make the book as accessible as possible. I am also grateful to the great number of students and museum professionals from whom I have learned much over the course of my career and whose dedication to museums inspired me to write the vignettes I have included in the book. Finally, I am indebted to Pamela Derish, editor extraordinaire, who provided encouragement, perspective, and her great professional skill sets to this effort and without whom this book would not have appeared.

Contents

Contents **xiii**

Preface

A museum director is under fire in the press because an object the museum accepted from a board member many years ago had an unclear collecting history. Another museum is in the public eye because an employee went to the local media to complain about a board member who is a major donor and whose family has ties to a company with questionable business ethics. And yet another museum finds itself weathering a storm of attention when a board member makes comments to the press about controversial exhibit content without first consulting with the museum's leadership.

Each of these all-too-true situations could have a pervasive impact on the work of the museum's director. The director may be asked probing questions by the public, such as "Does your museum find it acceptable to house objects that may have been stolen from another country?" or "How does the board select its board members?" or "Are influential board members in your museum allowed to shape exhibits?" Because the public places its trust in a museum and its activities, and the director is the official face of the museum, the director can be expected to be called to account for the museum's behavior. And museums, with their special collection stewardship responsibilities, are in the spotlight today as past acquisitions are questioned and as the colonial roots of museums are examined. The stakes of not understanding the role of boards in the work lives of directors are high.

The museum leaders of today and tomorrow need to be conversant in how to work with boards and prepared to identify, assess, and successfully navigate the common issues they will inevitably encounter, so that museums can live up to their potential to serve as places of stewardship, learning, and community. For instance, how do directors work with their boards to help them understand the issues involved in being a good steward of the resources that the museum holds in the public trust, so that boards can make the best possible decisions about returning objects to source communities? Or how do directors work with boards to discuss presenting the content of controversial exhibits or changing the names of exhibition halls now associated with questionable donors?

Museum personnel do not always comprehend that the issue that they might be navigating at the time, such as returning objects that have questionable collecting histories, assessing whether major financial gifts from donors

with links to problematic businesses should be accepted, or determining how to manage the public reaction to a controversial exhibit, necessarily involves the board. Indeed, some of the most important issues museum leaders face today, such as defining what a decolonialized museum looks like, learning how to work with communities that have been disenfranchised from museums, or determining how to make museums accessible to all groups, cannot be well navigated by staff without understanding what role the board plays in the museum. As a museum faces any given challenge, it is essential to gather all relevant information, including seeking guidance from museum professional organizations, referring to ethical codes, and consulting with museums encountering a similar situation, as well as understanding the board's potential role, so that the best possible steps ahead for the museum can be developed.

It is very challenging to be a museum director today. Not only are museums under increased scrutiny for how they manage their collections and raise money but also the day-to-day skills required to lead a museum are numerous and complex. Directors must oversee personnel, finances, safety, and planning, do outreach, and manage people and projects with focus, integrity, and a deep knowledge about museums as organizations. As highlighted above, these diverse tasks require directors to have deep familiarity with a critically important area that will determine their success as leaders: their work with the museum's board. Although they spend a great deal of their time working with board members or on board-related issues, museum directors receive limited professional training or exposure to the literature about just how crucial the board will be to their overall efforts. Much can be learned while working in or toward a position of leadership in the museum sector, but it hardly seems wise that such an important area of career growth and museum operations is left to the hope that the critical skills and knowledge necessary to be successful are somehow acquired along the way.

Whether they know it or not at the time they enter the profession, emerging museum personnel also need to understand the impact of the board and the director-board relationship on their work. Acquiring such knowledge is not only an investment in long-term professional development but also supports day-to-day job satisfaction by promoting an understanding of leadership interactions with the board and how any individual's work contributes to the overall mission of the museum. Museum employees who understand how their efforts intersect with those of boards can also help ensure that the professional standards and practices they care so deeply about inform and guide museum operations.

Over the many years that I taught museum management and governance in a graduate program in museum studies, the most common comment alumni from my program shared is how valuable the time they spent examining boards in the classroom setting has been for their own professional development and career advancement. While being a director seemed remote to many while

they were in graduate school, before they knew it, they were either heads of departments who had to interact with boards or were in directorial positions themselves. As they were advanced to leadership positions for their curatorial, fundraising, programmatic, or administrative skills, they could draw on their training and access the resources needed to support their work with boards. For the many museum professionals who never formally studied boards, as well as those who did and need a refresher, this book will be a helpful resource.

Significantly, one of the main reasons nonprofit leaders leave their positions is because they were not prepared for the time required to interact with boards. They also leave positions because they were not aware of the kinds of tasks that involved boards or were not able to navigate commonly encountered issues with boards. This book therefore prioritizes examining the activities of the board that most impact the museum's director and senior staff so that they have the knowledge to work productively with boards.

Many excellent resources outline the day-to-day work of museum directors in the area of museum management and include overviews of museum administration, descriptions of the business operations of museums, or discussions of the skills required to be an effective manager and leader. The basics of museum management are clearly outlined by Lord and Lord (2009) and Genoways, Ireland, and Catlin-Legutko (2017), for example, while leadership skills are thoughtfully examined by Morris (2018), Ackerson and Baldwin (2019), and Catlin-Legutko, Taylor, and the American Alliance of Museums (2021). In addition, professional training is offered by the Museum Leadership Institute (2024), the History Leadership Institute (2024), and by most museum studies programs in North America (American Alliance of Museums, 2024a). Helpful academic resources on museum management include edited volumes by Moore (1994) and Sandell and Janes (2007) and articles in highly respected journals, such as *Museum Management and Curatorship* and *Curator: The Museum Journal*. Readers interested in how directors manage museums should refer to these useful resources but will note that they focus less on the director's work with the museum's board, simply because there is so much for a director to know about how to manage a museum's activities. Finally, one cannot discuss museum boards without acknowledging the seminal work of the late Marie Malaro, who, as a professor of museum studies and former lead attorney for the Smithsonian Institution, fundamentally shaped the museum field's understanding of the board's role in museums in works such as *Museum Governance* (1994) and, with Ildiko DeAngelis, in the *Legal Primer of Museum Administration* (2012). However, no books today focus solely on *museum* board issues, although, as we will see, there are many important articles and essays, most of which are difficult to access, let around read, for the busy museum director. While there is also a robust nonprofit literature on board issues, it is overwhelmingly practice based, does not integrate what we have learned from academic studies of museums into it, and is not focused on the special issues

that museums, as stewards of collections that are held in the public trust, encounter.

As a result, this book focuses on museum boards *from a director's perspective*, including outlining how boards are organized, discussing the common points of contact between the director and the museum's board, and examining the kinds of challenges museum directors will likely encounter in working with their boards. This book was designed for museum directors seeking to deepen their effectiveness; new directors of museums; museum professionals planning to be directors; consultants seeking to support the navigation of change in museums; and students enrolled in museum professional training programs, whose time spent learning about the topic is a key investment in their careers.

One set of goals of this book is to help museum personnel enhance their career prospects, understand how to be an effective director, and be prepared for when their time as a senior manager arrives. Another important goal is to gather in one place the information that museum leaders need to be successful to help support the smooth functioning of museums, so they can reach their potential as places of collections stewardship, learning, and community. Readers will find a discussion of the role that museum boards play in maintaining the public's trust in Chapter 1, along with a review of how museum ethical codes frame the director's work with boards. The nonprofit basis of museums and the nature of trusteeship is reviewed in Chapter 2, followed by a discussion of the director's role in working with the board in Chapter 3. In Chapter 4, the core responsibilities of museum boards are presented, and, in Chapter 5, basic board organization and procedures are outlined. In Chapter 6, friends and support groups, which often have relationships with boards and directors, are discussed. In the next set of chapters, issues of core concern to the board that involve the work of the museum's director are examined: stewardship of collections in chapter 7; exhibit content in Chapter 8; fundraising roles in Chapter 9; and support of strategic planning in Chapter 10. Finally, several key issues facing museum boards today that are relevant to museum directors are discussed in chapter 11, followed by conclusions about what the conscientious and engaged museum director needs to know about museum boards today in Chapter 12.

Museum directors are guiding museums through great change today, as long-overdue efforts to diversify museums, to reach underserved audiences, and to meet the needs of museum employees intensify. To address these and other pressing issues, museum directors need all the tools available to them. Together with their skills as managers, museum directors will find that a deeper understanding of boards will support their efforts to have museums implement their missions, to be thoughtful stewards, and to serve as centers of learning, inspiration, and community.

1

Why Understanding Museum Boards Matters

One of the most important skills museum leaders must develop to be professionally successful today is understanding museum boards. Not only do board activities occupy a greater proportion of a director's time than most new directors anticipate but also understanding the board supplies directors, and those on the pathway to directorship, with critical information and a powerful lens through which to analyze the activities of the museum they lead.

The board is where the museum's most important decisions will be reviewed, approved, and made public. Such decisions must be made in ways that maintain the public's trust and that are seen by all as being driven by ethical considerations. Yet, not all new museum directors will have been exposed to information about how and why the public trusts museums, what the board's role is in maintaining the public's trust, or how ethical codes guide the director's work with boards on a practical level.

To appreciate why boards are so important for museum directors to understand, two interrelated areas will be discussed in this chapter: first, the critical if underappreciated role that boards play in maintaining the public's trust of museums; and, second, the much-needed framework that museum ethical codes supply for the director's work with boards. Such knowledge will help directors see more clearly how their own work intersects with that of the board and how to better support their board in meeting its responsibilities. Because an understanding of the public's trust and ethical codes is so foundational for a director's work with boards, these topics will be discussed in much detail here and will also be threaded throughout all subsequent chapters.

BOARDS AND THE PUBLIC'S TRUST IN MUSEUMS

In 2018, the American Museum of Natural History in New York, which is one of the most widely respected and visited natural history museums in the world, received major media coverage when one of its board members, Rebekah Mercer, was reported to be deeply supportive of conservative groups, including those that denied the existence of climate change (for example, see Milman, 2018). Opinion pieces argued strongly that Mercer, as a board member of the museum, put the museum's credibility with the public at risk because her climate-change denialism was in direct conflict with the museum's science-based research mission and its leading role in discussing climate change. Calls for Mercer's resignation were made by some in the scientific community, who stressed that the museum was risking its reputation among the public by allowing her to remain on the board and, further, that Mercer's ongoing presence eroded the public's trust in the museum (for example, see Offenhartz, 2018; Powell and Mann, 2018). In the wake of the media attention, the museum's administration was forced to issue a statement that board members are not appointed based on their political views and that funders do not shape curatorial decisions (Pogrebin and Sengupta, 2018). In 2020, Mercer stepped down from the board when the second of her three-year terms ended (Pogrebin, 2020a).

Museum directors today need to consider what the public's trust in museums means for their museum and for their work with boards. For example, while museum leaders and staff may differentiate their own actions and behavior from those of board members, the public usually does not make that distinction. Consequently, when the media is critical of a museum, such as when media representatives learn that a board member has ties to a company or donates to causes that do not align with the mission of a museum, directors will want to understand that they may be expected to respond to related media inquiries and that the perception of the museum as a source of independent information may be questioned.

From art museums to zoos, American museums are consistently rated as highly trustworthy by the public (American Alliance of Museums, 2021a; Institute of Museum and Library Services, 2008). Aside from family and friends, museums are trusted more than all other sources of information, including the government, the media, and businesses or corporations. High levels of trust in museums are primarily based on the view that information provided by museums is fact based, that museum exhibits present real or authentic objects, and that museums are research oriented and offer independent and objective information (American Alliance of Museums, 2021a).

Although museum professionals understand that museums *interpret* information for the public and that what they communicate is not neutral but, rather, is embedded in specific historical and sociopolitical contexts, the

public continues to view museums as places for accessing reliable, thoughtfully assembled, and credible information. High levels of trust in museums result in donors continuing to contribute funds, community members being willing to donate objects, and community members volunteering at robust rates in the museum sector. Public trust of museums is therefore contingent on museums behaving well in *all* their efforts, ranging from how they run their programs and manage their collections to how their boards behave. In essence, the public expects nonprofits to be accountable, transparent, and focused on their missions, especially because the public funds nonprofits through individual giving or by supplying government-associated grants (DeAngelis, 2002).

Notably, People of Color have less trust in museums than do members of White households (American Alliance of Museums, 2021a). This is likely the result of the historic exclusion of People of Color from museum exhibitions, relatively few museum collections that are relevant to these communities, and low rates of employment for People of Color in museums. The existence of differing levels of trust suggests that trust should be viewed by museums as a precious commodity, one that it is earned through the actions of museums.

Assessment of museum actions through media scrutiny is a powerful form of accountability. For example, the media often criticizes museums that appear inattentive to or that delay reviews of claims calling for the return of potentially stolen objects. Underlying this and similar criticism are a questioning of the credibility of museums and a gap between how the museum behaves and how the public thinks the museum should behave.

Museum directors should not underestimate what high levels of trust mean for their efforts. When museums live up to public expectations of trust, the results can include not only strong attendance and participation in programs but also financial support, such as funding for innovative activities or new buildings. On the other hand, when museum activities are closely examined in the media because there is a sense that museums are failing to live up to public expectations, the consequences can include a drop in attendance, a reduction in donor support, or even a loss of faith on the part of staff members and the public in the director's leadership abilities. The high trust placed in museums means that, despite the daily pressure for directors to focus internally on completing a myriad of tasks, they must also consider what actions must be taken to maintain this trust.

Although the museum sector has a high level of trustworthiness, individual museums have challenged the confidence of the public when media reports detail internal board conflict or the firing of directors or when museums appear to be out of touch with important concerns raised by the public. Confidence in museums can be diminished not only when a board member has a conflict of interest but also when poor conditions of collections are brought to the attention of the public or exhibitions are found to be significantly out of step

with segments of a museum's community. Such developments are cause for concern for all museums, because they can lead to the public's questioning of the museum sector as a provider of reliable information.

In sum, while some new museum leaders may be surprised at just how much board member actions are relevant to levels of public trust, a director needs to be acutely aware of why the public places trust in museums, how levels of trust relate to board behavior, and what directors can do to support ethical behavior throughout the organization. When board members are perceived as influencing exhibits or when boards are passive about claims that the museum holds stolen property, the director can be called upon to explain the museum's actions, and the public's view of museums as sources of objective information can be compromised.

ETHICAL CODES

Museum ethical codes outline how museums *should* behave, whereas laws and statutes specify how museums *must* behave. As museum directors know, ethical codes are a cornerstone of museum professionalism. They are intended to guide professional practice, to assist museums in navigating challenges, and to educate museum professionals about standards of behavior, with the recognition that such guidance must evolve over time as circumstances change. Just a few short years ago, for example, most American museums resisted calls to return objects that may have been stolen from source countries during colonial times, arguing that they had been obtained legally at the time and, further, that, in countries experiencing political uncertainty or civil strife today, the objects were safer in the United States. With the recognition that circumstances do indeed change and that a gap sometimes exists between what ethical codes suggest and what the law requires, museums have been rethinking what stewardship means and whether the best way to care for an object is to return it to a community that considers it to be key to their world view or way of life.

Future museum directors typically receive training in the legal administration of museums and are exposed to the work of leading experts in the field, including essential books by Malaro and DeAngelis (2012), Phelan (2014), and Gerstenblith (2019). Usually, however, less time is spent on becoming familiar with the major ethical codes in the field. Indeed, new directors may find that they review ethical codes in any detail only once they are confronted with a situation that requires their guidance. However, it is important to have reviewed such codes and to have considered the issues they raise *before* they must be put into practice. Because not all new and aspiring directors have been able to review important ethical codes and because of their sometimes-great length, as posted on the websites of museum professional associations, several of the most well-known ones will be reviewed below.

Overall, key elements of ethical codes for museums include how and why collections are to be cared for, what role programs should play in museums, and how those who are ultimately responsible for the museum, referred to interchangeably as boards, governing bodies, trustees, or governing authorities, should behave. Ethical codes for museums are generally divided into three kinds: those that cover the entire museum profession; those aimed at specific kinds of museums, such as history or art museums; and those designed for specific museum professions, such as for registrars or curators. In addition, in the United States, individual museums sometimes have their own institutional code of ethics.

The discussion below focuses on two ethical codes that cover the entire museum profession: those from the American Alliance of Museums (AAM) and the International Council of Museums (ICOM), as well as two that relate to different kinds of museums, those from the American Association of State and Local History (AASLH) and the Association of Art Museum Directors (AAMD). That discussion is followed by a brief discussion of ethical codes that have been designed for specific museum professions and a review of institutional codes of ethics.

American Alliance of Museums

The American Alliance of Museums Code of Ethics, last amended in 2000 (the AAM Code; AAM, 2024b), outlines the ethical principles that all museums and museum professionals are expected to follow to guide their decision-making. A core tenant of the AAM Code is that "legal standards are a minimum. . . . Museums and those responsible for them must do more than avoid legal liability; they must take affirmative steps to maintain their integrity so as to warrant public confidence. They must act not only legally but also ethically" (AAM, 2024b).

The AAM Code consists of several parts: an introduction about the purpose of ethical codes and the role of museums in American society; three successive sections on governance, collections, and programs, each of which outlines specific guidelines; a section on the development and promulgation of the AAM Code; and an afterword recommending how museums should use the AAM Code.

Introduction

The introductory section to the AAM Code is useful for museum directors to review, particularly in the context of understanding issues that can arise within museum boards. The introduction not only emphasizes that museums exist to serve and benefit the public, for example, but also stresses that members of governing authorities, as well as employees and volunteers, must be committed to serving the interests of the public. The introduction further outlines that

loyalty on the part of all of those who are involved with the museum to the mission of the museum, and to the public it serves, is the essence of museum work. Finally, the introduction emphasizes upholding the mission of the museum and avoiding conflicts of interest at all costs. It further stresses that those working on behalf of museums, be they employees or board members, must never use their position for personal gain.

These introductory statements can serve as guardrails when directors observe the behavior of individual board members. At the same time, knowledge of them means that museum directors can work with boards to understand why these statements are important, especially given the potential consequences for a museum director if a board member is perceived to have taken actions that benefit the board member at the expense of the museum.

Collections

The section on collections in the AAM Code has several areas relevant to directors when they are considering their boards, including a review of the concept of stewardship, why and how museums should hold collections, and how collections are to be managed. For example, the section stresses that the stewardship of collections entails the highest public trust and that it carries with it the "presumption of rightful ownership, permanence, care, documentation, accessibility and responsible disposal" (AAM, 2024b). Of particular note is the guidance that collections-related activities must not "promote individual financial gain" and that collections ownership issues should be handled "openly, seriously, responsively, and with respect for the dignity of all parties involved" (AAM, 2024b).

Programs

Of particular interest to directors when considering boards in the area of programs is this section's stress on how museum programs serve society, further the museum's mission, and support its public trust responsibilities and its assertion that museum programs need to be responsive to the "concerns, interests, and needs of society" (AAM, 2024b). In addition to engaging the widest possible audiences, programs should also reflect pluralistic values. Finally, programs and activities that generate revenue should be compatible with the museum's mission and the museum's public trust responsibilities, and they should not promote individual financial gain but, rather, the public good.

Governance

The area of the AAM Code concerned with governance is likely to be of special interest to directors when considering their work with boards, because it focuses on the board's duties, expectations, and behavior to ensure that the museum is well organized and works cohesively to achieve its goals. The

preface to the specific guidance concerning governance clearly spells out the broad responsibilities of the museum's governing authority, for example, outlining that it "protects and enhances the museum's collections and programs and its physical, human, and financial resources" and that it must "respond to the pluralism of society" (AAM, 2024b).

The specific guidelines in the area of governance then emphasize that those who work on behalf of museums, particularly board members, must understand and support the museum's mission and public trust responsibilities; must understand and work to fulfill their trustee responsibilities as a group, rather than as individuals; must recognize that the responsibilities of staff members often differ from those of board members and that these separate staff roles are to be respected; must understand that working relationships in the museum, including among board members, are based on equity and mutual respect; and must accept that the public good, rather than the individual financial gain of a board member, is promoted by governing authorities. Finally, three areas of great interest to museum directors are outlined: governing authorities need to ensure that professional standards and practices "inform and guide museum operations," that policies are articulated, and that "prudent oversight" is practiced.

The AAM Code closes with a statement about the goal of the document, which is to encourage museums to regulate the ethical behavior of their staff, volunteers, and governing authorities and to encourage museums to use the AAM Code to develop an institutionally specific code of ethics in order to promote higher and more consistent ethical standards.

International Council of Museums

In an era when many museums are being scrutinized for their past acquisition of objects under colonial circumstances or during times of conflict, it is also important for directors to be aware of guidelines from the international museum community and to understand how this community frames the role of governing authorities in upholding standards in areas such as collections care, programs, research, and service to society. Knowledge of guidelines from the international museum community is also useful to directors because some areas of the AAM Code, particularly concerning collections stewardship, offer comparatively less guidance than does the main international ethical code promulgated by the International Council of Museums, or ICOM. If relevant issues are likely to arise in an American museum, it would prove useful for directors to be aware of and to possibly share international guidance directly with their boards and to compare American and international approaches.

The ICOM Code of Ethics for Museums (the ICOM Code), which will soon be updated after its last major revision in 2004 (ICOM, 2021), outlines a series of principles that are generally accepted by the international museum community. Each principle is supported by guidelines concerning museum

professional practice, and a useful glossary of key terms referred to in the principles is provided at the end of the ICOM Code.

The ICOM Code begins with a brief preamble and is then divided into eight major sections, each of which is associated with a core principle and a set of associated guidelines, many of which touch on the role of the museum's governing authorities. The preamble stresses that the ICOM Code presents minimum standards for museums but that in some countries such standards are defined by law or government regulation. Because many museums outside of the United States are controlled by branches of government, rather than by nonprofit boards, which is often the case in United States, the language in the ICOM document consistently refers to a museum's "governing body," which is defined as "the persons or organizations defined in the enabling legislation of the museum as responsible for its continuance, strategic development and funding" (2024). The "governing body" referred to here can be considered equivalent to the terms more commonly used in an American museum context, which are "governing authorities" or "boards," the detailed structure of which will be discussed in Chapter 4.

Principle 1

The first principle in the ICOM Code explicitly focuses on museum governing bodies and emphasizes that such entities have a primary responsibility to protect and promote collections or, as ICOM characterizes collections, "the tangible and intangible natural and cultural heritage" (ICOM, 2024a). Museum governing bodies also have a responsibility to ensure that the "human, physical and financial resources" that support collections are in place (ICOM, 2024a).

From this first principle derive many specific guidelines, which revolve around four items that museums need: founding documentation, adequate physical resources, sufficient financial resources, and trained personnel. Because the first principle involves understanding the responsibilities of governing bodies and how their members are to behave, which affects the work of a director, the specific guidelines associated with the first principle are reviewed below.

In the area of *founding documentation*, the governing body must ensure not only that the museum's purpose, legal status, permanence, and nonprofit nature are clearly articulated but also that its mission, policies, and the role and composition of its governing body are described. Next, in the area of *physical resources*, the governing body is responsible for ensuring that the museum's physical space is adequate; that appropriate access to collections is facilitated; that staff and visitors are safe in museum spaces; that disaster planning and procedures for keeping collections secure exist; and that relevant museum collections are insured and indemnified. In the area of *financial resources*, museum governing bodies must ensure not only that the museum has sufficient funds to support the activities of the museum but also that written policies about

income-generating activities are in place and, further, that such activities do not compromise the standards of the institution. Finally, in the area of *personnel*, the governing body must ensure that personnel policies are in place and that a director with professional knowledge and a high standard of ethical conduct is appointed. In addition, the governing body must ensure that the director is responsible to and can access the museum's governing body; that competent museum personnel work in the museum and that opportunities for continued training are made available; that governing bodies never require museum personnel to act in ways that conflict with the ICOM Code, national laws, or other specialist codes; and that a written policy on volunteers exists, and that volunteers are familiar with such policy and the overall ICOM Code.

Principle 2

The second principle concerns museum collections and emphasizes that they are held in trust for the benefit of society. Governing bodies are told that they should have a written collections policy in place that addresses the acquisition, care, and use of collections. This highlights that directors will need to work with boards to have them understand, approve, and possibly develop such policies.

Specific guidelines are outlined in three areas: the acquisition, removal, and care of collections. First, in the area of *acquisitions*, several noteworthy guidelines indicate that museums should acquire only objects that have valid title and a full ownership history. Further, in the case of culturally sensitive materials, such objects should be acquired in ways that are consistent with the interests and beliefs of the communities from which they are derived. In addition, when governing bodies are involved in the donation or sale of objects, special care must be taken if such items are being considered for acquisition. Next, in the area of the *removal of collections*, the guidelines emphasize, among other things, that deaccessioning must be legal and clearly discussed in policy. When an object is to be removed from a collection, the guidelines require considering any loss of public trust that could result from taking such an action. The guidelines are clear on another matter of great interest to directors and boards when objects are being considered for deaccessioning: any funds resulting from the sale of such items should be used solely for the benefit of the collection, meaning that governing boards should not permit objects to be deaccessioned so that funds can be used for noncollections purposes, such as covering a budget deficit. At the same time, the guidelines outline that those associated with governing bodies should not be permitted to purchase deaccessioned objects from a collection for which they are responsible. Finally, in the area of *collections care*, a series of guidelines are outlined, ranging from the need for museums to document their collections, their need to have policies in place that protect the collection during disaster, to their need for data security and conservation. Governing bodies, it is noted, should not be permitted to use

the museum's collections for personal reasons, such as, for example, loaning a work of art to a board member for use in his personal residence.

Principle 3

The third principle in the ICOM Code focuses on the value and significance of museum collections. This principle can be particularly useful for directors as it prompts them to be aware of when they need to educate governing bodies that collections serve as "primary evidence" and, as such, that governing bodies have particular responsibilities in caring for, making accessible, and interpreting collections (ICOM, 2024a). The guidelines emphasize that collections must be made accessible, that museums undertaking fieldwork should do it in ways that respect cultural practices and local communities, and that museums should cooperate with other institutions, share their expertise, and ensure that research done on the collection by museum personnel is mission based and conforms to legal, ethical, and academic practices.

In matters that are subject to intense discussion today in the museum profession, guidelines are also outlined in three areas: the *acquisition of objects without clear collecting histories*, or without clear provenance; how *destructive analysis* should be conducted; and how *research on human remains and items of sacred significance* should be approached. For objects without provenance, in exceptional cases, a museum can consider acquiring such an object if it makes such "an inherently outstanding contribution to knowledge that it would be in the public interest to preserve it" (ICOM, 2024a). In the case of research on human remains and items of sacred significance, such work "must be accomplished in a manner consistent with professional standards and take into account the interests and beliefs of the community, ethnic or religious groups from whom the objects originated, where these are known" (ICOM, 2024a).

Reflecting changes in the museum profession in the past two decades, it is likely that the areas of guidance concerning the acquisition of objects without clear provenance and research on human remains and items of sacred significance will look fundamentally different in the next version of the ICOM Code. If such guidelines are relevant to a museum's collections, directors should not only share this specific guidance with their governing bodies but also review how it has evolved since it was written, in order to highlight that it is the inherent nature of ethical codes to change over time.

Principle 4

The fourth principle relates primarily to the display and exhibition activities of museums, the related educational and service-oriented role of museums in these areas, and the obligation for museums to use their exhibition function to engage with wider audiences and the museum's constituent communities. Of note for directors in their work with boards, included here is specific guidance about interpretation in exhibits, which states that the information presented in

displays and exhibitions should be "well-founded, accurate and gives appropriate consideration to represented groups or beliefs" (ICOM, 2024a).

Once again, in areas subject to intense discussion today, guidelines are also outlined in three important areas: the *exhibition of human remains and materials of sacred significance*; requests for the *removal from public display of human remains and materials of sacred significance*; and the *display of unprovenanced material*.

In exhibiting human remains and materials of sacred significance, the guidance outlines that they must be displayed according to professional standards and in ways that take into account "the interests and beliefs of members of the community, ethnic or religious groups from whom the objects originated," where known. Further, the guidance requires that they must be "presented with great tact and respect for the feelings of human dignity held by all peoples" (ICOM, 2024a). The guidance about the removal of human remains and materials of sacred significance from public display states that requests must be "addressed expeditiously with respect and sensitivity," that requests for their return should be handled similarly, and that museum policies defining a process for responding to such requests should be in place (ICOM, 2024a). Finally, the guidance on the display of unprovenanced material indicates that museums should not display or use such material because it can be interpreted as condoning and contributing to the illicit trade in cultural property.

Principles 5–7

The next three principles relate the tangible benefits museums can provide to society in areas such as appraisal and object identification (principle 5); collaboration with the communities from which their collections are derived (principle 6); and the legal foundations of museums (principle 7).

Of particular interest to directors in their work with boards is the guidance outlined for collaboration with originating or source communities in principles 6 and 7, including the legal need for museums to conform to relevant legislation and treaty obligations. In principle 6, for example, guidance is offered in two specific areas: the origin of collections, which includes the return of and restitution for cultural property; and respect for the communities served. In the latter area, the guidance outlines how museums should interact with and support contemporary communities and how museums should use any associated collections. Some noteworthy specific guidance from principle 6 includes that museums should consider developing partnerships with communities that have lost a significant part of their heritage; that museums should be prepared "to initiate dialogue for the return of cultural property to a country or people of origin"; and that, under appropriate circumstances, museums should "take prompt and responsible steps to cooperate" in the return of objects that are to be restituted. In principle 7, on the other hand, the guidance stresses the importance of understanding the legal framework museums operate within,

how governing bodies must comply with any legal requirements, and what international legislation should be acknowledged in museum policy, when relevant.

Principle 8

The final ICOM Code principle, which simply states that museums must operate in a professional manner, is organized into two major areas, professional conduct and conflicts of interest. While both areas mostly concern staff behavior, it is important that directors ensure that their governing bodies understand how employees are expected to conduct themselves and understand the broader museum professional framework in which staff are enmeshed. In the area of professional conduct, for example, in addition to being familiar with legislation that affects museums and not supporting, in direct or indirect ways, the illicit market in natural or cultural property, employees are obliged to follow the policies and procedures of the museum, unless they perceive practices that may harm their museum, in which case they may "properly object" (ICOM, 2024a). In the area of conflicts of interest, the guidelines stress that "museum employees must not accept gifts, favors, loans, or other personal benefits that may be offered to them in connection with their duties for the museum" and that they should not compete with their museum by collecting objects on their own, referred to as "private collecting." Moreover, guidance about interactions with dealers or auctioneers urges caution, indicating that museum employees should not accept gifts or recommend specific dealers or auctioneers to members of the public.

The ICOM Code is widely influential in the international museum community, though less attention has been paid to it in American museums. This is unfortunate because the version in place over the past twenty years not only offers an expansive view of collections stewardship and demonstrates a deep understanding of the value of community involvement in museums but also prioritizes an understanding of the role of governing bodies, all of which are areas that American museums have found challenging in the past.

The American Association of State and Local History

In addition to the general codes promulgated by organizations such as the AAM and ICOM, codes of ethics have been developed for specific kinds of museums. Among the best known of these are those by the American Association of State and Local History (AASLH) (2018) and the Association of Art Museum Directors (2011). These two codes are discussed below.

The AASLH Statement of Standards and Ethics (the AASLH Statement, 2018) begins with an introduction that stresses that it expects its members to "take affirmative steps to maintain their integrity so as to warrant public confidence" and to comply with applicable laws, regulations, and treaties. The

AASLH Statement is then divided into nine sections that outline ethical statements and related professional standards in areas ranging from diversity and inclusion to human resources and access. Three of these nine sections, those concerning governance, human resources, and confidence and public trust, are of special interest to directors in their work with boards. In the *governance* section, the governing authority's responsibilities are outlined, including that they should ensure proper delegation of responsibility and that they should establish and review policies that reflect current legal, ethical, and professional practices. In the section on *human resources*, among the wide range of standards outlined, two touch on governing authorities: first, personnel policies that have been adopted by the governing authority need to be in place for those associated with the museum; and, second, governing authorities that employ an administrator need to recognize that this person alone "is responsible for the employment, discipline, and release of all other staff, subject to established personnel policies." This standard reflects the fact that, in some smaller history-based institutions, the organization's administrator may be a volunteer or a board member. Finally, an institution's service role to the public is emphasized in in the section on *confidence and public trust*. Governing authority members, staff, or volunteers cannot use their position for personal gain or for the benefit of other organizations or for personal collecting, for example, because history organizations "must always act in such a way as to maintain public confidence and trust" (AASLH, 2018).

It is helpful for all museum directors, regardless of the museum's type, to be aware of and to have spent time reviewing the AASLH Statement because of its clear differentiation of the responsibilities of governing authorities from the responsibilities of the director and its emphasis on the role of integrity in maintaining public trust.

The Association of Art Museum Directors

The Association of Art Museum Directors (AAMD) code of ethics, which is entitled "Professional Practices in Art Museums" (the AAMD document), is divided into roughly a dozen sections and appendices that outline fundamental principles that apply to all art museums in areas ranging from governance and planning to collections, programs, legal matters, and staff (AAMD, 2011). The AAMD document is noteworthy because it is explicitly aimed at directors, and, therefore, its characterization of principles speaks directly to the director's work with the museum's board or governing authorities. In addition to the AAMD document, the AAMD also issues statements occasionally on topics of concern to the art museum community. Since 2011, several of these statements have been produced, including two much-discussed ones, "Guidelines on the Acquisition of Archaeological Material and Ancient Art" (2013) and "Guidance on Art from Colonized Areas" (2022).

The AAMD document begins with a section on governance that defines the board (and other commonly used terms, such as trustee or governing body) as the entity that is legally responsible for the museum. Several of the board's responsibilities are outlined in the section, and it is emphasized that board members should not be compensated for their work and that board members should represent the museum's diverse communities. Other guidance includes that the director must work with the board in long-range planning, as well as in securing the resources to fulfill the museum's mission. These are important to highlight because boards, especially in smaller museums, sometimes assume that new directors will do the bulk of the museum's fundraising, resource development, or planning. In addition, the governance section states that policies relating to the museum's operations are to be approved by the board, that the board acts collectively in making decisions, and that, according to approved policy, the board can delegate (what is assumed to be) decision-making to board-appointed committees, which also should act collectively. The board's responsibility in appointing a director who possesses an appropriate balance of content knowledge and professional skills is also discussed, as is the importance of having a policy in place that relates to conflicts of interest and ethics.

The director's work with the board is stressed in the section concerning mission, policy, and long-range planning. Policy decisions and changes, for example, should be the result of "thorough discussions between the board and director" (AAMD, 2011). This is another important statement to highlight because it suggests both that boards should not "rubber-stamp" recommendations made by directors and that boards will need a thorough understanding of issues that affect policy in order to make informed decisions. In the area of planning, it is also made clear that initiating long-range planning with the board and implementing the resulting plan is the director's responsibility.

The sections concerning collections and programs include almost two dozen statements. The role of collections and programs in the museum's activities and the board's responsibilities are outlined at the outset. The section on collections further describes that the acquisition of works of art is the responsibility of the director and the staff and outlines detailed principles for the acquisition and lending of art, principles that relate to donation, ownership, deaccessioning, and private collecting. Of particular relevance to the director's work are the statements that the board is responsible for approving recommended acquisitions; that it is the director's responsibility to ensure that best efforts have been made when considering acquisitions that may have been stolen or illegally imported; and that cases of works of art in which there have been major changes in dating, attribution, or authenticity should be reported to the board and the public. Also relevant to the director's work are the statements that day-to-day activities with the collection fall under the purview of the director while the ultimate responsibility for the collection rests with the

board; that the director should periodically report on the state of the collection to the board; that the director should advise the board about loans and recommend or approve loans, according to policy; and that the director should make recommendations to the board about items to be considered for deaccessioning, with the board making the final decision on the matter.

The director's work with the board is also referred to throughout the remaining sections of the AAMD document, covering the areas of finances, fundraising, legal matters, and the staff, and especially in the final section, which focuses on the director. In the area of finances, for example, the director must advise the board if there is any significant change in the museum's financial situation; should identify priorities and allocate funds according to board-approved policies; and should prepare a budget for the board's approval that may need to be adjusted by the director over the fiscal year, with or without the board's formal approval, depending on relevant policy about the director's latitude in this area. In fundraising, the principles make clear that the director must play a significant role in meeting the financial requirements of the museum, but that it is the board's responsibility to secure and provide the funds to meet the financial needs of the museum. Speaking to the public's trust of museums, the principles also state that fundraising practices that could "damage the community's trust or its respect for the institution" should be avoided, which is of interest to the director because it involves how the director, as well as the board and staff, should behave. At the same time, the director must monitor the fundraising goals and related activities of any board-approved volunteer or auxiliary groups.

In the area of legal matters, the AAMD principles outline that the director is responsible for day-to-day oversight of how the museum complies with relevant laws and regulations and that information in these areas that are relevant to the operation of the museum should be shared with the board and legal counsel. Meanwhile, while the board assumes ultimate responsibility for the physical plant of the museum, it is the director's job to ensure that all day-to-day areas, such as public safety, planning for capital improvements, secure access and emergency situations are in place, as well as any changes to facilities plans or to the physical footprint of the museum, which must be reviewed and approved by the board. With respect to staff, the principles distinguish the role of the director and the board in staff appointment and in policy relating to the rights and benefits of employees in labor unions. In cases when labor unions are in place as the negotiating agent for employees, for example, while the board must "establish clear roles and responsibilities for negotiating agreements," the museum's director is responsible for the final contract.

The final area of the AAMD document concerns the museum's director; the director's qualifications, hiring, appointment, required knowledge, and termination; and times when there are transitions between directors. For each of these, the director's work with the board is described. For example, the

director should attend all board meetings, can be present at the meetings of permanent board committees, and, importantly, is responsible for informing the museum's staff about board decisions as well as for informing the board about "the ideas, concerns, and requests" of the staff. Finally, the relationship between the board and director is addressed in two key principles: the director should be supported by the board, and serious disagreements between the board and the director must be resolved for the well-being of the museum.

The practices set forth in the AAMD document are useful for directors in any type of museum to review carefully. While they focus on issues of concern to art museums, especially in the area of collections stewardship, they highlight what directors are expected to know in general about their interactions with boards and address issues of interest that range from long-term planning and fundraising to labor relations and board-director conflict.

Ethical Codes for Specific Job Functions

In addition to general ethical codes and those promulgated for specific types of museums, codes of ethics have been developed for specific job functions in museums. Some of the more widely known codes, including those produced by the Association of Registrars and Collections Specialists (ARCS, 2016) and the Code of Ethics and Professional Practices for Collections Professionals (AAM, 2021b), are for registrars and collections specialists. Some, including the Code of Ethics for Curators (AAM, 2009) and Professional Practices for Art Museum Curators (AAMD, 2011), have been promulgated for curators. It is important that museum directors are aware of these types of codes because they offer guidance about employee interactions with governing bodies about which directors, staff, and boards should be knowledgeable. Two of these codes, one for registrars and one for curators, are discussed below.

The Association of Registrars and Collections Specialists (ARCS) Code of Ethics (the ARCS Code) was last revised in 2016. After an introduction that includes the mission of the ARCS and a description of the work of registrars and related professionals, a preface discusses the role of ethical codes in general and describes the main work obligations of registrars and collections specialists. The core of the ARCS Code is then presented in two sections, one discussing personal and professional conduct and the other discussing integrity.

The section on personal and professional conduct in the ARCS Code consistently emphasizes that registrars and collections specialists must be committed to their governing authority. For example, registrars and collections specialists must support the governing body's mission and its responsibilities, implement the governing body's policies, and act in the best interests of the museum rather than in support of their own personal interests. All activities that could compromise the governing body's reputation, the public it serves,

or the governing body's mission must be avoided. In the area of integrity, registrars and collections specialists should establish a standard for the collection for the museum's governing body through the avoidance of even the appearance of conflicts of interest, through confidentiality, and by maintaining ethical professional relationships. Almost the entirety of the ARCS Code reflects a recognition of how registrars and collections specialists should behave in supporting the efforts of their museum's governing bodies.

The Code of Ethics for Curators (AAM, 2009) is divided into five major sections, the first two of which describe curatorial work and outline the role of a curator in museums; the last three outline a curator's values, responsibilities, and the common kinds of conflicts of interest curators encounter and how to address them. In the sections on work and roles, curators are described as ambassadors of the museum to the public, ambassadors who must not only respect the hierarchy of authority at their institution but also understand the responsibilities of the museum's governing body. In the section on curatorial responsibility, standards concerning interactions with boards are outlined in areas such as the acquisition, care, and disposal of collections and the use of and access to collections. For example, curators should expect to offer their professional expertise and guidance to the museum's governing body to prevent the museum from experiencing negative consequences when considering deaccessioning or lending of objects. Finally, although boards are not mentioned specifically in the extensive section on conflicts of interest, the kinds of relationships that should be disclosed to the museum while working with collectors and how to navigate them provides a framework for understanding how curators should work with a board member who also happens to be a collector.

Although codes of ethics for specific museum job functions mostly relate to positions that involve collections stewardship or interpretation, as outlined above, museum directors should also be aware of relevant codes from the broader nonprofit world to help inform their work with the board. One of the most helpful is the Code of Ethical Standards from the Association of Fundraising Professionals, which was first adopted in 1964 and which was most recently amended in 2014 (Association of Fundraising Professionals, 2024d). This Code has sections on public trust, transparency, and conflicts of interest as well as on solicitation and stewardship of philanthropic funds and the treatment of confidential information. These sections can inform directors, especially those newer to fundraising, about how they should work with boards on resource development within a clear ethical framework.

Institutional Codes of Ethics

The American Alliance of Museums recommends that individual museums should each have their own institutional code of ethics (AAM, 2024c). An institutional code of ethics is a statement of the museum's individual approach

to how it should behave, given its unique history, collections, structure, programming, and community. Quite often, these codes describe the relationship that should exist between the director and the board or the governing body of the institution; particular issues that relate to the management of the museum's own collection and that are of public concern; and how the museum approaches interpretation in its exhibitions. In American museums, the AAM's Code of Ethics is commonly adapted in developing an institutional version, and the resulting document is discussed, reviewed, and approved by the museum's board.

To illustrate key components of an institutional code of ethics that relate to the director's work with the institution's governing authority, two examples of such codes, which are accessible on each of the museum's web pages, are discussed briefly below: the code of ethics of the Museum of Science, Boston (2024), a private science museum, and the code of ethics of the Florida Natural History Museum (2022), a university museum.

The Museum of Science, Boston's code of ethics (the MSB Code) begins by describing the history of the organization and its establishment as a public trust. The MSB Code then outlines that "loyalty to the mission of the Museum of Science and to the public it serves is the essence of this Museum's work, whether volunteer or paid," and that when "actual, potential, or perceived" conflicts of interest arise, the duty of loyalty "must never be compromised" (Museum of Science, Boston, 2022). The MSB Code also outlines the board's "vital responsibility" in selecting and monitoring the Museum's director, which cannot be delegated and must be carried out "diligently and thoughtfully." The MSB Code indicates that museum board members should file and update conflict-of-interest statements that disclose any "personal, business, or organizational interests and affiliations and those persons close to them that could be construed as Museum-related." Moreover, the MSB Code outlines expectations concerning board interactions with staff (board members should "avoid giving directions to, acting on behalf of, or communicating directly with, or soliciting administrative information from staff personnel") and describes the director's obligation to the board (the director must provide the board with "current and complete financial information in a comprehensible form . . . bring before the board any policy questions not already determined, and keep them informed on a timely basis of all other significant or substantial matters"). Finally, the MSB Code includes a large section about collections, with a discussion of recent changes in how the museum cares for human remains and sacred objects; discusses fundraising practices, emphasizing that gifts should not be solicited with the promise of opportunities not offered to all donors; and closes with a statement about the Museum's ethical obligation to be a good citizen and to avoid practices that scientists have concluded are unhealthy for life on the planet.

In contrast, the institutional Code of Ethics for the Florida Natural History Museum (the FNHM Code) is much less explicit about how the director works with the Museum's governing authorities or how these authorities are to behave. While the FNHM Code is divided into sections on management and collections, it begins with an illuminating statement on governance that suggests much about how the director will work with the Museum's governing authorities. Specifically, authority for the Museum has been delegated from the State of Florida to the University of Florida. At the same time, the Museum's director reports to the University's chief academic officer, known as the provost, who, in turn, reports to the president of the University of Florida. As a result of this complex governance structure, some unspecified set of responsibilities that are vested in the State of Florida have been delegated to the University of Florida. Consequently, the FNHM Code focuses on what it can, which is the behavior of museum management and staff, in areas such as conflicts of interest and the acquisition of collections, rather than on how the University of Florida or the State of Florida should conduct itself. This likely means that the Museum's governing authorities may not be fully aware of ethical codes in the museum profession and that the director may need to be involved in educating them about appropriate ethical behavior. At the same time, it suggests that the director will need to work to delineate which responsibilities may have been delegated to them and what, if any, structures have been put in place at the University for oversight of the Museum.

In describing the importance of an institutional code of ethics, the AAM stresses that the code "puts the interests of the public ahead of the interests of any institution and encourages conduct that merits public confidence . . . [it] is important to ensure accountability. The effectiveness of a nonprofit institution is directly related to the perception of its integrity" (AAM, 2024c). And, very helpfully, the AAM outlines the practical elements of an institutional code of ethics, which are useful for directors to know: the code serves as an effective tool in risk management, "protecting a museum's assets and its reputation."

An example of real-life museum ethics concerns the changing status of collections housed in museums from the African kingdom of Benin. More than a dozen of the fifty or so American museums that hold objects associated with the looting of the Benin Palace in 1897 are now in the process of voluntarily returning artworks to Nigeria; the institutions include the University of Pennsylvania's Museum of Anthropology and Archaeology (Penn), the Field Museum in Chicago, and the Baltimore Museum of Art (McGlone, 2022). At Penn, the director recently outlined that the museum is ready to transfer legal ownership of nearly two hundred objects associated with the looting of the palace because it is the "right thing to do" and because collaborations with communities seeking the return of objects can be mutually beneficial (McGlone, 2022).

Meanwhile, in the summer of 2022, the board of regents of the Smithsonian Institution voted to return more than two dozen looted Benin objects, and in the fall of 2022, the Smithsonian Institution and the National Gallery of Art, along with the Rhode Island School of Design Museum, became the first American institutions to return objects associated with the looting of the Benin Palace to Nigeria's National Commission for Museums and Monuments (American Alliance of Museum, 2022a). The Smithsonian's actions here built on its institutional code of ethics, which was approved by its board of regents in 2007 and which outline how the organization is "committed to following the highest standards of ethical conduct" (2007. 2), as well as on a new policy on the shared stewardship and ethical return of its collections, which recognizes changes in ethical norms and professional standards (Smithsonian Institution, 2022). As the secretary of the Smithsonian, Lonnie Bunch III, stated at its repatriation ceremony, which was held in Washington, DC, "125 years is a long time to wait for justice, to wait for fairness, and to wait for an ethically driven return of the ownership to the Nigerian government of such beautiful and important artifacts" (American Alliance of Museum, 2022a).

Museum codes of ethics are designed to guide professional conduct, but, fundamentally, they exist to demonstrate to the public that they should trust museums. The principles, expected standards, and specific guidance that codes of ethics offer weave together museum governing bodies, staff, volunteers, and directors in a tapestry of continued inquiry about how best to behave. As high-profile media cases about conflicts of interest among board members or illicitly acquired art or antiquities highlight, museums have sometimes undermined this trust. However, the power and promise of the kind of regulation that ethical codes illustrate is their self-correcting nature. Museum directors understand that they and their professional staff must study, comprehend, update, and "live" ethical codes in their professional capacities but that they must also work to have their boards and governing bodies understand why codes matter so much to museum professionals and that key parts of museum ethical codes also apply to board members.

2

How Are Museums Organized?

MUSEUM ORGANIZATION: A REAL-LIFE EXAMPLE

In September 2023, the San Bernadino County Museum, which is located roughly sixty miles east of Los Angeles, in Redlands, California, returned more than a thousand archaeological objects to the government of Mexico (Shortell, 2023). The objects, which were transferred to the Mexican consul in a repatriation ceremony held at the museum, included ritual items, ceramic and copper bells, wind instruments, and burial remains (Akers, 2023). The event was timed to coincide with the museum's exhibit on Latino artists from the local community, Mexican Independence Day, and the beginning of Hispanic Heritage Month.

In a museum press release, the San Bernadino County Board of Supervisors, to whom the museum reports, commented that it fully supported the museum's recommendations to transfer the items, with one member of the board stressing that the event was an important day of respect and of recognition of the considerable meaning that the items hold for Mexico (San Bernadino County Museum, 2023). In the same press release, the museum's deputy director described the museum's work with its Mexican governmental partners as based on truth, collaboration, and support and noted that replicas of some of the items will remain in the museum so that the community can continue to see itself reflected in the museum. The San Bernadino County government, in highlighting its role with the museum, further outlined that the museum's exhibits, events, and programs are reflective of the board of supervisors' efforts to implement its "Countywide Vision Statement," which was designed to celebrate arts, culture, and education in the county and to create quality of life for its residents and visitors (San Bernadino County Government, 2023).

THE NEED TO UNDERSTAND MUSEUM ORGANIZATION

To support museums as stewards of collections, as places of learning, and as responsive centers of community, museum directors today must possess a range of finely honed skills. From fiscal management and public relations to oversight of operations and working to engage community members, museum directors have much to do to ensure that a museum runs smoothly and maintains the public's trust. At the same time, they must accomplish their work as a director with inclusivity, attention to the museum's overall goals, and deep knowledge of the museum sector and of the current issues that are of concern to it. To this set of required skills, one must add an understanding of how museums are organized, with a focus on the legal underpinnings of museums and what the concept of trusteeship means for museums.

As museum directors move into leadership positions, not all will have had the time to study the basic organization of museums or will have recognized how a museum's legal foundations can shape their work with boards. Therefore, this chapter reviews the organization of museums because of the outsized impact it has on a director's work and because an understanding of how museums are organized can also supply directors and senior staff with a powerful analytical tool to navigate important challenges that will involve their boards. Examples include the return of collections—as in the case described above—or the determination of which issues facing the museum the director should give priority to as he or she interacts with the board. Indeed, as much as the staff in the example above might have wanted the items to be returned to Mexico, the director's recognition of how the museum was organized, its legal foundation, and how the board of supervisors viewed its trusteeship responsibilities clearly paved the way for the board's eventual approval of the repatriation.

To illuminate why museum organization is so important for museum directors to understand, the seminal work of DeAngelis (2002) and Malaro and DeAngelis (2012) on the legal underpinnings of museums will form the basis of the discussion below.

THE MUSEUM AS A NONPROFIT

To begin a discussion of how museums are organized, directors can review the definition of "museum" that is outlined in the Museum and Library Services Act and its subsequent reauthorizations (Institute of Museum and Library Services, 2024a). The Museum and Library Services Act of 1996 created the Institute of Museum and Library Services (IMLS), a federal agency that is a major source of federal funding for museums (Institute of Museum and Library Services, 2024b). The IMLS definition is important because it recognizes the nonprofit nature of American museums, as outlined below.

The Museum and Library Services Act specifies that a museum is a public, tribal, or private nonprofit institution that is organized on a permanent basis for educational, cultural heritage, or aesthetic purposes. It further outlines that a museum uses a professional staff, owns or uses "objects" (including live ones, such as animals in aquaria or zoos, as well as "objects" held in digital collections), and cares for and exhibits objects to the public on a regular basis (Legal Information Institute, 2024).

This "big tent" definition of museums includes a range of institutions, from art museums to zoos, and recognizes the unique role of museums in caring for their collections. It also stresses the nonprofit nature of museums. This latter point is crucial because, as nonprofits, most museums are organized as charities under the United States tax code and receive the benefit of tax exemption as 501(c)(3) organizations in exchange for the primary service that they supply to the public, which is education. Moreover, as 501(c)(3) organizations, museums, like some other kinds of nonprofits, are permitted to accept donations that are tax deductible, as each implements its unique purpose or, as the museum sector characterizes it, the museum's mission (Malaro and DeAngelis, 2012).

Constituted as nonprofits, museums are therefore organized to offer "life-enhancing" benefits, such as education, to the public through their work with objects, in exchange for their tax-exempt status (DeAngelis, 2002). Like other nonprofits, museums are founded by members of the public to be independent of the direct control of government; as a result, they also support the expression of a diversity of views through the development of unique missions, which may differ from the interests of the government. For example, many culturally specific organizations, such as African American museums, were formed by groups of dedicated members of the African American community in the 1960s and 1970s. While their founders were passionate about their community's history and culture, there was little government interest in supporting the creation of these kinds of museums at the time or in preserving objects or stories from these communities.

Museums, like other nonprofits, are also sheltered from marketplace forces, and, while there is more and more pressure on museums to generate income, museums permit citizens to be involved in causes that they care deeply about, such as local history or contemporary art. Museums provide an entity in which the public can serve as volunteers or which the public can join as members (Malaro and DeAngelis, 2012). Each museum, however, must develop its own ways to implement, support, and attract a segment of the public to its purpose while not straying from the formally articulated mission outlined in its founding documents (DeAngelis, 2002).

MUSEUM ORGANIZATION AND TRUSTEESHIP

As charities, most American museums are organized as what is known as "charitable corporations." This means that they are organizations created in a

"corporate" or group form to pursue a specific charitable purpose, where the concept of "charity" is interpreted broadly. As Malaro and DeAngelis (2012) stress, however, a "charitable corporation" is a hybrid organization in that it blends the characteristics of two other legal constructs, those of a "charitable trust" and those of a "corporation," meaning that it has characteristics of both a trust and a business corporation.

To understand how museums are organized, it is therefore important to review the concept of the *charitable corporation* in some detail. Because the charitable corporation is a hybrid entity, which may be unfamiliar to some museum personnel, it can be helpful first to outline its more familiar components, the *charitable trust*, followed by a review of the *corporation* as a construct, and then to return to discussing the museum as a charitable corporation (Malaro and DeAngelis, 2012).

A trust is a legal arrangement in which someone holds property that is administered for the benefit of someone else. The someone who holds the property to benefit someone else is called a "trustee," while the property is being held to benefit the "beneficiary." Even if the trustee has legal ownership of the property, the trustee cannot use the "trust assets" for personal purposes. This is important because the trust relationship imposes a high degree of responsibility on the trustee. Indeed, the trustee must work to protect and preserve the trust assets while not enriching himself or herself. In this kind of arrangement, a "fiduciary" relationship is created, meaning that a special relationship of duty exists in which the trustee must consistently act in the interests of the beneficiary (Malaro and DeAngelis, 2012).

One trust-like situation that many people are familiar with concerns the arrangements that can made for young children to care for them in the event that their parents die. If a trust has been formally established, a trustee will be appointed to handle the family's assets. The trustee will have control of all the assets that were placed in the trust, such as the proceeds from any sale of the children's home (for example, if the children are moved elsewhere to live with a relative and their home has been sold). Any action the trustee takes must benefit the beneficiaries of the trust, who are the surviving children. The trust assets, for example, might eventually be used to fund the college education of the children. In the meantime, the trustee must manage the trust responsibly, without any hint of using the trust assets to enrich himself or herself, such as by using the trust assets to take a personal vacation.

Museums can be considered to hold collections in a trust-like situation and to manage their collections for the benefit of the public, so that the public is the "beneficiary." As discussed below, this arrangement has important implications for the actions the museum takes in caring for its collection, especially for the museum's board in acting as "trustees." With museum collections held in a trust-like situation, how concerned should a museum's board be about the state of care of the museum's collections, for example, as opposed to devoting

much of its energies to non-trust-like aspects of its responsibilities, such as the museum's business dealings? And, if a new director finds that collections housed in its museum are seriously neglected, what kinds of arguments can the director marshal about the board's core "trust" responsibility to its collections to support taking some action?

While trusts can be quick to establish, it is also important to note that it is very difficult to shift their purposes. As Malaro and DeAngelis (2012) outline, such a modification commonly involves taking the request to court, and, even with a compelling argument, a shift in purpose may be difficult to achieve. Significantly, if a museum were to be set up as a trust, it would be very difficult to shift its purpose, or mission, ostensibly making it impossible for museums to be responsive to changing circumstances (Malaro and DeAngelis, 2012). Over the past thirty years, for example, natural history museums would have been very ill-served to have been organized as trusts, because many have shifted their missions dramatically to respond to climate change and the loss of biodiversity.

Several other features of trusts with implications for museums are important to stress (Malaro and DeAngelis, 2012). First, as suggested above, trustees must not engage in self-dealing, meaning that they cannot personally benefit from their role as a trustee. Second, trustees must be very careful to avoid conflicts of interest and breaches of trust; as a result, the standard of conduct for a trustee is very high and exacting. Even a trustee's best behavior in managing the trust, for example, may not be enough to ward off an allegation that the trustee is not acting in the best interests of the beneficiary. Third, trustees cannot delegate their responsibilities, which is very different from the way museums are organized as charitable corporations. In museums, for example, boards delegate many day-to-day matters to their directors or chief executive officers (Malaro and DeAngelis, 2012).

To understand the museum as a charitable corporation, it is therefore important to outline the "corporation" aspect. In a corporation, or business, the assets of the business are held by the company for the benefit of stockholders, and the director and staff work to enrich the company and, hence, themselves (Malaro and DeAngelis, 2012). Significantly, the standard of conduct for corporations is less demanding than that in a trust; oversight of corporations is supplied by stockholders, who are quite commonly focused on whether adequate profits have been made (Malaro and DeAngelis, 2012). In a corporation, it is possible to behave less well than in a trust setting and not necessarily run afoul of stockholders; for example, the board of a corporation may decide to use some company assets to fund an exclusive "work" retreat for itself and not suffer any repercussions from stockholders, if the company is otherwise profitable.

As organizations, most museums can best be considered a blend of charitable trusts and corporations (Malaro and DeAngelis, 2012). Specifically, as

charitable corporations, museums are *trust-like* in that they hold collections for the benefit of others, cannot use their collections to enrich themselves (such as by unilaterally selling them to raise operational funds), and must work to protect and preserve their collections to benefit the public. As corporations, however, museums run a range of complex business operations, from hiring and firing employees to running museum shops and membership programs. Moreover, charitable trusts primarily involve the oversight of financial assets and do not operate the kinds of programs that museums do, programs that intersect with the business world. Museums, on the other hand, draw heavily on the "corporation" side of the model in their business operations.

For museum directors, understanding the organizational model of museums, as outlined above, provides great insight into how a board should behave in exercising its duties and, in turn, how museum directors can evaluate challenges facing the museum. When challenging issues emerge, whether related to questionable board behavior, the public's perception of the museum, or key issues facing the museum, a very illuminating question directors should ask themselves is the following: is the specific issue one that relates to the *trust* or the *corporation* side of the museum?

In making decisions, museums and boards also need to follow standards of conduct. As Malaro and DeAngelis (2012) outline, the general standard of conduct for corporations involves *gross negligence*, which is a reckless disregard for the safety of others, while, for charitable trusts, it is *mere negligence*, which is a careless, lower-stakes mistake that involves the safety of others. In caring for museum collections, Malaro and DeAngelis (2012) argue convincingly that boards should expect to be held accountable to the level of *mere negligence* rather than gross negligence because collections care is reflective of the museum's trust-like responsibilities. In the area of the business operations of museums, however, they argue that the board should expect to be held accountable to the level of *gross negligence*.

WHAT AN UNDERSTANDING OF MUSEUM ORGANIZATION MEANS

Understanding the distinction between mere and gross negligence, along with understanding the corporation and trust sides of museums, provides museum directors with a powerful analytical tool for assessing a particular issue facing a museum. After ascertaining whether the issue is related more to the trust or to the corporation side of the museum, the museum director can determine the appropriate standard of conduct that would apply, mere or gross negligence. Then, the director can develop appropriate measures to address the issue, which may include making strong recommendations to the board for specific actions, redirecting resources under the control of the director, or referring the matter to the board for discussion.

At the Smithsonian, for example, an assessment, done in 2021, of the vulnerability of its many museums to climate change concluded that the collections of two museums on the National Mall, the American History Museum and the museum adjacent to it, the National Museum of Natural History, were the most vulnerable to damage from flooding (Flavelle, 2021). During a flood, artifacts housed in basements could become damaged, and environmental control systems located belowground could be rendered inactive, affecting all parts of the museums. In the American Museum of History, for example, which houses more than two million objects and which was built in 1964, collections have grown over time. Some collections are now stored in the basement, which experienced water intrusions during storms in the spring of 2021, while other areas, such as the entrance hall, have either been flooded or are known to be highly vulnerable to flooding. The issue of flooding outlined here clearly speaks to the trust side of the organization and the museum's consequent responsibility to take proactive steps to protect its collections, which it holds in trust for the public.

As the Climate Change Action Plan (2021) notes, however, the Smithsonian faces challenges in the area of infrastructure and facilities that involve balancing the need to maintain ongoing resources for flood protection with other Smithsonian priorities, such as the planned construction or revitalization of several other Smithsonian museums. The Smithsonian receives more than half of its funding from the US Congress, which has vested responsibility for its administration in a board of regents (Smithsonian, 2024a). Indeed, for the past several years, the Smithsonian has repeatedly requested funding to begin work on a $160 million storage site in Maryland to house collections from the American History Museum and the National Art Gallery (Flavelle, 2021). While construction on the storage site has not yet begun, the American History Museum, in particular, is planning to seek government funding for infrastructure to protect it from flooding. Until Congress funds these efforts, "an institution that is beloved by the public . . . is protecting the nation's treasures with sandbags and garbage cans" (Flavelle, 2021). In the meantime, many efforts are being made by the staff to protect the American History Museum's collections from water damage, while the Climate Change Action Plan itself powerfully documents the consequences of inaction for those responsible for funding the organization. Should a catastrophic flood take place, the board of regents would be hard pressed to argue that its actions in failing to protect collections amounted to mere negligence, an understanding of which is useful to senior staff who need to prioritize what issues must be put before its board for consideration.

In the case of a museum with very limited resources that finds itself facing a minor leak in its roof, on the other hand, the museum director can ask if the water is damaging objects in the museum's collections area or if water is leaking on items in the museum's gift shop. Both require immediate action, but the leak in the collections area can be considered more urgent because it

strikes directly at the *trust* side of the museum while also once again raising the standard of *mere negligence*, meaning that even the possibility of a little damage to collections is of major concern and must be avoided at all costs. Although the items in the gift shop are important as a revenue source, if resources are limited in the museum, action in the collections area will need to be prioritized. If the potential damage to collections turns out to be of greater concern than initially thought, the director may also decide to alert the board.

Similarly, in the case of a museum facing long-term and public calls for the return of an object acquired years ago from a source community that has long sought its return, the director clearly has an issue in hand that relates to the *trust* component of the museum. Boards are inevitably involved in such claims for precisely this reason, though neither new directors nor boards may realize this. At the same time, the standard of care demands that any such claims should be handled urgently, because even a hint of poor management of a museum's collections, such as through long delays in reviewing claims from community groups, raises doubts among the public that items of great cultural and historical importance to these communities are in fact being well managed by the museum.

By referring to features of museums that are embedded in the museum model itself, directors may learn how museums are organized, allowing them to assess and prioritize the specific issues they face that involve their boards. By considering the legal underpinnings of museums and the nature of trust-eeship, along with understanding the role the board plays in maintaining the public's trust and in modeling ethical behavior, museum directors have a useful analytic framework that will help inform their work with boards and provide them with a strong foundation for advocacy about the issues that are most important to the museum's overall success.

3

What Is the Director's Role in Working with the Board?

THE DIRECTOR AND THE BOARD: A VIGNETTE

A museum located in a major metropolitan area has a large and well-managed collection, robust K–12 education programs, and several somewhat dated permanent exhibits. The staff is very busy and works hard on multiple projects, especially in caring for collections and implementing educational programs. The director of the museum was just promoted to the position from within the organization and, as a senior staff person prior to assuming the directorship, had demonstrated excellent management skills and a deep enthusiasm for the museum. Staff work well together and, typically, have developed projects on their own, though in consultation with the museum's director; once implemented, these projects are of the highest quality.

The museum also has nine board members. Unfortunately, each board member has a different idea of the museum's purpose and what he or she hopes the museum will achieve. Several times in the last year, for example, an individual board member has contacted a staff member and "pitched" an idea for a program or an initiative that he or she thought would crystallize the museum's purpose. The staff members communicated this development to the director at the time and, on a more informal level, to one another and discussed how they felt that they were being pressured to develop projects in areas that were of interest to board members. Over time, in attempts to try to please individual board members, the staff began to realize that they were developing programs that did not complement one another or, in their view, did not speak clearly to the museum's mission. Rather than developing new programs or initiatives, the staff began to deepen their work on those efforts that they already knew were successful, so that they would not draw the attention of board members to their activities.

The board also has a board chair, an affable and accomplished person who is also a strong advocate for the museum in the community. However, the director, who is now attending board meetings for the first time in his career, is also learning that the board chair is not skilled in setting and managing meeting agendas or in allowing the director to bring issues of concern to the board for discussion. The board chair also appears to want to avoid conflict during board meetings and is particularly interested in the operational issues of the museum, such as programming, rather than in strategic issues, such as developing plans for the how the museum could be more relevant to its diverse community. Moreover, as part of the director's hiring process, the board chair did not discuss when and how the director will be evaluated and informally offered the new director a salary without a written employment contract that included clearly delineated expectations for the job. The board's chair also has a busy professional life and, consequently, finds it challenging to meet one-on-one with the museum's director to help plan board meeting agendas together or to be available for guidance and perspective when issues arise that could affect the entire museum.

With growing concern, the new director begins to see that board members do not seem to be able to discuss the museum's long-term plans during board meetings. Instead, one board member makes the case that the museum needs to apply for a specific grant to support the work of a certain division of the museum, while another argues that the museum needs to put all its energies into a completely different area. Discussion inevitably focuses on areas that are of interest to an individual board member and on the activities and programs of the museum that are related to those interests. In the end, the board member who argues the most persistently at meetings usually gets his or her way about the kinds of initiatives the board adopts, with minimal input from the museum's director.

The director also notices that, during board meetings, the board appears unwilling to discuss or to make decisions about the challenges that the director has concluded face the museum. When the board makes decisions, it becomes clear that resources are being placed into already-successful programs, which staff members have previously developed through their own assessments of what they thought the museum's long-term goals should be. The new director also learns that individual board members have contacted certain staff members over the past several months and have given them guidance about how to "refine" the museum's more successful programs; these staff members report being told by another board member to do something quite different. It is often unclear to staff what they should do in these situations and who oversees the museum as a whole. Staff wonder if these board "assignments" are considered part of their "real" day-to-day work or are some kind of "add-on" that they are somehow expected to integrate into an already-full workload in order to keep the peace with board members.

The museum's new director soon finds that interpersonal conflict among the staff is rising and that this is undermining even the museum's strongest programs. Staff are becoming demoralized, feel as if they are competing with one another for key resources, and are increasingly concerned about the potential influence of board members on how their own work will be evaluated. In accepting the new position, the director had assumed that he would be running the museum and did not dwell too much on the role the board would play in the museum or in his day-to-day working life. If anything, the director assumed that interactions with the board would be limited and perfunctory and, because of the perceived need to socialize with board members at museum events, somewhat distracting from the "real work" going on within the museum's walls every day, which would focus on the museum's staff.

Finally, in working with the board, the director came to see that, on some issues, he had complete autonomy, while, on others, which were usually of interest to an individual board member, he had none. Disturbingly, the director's level of autonomy in some areas seems to shift from board meeting to board meeting. At some meetings, for example, board members were not interested when the director updated them about museum applications for funding, but, at others, the director felt pressured to prioritize those that were relevant to the interests of individual board members. Meanwhile, when staff come to the director for guidance about how to integrate board member requests into their work, the director increasingly found himself in the position of managing everyone's expectations about when and how staff should interact with the museum's board.

With deep concern, the director realized not only that he was unprepared for working with the board but also that board actions were beginning to sap his confidence in managing the museum. It was necessary to do something—but what?—the director wondered, as he also asked himself what could have been done to anticipate or to have addressed board-related issues more meaningfully as they emerged.

THE NEED TO UNDERSTAND THE DIRECTOR'S ROLE IN WORKING WITH THE BOARD

The vignette above illustrates why it is important for a museum director to understand what the director's role is in working with the board. With some foundational knowledge in hand, including understanding what processes are in place for decision-making in museums, how the chair of the board can manage board members, and the kind of working relationship between the director and the chair of the board that should be in place, the new director would have had information useful for navigating many important concerns.

For example, if the new director had known more about the group decision-making responsibility of boards that is inherent in how museums are

governed and had known that the work of a board chair can involve educating board members about the kinds of behavior that are appropriate for interactions with staff, he would have been able to identify areas of possible tension as they became apparent and, in response, could have developed plans to address them proactively. As another example, if the director had known that the museum board should have offered a written employment contract that outlined work expectations for the director, he could have requested one at the time the position was offered. In still another example, if the director had known about the importance of his relationship with the chair of the board, had known which tasks a director and a board chair typically work on together, and had known what makes for an effective partnership, he could have assessed these areas before accepting the position. Such information allows the director to understand how the board conducts itself in areas that should be of central concern to the success of the museum and, therefore, to make decisions about how to best lead the museum and to understand his own likely career trajectory.

As highlighted in the vignette, new directors may view the topic of working with boards as a distraction because they believe that their actual work in this area will be modest and that the bulk of their time will be spent in the oversight of staff activities. This chapter discusses three foundational areas in working with boards that new and aspiring museum directors need to appreciate: museum governance, which involves understanding how museums are structured; the role of the chair of the museum's board, with whom the director must work closely; and the nature of the board-director relationship. These areas build on the discussion in Chapter 1 of the board's role in maintaining the public's trust and the importance of understanding the board's ethical behavior and, as discussed in Chapter 2, the need for directors to appreciate the nonprofit basis of museums, the legal underpinnings of museums, and the implications of trusteeship. With this knowledge ready for use, directors have a fuller set of tools to navigate their important work with their board.

WHY MUSEUM GOVERNANCE IS IMPORTANT

Who is really in charge of what activities in museums and how much of the director's energy and time should be taken up by issues that involve board member behavior? What role should the director play in implementing the museum's mission, planning for the museum's future, or assessing if the museum's mission remains relevant to its communities? How does a museum's governing structure affect the director's interactions with its board, and how are important decisions made in the museum? The answers to these and other important questions about how the museum operates can be found through a consideration of museum governance.

Governance is the overall processes and structures that are in place and used to guide the museum as it works to meet its goals. At its core, governance is how a museum's board or governing body, in consultation with the museum's director, works to maintain the mission of the museum. If the mission of the museum is to serve as a place of education on the topic of climate change for K–12 learners, for example, how does the board act to ensure that this is the case? What financial, physical, and human resources has the board provided to support the museum's mission as a center of education for youth on the topic? The processes that are put in place must also support meeting the museum's goals in ways that are efficient, wise, and ethical and that clearly differentiate the responsibilities of the board from those of the director and staff.

One helpful way to think about governance in museums is to focus on the division of labor that should exist between the director and the board. The director's work should be to lead the day-to-day tasks that take place within the museum, such as caring for collections and presenting exhibits and programs, while the primary concern of the board should be with making the long-term decisions that support and define the museum's purpose, which do not involve direct oversight of the daily operations of the museum.

It is the therefore the board's responsibility to define the mission and vision of the organization; to be aware of and to approve the museum's key policies; to ensure that physical and financial resources are sufficient to implement the museum's mission; and to set goals for the museum that can be met ethically and with an emphasis on the stewardship, learning, and community-oriented functions of museums today.

Most importantly, the division of labor that should exist between the director and the board needs to take place within a clear, workable, and comprehensible governance structure, which many in the museum profession refer to as "good governance." In a museum with "good governance," the director understands that creating the mission and outlining the long-term goals of the museum are the province of the board, while the board understands that that director runs the museum's daily activities and programs. In a museum with good governance, the director understands that he will work closely with the board to apprise its members of issues that may have an impact on the museum's mission; that the director is the main point of contact between the board and the staff; and that the director must ensure that he and staff fully grasp how boards should operate. Finally, in a museum with good governance, board and staff respect one another's roles, demonstrate an interest in continuing education on governance, understand that they are interdependent and must work well together, and accept that the museum's director will need to interact in regular and meaningful ways with the board, with the substance of those interactions communicated to staff.

Ambiguity in governance, or when there is a lack of understanding on the part of those involved of how museums are governed, can result in "poor

governance"—a mission that is not linked to programs, board interference in activities that should be the domain of the director or the staff, or an inappropriate reliance on either the board or the staff for core activities. The absence of clear structures and responsibilities can mean that museum personnel appeal to board members rather than to management for intervention on an issue, if they disagree with a museum director's decision, or that a museum's struggle to meet its responsibilities, especially toward its collections, is played out in the press rather than through informed discussion within the museum.

Poor governance also poses significant risks for the museum's director. If the director works with a board that is unaware of the nature and scope of its responsibilities, such as its responsibility to hire and evaluate directors, to not interfere with staff activities, or to make timely and informed decisions about matters of major importance to the museum, both the day-to-day work of the director and his or her career trajectory can be affected.

The antidote to poor governance, however, is education; and, with knowledge, the saying goes, comes power. The ability to assess situations and to address them proactively when they become salient can be actively cultivated by directors and staff through learning about the processes and structures for the division of labor, decision-making, and the monitoring of goals that exist in museums.

But whose responsibility is it to ensure that everyone is educated about how the museum should be structured and organized? Museum directors can certainly educate their staff about museum governance, but the division of labor between the board and the director suggests that boards should educate themselves. While one could argue that it is the board's job to both know and to educate itself, the reality is that there is much a museum director can and should do to educate everyone in the museum about how it should be governed.

Because the museum director interacts regularly with both the board and the museum's staff, the director is uniquely positioned to identify "poor governance" and its consequences. In fact, the director may be the only person in the organization who can clearly see that the issues hobbling the museum are related to governance. And, while directors can work to address issues involving an absence of board evaluations of their performance, interactions between the board and the staff, and how key concerns are brought to the board, they can only do so if they have an awareness of issues relating to poor governance, how diagnose to them, and a knowledge of the remedies.

With an understanding of how museums are governed and what good and poor governance look like, museum directors can distinguish their responsibilities from what the board should or must be doing; can use ethical frameworks developed by professional organizations to support decision-making when interacting with the board; and can be prepared to address common governance-related challenges, many of which revolve around an absence of information and related misunderstandings about who is responsible for what.

WHAT ACADEMIC AND PRACTICE-BASED STUDIES SAY ABOUT MUSEUM GOVERNANCE

To help directors understand more about museum governance, several useful practice-based resources can be consulted: these include the classic volume of essays by Malaro (1994); guidance from organizations such as BoardSource (2024a), the Museum Trustee Association (2024a), and the American Alliance of Museums (2024d); as well as books by Lord and Lord (2009), Genoways, Ireland, and Catlin-Legutko (2017), and Miller (2017). However, surprisingly few academic- or practice-based *studies* of museum governance exist, and those that do often caution against the prescriptive approach that has arisen in practice-based resources, in which a set of "one-size-fits-all" rules for operational success are implied, even though detailed studies supporting such an approach do not exist (for example, see Bieber, 2002).

Some of the academic- and practice-based studies that do exist focus on rethinking museum governance entirely, in part because of the domination of museum boards by legal, political, or business interests (Sandell and Janes, 2019); on examining how differing types of governance structures affect museum operations or decision-making (Lord and Gerson, 2015; Oster and Goetzmann, 2003); and on exploring how the wealth and status of board members shape museums (Ostrower, 2002). Other studies examine new models of governance that meaningfully integrate the public and other stakeholders into decision-making (Bandelli, Konijn, and Willems, 2009; Garthe, 2022; Scott and Luby, 2007); note that museums, in certain parts of the world, are moving toward increased self-financing and the lessening of direct governmental control (Boylan, 2006); or stress that a strong relationship between the board and the director exists in museums that are operating smoothly (Bieber, 2002; Dickenson, 1991). Still others emphasize that more research needs to be done on museum governance so that it can be integrated into museum practice (Rentschler, 2004).

To summarize, then, the state of research on museum governance suggests that, while museum directors need to understand practice-based resources, there is still much to be learned on the topic, and, consequently, they must be flexible, open-minded, and willing to adapt to situations that do not conform to some of the conventional wisdom outlined in practice-based resources. A central part of the director's position will always have to do with governance. As former museum director and author Stephen Miller jokingly wrote, fifty percent of a director's job involves working with staff, fifty percent involves fundraising, and fifty percent involves dealing with trustees and people outside the museum (2017, 37–8). Museum directors therefore have a very practical need to understand the roles and responsibilities of their museum's governing authorities and, as discussed in the sections below, to appreciate the pivotal role that the board chair plays in their work.

THE CHAIR OF THE MUSEUM'S BOARD

In museums with formally constituted boards, the board consists of at-large members along with officers who typically include a treasurer, secretary, vice-president, and, the most important of all for the work of the director, the board chair or president. The board chair is typically elected by other members of the board in a process outlined in the board's bylaws. In a comprehensive survey of boards conducted by the American Alliance of Museum (the AAM) and Board-Source (2017) called *Museum Board Leadership: A National Report,* just over half of museums were found to elect their board chairs for one- or two-year terms, almost half allowed board chairs to serve consecutively for either one- or two-year terms, and more than one-third did not limit the number of consecutive terms the chair could hold. The variable landscape for the length of time that board chairs serve highlights the need for directors to have skills both in working quickly to establish positive relationships with new board chairs as well as in working productively with a board chair who may serve for several years.

The main duties of the board chair include leading the board's meeting, managing the board's committees, serving as an external advocate for the museum, and regularly communicating with the director of the museum to offer opportunities to share information and concerns about the organization. The specific duties are outlined most succinctly by BoardSource (2024b), which lists the board chair's responsibilities as working with committees, leading meetings, and recruiting, orienting, and assessing board members. BoardSource also notes that the board chair needs to work with the director to ensure that board decisions are implemented; that board meeting agendas are prepared in consultation with the museum's director; that the board's director oversees the search for a new director; and that the board chair coordinates the annual performance review of the director.

Of interest to the director here is how the board chair manages the board and the kind of behavior or "culture" that the board chair fosters among its members. In the AAM survey of museum board leadership, the "culture" of the board is referred to as the "soft skills or 'cultural intelligence' of individual board members, or their predisposition to working well in teams" (2017, 32). For example, does the board chair signal the value of continued education to board members about ethical issues, interactions with staff, or by making time in meetings for discussion of board responsibilities? Does the board chair encourage an environment in which all board members make decisions collectively, respectfully, and with relevant input from the museum's director? Does the board chair create settings for discussions at board meetings that allow for the director to offer guidance on policy development, strategic planning, or changes in the museum's external environment?

While many of these management traits are not formally included in lists of duties for board chairs, the AAM's 2017 board leadership survey found that

the culture of the board is of great significance in whether boards are considered effective by directors. For example, in assessing board culture, almost four-fifths of museum directors agreed that "honest communication" exists among board members in their museum and that their board "encourages, supports, and listens to creative and innovative suggestions" (2017, 32). In addition, more than three-fourths of museum directors reported that the board was able to resolve internal conflicts professionally and positively. Tellingly, however, museum directors also reported that board culture was weakest in two areas: the efforts of the board to continue to learn about its work and the organization and its efforts in encouraging higher performance from board members and from the organization. These results suggest that the management skills of the board's chair, and the kind of behavior they encourage in creating a productive board culture, have a large impact on the director's work.

The specific responsibilities of a board's chair are often outlined in a museum's bylaws. For example, in the bylaws for the Lindsay Wildlife Experience, a small museum located in the San Francisco Bay Area, whose mission is to connect people with wildlife, the chair's responsibility to preside at meetings is outlined. Another provision in the bylaws indicates that the board chair is to simultaneously serve as the museum's director if, for some reason, a director is not in place (Lindsay Wildlife Museum, 2016). At the Knoxville Art Museum, the bylaws' description of the powers and duties of the chair emphasizes the role of the board chair in leading regular board meetings as well as in leading in the board's executive committee, which is a subset of the larger board; significantly, the bylaws state that, under the leadership of the board's chair, the executive committee is fully empowered to act on behalf of the board and, furthermore, is responsible for the selection and retention of the museum's director (Knoxville Museum of Art, 2016).

In addition, as the Society for Nonprofits points out, the chair of the board is responsible for meeting his or her regular member-at-large responsibilities; for complying with any additional stipulations in the organization's bylaws that pertain to the chair; for encouraging transparent communication; for guiding and mediating board actions related to organizational priorities and governance; and for developing and implementing strategic planning (2024). Of particular interest to the director in the duties listed is the chair's work to assess the performance of the organization, and the need for the board's chair to "play a leading role" in fundraising activities, including in cultivating and stewarding donors.

The chair of the board has an important set of duties that involve leading the board, facilitating productive meetings, shaping board culture, and ensuring that the board is well trained and ready to meet its responsibilities. The board chair also has a crucial role in his or her work with the director, and, through the partnership that is formed, the director can participate in discussions that shape the purpose and goals of the museum. At the same time,

the fact that board chairs mostly leave their positions during specified terms means that directors must be fully aware of the duties of the board chair so that they can determine when specific board chair responsibilities might need attention when board chairs change. Whether the chair of the board serves for one year or for several, however, the organizational capacity of the museum and the professional development of the director will be intertwined with the work of the board's chair.

THE BOARD CHAIR–DIRECTOR RELATIONSHIP

Much has been written about the nature of the relationship between the chair of the board and the nonprofit director, with a stress on the practical need for a partnership that is based on trust and an understanding of the difference in their respective roles (Howe, 2004; Robinson, 2001: The Nonprofit Answer Book 2012; Trower, 2012; Widmer and Houchin, 2000). While insightful, the literature does not focus on the museum sector and is mostly written for the edification of boards and board chairs rather than emphasizing what directors need to know about this relationship. Therefore, an overview of the core features of the relationship between the board chair and the director, one that is based on the available nonprofit literature, is presented below, followed by a summary of the most important source of information about the board chair–museum director relationship, the AAM's 2017 survey of museum board leadership.

The central theme in the nonprofit literature about the board chair–director relationship is that it is a trust-based partnership that must involve clear and honest communication. The many descriptions of what the director and the chair work on and how they work together, such as meeting regularly, developing board meeting agendas together, and being key participants in policy and strategic planning discussions, can all be seen as built on a foundation of trust and as part of a partnership that must be carefully managed at all times. The relationship is also characterized as one in which the director and board chair both understand who is responsible for what in the organization, in which the director is willing to take feedback from the chair, and in which the director is comfortable sharing concerns about the museum and the board with the chair. As leaders at different places in the organization, both the board chair and the director need to be able to navigate tensions in their relationship productively and to understand that their relationship is similar to a marriage or a business partnership in that there is a consistent need for mutual respect and open communication.

One of the most useful characterizations in the nonprofit literature of the director's relationship with the chair of the board is presented in the Board-Source publication by Williams and McGinnis (2011), in which several "rules" for directors to follow are outlined. In addition to the director emphasizing the

organization's mission and his or her deep knowledge of the organization in interactions, the rules focus on the director's need to build relationships, to communicate forthrightly, and to be able to take and offer constructive feedback. On a practical level, the rules also stress the need for the director to help the chair structure the work of the board, to create a balance between the chair and the director concerning their respective roles and responsibilities, and to plan for transitions of either the board chair or the director. One especially helpful feature of the publication is its characterization of the partnership between the chair of the board and the director as one that includes education on the part of the director and making the board chair and other board members aware of how they can make the organization live up to its potential.

The survey of museum board leadership conducted by the AAM in concert with BoardSource (2017) provides important information about how museum directors interact with and assess the performance of board chairs. For example, almost two-thirds of museum directors thought that board chairs did an excellent job in "cultivating a productive, consultative partnership" with the museum's director, and just over half of museum directors rated their board chairs as the "#1 go-to-person when they have a need to consult frankly on a tough decision" (2017, 10). At the same time, a little less than half of museum directors thought that their board chair did an excellent job in encouraging board members to "frame and discuss strategic questions" (2017, 10). And, in other areas heavily shaped by the board chair, only about half of the museum directors in the study agreed or strongly agreed that their "board members share accountability and take collective responsibility for failures and mistakes" (2017, 10), while the board's responsibility to evaluate its director was viewed by museum directors as being less important than most other board responsibilities.

Together with the nonprofit literature, the AAM survey of museum board leadership highlights key features and challenges of the partnership between the chair of the board and the director. Clearly, the relationship between these two individuals is important to understand because through it the board's and the museum's day-to-day operations are connected. The relationship is also a visible manifestation of museum governance as well as the place where decisions will be made about what issues will be elevated or considered unimportant for the board to address. And, while the relationship between the chair of the board and the director is undeniably critical for the success of the museum, it is also important for the professional development of the director. Given all this, it is in the best interests of directors to understand both the nature of the relationship with the board chair as well as how to develop and maintain effective partnerships with the chair.

In sum, the director's role in working with the board is to know that boards are concerned with the "big picture" of the museum, with defining and supporting the museum's purpose, mission, and vision, and in understanding how

the board's actions will affect the museum, all of which are a part of museum governance. Directors also needs to understand the role of the board's chair, to know how and why they will interact with the chair, and to recognize that the board chair–director relationship is infused with power. As outlined in the vignette that begins this chapter, however, new directors may find that the skills and training that they acquired in learning about museum management may not be sufficient for their ongoing work with boards. Fortunately, the resources for learning about a director's work with boards can be readily studied and the information provided can be absorbed by both aspiring and new museum directors.

4

What Are the Core Responsibilities of Boards That Directors Need to Understand?

BOARD RESPONSIBILITIES: A REAL-LIFE EXAMPLE

The Louisiana State Museum system consists of nine different museums, including the Capitol Park Museum in Baton Rouge, the Northwest Louisiana History Museum in Natchitoches, the New Orleans Jazz Museum at the U.S. Mint, and The Cabildo, a museum located in the French Quarter in one of New Orleans's most historically important buildings (Louisiana State Museums, 2024). The goals of the Louisiana State Museum system include collections care, education, and interpretation related to the state's history, culture, and people, and meeting these goals "with the highest level of professionalism, scholarship, management, and in accordance with the American Alliance of Museums" (Louisiana Office of the Lieutenant Governor, 2020; Waguespack, 2023, 1).

A recent state audit of the Louisiana State Museum system concluded that the system has "inconsistent leadership"; "no comprehensive strategic plan"; a governance structure that creates "political interference and tension"; "low employee morale" that may affect museum operations; an absence of "proactive budgeting" in key areas; and low levels of fundraising, with few staff permitted to actively raise funds (Waguespack, 2023, 4–20). Auditors also reported that staffing was inadequate, that workloads were unrealistic, and that the system's exhibits, a core feature of the system, were outdated. The audit was based was based on reports from consultants and extensive interviews with board members, museum staff, and support organizations (Sentell, 2023a).

The audit outlined that the Louisiana State Museum system is overseen by the State of Louisiana and is housed within Louisiana's Department of Culture,

Recreation, and Tourism. The Louisiana State Museum system director reports to a board, called the Louisiana State Museum Board, which was created by the state and is composed of twenty-one members who are appointed by an elected official, the state's lieutenant governor, who is also a member of the board and who has been empowered by state law to hire and terminate the director's employment. The audit reported that the Louisiana State Museum Board assists the museum system in certain fiscal, budget, and business areas and that, until 2008, the board had the power to hire and to terminate the employment of the museum system's director (Waguespack, 2023).

The audit further noted that "turnover and vacancies in the director position is one of the major challenges" facing the Louisiana State Museum system and that a "perceived politization" of the director's position has made it difficult for the recruitment of suitable candidates and for the retention of those that are hired (Waguespack, 2023, 8). In the past twenty years, for example, there have been eleven directors, seven of whom were interim directors. The audit attributes the frequent turnover to variation in the length of time any one individual remains in the position of lieutenant governor, who is responsible for appointing the director.

The Louisiana State Museum Board, in a letter to the auditor from its chair, emphasized that the board will work to "cultivate a better working relationship" with the Louisiana State Museum system to "form a constructive partnership to become stronger." Moving forward, the board chair also formally agreed with the auditor's recommendations to fill the director's position on a permanent basis, by selecting three candidates for the lieutenant governor's approval, and to work to "improve the functionality of the relationship" between the board and the museum system (Waguespack, 2023, A-2, 2).

The audit was widely reported in state media outlets, which described it as "blistering" and as a possible issue in the upcoming campaign for the election of the lieutenant governor (Sentell, 2023b). Media accounts highlighted the "woeful underfunding" of the museum system, saying that its "workforce has fallen sharply" in the past several years "owing in large parts to a lack of funding" and that, while a five-year plan that outlines goals for the museum system exists, "it does not include a plan or [indicate] who is responsible" for implementing the goals" (Potter, 2023). Upon its completion, the audit was sent to the president of the Louisiana State Senate and to the speaker of the Louisiana House of Representatives for review (Waguespack, 2023); media reports noted that the lieutenant governor "could not be reached for comment" (Sentell, 2023a).

THE CORE RESPONSIBILITIES OF BOARDS

What are the board's core responsibilities in museums? What does guidance from nonprofit and museum-specific resources outline about who in

the organization has the authority to hire and to terminate the employment of directors, for example, and who has the responsibility for strategic planning or for ensuring that fiscal, human, and physical resources are sufficient? And how does a museum's particular governance structure, such as in museums that are part of large state governments or universities, affect the director's work?

As the case of the Louisiana State Museum system illustrates, the answers to these questions have important implications for the success of a museum as well as for how directors go about their work. Had the Louisiana State Museum Board understood its core responsibilities, it is unlikely that so many directors would have been come and gone and likely that plans to identify the resources to update exhibits and to stem the loss of employees would have been developed. In addition, the audit, which sheds a very unflattering light on the board and the museum's governance, might not have even taken place.

To ensure that their museums are successful, directors of museums of all kinds need to understand the core responsibilities of board members. Given the museum's unique role in collections stewardship, as a place of education, and as a center of community, a knowledge of these responsibilities can help directors understand what museum boards are supposed to do rather than accept what boards believe they *should* do. Directors can also use their knowledge of these responsibilities to develop plans to respond to situations when boards do not appear to comprehend their responsibilities or seem unable to act upon them.

Museum directors must realize that they may be working with board members who are not completely aware of their responsibilities or who may find it more interesting to focus on the day-to-day operations of the museum rather than on the larger-scale issues that should concern boards, such as the museum's mission. At the same time, boards are composed of volunteers who typically cycle on and off a particular board every few years; many boards meet as infrequently as once a month; and the training of new board members varies considerably across organizations. If confronted with a board that will not engage with its core responsibilities, museum directors may want to consider developing strategies to educate their board about its core responsibilities, though directors themselves must first be aware of them.

In the last chapter, the importance of the division of labor that should exist between the director and the board was discussed as part of understanding museum governance. It was stressed that the director's work should be the day-to-day tasks that take place within the museum while the primary concern of the board should be with making the long-term decisions that support and define the museum's mission. In this chapter, the core responsibilities of boards that directors need to understand are discussed in depth so that directors have the knowledge to comprehend when a board is not living up to its responsibilities, what the director should expect boards to do in areas that

intersect with the director's own responsibilities, and how differences in governance structure can affect how boards interpret their responsibilities.

Board Responsibilities and Nonprofit Resources

Before discussing museum-specific information about the board's core responsibilities, it is first useful to review influential resources from the broader nonprofit sector. The leading guidance in the nonprofit world, *Ten Basic Responsibilities of Non-Profit Boards*, was written by Richard T. Ingram (2015). Any training that a museum board may have received to date either will have included Ingram's work or will have been based upon it. This popular and practical guide, which has been revised over the years, succinctly outlines general principles of which boards and directors must be aware.

An overview of Ingram's ten responsibilities is presented here. These can be grouped into three major areas: 1) mission and direction of the organization; 2) oversight of the organization; and 3) ensuring sufficient resources are in place for the organization to implement its main purpose, or mission. The first responsibility is to establish the mission and purpose of the organization, followed by the second, which is to select the director or chief executive officer (CEO), and the third, which is to support and assess the CEO. The fourth is to ensure that the organization's planning is effective; the fifth is to ensure adequate resources are in place; and the sixth is to manage finances and resources effectively. The seventh responsibility is to monitor and to strengthen programs and services, and the eighth is to enhance the public standing of the organization. Finally, the ninth responsibility is to ensure the legal and ethical integrity of the organization, while the tenth is to maintain accountability.

Another leading place for guidance about nonprofit boards is the nonprofit organization BoardSource, which offers an array of highly useful resources that focus on board education, research about boards, and guidance about board operations (BoardSource, 2024a). Although these resources have been developed for board member education, it is well worth the time of any new or aspiring museum professional to review them because the topics examined highlight the core responsibilities of boards and discuss important features of the board's relationship with the director.

One publication from BoardSource, titled "The Source: Twelve Principles of Governance That Power Exceptional Boards" (2005), is read more commonly by museum professionals than others published by BoardSource because it was reprinted in the widely circulated book *Reinventing the Museum: The Evolving Conversation on the Paradigm Shift* by Gail Anderson, which itself was published in 2012. The "Twelve Principles" publication presents the features of what it calls an "empowered board" and, in doing so, outlines a set of responsibilities that all boards should be striving to meet, not just well-educated, well-functioning ones. Specifically, boards should have constructive

relationships with their organization's director, should shape and uphold the organization's mission, and should practice strategic thinking. Boards should also have a culture of inquiry that leads to shared decision-making; they should have in place rigorous conflict-of-interest procedures that speak to putting the interests of the organization above all else; and they should promote transparency in all their activities and in the organization for which they have oversight.

Boards should also be accountable, practice oversight, and promote ethical values, as well as ensure that resources are in place both to sustain the organization and to have it flourish. In addition, boards should be "results oriented," or concerned with assessment of their organization's major programs, and they should be "intentional" in their efforts to understand how governance operates in the organization while continuing to learn about both the organization and how the board itself should function. Finally, boards should recognize that revitalized boards are those that have turnover of board members, continual recruitment of board members, and a focus on inclusiveness.

New museum directors may find that the "Twelve Principles" publication outlines a rather daunting list of responsibilities that boards need to be concerned with while not recognizing the education- and collections-based nature of most museums. Nevertheless, several of the board responsibilities that are outlined will have a direct impact on the director's work. Such responsibilities include the development and implementation of the museum's mission; the selection and evaluation of the museum's director; oversight of the museum's finances, which includes activities such as audits and the management of any investments; the supply of sufficient financial resources, typically in the form of an annual budgeted allocation that the director uses to operate the museum; the assessment of programmatic effectiveness; the practice of transparency and the enhancement of the public standing of museums; and participation in fundraising.

The overall utility of BoardSource's "Twelve Principles" publication for museum directors is that it is accessible, it outlines what an "ideal" board looks like when it comes to board responsibilities, and it offers a clear template for understanding the areas with which a board should be concerned. Along with creating a set of expectations for how board members should behave in their official capacity as board members, directors can use the information in the publication to informally assess the strengths and potential weaknesses of their board.

Board Responsibilities and Museum Resources

Several museum-focused resources, which focus explicitly on the board's responsibilities in museums, are especially helpful for new museum directors to know about, as discussed below.

First, in its articulation of the professional practice and standards that museums must have in place in the area of governance, the AAM clearly follows the ten core responsibilities outlined by Ingram (American Alliance of Museums, 2024c). Ranging from determining the mission and purpose of the museum to selecting and assessing the director, ensuring that programs are relevant to the museum's mission, and ensuring that effective organizational planning is in place and that the museum's public standing and legal and ethical integrity are enhanced, the list of core board responsibilities outlined in the AAM governance standards helpfully frames broader nonprofit responsibilities in a museum setting (American Alliance of Museums, 2024c).

It is noteworthy that the AAM interprets part of Ingram's sixth responsibility, managing finances and resources effectively, in terms of collections and stresses there that the stewardship of collections is a core board responsibility. Furthermore, similar to the approach taken in the "Twelve Principles" publication, the AAM standards emphasize the importance of recruiting and training board members, as well as assessing the performance of the governing authority itself, which is viewed by the AAM as an expression of the museum's overall accountability to the public.

Another museum-focused resource, by Marie Malaro and Ildiko DeAngelis (2012), takes a different approach to outlining the responsibilities of boards. In reviewing a series of legal cases involving museum board action, they conclude that boards have responsibilities in three main areas: duty of care, duty of loyalty, and duty of obedience.

For duty of care, Malaro and DeAngelis argue convincingly that museum boards are responsible for ensuring that the core function of museums, the care of collections, is carried out in a good-faith manner. They conclude that boards should demonstrate their concern with collections by giving attention to the development, setting, and monitoring of a reasonable collections management policy, which they emphasize is also an important component of ethical codes promulgated by the museum profession.

For duty of loyalty, because loyalty to the museum's purposes outweighs any individual's personal interests that may be pursued through the museum, Malaro and DeAngelis assert that boards must disclose any conflicts of interest. Such conflicts can arise, for example, if a museum board member knows in advance that her family-owned construction company will benefit financially if the museum is to expand or upgrade its collections facility.

Finally, for duty of obedience, Malaro and DeAngelis conclude that board members are obliged to focus on the mission of the museum and that this should invariably involve the board considering whether the museum has sufficient resources to support the museum's approach to stewardship of its collections. In other words, if board members are inattentive to major issues involving their collections, they risk failing to meet their duty of obedience.

Moving beyond the legally inspired approach discussed by Malaro and DeAngelis, the well-known essayist and museum professional Stephen Weil (1995) contends that the core responsibilities of museum boards must include three areas: defining the museum's focus, monitoring the museum's performance, and maintaining the museum's competitiveness.

In the area of a museum's focus, Weil asks a compelling question: "What is the bottom line for your institution?" For example, is the museum's primary focus on research or education, or on public service, or is it to preserve collections? He thinks that boards need to ask what the museum ultimately hopes to accomplish with its limited resources and that the answer to this question is critically important, for it will shape the ideas, values, and objectives of the museum.

Next, in the area of performance, Weil asserts that it is the board's responsibility to assess if the museum is achieving its stated outcomes, particularly in the area of programs. He argues persuasively that museums in general need to become more conversant in assessment as a way of sharing information about their achievements with boards.

Finally, in the area of competitiveness, Weil argues that each museum should be doing something different from what other museums are doing. Boards need to ensure that their museum offers a unique value and that the museum is well worth what is costs to run it.

The core responsibilities of boards may seem abstract at first, but an understanding of them offers clarity for what new and aspiring museum directors need to focus on as they assume leadership of an organization as well as a way of understanding and navigating ambiguities that might be encountered about who is responsible for what. Far from being a dry list of duties, a knowledge of board responsibilities supplies new and aspiring museum directors with a foundation from which they can assess their boards, identify areas in which boards may need to strengthen, and examine whether their museum is meeting its trust responsibilities and maintaining its relevance to the community.

Museum Boards and Policy

One last area to discuss in the area of board responsibilities concerns what part of the organization is responsible for policy. While experts agree that the board approves policy, there are different approaches to how policy should be developed. Some experts recommend that the board's role is to develop and approve policy (for example, Carver, 2002), but museums tend to take a more pragmatic approach and either develop policy through the joint efforts of the museum's director and the board or simply have the senior staff coordinate policy development for approval by the board.

What part of the organization is responsible for policy development is a gray area in museums because those with the most knowledge about

professional standards, best practices, and current issues of concern tend to be the professional staff rather than volunteer board members, who have limited time to devote to learning about critical policy-related issues. Although there is no hard-and-fast rule for how to best develop policy in museums, developing policy for certain areas of collections stewardship today, for example, involves being aware of a range of complex laws and regulations that may require considerable time for boards to discuss and understand before developing policy.

No matter who develops policy, however, museum directors must monitor the effectiveness of current policies that impact museum operations, work to have board members understand the museum's policies, and use updates to policy as an educational tool for the board, especially in areas such as collections stewardship that relate to the trust components of the museum's work.

In sum, new and aspiring museum directors have a set of materials about the core responsibilities of museum boards at their disposal, ranging from nonprofit resources and museum professional standards to museum-specific literature. These resources can help directors assess the work of museum boards and can potentially be used to educate them. To be an effective museum director today, and certainly for a first-time director, it is important to understand what the board's responsibilities are, how they are expressed in museums, and, if necessary, to find ways to help the board meet its responsibilities.

CORE RESPONSIBILITIES AND GOVERNING AUTHORITIES

The need for assessment and accountability, including of the board itself, is a theme that is interwoven throughout discussions of the core responsibilities of boards. It is only possible to assess the governing authorities of a museum, however, if everyone is aware of who these authorities are. While this may seem obvious, in practice, new directors and many staff members may have given little thought to governing authorities or to the governance structure in their museum. In some museums that are part of larger organizations, for example, such as museums in state or city governments or those in universities, it may be unclear to new directors what part of the larger organization is responsible for ensuring that core responsibilities are met. Museum directors and staff will also likely be confronted with a range of entities that either are called boards or act like boards. If there is something in a museum called an "advisory board" or an "assessment committee" or a "friends group board," for instance, which responsibilities have been formally delegated to these entities, and how do these differ from those that they *believe* have been delegated to them? And which of these "boards" or "committees" is technically responsible for evaluating the museum's director?

To distinguish the museum's true governing authority from other entities, and to understand how core responsibilities have been formally assigned in a museum, directors must understand the type of *governance structure* that is

present in their museum. To assess the governance structure in a museum, directors of nonprofit museums must ask a key question: is the museum part of a larger organization, such as a university, a foundation, or a state or local government?

If the museum is part of a larger organization, as the Burke Museum is, as a component of the University of Washington, or as the Illinois State Museum is, as a component of the State of Illinois, the museum is part of what is most clearly termed a "nonmuseum parent organization." This simply means that the museum is part of a broader organization whose purpose is not usually related to museums. The "parent organization" here is the university or the state, and, because the "parent" is not a museum, the term "nonmuseum" can be applied. The Louisiana State Museum system, discussed at the beginning of the chapter, is another example of a museum with a nonmuseum parent, once again a state government.

If a museum is part of a nonmuseum parent organization, its purpose may not fully align with the mission of its parent organization. In the case of universities, for example, the parent organization's mission is to educate college students, and, in the case of a state or local government, its purpose is to provide public services. If a university museum develops a mission that focuses on educating children, rather than college students, for example, or if a city has a history museum rather than a community center that offers courses on arts and crafts, these museums might find their parent organizations asking them to justify their relevance to the parent organization. Moreover, the parent may be responsible for more than one "child" organization. While many states operate museums, for example, they may also be responsible for units such as parks or recreational sites as well as for providing social services and ensuring public safety. Directors of museums with nonmuseum parent organizations therefore need to be acutely aware of potential misalignments of missions between the parent and child for several reasons, not the least of which is because, in tough financial times, the parent may wish to divest itself of the museum, claiming it is "not critical" to the parent organization's mission.

In the case of private nonprofit museums, such as the Philadelphia Museum of Art or the California Academy of Sciences, the parent organization is the museum itself. If a museum is not part of a larger organization, it is therefore its own parent, and there is no "child."

Knowledge of whether a museum is part of a larger organization that possesses a parent, or if the museum is its own parent, makes it is possible for directors to more easily understand what part of the organization is responsible for oversight of the organization's core responsibilities.

In the case of a private nonprofit museum in which there is no broader parent organization, as in the cases of the Philadelphia Museum of Art and the California Academy of Sciences, the museum's director reports directly to the museum's board. In this situation, the museum's board is responsible for

a museum's core responsibilities and, therefore, as discussed above, focuses on establishing the museum's mission and direction; supplying oversight of the museum; and ensuring that sufficient resources are in place for the museum to accomplish its main purpose.

Although in museums without parent organizations there may be board subcommittees that may have some authority over activities in their charge (such as an acquisitions committee), these subcommittees work closely with and usually clearly report directly to the museum's governing board. In this sense, there is little distance organizationally between the director and the museum's governing authority. However, ambiguity in what a board is responsible for can be an issue for museums that are not part of a broader parent organization. In these settings, boards may seek to be closely involved in museum operations because the only separation between the day-to-day activities of the museum is the position of the director.

In contrast, in the case of a museum with a nonmuseum parent organization, a more "remote" kind of governance structure commonly exists in which the university or government museum may have delegated, formally or informally, some or many of its responsibilities to an entity that is "closer" to the museum organizationally, such as a university administrator or a branch of state government. In this sense, the parent is somewhat "remote" organizationally from the child organization, which is the museum.

For example, in the case of the university museums at the University of California, the parent organization is "The Regents of the State of California," though many responsibilities have been delegated from the regents to specific administrative units on each campus that possesses a museum. In the case of government-associated museums, such as the San Francisco Zoo, the parent organization is "The City and County of San Francisco," which has delegated its responsibility to San Francisco's Department of Parks and Recreation, which then works with an affiliated board of directors.

In these kinds of nonmuseum parent organizational settings, any ambiguity that exists by design or in practice can create significant problems for directors because it may be unclear what authority the designated delegated entity really possesses and which entity is responsible for what. If a university administrator has "responsibility" for a campus museum, for example, does this include the ability to fire the museum's director as well to decide that an object found to have been looted can be returned to a claimant or source community? Or does one or do both actions need to be approved by the parent organization itself at its highest level? Does the director of a state museum have the authority to develop a strategic plan or to raise funds for basic needs that the parent organization may not be meeting, such as for renewing exhibits or for hiring additional staff? The answers to these questions should be sought *while they remain hypothetical* because situations like these can and do occur in museums that are part of nonmuseum parent organizations.

In museums with a nonmuseum parent, the governing authority usually also has a hands-off approach to the museum for which it has oversight because it has a range of significant responsibilities of its own elsewhere. In such a governance structure, the parent organization may have little expertise with museums or, likely, may only want to be involved with the museum in cases of extreme importance that could affect the entire parent organization and that may require approval from the very top of the organization. Depending on the system, issues involving the return of collections from university museums, for example, may require formal approval from the governing body, often referred to as regents, trustees, or governors, because the transfer of the university's "property" raises the parent organization's own trust responsibilities toward collections.

Museum directors will also want to be aware that the scope of governmental regulations to which their museums and their museum's boards are subject will differ depending on the museum's legal structure. As Marilyn Phelan notes in *Museum Law: A Guide for Officers, Directors, and Counsel* (2014), private museums, which include nonprofit, tax-exempt, nongovernmental museums, are subject to some governmental regulation, while public museums, such as federal or state museums, are generally subject to much more regulation.

In sum, whether or not there is a parent organization for a museum and whatever the legal structure of the museum, directors will want to understand which entity or entities are responsible for ensuring that the museum meets its core responsibilities, which include establishing a mission and purpose, evaluating the director, caring for collections, defining an institutional focus, and assessing the board's own performance. Furthermore, directors will want to see that that these responsibilities have been clearly assigned, so that everyone in the organization has the same understanding of who is supposed to do what, is aware of the museum's particular governance structure, and can work together to implement the museum's mission wisely, efficiently, and with all the necessary resources in place.

5

The Importance of Board Structure, Committees, and Meetings

BOARD STRUCTURE, COMMITTEES, AND MEETINGS: A VIGNETTE

A private, nonprofit art museum that is nationally recognized for the quality of its exhibits and its curatorial expertise has a large board composed primarily of wealthy businesspeople, lawyers, and local celebrities interested in the arts. A few of the museum's board members are nonprofit professionals or academics with expertise in the museum's collections, and two board members with ties to the region's very diverse communities were recently elected. The museum has a clear but dated mission; has foundational documents, such as bylaws, of which few board members are aware; and has a new director with emerging management skills, deep expertise in the museum's collections, and knowledge of the latest standards and best practices in the museum profession. The newly elected board chair is well liked and accomplished in her field of business but is not very experienced with nonprofits and, because of her professional background, has been a member of the board's finance committee during her two years on the board.

The museum's collections are extensive, well cared for by a dedicated staff, and focus on pre–World War II American art, though the museum also possesses small but very significant cultural collections from the global south, including Southeast Asia and Oceania. Due to staff size and the allocation of resources for exhibit development and curatorial research elsewhere, the collections from the global south have not been the focus of extensive collections care efforts, and the museum only has a single, small gallery dedicated to collections from the area, which was developed more than twenty years ago.

The museum's regional audience includes groups with strong community interests in the collections from Southeast Asia and Oceania, though the museum's involvement with these communities has mostly been limited to

the development of the single gallery many years ago. Recognizing changes in museum practice over the past several years, however, museum staff have recently begun to develop relationships with cultural experts from these communities to improve the museum's care and understanding of its collections. The staff finds that doing this work is rewarding; that changes in collections care and working with these communities involves increased spending and changes in who can access items; and that developing relationships with groups who do not believe that they have been valued, seen, or understood by the museum is important but time-consuming. Staff members are also hopeful that the museum's work with these communities can be formally recognized when the museum's mission is next reviewed and when long-term planning for the museum commences.

The museum's board is composed of forty-five active members and another set of twenty-five who are retired. Active board members are elected by the board as a whole and serve three-year terms, though they may be reelected multiple times. There are no term limits in place for retired board members. The board has fifteen committees, ranging from budget and finance to collections, facilities, and audit, and both active and retired board members are permitted to serve on committees. Until recently, the board prioritized the work of the fundraising and finance committees, emphasized that the board's paramount role was to raise funds for the museum, and had informally established that each board member needed to make a specific personal financial contribution annually upon joining the board. The board also has an executive committee, which oversees all other committees and which, as outlined in the museum's bylaws, can act on behalf of the full board if a situation is deemed urgent.

Both the new director and board chair recognize that at least half of the active board members do not regularly participate in meetings, though recent steps taken by the board chair have resulted in more becoming involved. Increasingly, the director sees that board members better understand their basic responsibilities, but, in the view of the director and the board chair, the large number of board members and committees, together with the existence of the executive committee, seems to undermine attendance at meetings. During the time when the prior director and a former board chair were in place, most board meetings were taken up with updates on staff activities and programs, socializing, voting to approve new board members, and discussing the museum's budget, which dissuaded some board members with other skills and interests from regularly attending.

For many years, new board members were recruited through the professional networks of currently serving board members, which led to a homogeneity in wealth levels, age, professional backgrounds, ethnicity, and gender. Indeed, most board members, until recently, were wealthy White men over the age of fifty who lived in the suburbs away from the museum's urban location.

However, in the past five years, more women have been added, and, through the professional network of the new board chair and director, young women with ties to communities in Southeast Asia and Oceania were recently elected.

In the first several months of their work together, the new director and board chair established a productive trust-based relationship with clear channels of communication, as they reviewed organizational, legal, and governance information about the museum, discussed the nature of trusteeship, and decided how to prioritize some of the issues facing the museum. Their work with the board has gone well: plans are in place to update the mission; education about changes in museum policies is taking place; the need for the board to develop a plan to assess its work has been raised; and efforts to move the museum toward inclusivity in staffing, board membership, and collections care are underway, with one notable exception.

A longtime, retired board member is disrupting board meetings, dominating committee gatherings, sending emails to staff directing them to take certain actions related to the collections, and creating a climate at meetings in which other board members are reluctant to speak on issues that are of concern to the disruptive board member. Board members who have become newly engaged in meetings through the efforts of the new director and board chair are dismayed to see the impact that this single board member is having on meetings, on the operation of the board, and on the museum's staff. In fact, the board chair has been told by these newly engaged board members that they stepped back from regularly attending meetings in the past because of this board member's behavior.

Alarmingly, the disruptive board member, who is well-known for his academic expertise in the study of collections from the global south and who for many years has done research on the museum's collections, prioritizes the research agenda of his own academic field over museum professional standards. He is also openly disdainful of museum ethical codes that outline the necessity of engagement with communities connected to a museum's collections and expresses this view at board meetings, from which he is never absent.

Furthermore, the disruptive board member has been the chair of the collections committee for more than six years and, as a retired board member, serves without a term limit. The disruptive board member is particularly upset about and opposed to efforts to involve communities in the care, display, and preservation of collections connected to them; indeed, the board member has written a series of detailed emails to staff and to the board's executive committee in which staff members are instructed not to do work that will support such engagement efforts because they will "break the museum's budget," because "nonexpert views" of the collection will be "forcibly included" in museum documentation and exhibitions as a result, and because the "integrity of academic research" into the collections will be "violated."

Meanwhile, the two new board members, who have learned much about the museum through its newly developed board orientation program, are taken aback to see the disruptive board member speak stridently during meetings, take up excessive amounts of time, and stifle discussion on topics about which the new board members are knowledgeable. The two new board members also note with concern how the disruptive board member is working through the collections committee to develop collections care and access policies that are at odds both with how their communities have interacted with similar museums in the region and with what the museum director has outlined to the board as being current professional practice elsewhere.

After a recent board meeting in which the disruptive board member shouted at another board member about a proposal under discussion to supplement the museum's annual budget to support work on the care of collections from the global south, the two new board members wrote to the board chair and the museum's director. In their note, they respectfully expressed their concern that the disruptive board member had created a climate that discouraged substantive discussion, that quarrelsome behavior on the board appeared to be tolerated, and that, even as more pressing concerns needed to be addressed, the concerns of one board member were dominating meetings.

Finally, after consulting with the museum's staff and raising the topic at several board meetings, the chair of the board and the director have decided that they need to embark on the process of updating the museum's strategic plan with the board. A component of this update will be to discuss ways that the museum can support long-term engagement with communities that have connections to the museum's collections.

The disruptive board member, upon learning of these plans, outlined in a series of emails to board members that he vociferously opposed changing the ways the museum engages with its communities, that formalizing such a change would be a "disaster" for the museum, and that making such a change would endanger "all funding" from donors. The disruptive board member then demanded that the executive committee meet immediately to address this "extremely serious" issue and gave notice that a "white paper," which was recently completed by the collections committee, would soon be forwarded to the executive committee to "educate" executive committee members about the putative hazards of the approach, particularly for the discipline of art history. The collections committee, like all the museum's committees, does not have a clearly defined statement of purpose.

The new director and the new board chair have taken the time to study how their museum is organized and governed, to examine the legal underpinnings of museums in general, and to understand the nature of trusteeship. They have also spent time together reviewing the core responsibilities of boards and what leading ethical codes outline about museums, and they have established a productive, trust-based partnership.

At the same time, however, they also recognize that they face some real challenges in moving the museum forward, not the least of which is dealing with the disruptive board member. Is it appropriate to sideline the disruptive board member, they wonder, or to work actively to remove him from the board, and how would either be accomplished? What role can the museum's bylaws play in addressing relevant changes that could be made, and what broader resources are available to educate board members about how they should be carrying out their work? How can they prevent board meetings, with their carefully planned agendas, from being dominated by a single board member, and how can they shift the work of the board to include work on pressing issues, such as mission revision, strategic planning, policy updates, and diversifying board membership, so that the board is representative of the communities the museum serves?

In the work ahead to plan how to best steward the museum's collections, to educate the public, and to serve as a place for community for those with ties to the museum's collections, the director begins to see clearly that he will need to understand more about how boards are structured and how they operate. The director also realizes that he would benefit from a deeper understanding of how board meetings should be conducted, what role the director plays in them, and how the work of the board's committees contributes to the work of the board and to the museum.

WHY UNDERSTANDING BOARD STRUCTURE, COMMITTEES, AND MEETINGS IS IMPORTANT

Once they understand that they will be working closely with boards on a range of issues, new museum directors begin to wonder more about how the board operates. If directors are to partner with their boards to serve as a trusted source of information about museum operations and if they will also be asked to contribute to board discussions about the institution's mission, policies, and plans, those directors will want to understand more about how boards are structured and how they conduct their business.

The vignette outlined above illustrates the stakes for museum directors when they do not know enough about how boards are supposed to be structured and how they should operate. With some knowledge about the kinds of limits museums have placed on how many terms a board member can serve, the typical size and composition of boards, the standard kinds of committees on boards and the work they complete, and what resources exist about board education, the new director could have determined what role he might have played in navigating many of the issues he observed as a new leader.

For example, if the director had known more about the foundational documents of museums, such as bylaws, he would have been able to understand why some of the museum's board members seem never to leave and why

working with the board chair to reactivate a governance committee to update the bylaws might have been an effective way to address board member term limits and unhelpful or disruptive behavior.

As another example, if the director had known about how pervasive an issue the absence of diversity on museum boards is today, and what characteristics and skills potential and current board members should have to be effective, he might have worked with the board chair to address board diversity in their own museum. A strategy to recruit board members from the communities that the museum's collections staff have recently engaged could have been developed, for instance, or a formal assessment of the characteristics and skills the board needs at this time could have been made.

In yet another example, if the director had known more about how board meetings and committee work are supposed to be conducted and how the presence of too many board members or committees can undermine the board's operations, the director might have been able to share ways to promote board unity, to determine what part he could have played in fostering informed dialogue among board members, and to know when it is appropriate to assert himself in board meetings. Such information permits directors to address issues that will affect their work and that of the museum's operations while also providing a clearer view of what is best resolved by the board chair alone or together with the help of the director.

New directors and senior staff can also be quite surprised by the amount of time that they will spend with boards or the amount of energy required to prepare for productive board meetings. Board decisions, however, will shape both the director's actions and the direction of the museum, and directors will need to work with their boards to update them about the management of the museum's resources and museum professional standards, to outline issues relating to the trust responsibilities of the museum, and to supply insight about the museum's long-term goals.

Even if boards have clear rules for how they do their work, are composed of members that represent the diversity of the museum's community, and have a highly skilled leader in place, it is helpful for museum directors to understand that boards are not static entities. Board members should come and go, and the fiscal and legal environment for museums changes over time. The demographics of a museum's community can also shift, the perspectives of new board members may prompt discussions about the mission of the museum, and directors may retire. Cultivating an understanding of what procedures are in place on boards to manage the fact that change is inevitable is therefore prudent.

On a more pragmatic level, if staff members are asked to participate in a board meeting or to write a report that will be reviewed by a board committee, the employees' efforts will be much more effective if they understand how their work will be used and integrated into the board's activities. A

knowledgeable director can outline to staff how boards operate in these situations, share relevant resources, and describe how the museum's board will likely use the information.

This chapter discusses the structure of museum boards, including how they function and the kinds of activities they typically work on. In addition, foundational documents like bylaws, what is known about the typical size and composition of boards, the main characteristics of board members, term limits on boards, and how board members are recruited, oriented, and educated will be reviewed. The chapter then outlines basics about board meetings and ends with a review of the most common kinds of board committees and their activities. Throughout the chapter, the emphasis will be kept on areas of board operations that are most important for museum directors to understand rather than on what board members themselves should know.

BOARD STRUCTURE: FOUNDATIONAL DOCUMENTS

Directors should always identify and review the museum's "articles of incorporation" because they clearly outline the purposes of the museum. Articles of incorporation establish the museum legally in its home state and are typically filed with a branch of that state's government, either when the museum is formed or later, if they are revised because of a reorganization of the museum (American Alliance of Museums, 2024e; Gardyn, 2006).

For example, the articles of incorporation for the Los Angeles County Museum of Art (LACMA) were revised in 1994 and filed at that time with the Office of the Secretary of State in California. The articles of incorporation outline that the organization's purpose is "to encourage activities and to promote education in the field of art and to aid and connection with the Los Angeles County Museum of Art, located in Los Angeles, California" (Los Angeles County Museum of Art, 2024). LACMA's articles of incorporation can be found on the museum's web page as well as on the web page of the California Secretary of State (California Secretary of State 2024).

Usually, the articles of incorporation outline the museum's purpose in broad terms so that, if there is a slight shift in the mission of the museum, the articles do not need to be formally modified and resubmitted. Nevertheless, a shared understanding of the purpose of the museum is crucial in any discussions between the staff and the board about the museum's current programs, any possible revisions to the mission, and the museum's plans for the future.

Another foundational document that directors will want to become familiar with is the museum's bylaws. In general, bylaws describe how the museum is governed and how the museum, as an organization, manages itself through the activities of its board. Directors should know that, although bylaws are typically in place for some time, they should be reviewed every several years as part of ongoing board assessment efforts and to ensure that they remain

effective, though they can usually only be altered or updated by an action of the board. Bylaws are sometimes posted on a museum's website and typically can be obtained from the museum's administration.

Some of the major areas outlined in bylaws include how board members are selected, how the board makes decisions, and information about board meetings. Bylaws also usually outline officers and board positions; the duties and powers of board positions; how voting takes place on the board; board committees and their areas of concern; information about reports the board must compile; information about different status levels for board members, such as active, retired, honorary, or other designations, which should be carefully reviewed; board member term limit information; and whether or not board members are held harmless for their actions while on the board. Procedures for dealing with conflicts of interest are also commonly detailed in bylaws or in an addendum to them, and some outline ways to move board members from active to more honorary roles. Finally, bylaws may also describe the overall duties of the museum's director and will be the place in the museum's core documents where it is specified that the director reports to the board. Significantly, the bylaws are also often where information is outlined about how the museum's director is evaluated.

Admittedly, many employees consider bylaws to be of the last set of documents about a museum that they would willingly take the time to read because the workings of the board seem remote from their day-to-day work. The detailed language can also feel abstract, or even tedious. Because museum personnel already have enough to do in their specific content area of the museum, be it collections care, education, or outreach, they may place reviewing their museum's bylaws low on the "to do" list.

The museum's bylaws, however, are better viewed collectively as a manual of internal operating rules that specify how board decisions are made. For example, if a museum board approves its acquisition committee's recommendation to purchase a set of objects on behalf of the museum, that decision will directly affect the registrar, conservator, curator, and others. If a board committee makes a policy recommendation to the full board about how the museum should interact with communities that have ties to the museum's collections, the outcome of any deliberations will have an impact on the museum's collections managers and on its exhibition development team. *Museum personnel therefore not only should want to be aware of any board processes that will have an impact on their work but also should take the time to prepare for the time when, as senior managers or new directors, they will interact with the board and can potentially impact board decisions.* In particular, the director will want to understand the museum's bylaws thoroughly when clarity about rules and authority can help resolve disagreements on the board about issues that affect the museum.

In sum, the museum's foundational documents outline the purposes of the museum and clearly describe the structure and operations of the board. A careful review of these documents by directors and staff reveals the reason why the museum exists and how it proposes to reach its stated purposes on an organizational level, through the activities of its board and the operation of its governance system.

BOARD STRUCTURE: BOARD SIZE AND COMPOSITION

Helpful information about the size and composition of boards comes from *Leading with Intent: BoardSource Index of Nonprofit Board Practices*, a comprehensive study of nonprofit boards that is issued every few years (most recently in 2021, 2017, and 2015), and *Museum Board Leadership 2017*, a national report commissioned by the AAM (2017), which will soon be updated. Because the specific questions asked in the BoardSource studies can be rephrased from year to year, and the areas emphasized can be refined over time, it is useful to examine several of the most recent different iterations of these studies to glean useful information.

Size

The average size of a nonprofit board is fifteen members (BoardSource, 2015), but, interestingly, museum boards are significantly larger than those of other nonprofits, with more than 20 percent of museums possessing more than twenty-five board members (American Alliance of Museums, 2017). While it appears that attendance rates at board meetings are affected in museums with larger boards, the main issue concerning the larger size is keeping all board members engaged (American Alliance of Museums, 2017). There is no one "right" size for the number of board members, though a board may be either too large, resulting in important decisions being made mostly by an "executive committee" (a subgroup of the board's leadership), or too small (fewer than five members), resulting in a lack of access to relevant expertise or adequate oversight (BoardSource, 2017).

As some examples of the size of boards in museums, the board of the Asian Art Museum in San Francisco, which is called The City and County of San Francisco Asian Art Committee, has twenty-seven members (Asian Art Museum, 2024), while the board of the Corning Museum of Glass in New York, which is called the Board of Trustees, has sixteen members (Corning Museum of Glass, 2024). The Field Museum in Chicago has a twenty-seven-member executive committee and around sixty additional active trustees (Field Museum, 2024); the National World War II Museum New Orleans has close to fifty active board members, in addition to an eight-member executive

board (National World War II Museum New Orleans, 2024); and Zoo Atlanta has thirty-one board members (Zoo Atlanta, 2024).

Composition

With respect to gender, race, and ethnicity, surveys show, strikingly, that most museum board members are male and between fifty and sixty-four and that nearly 90 percent are White (American Alliance of Museums, 2017). Indeed, almost half of museum boards are all White, whereas just under one-third of boards of other nonprofits are all White (American Alliance of Museums, 2017). The 2021 BoardSource survey of nonprofit directors found that almost half of directors also believed that they did not have the right members on their board to establish trust with the communities that they serve, and less than one-third of boards placed high priority on including board members from within the community served (BoardSource, 2021).

Together with a series of high-profile reports, which found an absence of diversity in art museum staff (Sweeny, Harkins, and Dressel, 2022a), the results of the *Museum Board Leadership 2017* report generated much media attention and calls for professional action. At the same time, an important analysis of Black membership on museum boards found that Black individuals were present in low numbers on museum boards because they had not been approached to serve and because museums use familiar social and professional networks, which are racially stratified, in recruiting new board members (Sweeny et al., 2022b).

As BoardSource (2017) explains, the lack of racial and ethnic diversity on nonprofit boards creates "blind spots" for organizations in key areas, such as in understanding the nonprofit's broader environment, in enhancing its ability to respond to change, and in understanding the population that the nonprofit serves. As Laura Lott, former CEO of the AAM, further stressed, "In the more than 20 years that museums talked about the importance of diversity and inclusion, the number of people of color serving on boards has barely budged . . . that's a real problem. The tone of an institution, the priorities for each museum, the budgets, they're all established at the board level" (Lott in Wallace, 2019).

It is important to emphasize, however, that museum directors and board members understand that the lack of board diversity is a serious issue, one that impacts efforts to advance the museum's mission, to understand the museum's broader environment and its visitors, and to enhance the museum's standing with the general public (American Alliance of Museums, 2017, 2018a). Nevertheless, the *Museum Board Leadership 2017* study found that only 10 percent of museum boards surveyed had developed a plan for their boards to become more inclusive and only around one-fifth had changed related policies and procedures (American Alliance of Museums, 2017).

Although studies underway now are likely to show an increase in the number of diverse board members in museums over the past two or three years and to show that museums have developed plans and policies to make their boards inclusive, there is a great deal of work ahead for directors to support these efforts. It is likely that, eventually, some measure of board diversity will be a component of the revisions of the core museum standards now underway by the AAM (American Alliance of Museums, 2024f). At the same time, it is important that directors support efforts to have board members understand the significance of board diversity for the museum and its communities, to participate in the development of action plans, and to advocate for the need for continued board training on the issue.

Information that is useful to directors on the composition of specific museum boards is available from GuideStar (Guidestar, 2024), which is a nonprofit organization dedicated to transparency that provides information about nonprofits based on self-reported data and from the Internal Revenue Service. Information on the race and ethnicity, gender identity, sexual orientation, and disability status of board members is sometimes included in the profiles of nonprofit organizations in Guidestar, which includes data on more than twenty thousand organizations with the word "museum" in their title alone.

In addition to making basic information about nonprofits more accessible to the public, Guidestar uses the information it gathers to assess levels of organizational transparency. At the highly transparent Newark Art Museum in New Jersey, for example, half of the museum's board is non-White, more than 10 percent are Gay, Lesbian, or Bisexual, and a little over half of board members are male. At the very transparent Children's Museum of Philadelphia, 63 percent of the board members are White, and at the similarly transparent Dallas Art Museum, 60 percent of the board members are female, 5 percent of the board members are Gay, Lesbian, or Bisexual, and, in the area of race and ethnicity, 12 percent are Asian/Asian American, 18 percent are Black/African American, 9 percent are Hispanic/Latinx, and 60 percent are White (Guidestar, 2024). Information on the board's composition is not available for museums that are considered much less transparent, such as the Museum of Modern Art in New York.

One additional area of board composition to consider is whether the museum's director should be a voting member of the board. It is recommended that directors of nonprofits *not* serve as voting members of the board due to the conflict of interest such membership raises (BoardSource, 2016). Not only is the director supervised by the board, for example, but board members must put the interests of the organization first, while at times a director may need or want to give priority to operational or personal concerns (BoardSource, 2016). Nevertheless, the director should attend board meetings as a nonvoting or ex officio member so that the board can make informed decisions about matters that affect the museum, while also being aware that the director's job is

to implement board decisions and not to supply board-level oversight of the museum.

BOARD STRUCTURE: RECRUITMENT, ORIENTATION, AND EDUCATION

The recruitment, subsequent orientation, and continued education of board members are useful for directors to understand so that they can identify strengths and weakness in boards and then consult with board chairs to decide how to support strengths and improve weaknesses.

Board members typically recruit new members and then bring information about candidates who wish to be nominated to the board for review, after which elections take place to approve nominated candidates, as specified in the museum's bylaws. Once members are elected, an orientation should take place, though the nature of that orientation varies considerably among museums. As a baseline, it is helpful if a manual including bylaws, past minutes of meetings, strategic plans, written descriptions of expected duties, and information about the museum itself is shared with the new member. The orientation is only the beginning of the board member's education, however, and education should be ongoing for new and continuing board members.

Board Member Recruitment

General guidance on the recruitment of board members is supplied by Board-Source (2024c), the National Council of Nonprofits (2024a), and the AAM (2024g). Resources emphasize the need to outline the responsibilities of the board, the mission of the organization, the kinds of work the board does, the time required to serve on the board, and how potential new board members are identified. BoardSource recommends using a board matrix, which is a board-completed inventory of skill sets, perspectives, and characteristics that the board needs at the time in order to identify gaps in the board's current composition, so that a framework for recruiting suitable candidates exists (BoardSource, 2024d).

The recruitment of new board members is of special concern to directors today because of the homogeneity of museum boards; the role that directors can play in suggesting candidates; the fact that directors work so closely with boards; and the powerful impact board decision-making has on the director's work. Indeed, directors have a vested interest in seeing that boards are composed of members who are appropriate for the work that must be done. *Learning about recruitment is therefore perhaps best viewed by directors as an investment in a better functioning museum.*

The characteristics that organizations typically seek in likely new board members is reviewed below, followed by a discussion of a key recruitment

issue, the role of expected financial contributions in board membership, and its link to board diversity.

From the broader nonprofit literature, Hall (2003) succinctly outlines characteristics of potential new board members by listing a range of abilities candidates should already possess, such as listening and analytical skills, creativity, the ability to work well with others, and the willingness to be prepared for and engaged in board meetings. Candidates should also be able to follow through on assignments, ask questions, and, significantly, "contribute personal and financial resources in a generous way according to personal circumstances," and, if they do not already possess such skills or ability, be willing to participate in fundraising by cultivating and soliciting funds (2003, 21).

Hall emphasizes that potential board candidates need to be honest, sensitive to differing viewpoints, responsive, friendly, and patient and to have a "developed sense of values" and personal integrity. In addition to these personal characteristics, the candidate should be able to understand financial statements, be willing to learn about the nonprofit's programs, and be able to support the development of the organization. Hall also highlights the time and skill required to assess the many personal characteristics needed for board membership. Museum directors should appreciate that the characteristics needed for board membership in a museum include a passion for a museum's specific mission as well as an understanding of the special responsibilities that museums have in stewarding their collections, educating the public, and serving community.

Financial Contributions by Board Members

One area that is much discussed in the museum world, but for which little detailed information is available, is how much board members in museums are expected to contribute annually to the organization or at the time they join the board. The classic formulation in nonprofit fundraising is that board members should be able to contribute their "time, talent, and treasure," but nonprofits have struggled to find a balance among these three areas. One compelling argument is that, in limiting board membership to those who can contribute financially with their "treasure," the viewpoints and skills of certain groups, especially those of members of diverse communities, are not accessed by boards. Similarly, such a limitation restricts the involvement of those who are young, disabled, or involved in professions that are not financially remunerative.

The BoardSource surveys of board chairs offer some broad insights into how boards approach financial contributions (BoardSource, 2017, 2021). More than 80 percent of nonprofits require their board members to make a personal contribution to the organization, but, when board chairs and directors were asked what areas of board performance needed the most improvement,

two-thirds responded that fundraising needed the most improvement (Board-Source, 2017) and, furthermore, that, of all their responsibilities, boards struggled the most with fundraising (BoardSource, 2017, 2021).

More tellingly, the 2017 survey found that expectations for contributing to fundraising, which likely include annual contributions, were set at the time of recruitment. Specifically, when expectations were articulated at the time of recruitment, nonprofit directors reported that more than half of board members participated in fundraising, while, of those board members who were *not* apprised of expectations about contributions, only around 10 percent participated. Considering these results, BoardSource concluded that boards need to be "honest" and "transparent" about fundraising expectations in their recruitment efforts and that "being candid about how an organization wants board members to engage in fundraising ensures that potential board members understand the expectations and can opt out" (2017, 42).

Interestingly, the AAM study of museum board chairs and directors found that, while just over 80 percent of board members made a personal financial contribution to their museum, three quarters agreed that fundraising was the area most in need of strengthening (American Alliance Museum, 2017). Whether personal financial contributions were required as part of board membership was not examined in the study. Significantly, however, the survey also found that fundraising expectations were set at the time of recruitment, but that only just over one half of the museums included information about fundraising strategies in their recruitment efforts. Interestingly, close to 40 percent of museum directors also agreed or strongly agreed that their board "actively participates in fundraising versus relying mostly on the director and staff" (2017, 23).

Virtually all museums in the United States engage in some form of fundraising. The AAM (2017) study indicates that, while nonprofit and museum boards need to do a better job of meeting their fundraising responsibilities, a simple change in how board members are recruited can have an outsized impact on who contributes. At appropriate times, directors can fold information about the impact of expected contributions into conversations with board chairs who are not aware of this information so that the board can understand the power of outlining expectations for contributions in recruitment efforts.

At the same time, not all potential board candidates with useful skills and deep interests in the museum's mission will be able to contribute financially at the levels that museums have established as necessary for board membership. In the classic "time, talent, and treasure" formulation that outlines what board members typically contribute to organizations, some nonprofit organizations, especially large art museums, have been accused of giving too much weight to the "treasure" component. Indeed, the latest BoardSource survey found that boards that prioritized fundraising "above all else" did so at the expense of

other key indicators of board performance, particularly when it comes to "setting the organization's strategic direction" (BoardSource, 2021, 5, 22).

With expected contributions at some art museums sometimes exceeding hundreds of thousands of dollars per year, it is easy to see how such levels could serve as a barrier for membership for many individuals and could undermine inclusion efforts. As a *New York Times* article on board membership in art museums noted, in return for their donations as part of board membership, board members gain admission "to an exclusive cultural club others yearn to join; give arts organizations their cachet and connections; and provide a power base that commands the attention of public officials" (Pogrebin, 2020b). Indeed, in the same article, an analysis of how board members in the nation's ten most popular art museums had acquired their wealth found that roughly 80 percent had acquired it from business, with the highest percentage of that group having acquired their wealth from the world of finance alone (Pogrebin, 2020b).

The AAM study of boards also reported that, of the main areas of diversity on boards that were examined, which included age, economic status, and sexual orientation, museum directors were most dissatisfied with the lack of racial diversity on boards (2017). Almost two-thirds of museum directors, for instance, were dissatisfied with the board's racial diversity and almost half with its age diversity. Notably, in a study of Black museum trustees in art museums, Sweeny et al. (2022b) found that more than a quarter of Black trustees reported that they had a preexisting relationship with the museum's director and almost half with a board member, suggesting that preexisting networks can be a strategy for board diversification if board networks are diverse. Taken together, an understanding of how museum directors view racial diversity on boards and the importance of networks in recruiting diverse board members allows museum directors to develop strategies to support changes in board composition that can benefit the entire organization.

Given the notably skewed demographics of museum boards and the concern with equity and inclusion in museums and among the public, American museums should each examine and possibly recalibrate the balance they have in place for the "time, talent, and treasure" formulation, consider the power of personal and professional networks in recruitment, and invest in board education. Museum directors can play an important role in all these activities by sharing information and resources with boards. While it is undeniable that many museums depend on the philanthropy of contributions from individual board members, museums can remove barriers for those with desirable or even necessary skills and viewpoints by adjusting expected levels of contributions for board membership, and, through well-considered recruitment, make it clear that whatever a board member contributes will be valued. As the BoardSource study of nonprofit boards concluded, "boards will not become more diverse without changes in their board recruitment practices" (2017, 14).

Board Orientation and Education

Depending on the board, directors may be asked to brief new board members about the museum's history, programs, or operations. Because directors benefit from having well-oriented board members who can assume their responsibilities with knowledge of the board's role in the organization, it is in the director's best interest to understand how the board prepares new members for their work and to consider how the director can support and strengthen the orientation process.

BoardSource (2024e), the National Council of Nonprofits (2024b), and the Museum Trustee Association (2018) recommend a formalized orientation process in which written guidance is reviewed and interactive experiences, such as webinars, are offered. These resources also stress that new board members should understand what is expected of them and that the organization's policies and governance should be carefully reviewed. According to BoardSource (2024e), the director plays a key role in the orientation process because the director will share his or her knowledge of the organization with the new board member and because he or she usually supports the organization of any orientation sessions.

On the topic of board education, an array of additional resources is available from BoardSource (2024f), the AAM (American Alliance of Museums, 2024h), and the Museum Trustee Association (2018). The Museum Trustee Association, whose mission is to provide "ongoing board education programs, services and resources for the special needs of museum trustees and senior staff" (2024b), offers a detailed four-part education series that focuses on building museum boards, strategic planning, and—of special interest to directors—guidance on directorial transitions and on how to strengthen the partnership between boards and their directors. Organizations such as the National Council of Nonprofits also provide guidance on board education (2024c), including how to access educational resources from state-based nonprofit associations (2024d), whereas Independent Sector offers an annual review of the health of the nonprofit sector that is helpful in educating boards about the broad environment in which nonprofits operate (2023). Resources from these organizations typically focus on what boards need to do for self-education; the need for continuous and collective learning in specific areas of board operations; how the board chair can facilitate and create an appropriate environment for ongoing education; and how boards can identify the areas of board functioning about which they need to know more.

Interestingly, in evaluating how directors and board chairs view the importance of continued education, the AAM (2017) found that less than half of museum directors thought that their board members considered further learning and growth to be a high priority. On the other hand, two-thirds of board chairs believed that board education was a high priority, indicating that

directors saw more of a need for continuing education than did board chairs. In noting this difference, the study recommended that board chairs consider whether they should work with their directors to strengthen board leadership (American Alliance of Museums, 2017).

One additional area that organizations concerned with board education emphasize is the need for boards to assess their own performance because it results in an understanding of what the board can do better and in what specific areas ongoing education is most needed. For directors, board assessments are also opportunities to determine how well informed boards are about areas that are of critical concern to them, including the museum's mission, programs, and policies, and to advocate for the inclusion of specific areas in assessment that directly impact the director's work, such as evaluating the board's efforts in its review of the director's performance.

In general, almost 60 percent of nonprofit boards have conducted self-assessments, and about half of these have conducted one within a two-year timeframe, which is the time period BoardSource recommends (BoardSource, 2017). In the museum sector, however, the numbers are much worse: 70 percent of boards have not completed a self-assessment at all, only around 15 percent have conducted one in the past two years, and only one-fifth of museum boards have self-assessed in the past three years (American Alliance of Museums, 2017). The reasons for not prioritizing the self-assessment of museum boards are unclear. Even if they relate to the perceptions that museum boards are already overworked or that addressing immediate needs in museums must always take priority, an understanding that deficiencies in board self-assessment exist in museums enables directors to identify specific areas of board education that need to be strengthened and to make the case that assessment is necessary and valuable not only for museum programming but also for the board itself.

Overall, while it might seem that there might be more pressing issues for directors to attend to in their work with boards, such as preparing for upcoming board meetings with the board's chair, compiling updates for the board about recent museum operations, or developing proposals for policy updates, board orientation and education are important for museum directors to understand because they represent critical, long-term investments in the health of the board. Boards that invest in their education and that make time to step away from routine matters make the director's job easier because education clarifies what the board is supposed to do and what directors can do to support areas that need to be strengthened.

BOARD STRUCTURE: TERMS AND TERM LIMITS

More than 90 percent of nonprofits have term limits of either one, two, or three years, with most having three-year term limits in place (BoardSource, 2017,

2021). These numbers are broadly similar in museums (American Alliance of Museums, 2017). Most board chairs in museums have term limits of either two or three years (American Alliance of Museums, 2017).

Almost three-fourths of nonprofit boards also have limits on how many consecutive terms a board member can serve, which is a change from the 1990s, when only around one-fourth had such limits (BoardSource, 2017). For museums, specifically, around two-thirds have limits in place concerning how many consecutive terms a board member can serve (American Alliance of Museums, 2017).

Term limits are considered important because they allow for new talent, viewpoints, and leadership on boards, especially as the communities served by nonprofits change (BoardSource, 2017). However, in recognition of the fact that some museums in the United States have parent organizations that may have delegated some or most of their formal responsibilities to entities such as advisory or support groups, the AAM does not specify that museums must have term limits in place (American Alliance of Museums, 2024i).

Some examples of terms limits in museums include five years at the Science Museum of Virginia, with the possibility of serving no more than two terms (Virginia Law, 2024); three years at the Walters Art Museum, with possible reelection three additional times (Walters Art Museum, 2021); and three years at the Denver Art Museum, where there are no limits on the number of terms that can be served (O'Brien, 2021).

Overall, directors should pay attention to whether they will be working with term-limited board members or boards composed of the same people for many years, how new perspectives and skill sets are integrated into boards, and what mechanisms are in place for the community to supply input to its governing authorities.

BOARD STRUCTURE: THE BOARD CHAIR

The chairmanship is one of the most important positions on the board, both for the smooth functioning of the board and for the director's work in managing the museum. The chair is the designated leader of the board, and the chair's main responsibilities are to lead board members to work as a group and to support and supervise the museum's director. The chair also facilitates board meetings and is knowledgeable about the governance of the museum.

The duties of the board chair and the importance of the relationship between the board chair and the museum's director were discussed in detail in Chapter 3. To add to that discussion, it should be stressed here that board chairs are elected by their fellow board members according to procedures outlined in the museum's bylaws; that a detailed description of the chair's duties is usually outlined in the bylaws; that procedures for ensuring that the board chair is prepared to assume the position should be in place; and that training

and resources from organizations such as the Museum Trustee Association (2024b) about how to address typical challenges should be made available to new chairs of boards. The director's understanding of these basic areas can be very useful when he or she become aware of a gap in the knowledge base of new board chairs, in which case the director can decide if and how to share relevant information as the relationship between the director and the board chair develops.

BOARD COMMITTEES

Committees help boards do their work by focusing on a specific topic, and, depending on the committee, museum directors and, sometimes, senior staff can expect to interact with many of them. Typically, a committee will report to the board on an issue of concern in order to apprise the board of its importance or to recommend how the board should proceed. As BoardSource's study of nonprofit boards notes, "committees can help or hinder a board. When working well, they support the work of the board . . . when ineffective, they can result in report-driven meetings or give the false impression that only a portion of the board needs to pay attention to issues" (2017, 13).

Permanent or "standing" committees conduct the ongoing work of the board on topics of importance to the organization. The average number of standing committees in nonprofits has dropped from six in the 1990s to about four today, which reflects efforts in the nonprofit sector to make the work of nonprofit boards more efficient (BoardSource, 2024g). In the most recent survey, museums were found to have slightly more committees than did other nonprofits, with an average of around five (American Alliance of Museums, 2017). One-fifth of museums have eight or more committees, and, interestingly, as an indicator of possible problems in the operation of both boards and their committees, less than one-third of museum committees have charters with a clear statement of purposes and defined responsibilities, which are typically outlined in the museum's bylaws. Too many board committees can also be problematic because of the challenges of managing so many groups and because there may be an informal delegation of decision-making to them, which can disrupt the consideration of key issues by all board members.

One of the most common and important committees is the executive committee, which typically handles key matters before these are considered by the full board. It is commonly composed of the board's officers, the chair, the vice chair, the treasurer, and the secretary. Three-fourths of museums have an executive committee (American Alliance of Museums, 2017). Sometimes, in larger organizations, executive committees have the power to act on behalf of the full board; if this is the case, the powers and the authority of the executive committee need to be specified in the organization's bylaws, so that the full board is aware of and can confirm all decisions (American Alliance of

Museums, 2017). How organizations can avoid creating executive committees that do the bulk of the board's work is helpfully discussed by Hirzy, who calls this phenomenon the "inner board syndrome" (2018) and who notes that, in such cases, executive committees can place limits on the power they have to make certain kinds of decisions and can develop ways to keep the full board informed about their work.

Common "standing" committees on museum boards, in addition to an executive committee, include those in fundraising; collections/acquisitions; facilities; finance; and governance. Some museums may also have committees on exhibitions, education/outreach, personnel, investment, and, especially in the last few years, on diversity, equity, accessibility, and inclusion (DEAI). Knowledge of the typical kinds of committees that are found in museums and familiarity with the activities of their own museum's board committees prepare museum directors to assess the activities of these committees, interact with them, and ready senior staff to brief them.

For example, the Getty Trust, which includes the Getty Museum, has eight standing board committees: executive, antiquities review, audit, compensation, development/external affairs, finance, government, and investment (J. Paul Getty Trust, 2017). The areas tracked by these committees reflect both the common kinds of ongoing activities associated with many museum boards as well as the Getty's particular circumstances as a museum that actively acquires antiquities and has a sizeable financial portfolio to manage.

All Getty board committees also have a charter; for example, the charter of the antiquities review committee specifies that it "shall assist the Board of Trustees of the J. Paul Getty Trust by reviewing all proposed acquisitions of ancient art and archaeological material to assure that such acquisitions are consistent with Getty policy and relevant legal and ethical standards, and by conveying its findings to the Board of Trustees in advance of any such acquisition" (J. Paul Getty Trust, 2017, 1). The charter also outlines that the antiquities review committee does not have the authority to act on behalf of the full board, which indicates that, on a topic of much public and professional scrutiny today, the entire board must be involved. The committee also has an educational role, in that through consultation with the board's chair and others in positions of authority, the antiquities review committee can arrange to report to the full board about recent changes in "the law and best practices relevant to ethical aspects of collecting antiquities" (J. Paul Getty Trust, 2017).

Museum boards also sometimes create task forces that focus on time-limited activities, as opposed to ongoing ones, because they are more efficient and use a board member's time, interests, and expertise more meaningfully (American Alliance of Museums, 2017). One high-profile task force that was formed after a scandal at the Orlando Museum of Art involving faked artworks, art dealers, a high-profile exhibit, an FBI raid, and the firing of museum

leadership, is called the "exhibition task force," which examines museum exhibition policies (Benzine, 2022). As another example, the Isabella Stewart Gardner Museum, like other museums reflecting on concerns raised in the wake of the Black Lives Matter movement, created a DEAI Task Force on its board in 2020, which also built on its strategic plan to focus on how the museum manifests its commitment to DEAI throughout the institution (Isabella Stewart Gardner Museum, 2023).

Whether they will interact with board committees or task forces, museum directors who understand the basics about the kinds of subgroups that exist on museum boards are well positioned to interact with them, to understand if they are conducting their work according to practice across the field, and to determine how to support such groups.

BOARD MEETINGS

The main point of interaction between the museum's director and the board are board meetings. One of the best ways for new directors to learn about how such meetings are structured and run is to review the museum's board meeting minutes for the past several years. The minutes will reveal how much of the board's time is spent on staff or committee reports, as opposed to policy development or strategic planning, or, in other words, reveal how much energy is expended in meeting the board's core responsibilities rather than in focusing on the day-to-day operations that should fall under the purview of the museum's director. Such information is essential for the director in preparing future meeting agendas with the board chair and to ensure that the board has relevant and useful information about museum operations that will support the board's oversight of the museum.

Guidance on running productive board meetings that is aimed at board members is plentiful in the nonprofit literature. Some of the most useful material from the nonprofit sector for directors is by Flynn (2009), who outlines what is needed to make a meeting successful. Also helpful are resources from BoardSource, which include frequently asked questions about board meetings (BoardSource, 2024h) and how to address issues with virtual board meetings (BoardSource, 2024i); and tips from the National Council of Nonprofits about how to have meetings be "strategic, outcome-oriented and productive for all" (National Council of Nonprofits, 2024e).

For museums, guidance for board meetings is framed by the Museum Trustee Association (2024c) and the AAM (2017, 2024j). The former emphasizes ways that board members can stay engaged in meetings, whereas the latter outlines some common issues that can arise at board meetings, such as mediocre attendance, board members who are unprepared, too much emphasis on operations rather than on strategy, and meetings that are too infrequent or not lengthy enough to permit substantive discussion.

Specifically, the AAM study of museum directors and board chairs (2017) found that almost one-fourth of museum board members skipped meetings, as opposed to only 15 percent in other nonprofits, which may be a function of the larger-sized boards in museums in general and the need to keep board members in larger boards engaged. The same study also found that museum boards spent almost half the time of board meetings focused on routine staff or committee reports rather than on strategic or future-oriented issues, which suggests that museum boards could do a better job at exercising their governance responsibilities. Finally, the study found that almost three quarters of museum boards met five times or more per year, but that it may be better to have fewer but lengthier meetings so that they focus on "fiduciary, strategic, and generative" work (American Alliance of Museums, 2017, 34).

The minutes from museums that are associated with local, state, or federal government are often posted on museum websites or on the website of the governing authority; this is the case with minutes from the Illinois State Museum (2023), the Montana Historical Society (2023), and the Fine Arts Museums of San Francisco (2024). Board meeting minutes can be useful to review to see how different museums organize time during meetings and to consider why some museum boards seem unaware of how they should be spending their time.

Helpful resources that outline the kinds of behavior that are not productive during board meetings and how to address them are also available (BoardSource, 2012; Counts, 2020; National Center for Nonprofit Boards, 1994; Wisconsin Historical Society, 2024). Such behaviors range from the unhelpful, which includes interrupting other board members while they are speaking— as was illustrated in the opening vignette for this chapter—not participating in discussions, and being conflict averse, to more worrisome ones, such as expressing antagonism to staff, engaging in belligerence that gets in the way of group decision-making, and exhibiting even unprofessional and unethical behavior, though these are seldom reported in meeting minutes.

Examples of board members with other behaviors that can pose challenges include board members who are preoccupied with a specific functional area of the museum at the expense of other concerns, such as those who only express an interest in the museum's budget or acquisitions; board members who are unable to accept that the board has made a decision with which they disagree; and board members who lecture the director on aspects of the director's job that they believe the director does not understand or in which they have some expertise.

While it can be difficult to acknowledge that these kinds of behavior exist, museum directors are well advised to be aware of them so as to determine which ones a director has some power to influence and which ones are best addressed by the board itself. Unfortunately, the topic is not as widely discussed as it should be, though dysfunctional board meetings can have a large

impact on the organization, such as when board-level decisions are not made promptly, when such decisions are made on an uninformed basis, or when board member actions spill over into museum operations.

In summary, an understanding of museum board structure, meetings, and committees is essential for new directors because these areas will have an impact on the director's work, including the need to develop strategies for addressing the issues that will likely arise. Given that boards are composed of members who sometimes rotate on and off boards quickly or who stay too long, that some boards are composed of too many or too few people, and that some board members may behave in ways that are unproductive, museum directors who possess knowledge of board structure and operations stand prepared to face a range of issues, and their understanding will support the smooth functioning of the museum. With so many museums involved in expanding the role of their communities in how they steward collections and develop exhibits and programs, museum directors who do not understand how the board structures and completes its work may not have the tools to ensure that the entire organization supports these efforts, and such organizations may risk failing to serve their communities adequately.

6

Museum Supporters

FRIENDS GROUPS AND ADVISORY COMMITTEES

FRIENDS AND ADVISORS: A VIGNETTE

A small natural history museum founded in the 1920s that is associated with a major research university has collections that include rare specimens of dried plants that were carefully collected by faculty from geographic locations that have seen much environmental degradation over the years. The specimens have been systematically organized as an herbarium and today are recognized by researchers around the world as invaluable because they include species that are now endangered and that also hold clues to how climate change is affecting the world's environment. The museum has several staff members, a small exhibit hall that includes historic dioramas with taxidermied animal specimens acquired at the time of the museum's founding, and an incoming director with a mandate to make the museum more accessible to the public while also maintaining its central role as a place of collections research.

The museum has also a collection of living plants from around the world that are situated in a large, adjacent, and well-maintained botanical garden that was created when the museum was first founded. Although the botanical garden developed out of the interests of avocational plant enthusiasts and is not considered to be particularly valuable for research, it is the subject of much interest and care from members of the local community who are associated with a nonprofit group called the "Friends of the University Museum," which is affiliated with the museum.

The friends group has been in place for more than forty years, and oral history passed down about it over the years relates that it is the successor to an earlier version of the organization that was created by a small group of local women who had developed and maintained the botanical garden for the

first several decades of the museum's existence. From its roots as a dedicated group of amateur plant enthusiasts that had created a botanical garden to cultivate species of importance to them, the "Friends of the University Museum," grew over time to become quite successful by offering guided tours, developing educational programs, and hosting fundraising events.

Over the past twenty years, however, the friends group has come to focus almost exclusively on activities that relate to the botanical garden. For example, the board of the friends group raised enough money during this period to renovate a historic greenhouse located in the center of the garden. A large meeting room and kitchen facilities were added as part of an architecturally appropriate renovation of the greenhouse, creating a sought-after setting for special events, such as weddings, as well as a central gathering place for the botanical garden's docents and a locale for educational programs hosted by the friends group. Because of the rental fees that the friends group charged for events hosted by outside groups, the space has also become a generator of significant revenue, though few of the funds raised have been transferred to the museum.

Instead, since the renovation of the greenhouse, the friends group has allocated the funds it has raised to support its own educational programs, to hire staff to help run the group, and to develop plans to raise even more funds so that the revenue-generating capabilities of the greenhouse facility can be expanded. The friends group also uses the funds it has raised to support engagement activities such as its signature monthly "sick plant" clinic, in which people from the broader community bring in their unhealthy plants to the greenhouse to be evaluated by local experts, and a regular "plant sale" event, in which visitors can purchase plants like those grown in the botanical garden. Particularly because of these events, the friends group has been featured numerous times in the local media in a very positive light, with its board president interviewed about the group's programs and activities, its newly hired volunteer coordinator, and its plans for the future.

Despite the success of the friends group, the museum itself has been struggling to find a director who will remain in the position for more than a year. In fact, over the last six years, the museum has had four different directors, each of whom was hired through the efforts of the museum's advisory committee, which is called the "University Natural History Museum Advisory Board" and which is composed exclusively of university professors. The advisory board wrote the job description for the recent museum director searches, stressing in it that the director's primary role was to "facilitate and to expand access to the museum's world-renowned research collections" and that a key requirement for successful applicants was to have an active research program that used museum collections.

During the process of hiring directors, the advisory board said very little to candidates about the role of the botanical garden in the museum's mission,

research, operations, or fundraising plans or about how the efforts of the friends group were linked to other activities of the museum. Although the university's office of the provost, which has actual oversight of the museum, had approved the position description for the director's search and each of the candidates who were hired, it was preoccupied with student-related issues for much of the time searches were underway and had informally delegated almost all key responsibilities, including the approval of policy, to the advisory board.

The museum's most recent director was a highly esteemed academic who had spent much time researching the museum's collections and strongly believed that the best way forward for the museum was to develop an expensive molecular lab to support analysis of the dried plant collections that had been collected and stored over the years. To fund this vision for the museum, this director approached the president of the friends group to request that some of the funds that were being raised be transferred to the museum itself to support development of the molecular lab. When the director was told that the friends group had decided not to support activities that were "unrelated to the botanical garden," based on a written agreement that had been approved by one of the museum's former directors, the relationship of the museum's director to the friends group, which had previously been one of detached observation, turned acrimonious.

The director asked the friends group members to reconsider their decision, and, when they flatly refused, the director wrote to the president of the friends group and threatened to sever the museum's relationship with it and to have the museum take over some of the friends group's activities in the greenhouse facility.

In the meantime, the director briefed the museum's advisory board about the situation and recommended that it develop a policy to eliminate friends groups at the museum until such time as their role in the museum could be clarified. The advisory board members initially supported the director's approach because it meant that the museum could use the rental fees from the greenhouse facility to fund the molecular lab and because they did not believe that the friends group contributed to the research purpose of the museum.

Outraged by the director's actions, the board of the friends group and its members began a concerted campaign to retain their ties to the museum by first contacting the university's president, who had attended some of their special events in the greenhouse facility, and by repeatedly complaining to the president about the museum's director. A series of negative articles about the director's actions concerning the friends group then began to appear in local media, the most-read of which quoted a docent of nearly twenty years who said how deeply upset friends group members were to be threatened with "dismissal" by a "dictatorial director" who was "viciously attempting to remove a group that had served the broader community in ways the university always says it wants to do but actually rarely does." In another piece, a board

member of the friends group stated that the director was simply trying "to take the money we've raised from the plant conservation community to support a need that should be filled by the university." Another docent, writing in the comments section of one of the media pieces, stated that the director is "prioritizing dead plants over living ones."

When the museum director said in a media interview that "the botanical garden is clearly a secondary part of the museum with much less research value than other of its collections" and that no one sought to eliminate the friends group but that the plan was simply to "refocus its efforts to support the real work of the museum," the university's provost, who has oversight responsibilities for the museum, contacted the chair of the museum's advisory board. A week later, the director announced that she was leaving the position to return to her academic position in order to "devote more time to research."

In a note to the museum community that was posted on the museum's website and sent to the friends group, the provost's office thanked the departing director for her service and wrote that no further actions would be taken at this time to change the activities of the friends group and that, after consulting with the advisory board, a new director from the museum's senior staff had been appointed as a replacement and would begin the following month.

The incoming director, who had come from the educational division of the museum, had been observing developments with increasing concern and, despite having worked successfully with the friends group on programming, began to wonder what the charter of the friends group was, how it was operated, and what the nature of the agreement was for any funds that the group raised. At the same time, the incoming director had never interacted with the museum's advisory committee and could not locate any documents about how it was organized, who its members were, or what its responsibilities were. As they prepared to take over leadership of the museum, the incoming director realized that they needed to learn about support groups in museums quickly, to understand how they are supposed to operate and to establish what, if any, relationship they had with the museum's governing authorities.

WHY UNDERSTANDING MUSEUM SUPPORT GROUPS AND ADVISORY COMMITTEES IS IMPORTANT

The vignette above involves a friends group that has been become a formidable force over time, an advisory committee that is unaware of its limited oversight capabilities, and a series of museum directors who are seemingly unconcerned about either until the most recent one is faced with the consequences of a decision to shift the purpose of an influential support group.

The incoming director now has the challenging tasks of resetting relationships with members of both the friends group and the advisory committee and of appreciating that the pathway through this requires navigating how these

groups are structured, how they are supposed to operate, and how the efforts of such groups relate to the museum's governance structure. The incoming director will also need to consider whether the relationship with the friends group needs to be reformulated as well as what can be done to have the advisory committee understand that its role is to *recommend* rather than to *assume* the responsibilities of the museum's governing body, even if the governing body only makes its views known in times of crisis.

When lines of authority and their role in the organization are clear, support groups, such as friends groups and advisory committees, provide numerous benefits to museums. As semi-independent and self-managed entities closely allied to a nonprofit, friends groups are particularly important in the fundraising efforts of many museums, while advisory committees, usually formed to give wise counsel to staff or boards, are critical in providing professional guidance to museums, especially those that have nonmuseum parent organizations, such as universities or municipal museums. Confusingly, advisory committees are also sometimes called "advisory boards," which can cause issues for organizations when members of such groups believe and act as if they have oversight responsibilities because of the presence of the word "board" in their titles. The sections below outline what directors need to know about how friends groups and advisory committees function, the director's role in working with such entities, and the common challenges they present, including terminological ones.

FRIENDS GROUPS

A museum's director and senior staff can expect to interact regularly with a friends group because the group's work for the museum supports it in various ways. However, the work done by members of a friends group needs to be understood as not being done as staff members or as volunteers *within* the museum but as being done as volunteers outside of the museum *for* the museum. This is because the friends group is a semiautonomous organization with its own membership, whose purpose is to contribute funds to, advocate for, or create public interest in the museum.

Friends groups need to be clear about their purpose, which must include specifying in their core documentation the publicly supported nonprofit on whose behalf the group is operated. Friends groups are generally organized so that any financial contributions made to them are tax deductible under relevant provisions of federal and state law, with any such contributions benefiting the named nonprofit with which they are affiliated or collaborate. Because of the relationship set up between the nonprofit and the friends group, the latter can use the name of the nonprofit in its activities and to raise funds on behalf of it.

Friends groups need to have their own articles of incorporation that outline the group's purpose; bylaws that describe how the group is governed and that

specify board positions; statements that outline the organizational relationship between the museum and the friends group; information about who can become a member of the group and how; and what procedures exist about when meetings are to be held and how they are to be conducted. Incoming directors should be aware of these areas so that ties between friends groups and the museum can be reviewed from the start and so that strong partnerships can be developed and maintained. Misunderstandings that can arise about the purposes or activities of a friends group, like those described in the vignette, and efforts to reset or reformulate relationships with them, can be successfully accomplished by new directors who understand and can communicate to everyone what structures must be in place for friends groups to flourish.

A key function of friends groups in many museums is to raise funds. When authorized to do so, friends groups can therefore use museum facilities to hold related activities, can cosponsor events with the museum, and can use museum staff time to facilitate friends group activities. Funds raised by friends groups can be used for a range of purposes in a museum, including to support the acquisition of new items for the collections, to conserve objects, to fund exhibits, and to host educational and fundraising events, among other things.

In some museums, particularly those associated with a state or local government, the museum may be organized in such as a way that it cannot raise funds on its own or, if it can do so, the funds cannot be easily differentiated from those supplied in general by the parent organization, making it impractical to accept financial donations directly. In such cases, the friends group is the primary way for the museum to raise funds and will be of special importance to the work of the museum's director in planning and supervising any museum activities that support such efforts.

No matter what the setting, however, friends groups can be composed of some of the most dedicated constituents of the museum, who, in return for their service, usually receive a range of benefits that may include invitations to social events held in the museum, discounts in museum shops, free or discounted admission, the ability to attend lectures or to receive special updates about museum activities, and the ability to connect with others over shared passions.

Although the types of friends groups present in museums vary widely, such groups, at their core, revolve around raising funds for the museum. At one of end of the spectrum are the almost two dozen friends groups at the Metropolitan Museum of Art (2024a), which focus on fundraising for areas such as photography, Islamic art, costumes, and arms and armor. Each friends group at the Metropolitan Museum of Art has an expected level of dues one must contribute annually that ranges from $2,500 to $15,000; a portion of these dues are tax deductible. The photography group, which is called "Friends of Photographs: The Alfred Stieglitz Society," has around sixty members and annual dues of $12,000 for those over and $6,000 for those under the age of

40. The benefits of membership in the Met's friends groups include special recognition in the annual report and, for some of the friends groups, activities such as trips to other museums with noted researchers or private presentations from curators.

The main friends group at the Metropolitan Museum of Art is called the "Friends of the Met," which meets four times per year for events such as curator-led discussions, private receptions, and behind-the-scenes tours. Membership in the main friends group, like that for the more specialized friends groups in the museum, is by invitation, has annual dues of $6,000, and provides "essential operating support for all facets of the Museum's activities, including its exhibitions, conservation efforts, and educational programs" (Metropolitan Museum of Art, 2024b).

Another example of a friends group is the one associated with the North Carolina Museum of Natural Sciences, which is part of the state's museum system and is located in Raleigh. The purpose of this friends group is to support the museum's work to "illuminate the natural world and inspire its conservation" (North Carolina Museum of Natural Sciences, 2024a). In addition to its officers, the friends group has a board of more than twenty members; senior staff members that include an executive director and directors of finance and development; and several staff members who work in one of two divisions, development and administration or retail and rental operations. As is the case in some museums, the museum's store and membership program are operated by the friends group. Becoming a member of the friends group at the baseline level of $65 per year has as its main benefit free admission to special exhibits, and becoming a member at the level of $10,000 per year has the benefit, among others, of having lunch with the museum's director (North Carolina Museum of Natural Sciences, 2024b).

Closer to the other end of the spectrum for friends groups in museums is one final example associated with the Mark Twain House and Museum in Hartford, Connecticut. Originally formed as the "Mark Twain Memorial Women's Committee" in 1967, the group changed its name in 1994 to "Friends of the Mark Twain House and Museum" and, since then, through developing and sponsoring fundraising events to support preservation of Twain's home and his literary legacy, has raised more than $1 million (Mark Twain House and Museum, 2024). Membership is open to all, with annual dues of $30, and those who join can select to be part of several committees, including those in membership, programs, leadership, fundraising, and communication.

For groups that are so important for museums, it is interesting to note that a national snapshot or registry of friends groups is not available and that research on friends groups in the nonprofit sector, let alone in museums, is very limited. The available studies focus on friends groups that are associated with public agencies, such as national parks, state or local governments, or libraries. Nevertheless, as Trimbach (2016) notes in a study of friends groups mostly

affiliated with parks and recreation in Oregon, the biggest challenge these groups face is board member and volunteer burnout. A study of friends groups associated with libraries in Indiana found that the groups were invaluable for public libraries of all sizes but did not "preserve their documentation and history in any organized or formal way" (Brown et al., 2001, 13). Finally, a study of friends groups affiliated with the National Park Service found that only roughly half had some kind of formal agreement with the park that they supported and that such groups were "increasingly being put in the position to support core functions" (Vaughn and Cortner, 2013, 143).

In the absence of similar studies that focus on museums, the studies reviewed above identify challenges that may also be encountered in museums and suggest that new museum directors are well advised to understand how the friends groups in their museum are organized and to determine what role they play in the museum's overall fundraising efforts.

New directors almost always assume their positions with friends groups already in place, though such groups may be inactive or not living up to their potential and, thus, may need guidance from staff about how to reinvigorate the groups' efforts to best support the museum. A helpful resource for directors who would benefit from understanding how friends groups can revitalize themselves is a tool kit published by United for Libraries, which is a division of the American Libraries Association (Reed, 2012). The tool kit recommends, for example, that formal agreements between the organization and its friends group be in place and that such agreements specify that goals for fundraising, advocacy, and volunteer services be revisited annually (Reed, 2012). Because senior staff and directors are likely to be the ones engaged in any conversations related to planning and the setting of goals, it is helpful for new directors to be aware that annual check-ins can be built into such agreements and that this can be useful in revitalizing friends groups.

In museums with well-run friends groups, staff can expect that they might work closely with the groups in planning for the use of facilities, in consulting about fundraising goals, and in planning events that may involve the cultivation or stewardship of key donors. In contrast, friends groups with an ill-defined connection to the affiliated museum or those whose purposes are no longer clear or closely tied to museum plans can become problematic for the museum, especially when it comes to their fundraising activities. The United for Libraries tool kit notes that "nothing has doomed the relationship between Friends and the Library more than misunderstandings about how the money and the time of the Friends group will be spent" (Reed, 2012, 8). This holds true for museums as well.

As highlighted in the vignette at the beginning of this chapter, new directors should be aware of various other issues raised by friends groups, including their members taking up too much staff time; the groups competing with the museum for use of its facilities; and group members not coordinating with

museum staff in planning when both the museum and the friends group are both very active in fundraising. In addition, friends groups may develop activities or fundraising events that are not consistent with the museum's mission or that undermine, compete with, or coopt the museum's work in these areas. Also, the museum should not deploy members of the friends group to serve as ambassadors for the museum and should not include friends group members on organizational charts, so that both the staff and the board understand their positions in the museum. Further, there may not be clear communication and a deep partnership between the group and the museum, and having the group serve as an exclusive club or "clique" for supporters of the museum may exclude certain members of the community.

To address this range of concerns, museum directors should pay special attention to the bylaws of friends group, work to facilitate the development of a trust-based relationship with friends groups, and clarify ambiguities in the purpose and the organizational position of the group in the museum *proactively*. An understanding of how friends groups work, together with the existence of good governance and the recognition that a friends group will require staff attention and time, will support the ability of friends groups to raise funds for museums, to appreciate the role they can play in developing leaders and advocates for the museum, and to perceive how they can contribute to supporting the museum's mission.

ADVISORY COMMITTEES

Advisory bodies that offer guidance, serve as advocates, and can assist in fundraising activities are known in the nonprofit sector as advisory committees and are a particularly common feature of museums that are part of nonmuseum parent organizations, such as those in universities and local and state government. Composed of volunteers with skills and abilities that are relevant to the museum's mission, advisory committees can play an important role in advocating for the museum's needs, in educating governing authorities about the museum, and in offering professional assistance and wise counsel to the museum's director.

Advisory committees can also supply informed feedback to the museum on specific programs or initiatives, such as the many that have been formed by museums over the past thirty years to access expertise from cultural communities about exhibit development or collections care or to serve as a place to evaluate a museum's performance. At the same time, advisory committees can play a critical role in leadership development, in that individuals from the community who have a strong interest in the museum and relevant expertise can be asked to join them, thereby deepening their connection to the museum as a prelude to asking them to become a member of the museum's governing authority.

Advisory committees do not have the formal responsibilities of the museum's governing authorities and, thus, are not generally authorized to make decisions that can be enforced in the museum, to enact policy, or to be legally responsible for the museum. When advisory committees begin to act like the governing authority that is truly responsible for the museum because of confusion about the committee's charge or because the governing authorities are occupied elsewhere or are lax in their oversight, difficulties may emerge. For this reason, it is best not to use the term "board" when naming or referring to advisory committees, so that governing authorities, advisory committee members, and museum staff are clear about the committee's roles and responsibilities in the museum. For example, some museums include the word "council" in the group's name, which can convey its advisory capacity. Whatever the name of such groups, new museum directors should refer to a museum's bylaws to determine if advisory committees can be established, who establishes them, what their role is, and what their reporting relationship to the museum is (Axelrod, 2004).

With respect to their purposes, advisory committees need not be in place on a permanent basis. They can be created to address a specific need, such as to ensure that the views of community members are included in an upcoming exhibit about that community, and then dissolved when the need has been addressed, though it is important to establish if the need is indeed temporary. If they are regularly reviewed by the museum, the purposes of the advisory committee can be adjusted over time, so that one initially created to offer guidance about the care of collections from a particular community, for example, can be broadened to include advice from a range of communities with connections to the museum's collections.

The purpose of some advisory committees includes fundraising, though this may be limited to seeking contributions from the members themselves, rather than the group taking on the responsibility for raising funds. As with friends groups, it is important to outline any expectations about fundraising or annual contributions, and, as Axelrod (1998) emphasizes, not to delegate a task like fundraising to an advisory committee because the governing authority does not wish to engage in it.

A written statement about why the advisory committee exists should include who created it and, again, a clear indication of to whom the advisory committee reports. This statement should describe the work of individual members, what is expected of them, and the length of service as well as specify information about meetings and criteria for joining. Such a document can be useful in recruiting and assessment efforts, and it can be adjusted if the work and structure of the committee changes over time (Axelrod, 1998). The document can also clearly outline that the committee *does not* have a governance function, that its work is wholly advisory in nature, and that its purposes may be reviewed annually to ensure that it is functioning

adequately. It can also emphasize that the advisory committee does not make any final decisions and that the museum is under no obligation to listen to its advice, though this begs the question of whether the committee is needed in the first place.

To complicate matters, it is possible that a member of the organization's governing authority, such as a trustee or a board member, also serves on an advisory committee (Axelrod, 2004). In these circumstances, it is particularly important that everyone understand the governance structure of the museum and the role and purpose of the advisory committee.

To help advisory committees accomplish their goals, new directors and staff may be required to brief them on relevant developments, to listen to their guidance, or to seek their support in advocating for the museum externally. It may be useful for the director to assign a staff member with expertise about the purpose of the advisory committee to act as a liaison with it, in which case the staff member ought also to have a good understanding of the museum's governance structure and the role of the advisory committee.

Advisory committees, like committees for the museum's board, need to have meetings that are run well, to have sufficient support to carry out their tasks, and to be composed of members who are qualified, trained, and motivated. Advisory committee members also need to see that their guidance is listened to, if not fully heeded, and that their contributions are valued by fellow committee members and the museum itself. Leadership of the advisory committee is therefore important, and board members, in consultation with museum staff, may work together to identify suitable candidates. Advisory committee members should also have continuing education that includes explanation of the need to regularly assess their performance, which may include working with staff who have skills in assessment.

Perhaps because of the perceived internal nature of the work, little public information is posted on museum websites about their advisory committees. In a survey of museums in California, Southard (2015) found that just over 15 percent supplied any information about advisory committees on their websites, and, of those museums that did, the purposes of these committees were either undefined; to provide guidance on sustainability, fundraising, or technology; or related to connecting the museum to specific communities. While the absence of information about advisory committees does not mean they do not exist, for those museums using advisory committees to seek guidance from their communities for collections care or exhibition development, transparency in this area might demonstrate to the public how these museums are seeking to involve and represent stakeholder communities in their work.

Some examples of advisory committees for which information is available are described below, beginning with the one at the Jule Collins Smith Museum of Fine Art (JCSM), which is located on the campus of Auburn University in Alabama.

With roots in the art department during the 1940s, JCSM was renamed in the early 2000s to honor a donor's wife after a $3 million donation was made to assist with the expansion of the museum's exhibit galleries (Encyclopedia of Alabama, 2024). Today, the museum has positioned itself as the "cultural heart" of a public research institution and as a campus resource with an emphasis on teaching, research, engagement, and service to community (Jule Collins Smith Museum of Fine Art 2023, 2024). The museum has a diverse collection and six exhibition halls in a forty-thousand-square-foot building that opened in 2003 and is surrounded by ten acres of grounds with pathways and outdoor sculpture.

The JCSM's advisory committee is called the Advisory Board and is described in the most recent annual report as being composed of volunteers who serve the museum as "advocates, advisors, and fundraisers" (Jule Collins Smith Museum of Fine Art, 2023). Advisory Board members are appointed by the president of Auburn University, and about a dozen members of the group, many of whom are alumni of the university, are pictured in the annual report. The annual report describes a recent assessment of the museum that noted its strong efforts and commitment to diversifying the Advisory Board and how an Advisory Board member established a fund to acquire artworks from a specific community of artists.

Finally, as an example of best practices in this area, the most important professional association for museums in campus settings, the Association of Academic Museums and Galleries (AAMG), has posted the 2014 version of the *Jule Collins Smith Museum of Fine Art's Advisory Board Handbook* on its web page (Association of Academic Museums and Galleries, 2014). Clearly outlined in the document are Advisory Board duties and responsibilities, which include performing "an important and active role in maintaining the health and vigor of the museum" by advising the director on general principles that guide the museum (2014, 2). The university's Board of Trustees, which is characterized as "ultimately responsible for the operation of the museum" and as the group that sets policies for the museum, is differentiated from the Advisory Board, which "does not have fiduciary responsibility and is not legally liable for any improprieties occurring within the museum's governance" (2014, 2). Advisory Board members are "constant ambassador[s] and proponent[s] of the arts to the general public" and are expected "to develop a network of patrons to promote JCSM and its membership/fund raising activities" (2014, 2–3). The guide includes information on key polices, the museum's code of ethics, the museum's long-range plan, and an organizational chart that depicts the museum's major units, the Advisory Board, and the director's reporting line through university administrative levels to the Board of Trustees.

Much more typical of those museums that do supply information about their advisory boards or committees on their websites is a list of members' names with information about their backgrounds, along with a broad

description of the board or committee's charge, which is the case for the Advisory Committee at the Walt Disney Museum in San Francisco (2024), the Indigenous Advisory Committee at the Natural History Museum of Utah (2024), and the Advisory Committee at the Andy Warhol Museum (2024). Profiles of advisory board members for each of the Smithsonian's many museums, who "provide advice, expertise, and assistance to the Institution's leadership" are also listed on a single web page with links to each museum (Smithsonian Institution, 2024b).

In museums with well-functioning advisory committees, directors can expect that advisory committees will be offering guidance to them or the governing authority; that staff may need to support their efforts; that directors may have a role in the selection and recruitment of the committee's members and in the development of the group; and that the director and staff may need to prepare for and attend their meetings. As a result, it is useful for directors to understand core features of advisory committees and to be able to discuss them with both their staff and governing authorities.

Advisory committees that lack clear purposes, that are run poorly, or that have members without genuine or relevant interests, however, can pose real challenges for directors. For example, some advisory boards overstep their role in the museum and act as if they have the responsibility and authority of the governing board. As highlighted in the vignette, directors may find themselves working with an advisory committee whose members view their recommendations as requirements, who feel empowered to step into policy approval or to interfere in personnel matters, or who wish to further their own interests through the museum. Because of the outsized influence that advisory committees can have on their activities and the fact that they are part of complex nonmuseum organizations, university-based museums have been perhaps the part of the museum sector that has grappled the most with some of these challenges, as discussed below.

In 2017, the Association of Academic Museums and Galleries (AAMG) published a helpful set of best practices that pay special attention to advisory committees in university museums. The document, which is called "Professional Practices for Academic Museums and Galleries," notes that academic museums often benefit from the presence of what it calls "advisory boards" because such groups have the "capacity to advance the mission, financial sustainability, collections development, and institutional plan of the museum" (AAMG, 2017, 7). The document outlines that members of advisory boards in campus settings typically include alumni as well as collectors and financial donors, and that such groups may also be composed of faculty, staff, and students from academic subject areas relevant to the museum's collections or mission.

As is the case with advisory committees in nonacademic settings, AAMG best practices specify that written documents, including bylaws, a charter, and

an outline of member responsibilities that has been approved by the museum's governing authority, should be in place. Unlike other guidance about advisory committees, however, the best practices document places particular emphasis on clearly delineating the division of labor between the advisory group and the governing authority in academic museum settings, no matter how formally or informally the advisory group is constituted. The AAMG guidance also stresses that advisory board members, along with the museum's governing authorities and volunteers, are bound by the institution's code of ethics.

In addition, because governing authorities in academic museums may be more focused on what they perceive to be more immediate responsibilities elsewhere in the university, the best practice document recommends that the advisory committee be involved in two key areas: in approving the museum's mission statement and in developing the museum's institutional plans. The involvement of advisory committees in these two areas outlines a more robust role for such entities in universities than is usually the case in nonacademic museums. Consequently, an academic museum director may have to educate advisory committees about issues, such as planning or mission revision, as well as work to ensure that the museum's governing authorities review and formally approve any advisory committee recommendations in these areas.

Whether in academic or nonacademic settings, many museum professionals are aware that advisory committees have been particularly important in the development of exhibits that seek to depict, integrate, or present the voices and perspectives of groups that have been marginalized, were not previously welcomed, or were not represented in museum displays (for example, see Bench, 2014; Kadoyama, 2018; Lomawaima et al., 2018). Advisory committees have also been used to guide museums about how they can best care for collections from communities that have links to the collections they hold and for obtaining community-based information about accessibility, programming, or preservation concerns (for example, see Art Beyond Sight, 2024a; Berlinger, 2018; Persson, 2012; School for Advanced Research, 2023; True, 2019). Indeed, while there are many descriptions of the role of such advisory committees in museums (for example, see Lord and Lord, 2009; Piacente, 2022), little is known about the impact of governance structures on the effectiveness of advisory committees; the typical kinds, number, and range of purposes of advisory committees in museums; and if and how advisory committees fail. Such information could be useful in supporting the work of new directors, especially when museums use advisory committees to develop relationships with key communities who have not previously been involved with the museum or to whom the museum has been unresponsive in the past.

As Axelrod (2004) notes, there is remarkable diversity in advisory committees; one size does not fit all, and many variables, such as the governance and management structure of the organization it advises and its leadership, influence its role and effectiveness. Advisory committees are clearly a part of

the portfolios of many museum directors, and, for those who are new to the job or who have not considered how advisory committees function and will interact with them, it is useful to know how they differ from governing authorities, what their core features are, and how to assess when they are working well and when challenges are emerging.

In conclusion, museum support groups, such as friends groups and advisory committees, are important for new directors to understand because, although these groups generally do not report to boards, they can be a source of confusion for directors who are just beginning to learn about governance, particularly when the core documents of such groups are outdated, ambiguous, or weakly formulated. New directors will want to know how such support groups are organized, what their fundamental purposes are, and what kind of relationships they have with the museum's staff and governing authorities. Although friends groups and advisory committees can pose challenges for directors, in museums with good governance, they have proven their ability to make vital contributions.

7

What Could Go Wrong? Collections Management Issues

BOARDS AND COLLECTIONS: A VIGNETTE

A private, nonprofit history museum founded in the 1950s in a medium-sized city with a rich and complex past has an extensive collection of items related to the time when the city was a regional center for industry. The museum's collections are mostly composed of objects donated during the first twenty years of the museum's existence, when most of the city's industries left, the local economy collapsed, and residents who had lived there for many years began to donate historic items as people moved away from the city or as structures fell into disrepair. Along with locally prominent families who stayed, an array of historical and cultural material was donated to the museum, ranging from daily household items, historic vehicles, and decorative arts to tribal objects, equipment associated with the manufacture of ships, and a large collection of historic photographs, documents, and rare books. The museum's mission is to educate the public about the history of the city through the preservation, display, and interpretation of objects.

In the past twenty-five years, the city has undergone a rapid demographic transformation as historic buildings have been rehabilitated by newcomers who have opened artists' studios and small businesses, such as microbreweries, and who, alongside the diverse population that never moved away, have made the city a nascent center for local arts, craft, and culture. Museum staff have made great efforts to reach out to engage both longtime and new community members and have developed exhibits that have gained recognition as the museum begins to tell more complex stories about the city's past and how this past has shaped the city today. A community advisory committee, which was formed by the museum's long-term director and which has been well managed by the museum's assistant director, is composed of diverse residents

of the city and has been particularly helpful in advising the museum about acquiring new objects for display that relate to the history of diverse communities who had long felt overlooked by the museum. The museum's staff is proud of the museum's work in this area, believes that the museum has begun to reshape the relationship between the city and its diverse populations, and looks forward to continuing to develop collections and exhibits that expand its involvement with all segments of the city's population.

The museum has a long-term director who was trained as an academic historian but who acquired fundraising and project management expertise through continuing professional education. Over time, the director developed a highly committed, loyal, and professionally trained staff and built a strong, trust-based relationship with successive board chairs. The current chair of the board, who has been in place for five years after being reelected once, is a successful developer with deep community ties, a commitment to local history, and an interest in continuing to support the city's growing arts and culture scene.

The museum's board consists of twenty members and is composed almost entirely of those working in for-profit settings, including accountants, small business owners, lawyers, and real estate agents. The museum director has worked hard with recent board chairs to support efforts to develop clear board committee charters and to update the museum's bylaws, including establishing term limits, while also emphasizing the need to diversify board membership, to develop recruitment and orientation plans, and to run productive board meetings.

Based on the board's successful work to improve how it functions, the museum embarked on a transformative construction project that was spearheaded by the current and former board chairs. The project focuses on two areas: updating elements of the museum's main building, a former library built in the 1920s that is located in a struggling part of the downtown; and erecting an innovative parking structure to replace an aging parking lot located adjacent to the main's building.

The museum's main building contains four exhibition galleries, administrative offices, and a collections storage area located in the structure's basement. The construction project will add energy-efficient lighting to the galleries, enhance the building's accessibility, and create a signature entrance with the addition of a new lobby that will include a gift shop, a café, and a large atrium for hosting museum programs and nonmuseum revenue-generating events. The plan for the parking lot is to transform it into a smart, green "transit center" for electric vehicles, bicycles, and cars; it will be pedestrian friendly, filled with public art, and will incorporate a new stop at the urban light-rail system that runs near the museum. The board has placed significant amounts of energy into raising funds for the project and in working with the city to advocate for adding a new stop for the light-rail system, which they believe

not only will make the museum more accessible for visitors but also will be a cornerstone of efforts to spur redevelopment of nearby properties in the downtown area.

Unfortunately, because of the time required to work with the city and due to unavoidable production delays, construction costs have risen substantially, and the museum finds itself without the funds to complete the project as originally planned. At the same time, the museum's director, who, before the project began, was readily able to manage activities within the museum, has found that almost of all her time in the past three years has been spent on raising funds, working with the board to support fundraising, or managing key elements of the construction project. Based on the guidance of the community advisory committee, the museum's director therefore has not had the time to discuss updating components of the museum's collection management policies with the board, to outline how issues with the physical state of the warehouse are impacting collections care, or to share how the collections staff have requested additional resources to improve collections storage, conduct inventories, and review museum documentation. The board's collections committee, which is composed of five board members, has routinely approved the acquisition of new objects, loans to other museums, and the museum's first deaccession in many years, which consisted of household items from the 1950s for which the museum has many duplicates, without any real discussion.

The museum's collections are stored in two locations: in the basement of the main building, which was rehabilitated twenty-five years ago and outfitted at the time with appropriate collections storage and climate control; and in a former warehouse that was previously used to store equipment used in the production of ships. The main building houses the museum's earliest and most historically significant collections, including late-nineteenth- and early-twentieth-century furniture, ceramics, and textiles; objects acquired under the guidance of the community advisory committee; items from the city's former shipyards; and cultural collections donated to the museum from families who had become wealthy running local industry, began to travel, and brought back objects from places they considered "exotic" and eventually donated to the museum. The warehouse, which was gifted to the museum by a board member in the 1960s and is located several miles away from the museum's main building, houses the bulk of the museum's collection, including oversized ship-manufacturing equipment, historic vehicles, a large amount of household goods and furniture from the past 150 years, and many crates of objects that are labeled in broad categories such as "1940s flatware," "ceramic plates, fragile," or "early electrical appliances" and have yet to be completely inventoried.

Most of the museum's collection was acquired during a time when the museum did not consider the type, quality, and condition of objects in any depth and did not consider whether appropriate space was available to house

donated objects. During the museum's first two decades, it also did not consider if it was collecting too many objects, collecting too many of the same kind of objects, or collecting objects that were representative of all chapters of the city's history and communities. Indeed, until a professional staff was hired in the 1980s, standards for collections management were loose, with museum staff later coming to realize that many objects had been acquired without sufficient attention to their condition, associated documentation, or ownership. Moreover, the collections staff learned over the years that the volunteers who had been in charge of processing the large number of objects flowing into the museum in its early days had moved many groups of objects to storage, to be cataloged at some later date, but that subsequent cataloging and documentation efforts were cursory.

An example of a collection about which not much was known until recently was a collection that was found in four crates marked "Martin 1966, French Sudan, needs numbers" during routine inventory work in the warehouse in the early 2000s. After the objects in these crates were inspected, collections staff realized that these crates' contents were particularly susceptible to degradation due to the materials of which the objects were composed, and so they quickly moved them to the then-new collections storage area in the museum's main building, where objects were rehoused, cataloged, and placed in areas with climate control. The collection was found to consist of roughly one hundred objects, including carefully labeled, elongated figurines made of wood, copper ornaments, musical instruments, wooden stools, and masks with textiles, many of which were labeled with collecting dates from the mid-1950s and the name of a well-known West African ethnic group.

More recently, museum staff began to assess the documentation associated with the West African collection so that they could learn more about the collector and the collection's ownership, history, and meaning. Museum staff determined that the collection had been donated in the 1960s by a board member who had been an executive in one of the city's important industries and who had inherited the collection from an uncle who had collected the items in West Africa as part of the latter's work as a French colonial administrator. Staff also learned that the collection could be linked to a particular West African country that became independent from France in 1960, and that it had been appraised at a very high value at the time of its accession. They shared this information with the director, who, in turn, alerted the board.

Finally, in their work to develop partnerships with communities who might have ties to the museum's collections, staff learned that a delegation from the national museum of the West African country that was linked to the collection was visiting a nearby art museum. Staff reached out to the group and invited its members to view the museum's West African collection after they completed their work at the art museum. Group members visited, identified the collection as linked to a well-known tribal group that lived in their country,

made recommendations to the staff for the culturally appropriate care of many objects, and requested that the museum restrict access to certain items due to their sacred nature. Based on the group's cultural expertise, the museum also amended descriptions of many objects.

Meanwhile, as the construction project proceeds, the collections staff increasingly sees that it is being pulled in too many directions and that it has been left without enough resources to address several important areas of concern, such as the continued housing of collections in a warehouse that was not designed for such activity, the lack of a comprehensive inventory of collections in the warehouse, and issues concerning the museum's basic documentation, such as unclear ownership of objects, unresolved loans, and the existence of multiple catalog numbering systems.

Specifically, the warehouse's physical infrastructure is aging; many items are stored on original shelving; the warehouse's roof is old and has a drainage system that requires constant monitoring and repair; and objects used in the construction of ships, which are subject to rusting, are housed in the warehouse, even though there is no climate control. Although the warehouse has an alarm system, it also has several security vulnerabilities, such as multiple entry points, many large windows, and a location away from staff members, who are housed in the museum's main building. Concerningly, the warehouse also houses scores of boxes of photographs, letters, miscellaneous documents, memorabilia, and rare books that became the property of the museum when it took over the library and were later moved to the warehouse; this material was donated to the museum because it was agreed by both parties at the time that the museum would be better suited to care for them. None of the boxes containing these items has been fully inventoried or cataloged, however, and these items are stored on rusting shelves in large nonarchival-quality boxes that are visibly deteriorating.

The collections staff has taken many measures to ameliorate these concerns, such as placing almost all collections on pallet crates above floor level or high on shelves in the event of water intrusion, blocking views into the warehouse from all windows, and covering collections with plastic to impede the settling of dust or damage from light, but object preservation is being compromised. Along with the museum's assistant director, the collections staff have concluded that their efforts with the community advisory committee are also being undermined because they do not believe the museum is in a position to acquire more objects under the group's guidance when the museum does not yet have a sufficient inventory of its holdings and does not yet understand the collecting history and ownership of many of its objects.

With the director's attention consumed by the museum's construction project, the collections staff members find that they must do what they can with the resources they have and that they must continue to put standards in place in areas where this is possible. Among other things, the collections

management staff very much wants components of the collections management policy revised, including statements about how the museum facilitates the comanagement of collections with communities, and using language throughout the policy that emphasizes the stewardship role of collections staff. Although they have regularly updated the director about their concerns about the state of the museum's collections, they also see that the director's attention is focused elsewhere.

When the museum's director is offered a position that she cannot refuse in another state and leaves within a few weeks, the board perceives that a crisis has emerged: the construction project is stalled just when board members believe leadership and support is most needed. Fortunately, the museum's assistant director, who in the past several years has drawn upon their experience as an exhibit designer to manage the museum's finances, supervise special projects such as oversight of advisory groups, and assist in fundraising, is able to step in and is unanimously appointed director by the board, though the incoming director has rarely interacted with the board before.

Over the course of the next two weeks, however, the new director is challenged by three developments: the board is alerted to a flood in the warehouse, resulting from an intense thunderstorm that quickly overwhelmed the structure's antiquated drainage system; an interview with a relatively new member of the board's collection committee is published in a local media outlet in which it is suggested that the museum will sell the West African collection to raise funds to complete the construction project because the collection has "no real value to the museum"; and a formal request is received from the national museum that is linked to the museum's West African collection, asking the board to supply documentation about how the collection came into the possession of the museum, given that cultural property laws were in place at the time that supposedly prohibited the export of such material.

The incoming director is no stranger to navigating situations that require strategic thinking, or interacting with community groups, and has a deep knowledge of how to manage complex projects. The incoming director also understands how the museum is governed, what the core responsibilities of boards are, and how these responsibilities should be broadly expressed in board actions. The director also understands that boards often discuss and approve policy developed by the staff, knows how important it will be to establish a trust-based relationship with the chair of the board, and appreciates the critical role that advisory committees can have in museums.

After reviewing the minutes of past board meetings, however, and consulting with the departing director, the new director notes with growing alarm that discussions about the construction project have almost entirely dominated board meetings over the past few years and that the board's collections committee seems to have approved, in a perfunctory manner, any recommendations made to it. At the same time, in meeting with the collections staff, the

new director begins to understand the breadth of issues that exist in how the museum currently cares for its collections. In the work ahead, the director wonders how to press ahead with the construction project while working with the board to address the long-term and urgent collections issues that have arisen and what information is needed to reeducate the board about its oversight responsibilities for collections.

The new director realizes that, to work productively with the board, they will need to review or learn quickly about several key areas: how trusteeship relates to collections; what standards and ethical codes state about collections stewardship; and the composition of collections management policies. To brief the board with authority and to help it make informed decisions, the director also realizes that it would be helpful to know more about how serious the museum's collections care challenges are compared to those in other organizations and what the basic resources in collections stewardship are. In addition, the director seeks an understanding of how the museum community addresses issues involving culturally significant objects and what that would reveal about the museum's particular situation.

Finally, the incoming director also wonders under what specific circumstances the museum profession considers it acceptable to deaccession objects, what role the board plays in requests for the return of objects or in disputes concerning ownership, and who has the authority to make the final decisions in such cases. Without an adequate inventory of the museum's collections, with objects housed in less-than-ideal circumstances, with growing publicity about the West Africa collection, and with a request for the return of this collection being a real possibility, the new director realizes that how they proceed with the board and what they share with it will be instrumental in addressing the museum's many challenges.

WHY UNDERSTANDING COLLECTIONS ISSUES IS IMPORTANT

Directors understand that collections are what give museums their distinctive nature and meaning, whether the museum cares for its own collections or borrows objects from elsewhere for display, programming, or research. As the AAM emphasizes, the stewardship of collections "entails the highest public trust," and, as a consequence, the public expects museums "to maintain the highest legal, ethical, and professional standards" in managing them (2024b).

Not all new directors, however, will have been exposed to how boards should view their responsibilities toward collections or will have learned what core standards outline about collections in order to share such principles with boards. They also may not have much experience in working directly with collections, may not yet have had to navigate in their work the challenges museums typically face in caring for collections, or may be unfamiliar with recent changes in museum practice concerning how museums steward collections.

New directors who may need to work with their boards to ensure that appropriate oversight for collections is in place are therefore well advised to understand the museum's core documents concerning how collections are managed and to know how collections stewardship is framed by the museum profession. They should also spend time considering the central issues that relate to collections care so that they can determine if their board needs education in this area and, if so, have the most focused and relevant resources at hand to share.

In the vignette outlined above, the incoming director's knowledge of how boards should operate, who is ultimately responsible for supplying oversight of the museum's collections, and why museum's collections management policies are so important will be critical in determining what steps the director next takes to move the construction project forward while addressing the museum's underlying and emerging collections-related issues. At the same time, the new director's understanding of the general state of collections care in American museums, what ethical codes outline about collections stewardship, and when ownership issues are considered by boards will be helpful in supporting informed decision-making by the board on a range of topics.

For example, the new director's understanding of the nature of trusteeship as it relates to the oversight of collections may result in the director proposing that the board chair consider reassessing the goals of the construction project. The director might discuss why revisiting the goals of the construction project might be prudent in light of existing resources and how such a change could demonstrate the board's renewed understanding of its trust responsibilities toward collections. The director might also be able to outline the place of collections care in the hierarchy of the museum's current needs, so that the board's chair has all the information that she needs to decide if immediate steps should be taken to improve or prioritize stewardship of the collections, what plans might be developed to identify resources to enhance future care of the collections, and what changes in how collections needs are met might mean for the goals of the construction project. At the same time, the new director could share with the board's chair museum professional statements that outline how the proceeds from the sale of deaccessioned items can be used.

In another example, if the new director is able to remind the board that the museum has a detailed disaster response and emergency management plan that accompanies their collections management policy, they could quickly reassure the board that the immediate situation involving the water intrusion is under control, that the museum's staff is addressing it accordingly, and that the board was informed about the event as part of the disaster response plan. To build on the board's understanding of the true cause of the water intrusion, the director could also work with the board chair to develop a strategy to inform the board about the declining state of part of the museum's physical

plant and what this means for the care of the museum's diverse collections. The director could also provide the board with information about the scope of the work that will be required to rehouse, inventory, and assess the ownership of collections; place the museum's collections needs in context by sharing the results of national surveys of collections care with the board; and discuss how the resources to address the museum's pressing collections needs might be acquired.

In a final example, the understanding that a collections management policy is one of the museum's most important documents will supply the new director with a pathway to remind the board about its oversight responsibilities and how it can respond to possible requests to return materials. Significantly, the museum's collections management policy almost certainly already outlines the international and federal laws, regulations, and conventions the museum must comply with when acquiring objects and states that the museum does not acquire objects that were removed illegally from their country. The policy may even outline how any evidence presented that suggests collections were acquired in violation of relevant laws, regulations, and conventions will be investigated. The policy also likely describes how the museum understands ownership of its collection; who can access museum documentation; what the museum's responsibility is in inventorying and examining the ownership of its collections; the circumstances under which the museum allows deaccessioning and the use of any funds from it; and the values, ethical standards, and principles of the museum that guide the conduct of decision-making. Together with reviewing how museums approach the return of culturally significant objects, which are often called cultural property, the new director's knowledge that museum policies are to be updated from time to time will also provide the director with an opportunity to discuss with the board how the museum's ongoing work with groups linked to its collections may result in proposals to modify policy that relate to collections care or to the actual return of objects that are important to such groups.

New directors are not likely to be surprised by the amount of time and attention that collections-related issues require from staff but may have become disconnected from such requirements because of other demands on them and the presence of highly skilled collections staff who understand the complex legal dimensions of managing museum collections and the subtleties of developing collections-related policy. Even if a new director relies extensively on staff expertise in the area of collections stewardship, however, the director's ability to speak with authority to the board about collections issues is critically important to informed oversight and decision-making.

Consequently, the sections below review what new directors need to know about trusteeship and collections, including collections management policies; the general state of collections care in museums across the United States; key resources about museum collections management; and how museums

manage cultural property—a high-profile area of collections stewardship that often involves the director and the board, especially when calls for its return by those linked to it are made. The closing section outlines what directors need to know about boards and collections.

TRUSTEESHIP AND COLLECTIONS

It is important for new directors to be reminded about the nature of trusteeship in museums and to appreciate what trusteeship means for how boards should express their oversight responsibilities. As discussed in earlier chapters, the way that museums are organized as charitable corporations means that they have a trust-like relationship with their collections and must manage them in ways that benefit the public. Even a hint of impropriety or self-enrichment, or a sense that the museum is somehow negligent in its oversight of collections, for example, is enough to raise the issues of whether the resources the board supplies are sufficient, whether the board fully understands the legal and ethical environment for its collections, and whether the board is aware of the museum's trust-like relationship with its collections. On the other hand, for the many issues a museum might face that do not relate to collections, such as its business operations, the museum is held to a lower standard when it comes to activities that might be considered negligent.

In understanding that the oversight of collections is premised upon the concept of trusteeship, new directors have a potent lens through which they can examine board actions, a clear basis for bringing serious collections-related issues to the board's attention, and an explanatory framework they can use to educate boards about collections-related responsibilities. When boards explore selling collections to address budget issues, prioritize efforts that are unrelated to collections in the face of pressing collections-related needs, or do not appear to understand the value of collections to communities that have strong links to them, as seen in the above vignette, they risk being criticized for not truly understanding their trust responsibilities. Indeed, it is helpful for directors to know that their boards understand that trusteeship is the foundation of collections stewardship; that trusteeship challenges boards to act consistently, diligently, and in good faith to protect and preserve collections; and that boards can expect to be held accountable to a high standard of conduct in their oversight of collections, including in cases where objects may have been obtained without appropriate examination of their collecting history, or provenance, at the time of their acquisition.

No discussion of trusteeship and collections is complete without referring to the seminal work of Malaro and DeAngelis (2012), who note that, although museums have a responsibility to care for their collections, this has "not always been evident to museum boards" and, further, that when museum budgets are under consideration, "collections care is usually the dowdy stepsister

who is expected to defer to her more appealing siblings, public programming, new construction, and marketing" (2012, 445).

Significantly, by highlighting the legal implications of failing to have appropriate oversight of collections in place, Malaro and DeAngelis (2012) argue that boards can best demonstrate meeting the responsibilities they have toward their collections by developing a well-conceived collections management policy that outlines how the museum's collections are cared for and protected, given the museum's particular circumstances and resources. In particular, such policies should focus on how the museum approaches loans, accessioning, deaccessioning, inventory procedures, missing objects, security, conservation, and disaster planning (Malaro and DeAngelis, 2012). Malaro and DeAngelis's approach is the foundation upon which the museum professional literature about collections management policies is built; what this literature outlines about collections management policies is discussed below, with an emphasis on what new and aspiring directors most need to know.

COLLECTIONS MANAGEMENT POLICIES: KEY COMPONENTS

The AAM describes a collections management policy as a core document that outlines "the scope of a museum's collection, explains how the museum cares for and makes collections available to the public, and clearly defines the roles of the parties responsible for managing the museum's collections" (American Alliance of Museums, 2024k).

Although the components of collections management policies are well discussed in the museum professional literature (for example, see Clarke, 2013; Simmons, 2018), less attention is given to the board's role in the development, implementation, and monitoring of such policies. There are good reasons for this: great variability exists in how museums work with boards to develop collections management policies; museum personnel often develop procedures that are not addressed by policy or make well-judged exceptions to policy in order to get their work done; not all staff are aware that the board's work includes policy approval; much of the literature about collections management policy is aimed at museum professionals and not at board members; and there is little academic literature that examines the overall effectiveness of collections management policies or the processes involved in developing them.

New directors should understand that the main components of collections management policies include how collections are acquired and accessioned, deaccessioned and disposed of, loaned or borrowed; how objects in the possession of the museum, whether permanently or temporarily, are cared for; how the museum manages the documentation about the objects it holds; how the museum approaches access, insurance, conservation, access, and risk, including information about disaster and emergency planning; how and when inventorying is conducted, and information about cataloging and

collections management databases; how the museum approaches appraisal and authentications, conflicts of interest, and intellectual property concerns such as copyright; and information about legal and ethical concerns relating to the ownership and protection of the museum's collections, including legal requirements (American Alliance of Museums, 2012a; Clarke, 2013; Connecting to Collections, 2024; Genoways, Ireland, and Catlin-Legutko, 2017; Malaro and DeAngelis, 2012).

Collections management policies should also outline the museum's mission, the scope and use of its collections, the kinds of collections the museum houses (for example, an educational collection that is used differently than the rest of the collection), and, ideally, the museum's goals for its collections, such as a collecting strategy or plan. Collections management policies should also define areas of responsibility in the museum and indicate what codes of professional conduct are to be followed in making decisions; identify who is responsible for final decision-making and in what areas, particularly if some decision-making has been delegated from the board; outline that exceptions to the policy can be made when appropriate; note the date on which the policy was approved and that the policy itself is subject to formal review in a set number of years; and address the issues (such as repatriation, possible Nazi-looted art, care of sacred materials, acquisition of ancient art, archaeological objects, or historic structures, destructive analysis, or specific legislation or federal rules) that might have a major impact on the museum's particular collections (American Alliance of Museums, 2012a; Clarke, 2013; Connecting to Collections, 2024; Genoways, Ireland, and Catlin-Legutko, 2017; Malaro and DeAngelis, 2012; Simmons and Kiser, 2020). Overall, as Simons and Kiser (2020, 32) note, collections management policies should "reflect current standards, be sensible and logical, and be clearly stated . . . [they] should be written to meet the needs of a specific museum, its collections, and how those collections are accessed and used."

Because of the complexity and professional expertise required to manage collections in museums today, many museums have their staff develop the museum's collections management policy; directors then bring the policy to the museum's board, and the board reviews and approves it. The review process can vary dramatically among museums, however, with some boards "rubber-stamping" the policy, others having some discussion of the details of the proposed policy before its approval, and yet others engaging in detailed discussion that might lead to clarification being sought from staff, which results in some modifications in approach or language. The trust-like responsibility that museums have with collections underscores the importance of having boards be involved with collections management policies as much as is practicable. New and aspiring museum directors can use information about trusteeship to empower their educational work with board chairs to ensure that the many decisions that are embedded in collections management policies—such as

how objects are to be acquired or when they are to leave the museum—are fully understood by boards.

COLLECTIONS MANAGEMENT POLICIES: EXAMPLES

One noteworthy example of a recently approved, comprehensive collections management policy is from the Museum of the City of New York, a private nonprofit museum in Manhattan that cares for more than 750,000 objects, including books, textiles, furniture, decorative arts, paintings, and photographs (Museum of the City of New York, 2024a). The Museum of the City of New York is run by at least thirty staff members and is governed by a Board of Trustees, which has roughly three dozen members and includes a small Executive Committee (Museum of the City of New York, 2024b). The museum's collections management policy is divided into almost two dozen brief sections, beginning with the museum's mission statement, which is to foster understanding of the "distinctive nature of urban life in the world's most influential metropolis" through "celebrating, documenting, and interpreting the city's past, present, and future" (Museum of the City of New York, 2023).

The purpose of the Museum of the City of New York's collections management policy is to "document the basic policies, procedures and practices that guide the development and care of the Museum's collection consistent with the mission of the Museum and with professional standards" (Museum of the City of New York, 2023). The policy includes all of the typical components described above as being core parts of such documents, including sections on the scope and categories of collections; acquisitions; deaccessioning; care of collections; records and inventories; access; loans; and appraisals and authentications. It has also a number of sections that appear in many collections management policies that relate to the professional behavior of staff, such as personal collecting, dealing in objects, and receiving gifts, as well as sections that outline the museum's approach to provenance and title in the acquisition of objects and compliance with applicable law in how it acquires and loans objects (Museum of the City of New York, 2023). Key terms are also helpfully defined, with, for example, an "acquisition," being defined as an object that has been "formally and legally incorporated into the Museum's permanent collection"; a "deaccession" being defined as "an object that was at one time incorporated into the Museum's permanent collection but [that] has been formally and legally removed" from it; and "Collections Steward" being defined as a "museum professional responsible for evaluating and advocating for objects accessioned into the Museum's permanent collection" (Museum of the City of New York, 2023).

A notable area of the Museum of the City of New York's collections management policy is about the role of a board committee called the Collections Committee, which is described as being responsible for implementing

and overseeing the collections management policy. Staff members who are described as interacting with the Collections Committee in one way or another include the director, other senior administrative staff, curators, collections stewards, and registrars. Significantly, the Collections Committee can be seen to have decision-making authority on acquisitions and deaccessioning; to have a consultative role in assessing the appropriateness of any personal collecting conducted by the director; and to be a part of the review process if any exceptions to how the museum loans objects are to be considered by the museum.

In the area of accessioning, for example, the Museum of the City of New York's collections management policy specifies that, while the director of the museum has the authority to approve the accessioning of objects valued under $50,000, those objects valued between $50,000 and $100,000 require approval from the Collections Committee in order to be accessioned. Objects valued above $100,000 require still further approval from the Executive Committee to be accessioned. Objects can also only be approved for accessioning by the Collections Committee after the collections steward has submitted a detailed report that outlines the object's key features, including its condition, provenance, ownership, relevance to an established collections plan, and importance to the collection. Acquisitions must also comply with relevant laws and conventions, including those that relate to protecting cultural property, endangered species, and objects covered by the Native American Graves Protection and Repatriation Act (NAGPRA), which is a federal repatriation law. Presumably as a way to educate potential donors, other museum staff, and board members, the section on the collection steward's report also stresses that is it not sufficient for objects to be recommended for accessioning simply because they were made in New York City, depict New York City, or were owned by someone who once lived in New York City, an approach that the museum in the vignette would benefit from considering, given the weak connection between the origin of its West Africa collection and its mission to educate the public about the history of the city in which it is located.

For a proposed deaccessioning, the collections steward also completes a report, which is then reviewed by senior staff. If the deaccessioning is supported, the report is then presented to the Collections Committee to decide whether to approve it; objects valued over $100,000 must also have the approval of the Executive Committee to be deaccessioned. Proceeds from the sale of deaccessioned objects must be reported to the Collections Committee by the museum's registrar, and the resulting funds can be used only for the purchase of objects or for the direct care of collections, which is defined as activities that support the care of collections, such as conservation, the purchase of storage equipment, or paying for the salaries of staff who work with collections. Any expenditures above $50,000 from such proceeds must be approved by the Collections Committee.

Finally, although most decision-making has been delegated to the Collections Committee, the Executive Committee is outlined as being directly involved in several situations: when permission is sought for the director to accept a commission or stipend as a dealer; when its approval is required for high-value accessions and deaccessions already recommended by the staff, as mentioned above; or when it must be made aware of gifts that were accepted by the director at certain times of the year when the board is not able to meet. The full Board of Trustees is also to be made aware of all approved or denied loans at the beginning of fiscal years, and, furthermore, only the trustees can approve loans to individuals from whom the Museum is also borrowing an object.

The Museum of the City of New York places most of its decision-making about its collections in the areas of accessioning, deaccessioning, and some aspects of loans in the hands of a board committee, albeit one that is required to be carefully briefed and updated, while physical care, preservation, and protection of the collection has been assigned to staff. Museums such as the Walters Art Museum in Baltimore, Maryland, which has an extensive collection of art from around the world, also has a collections committee on its board that, in consultation with the director, carefully reviews proposed accessions, deaccessions, and certain kinds of loans in order to make recommendations to the full board for approval (Walters Art Museum, 2021). Similarly, in the Genesee Country Village and Museum near Rochester, New York, which is one of country's largest living history museums (Genesee Country Village and Museum, 2024), the board's collections management committee makes decisions about deaccessioning, unless objects are valued over $10,000, in which case the deaccessioning must also be approved by the full board of trustees (Genesee Country Museum, 2015).

In other museums, however, decision-making about key areas of collections oversight, in addition to the physical care of the collection, is much more in the hands of the staff than the board. For example, in both the Science Museum of Minnesota, whose mission is to inspire learning, inform policy, and improve lives (Science Museum of Minnesota, 2024), and the Denver Museum of Nature and Science, which is one of the country's largest natural history museums (Denver Museum of Nature and Science, 2023), staff committees are allowed wide latitude in making decisions about accessioning and deaccessioning and in the lending, borrowing, or use of objects, according to either formal delegations of authority or written guidelines approved by the boards of the museums. In the case of the Science Museum of Minnesota, a fully developed section on the management of culturally sensitive materials, which are defined as "artifacts, specimens, or materials whose treatment or use is a matter of profound concern to living peoples," is particularly noteworthy because it undoubtedly reflects the ability of knowledgeable collections

staff to develop important components of policy that were later approved by the museum's board.

COLLECTIONS MANAGEMENT POLICIES AND NEW DIRECTORS

New museum directors should be aware that some of the most vital work taking place in the area of collections management today involves staff who are working to formalize into policy community concerns about how objects are accessed and cared for, so that any arrangements made about the management of culturally sensitive materials are based on *institutional* rather than *personal* relationships, meaning that such arrangements are part of formally approved collections management policies.

For example, work led by staff to modify components of collections management policies to include approval by Native communities for how collections related to them are accessed, loaned, or researched (see Wheeler, Arsenault, and Taylor, 2022), or to decolonize collections management policies in indigenous-led museums or those with substantial indigenous collections (see Spears and Thompson, 2022; Vetter, 2023), require directors who understand these activities, who can speak to the board about any concerns they raise, and who can work with the board's chair to move policy toward approval.

When decision-making about key areas of collections oversight is largely left in the hands of the staff, it is imperative that new museum directors work to have boards understand the policies they are approving so that boards are not surprised by the activities that result, conclude that directors have not educated them sufficiently, or perceive that a gap has opened between the board's vision for the museum and the museum's actual policies.

New directors should also be aware of important work that is underway in the area of collections planning, which involves establishing what the museum wishes to do with its collection so that it is acquiring and deaccessioning objects according to a thoughtful, agreed-upon, and time-delimited plan. Also sometimes referred to as collections development plans, such documents give shape to how museums refine and steward their collections and are the result of a museum first understanding its collection. Although closely tied to collections management policies, collections plans are much more specific in defining what kinds of objects will be collected, why certain kinds of objects will be collected, what resources will be used to collect such objects, and what personnel will be involved in collecting them.

A key resource in this area is *The AAM Guide to Collections Planning* (Gardner and Merritt, 2004), which outlines what should be considered in developing such plans, including defining collecting goals for the museum, specifying future collections needs, and, critically, understanding what the museum already possesses in order to assess the strengths and weaknesses

of the existing collection. Even though collections plans are not always formally approved by boards, Gardner and Merritt (2004, 34) assert that it is vital to consult governing authorities about them so that the planning process can be used to educate boards about their collections, the broad utility of collections plans, and "as a way to generate excitement about new collecting opportunities" (Gardner and Merritt, 2004, 34).

In addition, new directors will want to be familiar with the latest guidance from professional organizations about how museums can use the proceeds of objects sold as part of deaccessioning, such as that from the AAM (2019), the Association of Art Museum Directors (2022), and the American Association of State and Local History (2024), all of which outline that museums may only use such proceeds for the "direct care" of collections. For example, the Association of Art Museum Directors defines "direct care" of art as "the direct costs associated with the storage or preservation of works of art . . . for conservation and restoration treatments . . . [and for] materials required for storage of all classifications of works of art" and notes that "funds received from the disposal of a deaccessioned work of art shall not be used for operations or capital expenses" (Association of Art Museum Directors, 2022), while the American Association of State and Local History outlines that "collections shall not be deaccessioned or disposed of in order to provide financial support for institutional operations, or any reason other than direct care, preservation or acquisition of collections as defined by institutional policy" (American Association of State and Local History, 2024). New museum directors who work with their boards to modify collections managements policies based on this guidance will therefore find that proposals by board members to use the proceeds from the sale of deaccessioned collections for purposes not related to collections are not likely to gain traction.

Although many sources of information exist for developing and revising collections management policies, there are few studies of what makes such policies effective and whose responsibility in the museum it should be to develop them. There are also few comparative assessments of collections management policies within and across museums of different kinds or sizes. It is also clear that not all museums readily allow public access to their collections management policies by posting them on their web pages, which in light of statements about the need for board transparency, would seem to be sensible, though this area has also not been studied. Furthermore, there is little comprehensive data about where informed decision-making about collections management policies takes place within the museum's structure, such as on a board committee, or if certain collections policy issues might be better left to staff for development rather than others.

Regardless of the state of research on collections management policies, new museum directors ought to be deeply invested in how boards are involved in such policies and should have knowledge about collections management

policies to draw upon should their boards need to be educated about them. New museum directors should understand the main components of collections management policies and should also be aware of any explicit board responsibilities that might involve the director because such policies "give the governing authority, staff and public the opportunity to learn about standards and help the museum fulfill its responsibilities as a steward of collections" (American Alliance of Museums, 2012a).

New directors will also want to pay special attention to how collections management policies describe the board's role in decision-making in areas such as loans, acquisitions, and the circumstances under which board members can donate objects. These policies also address the board's role in deaccessioning and how any proceeds from such deaccessioning can be used by the museum and how deaccessioned items are disposed of. New museum directors should also understand if and how the collections management policy addresses the board's role in issues that might be specific to the museum's collections, such as the review of ownership claims from groups outside the museum, the consideration of requests for access to associated documentation, or the integration of guidance from communities that are linked to a specific collection into that collection's management.

In sum, given that trusteeship is the foundation of collections stewardship and that a new landscape is now emerging in which ownership of objects is increasingly contested on formal and informal levels, new museum directors will want to become knowledgeable about how boards are involved in collections-related issues. Such directors can gain such knowledge through involvement in the development, application, or revision of collections management policies.

THE STATE OF COLLECTIONS IN AMERICAN MUSEUMS

In 2005, the nonprofit organization Heritage Preservation, whose programs and publications later transitioned to the Foundation for Advancement in Conservation, published a now-classic report, titled "A Public Trust at Risk: The Heritage Health Index Report on the State of America's Collections," concerning the state of collections in American institutions (Foundation for Advancement in Conservation, 2024; Heritage Health Index, 2005). The report, which was partially updated in 2019 (Institute of Museum and Library Services, 2019), was based on a comprehensive survey of the tens of thousands of known collecting institutions in the United States. The survey was designed by Heritage Preservation in association with professional organizations, federal agencies, and leading collections professionals, and it asked institutions to report on the state of preservation of their collections. Most respondents were institutions associated with the museum sector, and one-third of respondents were associated with history in some manner (such as history museums, historic houses,

or historical societies), though a range of library types and archival institutions also made up a sizeable percentage of respondents.

The Heritage Health Index reports are important for new directors to be aware of because the information they contain can be shared with board members to provide context about challenges facing collections-based institutions, as outlined below, and to assist boards in making more informed decisions about how they can allocate resources.

The Heritage Health Index reports provide several disquieting statistics that call attention to the vulnerability of collections in the United States and the pressing need for collecting institutions to address a range of serious preservation issues. For example, the condition of almost one-third of all artifacts, which, among other objects, includes archaeological objects, manuscripts, unbound sheets (which consist of letters, artwork, notes, and other documents), historic and art objects, natural science specimens, photographs, books, sound recordings, and other media, was not known. Roughly one-fourth of institutions did not have environmental controls for their collections in place to mitigate damage from light, humidity, and temperature; more than half of institutions reported damage to their collections from environmental causes; and almost two-thirds of institutions lacked storage space to accommodate collections appropriately (Heritage Health Index, 2005). The Heritage Health Index report also found that only about one-fifth of institutions had a paid staff member whose duties were dedicated to preservation and that more than one-third of institutions had a significant backlog in cataloging their collections. In addition, items such as historic objects, natural science specimens, archaeological objects, and art objects were among the kinds of objects that were found to be most in need of care, with needs for unbound sheets, photographs, and books being particularly urgent. More than half of institutions also reported that their security systems were inadequate, and almost two-thirds needed storage improvement for their collections. Strikingly, almost three-fourths of institutions had no current overall assessment of the state of their collections, few institutions allocated funds for collections preservation in their annual budgets, and, perhaps most concerningly, four-fifths did not have an emergency or disaster plan that included collections (Heritage Health Index, 2005).

In the 2019 follow-up to the 2005 Heritage Health Index report, titled "Protecting America's Collections: Results from the Heritage Health Information Survey," collecting institutions were observed to have made progress in several areas, including a nearly one-third reduction in damage to collections from improper storage or light exposure; a doubling in the number of institutions with emergency plans; and a more than doubling of institutions that reported preservation was included in their budgets (Institute of Museum and Library Services, 2019). Changes in questions and methodology in the updated report also resulted in the ability to better differentiate collecting institutions

from one another, so that it was possible in some cases to report findings about museums separately from findings about libraries and archives, for example.

The 2019 report also noted many areas of concern. Smaller organizations, when compared with institutions of larger sizes, were found to be much less prepared for emergencies, less likely to be involved in preservation activities, and much more likely to have no one devoted to preservation working in their institutions. In a new area that had not been examined in the previous survey, digitized and born-digital materials were found to be at risk in institutions of all kinds. In addition, more than one-third of museums reported that their collections had been damaged in the two years prior to the survey, with water or moisture being the most common cause of damage; almost half of museums had not yet completed general assessments of the conditions of their collections; and two-thirds of institutions reported that their greatest preservation need was in inventorying, cataloguing, or developing finding aids for collections, with the need being especially acute in museums and historical societies. Finally, around one-fifth of museums had inadequate security systems in place; more than half of museums did not have preservation activities included in their annual budgets, fewer than one-third had an emergency plan, and roughly half of museums did not have environmental systems in place that controlled for humidity, even though fluctuating humidity levels are known to damage objects (Institute of Museum and Library Services, 2019).

A more general survey that examined museum financial practices asked respondents several questions about collections care expenses, and the results were reported in a publication sponsored by the American Alliance of Museums that was titled *2009 Museum Financial Information* (Merritt and Katz, 2009). Eighty percent of museums surveyed responded that they cared for collections, and those that did provided information about how much funding they devoted to collections care each year, where collections care included funding for staff, supplies, storage, and conservation. The median amount was close to $110,000, which was an increase from what was found in a 2005 survey, when the amount was closer to $80,000. Interestingly, the average amount spent by museums on collections care represented just 8 percent of the museum's operating budget. Art museums devoted the most funding to collections care, whereas science and technology centers and children's museums, which typically do not have large collections, devoted the least. Given that collections are considered to be one of the core purposes of museums and to be at the very center of why museums exist, the relatively low percentage of funding devoted to collections care in museums is noteworthy.

Overall, what the Heritage Health Index and Museum Financial Information surveys tell museum directors is that boards of collecting institutions still have much to learn about their responsibilities concerning collections. The serious issues that the Heritage Health Index surveys identified in particular speak to boards not appreciating or acting upon the trust-like responsibilities they

have for their collections while demonstrating the real-world consequences of boards not providing sufficient resources in their oversight of collections.

The results of these surveys also empower new directors to work with board chairs to find ways to educate boards proactively about their responsibilities toward collections by outlining the consequences of neglect and placing the efforts of their own museum in a broader context. Indeed, an understanding of the challenges facing all collecting institutions allows new directors to be strategic with their boards in planning future projects, helps new directors see what efforts they and their boards might prioritize at any given moment, given the museum's unique collections care circumstances, and supports informed decision-making by boards.

KEY RESOURCES IN COLLECTIONS MANAGEMENT

The professional literature about management of museum collections is extensive, accessible, and focused on describing and enhancing practice. Museum professionals have extensive information available to them, from general resources, such as the essential *MRM6: Museum Registration Manual* (Simmons and Kiser, 2020) and the influential *Things Great and Small: Collections Management Policies* (Simmons, 2018), to an array of specialized resources on areas such as condition reporting (Van Horn, Midgett, and Culligan, 2022), small museum registration methods (Reibel and Van Horn, 2018), inventorying (Vanderwarf and Romanowski, 2022), managing legal issues (Malaro and DeAngelis, 2012), working with undocumented collections or old loans (Buck and Gilmore, 2007; Kipp, 2016), and managing specific kinds of collections (National Archives, 2024; Warner and Childs, 2019).

Highly useful and practical resources on collections management basics are also supplied on the websites of organizations such as Connecting to Collections (2024b), the National Park Service (2024a), the American Institute for Conservation (2024), and the Northeast Document Conservation Center (2024). In the past twenty years, academic journals, such as *Collections: A Journal for Museum and Archives Professionals* (2024), *Curator: The Museum Journal* (2024), *Museum International* (2024), and the *Museum Management and Curatorship* (2024), have also published increasing numbers of articles that examine elements of or changes in practice in collections management in museums.

Although it is safe to assume that a museum's collections staff is conversant with these resources, there is an argument to be made that new museum directors should be broadly familiar with the major resources and the key issues involved in managing collections, given the trust-like relationship museums have with their collections. Such knowledge is likely to be particularly useful in interactions with the board during discussions related to policy or the allocation of board resources or when the board has to approve high-value, unique, or community-driven acquisitions, loans, or deaccessions of objects.

Most helpfully for new museum directors, statements about important legal and ethical issues, which often include guidance on topics such as repatriation, loans, monetizing or selling collections, Nazi-era looted objects, acquiring ancient art and archaeological artifacts, managing endangered plant and animal species, culturally appropriate care, and other areas, are accessible on the web pages of professional organizations such as the AAM, the Association of Art Museum Directors, the Association of State and Local History, the Association of University Museums and Galleries, and the Society for the Preservation of Natural History Collections. For example, the Association of Art Museum Directors recently posted "Guidance on Art from Colonized Areas" (2022) on its web page. Likewise, the American Association of State and Local History's website includes its most recent statement about monetizing museum collections, titled "Valuing History Collections" (2020).

Such statements are the result of considered reflection by museum professionals who are focused on examining a particular collections-related issue that is typically of great concern to museums. Any associated guidance should be adopted only after careful consideration of professional and institutional ethical codes and after discussion; however, these statements from professional associations often crystallize how museums should approach issues, clarify options available to museums, and serve as a foundation that new directors can use to educate boards.

Equally useful for new directors to be aware of is how to access standards for collections stewardship as outlined by the AAM (AAM, 2024l) and ICOM (ICOM, 2024b). Along with statements from professional associations, standards can be used by directors to have boards understand that such guidance, which is the result of professional consensus, can be valuable in board decision-making.

COLLECTIONS AND CULTURAL PROPERTY

The need for new directors to have their boards understand the trustee-like relationship museums have with collections, the importance of board involvement in developing collections management policies in some form or another, and the value of new museum directors being conversant in the literature, ethical codes, and standards relating to collections care all come together when the topic of cultural property is considered. Cultural property can be defined as "tangible items that are part of the cultural heritage of a group or society" (AAM, 2024m).

Across the globe today, formerly colonized countries, indigenous peoples, and descendant groups are calling for museums to return historically removed ancient art, antiquities, sacred items, and other culturally significant objects. Indeed, headlines such as "For U.S. Museums With Looted Art, the Indiana Jones Era Is Over" (Bowley in *The New York Times*, 2022), "Was That Painting

Stolen by the Nazis? New York Museums Are Now Required to Tell You" (Feldman in *Smithsonian Magazine*, 2022), and "Is the Metropolitan Museum of Art Displaying Objects that Belong to Native American Tribes?" (Sharp in *ProPublica*, 2023) appear almost daily.

In these and many other similar cases, viewing the objects under question as cultural property allows new directors to appreciate why museums need to better understand the meaning and collecting history of such objects, the significance of these items to those who are linked to them, and why groups may want objects returned. This information can then be communicated to boards when proposals to modify policy, to formalize comanagement agreements, or to review requests for the return of cultural property are made.

While there is debate about what kinds of objects should be included in designations of cultural property, such as whether World War 2–era looted art or ancient art are best viewed as cultural property, and there is discussion about the concept of cultural property itself (for example, see Cuno, 2008, 2012; Lowry, 1998; Prott and O'Keefe, 1992), museum personnel base their understanding of cultural property on the definition in the 1970 UNESCO Convention: properties that, on religious or secular grounds, are designated by a nation of being of unique importance to that nation for reasons relating to archaeology, prehistory, history, literature, art or science (UNESCO, 2024). Cultural property can also include ethnographic objects, antiquities, ancient art, items of artistic interest, and natural history collections and can also be associated with parties that are not associated with a state, parties such as descendant groups or specific ethnic or indigenous communities who are linked to such material.

For museums, viewing certain kinds of items as cultural property emphasizes that they manage objects that certain groups consider to be of unique and irreplaceable value, that such objects must be managed in ways that recognize the changing legal and ethical framework within which museums are enmeshed, and that there can be intense public interest and scrutiny in how museums manage cultural property.

Museum collections professionals are no doubt familiar with key resources on cultural property, such as those by Malaro and DeAngelis (2012), Gerstenblith (2019), Phelan (2014), and Taberner (2011), in which the concept of title (the legal ownership of objects) and important laws and cases that relate to repatriation, ancient art and archaeology, and objects that were looted or displaced during the Nazi era are discussed. These resources also address the legal and ethical setting within which museums navigate cultural property issues.

Unless new directors have had more specialized training in cultural property, however, they may not be familiar with other useful resources, such as overviews of cultural property issues by Anderson and Geismar (2017), Fitz Gibbon (2004), Hoffman (2009), and Vrdoljak (2008); important works

on repatriation by Chari and LeValle (2013), Fforde, McKeown, and Keeler (2020), and Kuprecht (2014); recent studies of colonial-era collecting and museums by Oswald (2022) and Reed (2023); and informative discussions about the meaning of cultural property or why museums should retain or return cultural property, including those by Cuno (2012), Merryman (2009), and Messenger (1999).

Other useful resources include the websites of the Claims Conference (2024), which assesses efforts by museums to return Jewish-owned art and cultural property that were looted during World War 2; National NAGPRA, which outlines the requirements of the Native American Graves Protection and Repatriation Act and efforts by museums to comply with the law (National Park Service, 2024b); the Antiquities Coalition (2024) and the International Council of Museums (2024c), which track the illicit trade in art and artifacts; and many thought-provoking articles in the *International Journal of Cultural Property* (2024).

Depending on the particular issue, new museum directors may want to become familiar with some of these resources so that they can use them to help inform any decision-making on their boards about managing or returning cultural property, modifying collections management policies, or responding to requests for information about or navigating claims for cultural property.

No matter what resources are available to museums and new directors to address cultural property issues with their boards, however, when a museum's collections are associated with cultural property, it is advisable for new museum directors to be able to discuss several key points about it with their boards, as outlined below.

First, the management of cultural property is a rapidly developing area that brings together ethics and law with diplomacy and public affairs, and, as such, any decision-making related to it, such as about claims for its return, requires careful deliberation. New museum directors therefore want to encourage their boards to take into account the totality of circumstances and to have all relevant information in hand when making decisions. Such information should include what museum documentation specifies about ownership as well as why groups consider objects to be culturally significant.

Second, it is essential that new directors draw upon staff expertise and guidance from professional associations to navigate cultural property issues when discussing them with their boards. Boards will make better decisions when they know that the complexity of, specificity of, and recent shifts in practice related to cultural property have been considered by their staff and directors and that any recommendations made by them are informed and deliberative.

Third, because cultural property is perceived to be a central part of a group's identity in significant ways, museums must engage with associated groups respectfully, thoughtfully, and openly. Most helpfully, directors may share with their boards relevant ethical guidelines and statements, such as

those contained in the College Art Association's 2016 "Statement Concerning the Acquisition of Cultural Properties Originating from Abroad, from Indigenous Cultures, and from Private Collections During the Nazi Era" and Section 6 of the ICOM Code of Ethics for Museums, which is titled "Museums Work in Close Collaboration with the Communities from Which Their Collections Originate as well as Those They Serve" (2024d).

Fourth, in situations in which museums appear to hold on to stolen or improperly acquired material, and they do not appear to the public and the communities linked to it to be acting transparently and in a timely manner when asked about it, the public's trust of museums is undermined. Moreover, museums that appear to be out of touch with public sentiment, such as those who have continued to hold on to ancestral Native American remains despite the presence of laws requiring repatriation of them, can see their role as credible, trustworthy experts erode. Museums need the public to have confidence in how they manage their collections, and how museums address cultural property issues can highlight both the strengths and weaknesses of how museums approach collections stewardship.

Fifth, groups with connections to cultural property have a clear interest in how museums manage their collections. Increasingly, such groups are seeking to comanage or to control management of such objects or to have items returned to them. As a result, museums must be prepared for such encounters and must develop ways to be in respectful conversation with such groups. It may be necessary to inform boards that additional resources may be needed to support related efforts.

Finally, based on the existence of faulty acquisitions, inadequate inventories, and the lack of understanding of the ownership history of objects, communities linked to cultural property are increasingly asking museums to consider if these kinds of objects were legitimately and ethically acquired or were acquired improperly under situations of duress, during colonial control, or during times of war. Considering certain objects as cultural property thus provokes museums to examine the very nature of ownership itself, realizing that, while museums are legally presumed to have acquired objects fairly, there are situations in which strong moral claims to ownership may warrant the return of cultural property, ultimately resulting in a more multifaceted understanding of what it means to steward collections on behalf of the public.

Having a cultural property issue inevitably involves a museum with one or more groups outside the museum, whether it be the interested public or groups linked to the cultural property itself. Furthermore, those outside the museum who perceive that the museum is managing cultural property inappropriately or that claims for its return are not being taken seriously, are responding to something that they understand intuitively: that the museum has a deep and compelling obligation to manage its collections responsibly, according to the highest ethical standards, and for the benefit of the public.

As a consequence, it is helpful for new museum directors to know that, when museums fall short in navigating cultural property issues, it is not just the groups whose cultural property the museum manages who question the museum's actions but also the public. New directors should also know that this questioning will lead back to those who have the ultimate authority to make decisions about a museum's collections: the museum's board.

NEW DIRECTORS, BOARDS, AND COLLECTIONS

The most important cause undermining collections stewardship in a museum, whether or not the museum faces the particularly complex issues surrounding cultural property, is poor governance. When new directors are working with boards 1) who do not appreciate the museum's trust-like relationships with collections; 2) who have misplaced priorities that result in an emphasis being placed on issues that are not related to collections at the expense of those involving collections; 3) who are unaware of institutional and professional guidelines and obligations concerning key collections issues; and 4) who are not familiar with their museum's own collections management policies, new directors may find that they are being held responsible for issues that are not of their making.

When new directors also realize that their boards are completely unaware of the challenges collecting institutions face in caring for their collections, when they themselves do not have the information at hand to advocate for collections, and when they leave the board completely out of relevant policy or planning discussions, they may find that they do not have sufficient resources to steward collections adequately. While there is rarely enough funding in most museums, and it is a truism that museums must live within their means, understanding how good governance supports collections stewardship supplies new directors with the information they will need to become knowledgeable proponents for the best possible care of collections.

Finally, new directors will undoubtedly benefit when their boards have a deeper understanding of their responsibilities toward collections because of the increasing need for museums to effectively navigate the many long-standing and emerging collections issues that await them, including the implementation of laws and regulations related to collections, the associated developments in ethics and practice, the need to address problematic acquisitions and pressures to deaccession, changes in how ownership and stewardship are viewed, and, critically, calls to return objects to groups to which they are linked. With an appreciation of good governance and the board's roles and responsibilities, new directors will find that, while challenges do indeed await them, much can "go right" in how they work with their boards to support their oversight of collections.

8

Why Are We Displaying That? Exhibitions and Boards

BOARDS AND EXHIBITS: A VIGNETTE

A culturally specific museum in the United States that holds one of the largest collections of objects associated with a particular cultural community is located in the flourishing area of a medium-sized city in a relatively new structure designed by a star architect. The museum is held in high esteem by the cultural community with which it is associated, who closely track developments related to the museum in local media, and who view the museum's exhibits and educational programs with particular pride because they are a relied-upon educational resource for schools in the entire region. The museum's mission, which was reviewed several years ago, is "to preserve, exhibit, educate, and to provoke discussion about the history and experiences" of the region's specific cultural community.

The museum has three state-of-the art galleries, the largest of which is occupied by a permanent exhibit with tightly focused text and engaging multimedia displays that seamlessly integrate objects that have special historical, cultural, and religious significance for the cultural community. The permanent exhibit was installed five years ago, focuses on outlining the history of the cultural community and its contributions to American society, and has been recognized for its excellence by the statewide museum profession for its ability to connect visitors with a group whose culture and history are unfamiliar to or stereotyped by mainstream society. With clear and accessible language and an easily understood overall message, the permanent exhibit deploys the latest professional resources and insights from exhibit design and interpretation to create a profound learning experience for visitors.

The museum's two other galleries house temporary exhibits that are developed in-house by a talented team of staff, which includes curators, exhibit

designers, preparators, collections managers, and educators. In the past, exhibits in the temporary galleries have focused on important aspects of the community's culture, including sharing the stories of historical and contemporary figures, presenting information about the adoption of the community's distinctive food, use of language, and literature by mainstream culture, and exploring key historical episodes that illustrate how the cultural community can be both accepted and excluded by broader society.

The current exhibit in the first of the temporary galleries emphasizes the prejudice the cultural community has faced in the past, which resulted in housing inequality and job discrimination. Using compelling videos of oral histories from a wide range of people from the cultural community who have experienced prejudice, along with well-written interpretive text and historically resonant objects, the exhibit creates an experience that is relatable to a variety of visitors. Developed after an extensive period of consultation with a community advisory group and relying on the latest professional resources in exhibit planning, interpretation, and visitor studies, the exhibit and its programming have proven to be so popular that the museum is considering displaying the exhibit on a semipermanent basis as a complement to the permanent exhibit.

The museum is organized as a private nonprofit and has a board of twenty-five members. The board is composed of business leaders, accountants, lawyers, and other entrepreneurs, as well as nonprofit professionals, collectors, and commercial art gallery owners, all of whom are either associated with the cultural group the museum represents or very familiar with it. Board members have term limits, although retired board members are still allowed to participate and vote on committees. The museum has a board chair who is serving a second term and is a retired executive from a nationally known financial management company that has generously sponsored many exhibits in the region. The museum's bylaws were also recently reviewed and updated; board meetings are well run and always include an educational component about board responsibilities; the board takes oversight of its collections seriously and supplied the funding for an innovative compact storage system that the museum now has in its new structure; the director has a strong working relationship with board's chair; an institutional code of ethics is in place; and the longtime friends group continues to work successfully with the museum's staff to underwrite educational programming, including supplying funds for field trips by local public schools to visit the permanent exhibit.

The museum's collections management policy, which outlines the museum's approach to loans for exhibits, acquisitions, collections care, and deaccessioning, was revised and approved several years ago after the board briefly reviewed it. The museum does not have a separate exhibit policy, has not borrowed objects for its exhibits from other museums or private lenders before because of the depth of its own collections, and has not yet had to consider

how someone it borrows objects from is involved in developing or sponsoring exhibits.

The board has an exhibit committee that was formed when the museum moved into its new building, which at the time was deeply involved in suggesting key themes, specific content, and objects that the committee believed should be included in the museum's permanent exhibit. Many of the committee's recommendations were integrated into the exhibit, but, in several key areas, the committee deferred to the museum's staff and to the exhibit design consulting firm with whom the museum was working. Since the permanent exhibit opened, the exhibit committee has been less involved with the museum's temporary exhibits but recently made specific recommendations to the director to refresh components of the permanent exhibit and commented on the draft of the plan for the exhibit on prejudice. Several committee members were especially passionate about certain objects that they believed had to be included in the temporary exhibit on prejudice. After discussion with the director and senior staff, the exhibit plan was modified, several objects that told of painful experiences the community had endured were added, even though their inclusion might be controversial with some members of the cultural community and the public, and the exhibit opened without any negative reaction.

The board also includes three retired members who are highly respected for their cultural knowledge, lived experiences, and commitment to the preservation of the objects and stories of the cultural community the museum focuses on and who serve as a touchstone for other board members who do not have first-hand knowledge of some of the major struggles the cultural community has encountered in the past. All three still serve on the board's exhibit committee and have been involved in supplying their cultural expertise to staff in collections care, exhibit content, and programming over the years, though they have done so considerably less since the permanent exhibit opened.

As culture bearers who are deeply familiar with the history and culture of their group, these three retired members are also a treasured living link to the museum's founding because their immediate families helped create the museum in the early 1970s when it was felt that the group was not being represented in mainstream museums and that its objects and stories were in urgent need of preservation. The families of the retired board members contributed not only most of the museum's unique collection but also the funds to purchase a house in the cultural community's historic urban neighborhood, which served as the museum's headquarters until ten or so years ago. After a highly successful capital campaign raised more than enough funds to redesign and rehabilitate a former department store downtown, a large endowment was created, and the museum began planning its move into its signature new building.

The museum's longtime director is retiring soon, at the end of the fiscal year, to be replaced by the museum's senior development officer, who, in

anticipation of taking over the directorship, has obtained professional training in museum leadership. The board is familiar with the incoming director from having worked with them on solicitations for major gifts, from interactions with them at numerous fundraising events, and from briefings from them at board meetings and understands that the incoming director is already an experienced manager, a strong communicator with excellent interpersonal skills, and someone who is very knowledgeable about and connected to the museum's cultural community.

The departing director, whose background is in arts education, has worked closely with the museum's exhibition development team to develop an exhibit in the museum's other temporary gallery, which the departing director has long wanted to do and which she views as the culmination of her lengthy career in the arts. The temporary exhibit in this gallery is intended to focus on art that advocates for social justice, and its principal aim is to generate discussion about how art from the cultural community can shape much-needed social change. The exhibit is a departure for the museum in that it will focus exclusively on art, will involve borrowing objects from private lenders and other museums, and will be sponsored in part by a board member who is loaning pieces to the museum from a collection the board member owns. The exhibit is also being supported by a grant from a program of the state's arts commission that is designed to support the display of art from diverse communities.

Although the artists whose work is to be displayed are mostly from the cultural community on whom the museum focuses, some of the artists have courted controversy with politically charged art, provocative statements, and high-profile acts that sometimes offend the sensibilities of others from the same community and those of the broader public. For example, some of these artists have integrated objects with sacred religious meaning into their artwork about political figures, have used their art to advocate for radical changes in public policy that relates to the cultural community, and have defaced some of their own pieces in commercial art galleries to illustrate the injustices the group continues to face.

Because the museum's collection of art does not lend itself to the temporary exhibit's social-justice theme, the departing director has placed much effort into borrowing the increasingly valuable artwork associated with artists from the cultural community and has reached out to individuals and institutions to borrow relevant pieces. For example, the departing director was able to borrow several thought-provoking video artworks closely related to the exhibit's theme from a museum board member who is also a prominent local collector and a sponsor of the exhibit, although the board member insisted that the museum also borrow and exhibit one other piece associated with another newly emerging artist whose art is more loosely connected to the exhibit's theme. The board member also declined to have his sponsorship of the exhibit recognized in announcements about the exhibit, even though his underwriting

of the exhibit allowed the departing director to successfully secure several important loans, the first from a nationally recognized art museum of two highly relevant pieces, and several others from artists working abroad who have links to the cultural community and who have created compelling artwork about social justice in their own societies.

As the departing director retires, the new temporary exhibit opens with much publicity. Events with the curators involved in developing the exhibit are planned, stewardship activities for museum donors who have supported the exhibit will take place, and several of the artists have been invited to give talks or to create artwork in the gallery itself in order to activate the space and engage visitors. All of these activities have consumed much of the time of the incoming director as part of directorial succession planning.

When the exhibit opens, however, the new director is immediately faced with a barrage of criticism from members of the cultural community, board members, and the public. Members of the cultural community are enraged that some of the artwork depicts stereotypes of the group without what they believe is sufficient context; that some of the art denigrates public figures from their own community whose identities are easily discerned; and that objects with sacred qualities have been integrated into artwork in ways they consider disrespectful, if not outright offensive.

The retired and rather inactive board members who remain on the exhibit committee are particularly upset about how the exhibit reflects on their families and feel that the newly departed director has broken their trust. In a media outlet aimed at members of their cultural community, two of the retired board members blast the board for deeply upsetting them with the exhibit's content, for allowing the exhibit to include art that they believe is designed to inflame rather than educate, and for including art that will embarrass the museum and undermine its many years of work with the cultural community. In the media interview, they note that, as board committee members, they were not made aware of the exhibit's exact contents, they ask why the board's chair does not appear to have consulted with members of the museum's core cultural community about the exhibit's content, and they announce that they have asked the new director to close the exhibit out of respect for the museum's founders. They also urge the community to join them in a demonstration outside the entrance to the museum, the goal of which is to shut down the exhibit.

The next day, a small group of protesters appears outside the museum, holding handwritten placards calling for the exhibit to be closed immediately, shouting "injustice!" and saying that the art on display is inappropriate, vulgar, and deliberately hurtful to the community. Later on the same day, a much more widely viewed story about the exhibit appears on local television, in which one of the retired board members states with emotion that the exhibit has compromised the museum's institutional integrity, asks why artists "who are not from our community and don't know anything about it" have been

included in the exhibit, and pointedly wonders if the community can even trust the museum anymore. Interviewed at the demonstration, a member of the museum's friends group asks, "who is paying for this travesty anyway . . . and why isn't the museum exhibiting its own collections instead of borrowing from 'con artists' who are trying to inflate the value of their 'art' at our community's expense?" The retired board member concludes with the statement that her late parents, who were founders of the museum, would be "heartbroken" and "devastated" about the exhibit, and that they would demand to know how the board let the exhibit be approved in the first place.

A much larger group of protesters soon appears outside the museum with handwritten placards calling for the exhibit to be closed immediately, shouting "outrage!" and saying that the art on display is inappropriate, vulgar, and deliberately hurtful to the community. Later in the day, when a regional newspaper posts images of highly provocative art that was completed by the some of the artists but that is not actually part of the museum's exhibit, complaints begin to be made to the museum about the "disgusting" and "upsetting" art on display. As the number of protesters grows over the next day, statewide media outlets film protesters attempting to block a planned school trip to the permanent exhibit, and social media posts begin to appear that ask, "why are our children being forced to deal with demonstrators and to be exposed to material that shouldn't be seen by them anyway and that they won't understand?"

Soon thereafter, the chair of the museum's board is contacted by a state legislator, who, as a friend, asks him to take some action "promptly" because the press has made the legislator aware that some of the exhibit's funding has come from the state's arts commission and that this funding could prompt closer governmental oversight if the situation is not controlled. The chair of the board's initial response to the state legislator, which he shares with the new director, is that "museums need to be centers of discussion and places where diverse views can be expressed. . . . We know that this sometimes makes people uncomfortable. While we have work to do with the board, our community, and the public to educate them about our mission, policies, and how we develop exhibits, the basis of learning is an openness to different approaches. But let me reassure you that the board will work with the new director to address this situation promptly and that we will examine what we can do better to ensure that our choices in exhibit-making continue to be principled and based on professional standards."

Confronted by community ire, misinformation about the exhibit, and divisions among board members, the newly appointed director wonders what the board's oversight responsibility is for exhibits, how involved the board should ever be in exhibit development, and what, if any, policy the museum has in place about its exhibits.

The new director also wonders if and how members of the cultural community were involved in the exhibit's development, how the prior director

navigated the exhibit's many loans and its sponsorship, and why the exhibit includes a piece or two that do not seem to be strictly related to the exhibit's stated themes. The new director is also curious about the existence of standards, ethical codes, or other professional resources that could help the director guide the board about how to respond to exhibit controversies, including situations in which the freedom of expression is threatened; about how to identify and address the kinds of conflicts of interest that exist when borrowing objects for exhibits; and about which professional resources might be best suited for sharing with boards to support informed decision-making about exhibition-related issues.

Most pressingly, the new director wonders what steps should be taken to address public concerns about the exhibit, what the job of the board and the board chair is when controversies develop about exhibits, and how the new director can build on the statement made about the exhibit by the chair of the board so that the cultural community, the board, and the broader public can be educated about the role of exhibits in implementing the museum's mission.

WHY UNDERSTANDING THE BOARD'S ROLE IN EXHIBITS IS IMPORTANT

In the vignette above, the museum's new director must deal with a controversial exhibit that has generated public attention, with individual board member comments to the media that both disrupt board unity and undermine the museum's public standing, and with attempts by the public and board members to close an exhibit that raises questions about freedom of expression. In addition to questions about how community members are generally involved in developing exhibits and how loans from board members are approved and integrated into exhibits, questions about the board's oversight responsibilities for exhibits will need to be answered by the new director in order to resolve the crisis that has engulfed the museum.

The new director will need to consider what level of involvement boards should have in reviewing exhibit plans and in questioning the staff's curatorial decisions, whether the museum's board understands its own policies about borrowing objects for exhibits, including when board members lend to and sponsor exhibits, and what the board's role is in addressing exhibit-related controversies. The director, with the board's chair, will also certainly need to quickly develop a strategy that calms public tensions, deescalates board divisions, and educates the board about who should be speaking publicly and what kinds of messages should be conveyed about exhibit-related controversies.

While the director will want to develop a plan with the board's chair to communicate to the public the museum's mission, policies, and processes for creating exhibits, the director can also work with staff to create new programming that discusses the content and context of the exhibit's controversial art, that opens up dialogue about the exhibit with members of the

cultural community, and that makes it clear that museums are places of open discourse. The plans for this new programming can then be shared with the chair of the board, who can be encouraged to inform the board about it and to stress that, although there are strong views about the art on display, the exhibit is mission-based and follows relevant museum policy. The director can also inform the board chair that they will review what areas of the museum's exhibit development process might be strengthened in the future to ensure community input and consistency with professional standards.

At the same time, the new director, with the exhibits team, may also want to quickly develop language, to be shared with and reviewed by the board chair first, for posting outside the exhibit, noting that some of the material on display may be upsetting to viewers. Placed at the entrance to the exhibit and on the museum's website, the language in this new signage could include information from the curatorial team about the pieces in the exhibit and outline relevant components of the museum's institutional code of ethics and core policies. While the work ahead to engage some members of the public in dialogue will undoubtedly be challenging, the new director has the experience, knowledge, and training of the staff to draw upon to support the exploration of the issues the exhibit has raised.

While it may seem to the incoming director that the cultural community was not consulted nearly as extensively as was the case in the museum's two other exhibits currently on display, this understanding could prompt the director to propose developing policy that includes the creation of a standing community advisory group that is involved in all future exhibits. Similarly, to ensure that board members understand conflict-of-interest issues when they loan objects to the museum for exhibits and that they appreciate that staff must maintain control over decision-making in exhibits whenever the museum borrows objects, the new director could also recommend that the board consider updating its collections management policy or even developing a new exhibit policy that addresses some of the concerns raised by the temporary exhibit, such as how to incorporate cultural sensitivities about objects into displays.

Moreover, the director may find that the board needs to be reminded more consistently about the institution's code of ethics, including what it specifies about the *actual* responsibilities of board members, as opposed to *perceived* ones; that board members would benefit from a clarification of the charge and role of certain board committees, such as that of the exhibits committee; that the board chair might review in the future how important it is for the board to have committee members, even if they are deeply valued, serving without term limits; and that board members should be reminded that their important responsibilities include serving as an external advocate for the organization, speaking with one voice on behalf of the museum at all times, and not pursuing their individual interests at the expense of the museum.

Finally, the new director may want to work with the board chair to remind everyone that the board's responsibilities include *monitoring* whether the museum's activities are effective and consistent with the museum's mission, rather than participating in staff-driven, day-to-day museum operational issues, such as developing exhibit content. In the end, it may be that the director also sees that the board's overall decision-making would benefit from a deeper appreciation of why museums develop exhibits in the first place and that any museum's exhibits, whether controversial or not, are fundamental expressions of how museums serve the public.

Because new museum directors may not have been involved in exhibit development, may not have faced situations when museums displayed controversial exhibits, or may not have worked with boards before, what new museum directors need to know about exhibits will be discussed in this chapter. After standards and guidelines related to board involvement in exhibits are reviewed, the role of the board when potentially controversial exhibits are in development or have opened will be discussed. Next, important professional and academic resources concerning museum exhibits will be reviewed, with a particular focus on information that new directors can share with boards. The chapter ends with an overview of what new directors should be aware of when it comes to the involvement of the board in a museum's most important outward-facing engagement activity, its exhibits.

STANDARDS AND GUIDELINES

Before reviewing the specific standards and guidelines in place for exhibits, it is helpful to first briefly consider why standards exist and what role they can play in museums.

As Merritt (2008) notes in *National Standards and Best Practices for U.S. Museums*, standards reflect areas of broad agreement, result from broad dialogue, sometimes address situations in which museums were called to account for their decisions due to controversy or the possibility of governmental oversight, and demonstrate that the environment in which museums operate changes over time. Standards are considered general levels that all museums should be able to achieve, while best practices are "commendable actions and philosophies that demonstrate an awareness of standards" (Merritt, 2008, 6). When museums are involved in controversy or are perceived to have acted unethically or in an objectionable manner, the media often uses standards to inform how they discuss the issue (Merritt, 2008).

Museum governing authorities should review standards and best practices because they help board members understand what guides the decisions of staff and how their "performance as board members will be judged by the outside world" (Merritt, 2008, 13). Because new board members may not understand how museums operate, it can be helpful for museum directors to

work with board chairs to see if orientations can include a review of standards and best practices, especially in those areas that can involve board members directly, such as when museums borrow objects from board members, when lenders for exhibits are somehow affiliated with the museum, or when exhibits are sponsored by board members. Furthermore, museum policies, which are approved by the board, should reflect an awareness of and be consistent with standards (Merritt, 2008).

The most influential standards for exhibitions in the United States for new directors to review are those developed by the AAM. Entitled "Standards for Museum Exhibitions and Indicators of Excellence" (American Alliance of Museums, 2012b), seven major categories of successful exhibits are defined, though it is stressed that a competent exhibit need not demonstrate all seven and that the standards are not prescriptive.

The first of these categories is *audience awareness*—ensuring that an exhibit is developed with a clear understanding of the intended audience's "prior knowledge, interests, learning styles, attitudes, or expectations about the topic" and that, if appropriate, the exhibit incorporates community voice and a diversity of perspectives in its development. The next three categories are *evaluation*—assessing the impact of the exhibit on its audience during its development and/or after it opens, including doing evaluations that establish that "audience learning and reactions are consistent with the exhibition's intended goals and impacts"; thoroughly researched *content* that is accurate and relevant to the exhibit's theme, reflects current knowledge on the topic, and reveals any biases or perspectives of the exhibit; and, next, selecting and presenting *collections* that are relevant to the exhibit, that further its intellectual content, and that express the significant ideas of the exhibition. The final three categories are *interpretation/communication*—ensuring that the "information/ message of the exhibition is clear and coherent" and understanding that, if appropriate, the exhibit need not provide definitive answers but can raise questions and provide a forum for ideas; *design and production*—integrating interpretive media "effectively and engagingly to communicate content"; and, finally, *human comfort, safety, and accessibility*—ensuring that visitors' experience of the exhibit includes a consideration of their "physical, intellectual, and social well-being" and that visitors "of varying ages and cultures feel safe and comfortable" and are appropriately forewarned of any "potentially troubling content or material" so that they can make "informed decisions about whether they want to see it."

Indicators of excellence are also outlined in the "Standards for Museum Exhibitions and Indicators of Excellence" (American Alliance of Museums, 2012b). These indicators include exhibits that are highly distinguished, serve as models, and surpass standards in "interpretation, content, integration of audience voice/evaluation, and/or design or by introducing innovations that stretch the boundaries of accepted practice" (American Alliance of Museums,

2012b, 5). Specific indicators of excellence include providing visitors with an experience that they consider to be transformative and using objects in surprising or provocative ways.

Another set of standards relevant to exhibits are the "Education and Interpretation Standards" developed by the AAM (American Alliance of Museums, 2024n). Many of the details of these standards echo those outlined above in the "Standards for Museum Exhibitions and Indicators of Excellence" in how they refer to the need to consider audience, interpretation, content, and evaluation in exhibit-related activities. However, the "Education and Interpretation Standards" include an additional section labeled "Professional Practice," which offers important guidance about borrowing objects for exhibits. As Merritt (2008, 62) observes, this guidance was developed in the wake of the controversy surrounding the "Sensation" exhibit at the Brooklyn Museum of Art in 1999, which attracted the attention of media and lawmakers in New York when noted collector Charles Saatchi lent his collection to the museum and "exerted considerable control over the curatorial content and provided significant financial support" for the exhibit. Saatchi also had a reputation for selling artwork once it had been exhibited in museums and had appreciated in value, raising the issue of whether Saatchi was "perhaps using the museum, which receives considerable city funding, for his private benefit" (2008, 62).

The "Professional Practice" guidance for exhibiting borrowed objects specifies that a museum should have in place a policy that has been approved by its governing authority and that addresses four major areas: first, that the museum determines that there is a clear connection among the objects to be exhibited, the theme of the exhibit, and the museum's mission; second, that the museum examine the relationship of the lender to the museum to determine if conflicts of interest exist, such as when the lender "has a formal or informal connection to museum decision-making (for example, as a board member, staff member or donor)"; third, that the museum will address any real or potential conflicts of interest, including by developing guidelines that "may require withdrawal from the decision-making process of those with a real or perceived conflict, extra vigilance by decision makers, disclosure of the conflict or declining the loan"; and finally, that the museum will not be allowed to accept any commission or fee from the sale of objects that have been borrowed for exhibition (except for displays explicitly organized for such sales, such as in the case of craft shows).

The "Professional Practice" guidance for exhibiting borrowed objects also outlines that museum policy on exhibits should offer the broad assurance that the museum will maintain intellectual integrity with regard to and institutional control over its exhibits. The policy should specify that, while museums may consult with potential lenders to determine if objects in the lender's collection might be relevant for an exhibit, museums must have full decision-making authority over the content and presentation of the exhibit. Finally, the policy

should outline that, when a lender is also a funder of an exhibit, the museum should make the source of funding public; moreover, if the lender/funder requests anonymity, this should be avoided if such anonymity would raise ethical issues or conceal a conflict of interest, whether real or perceived.

Another important set of standards is outlined in the Code of Ethics for Museums from ICOM, which outlines guidelines "desirable for professional practice" in several areas, including five that are specific to exhibitions (ICOM, 2024d). Some of these are not referred to in standards from the AAM: first, exhibits should be related to the museum's mission, policies, and purpose; second, information in exhibits should be accurate and "give appropriate consideration to represented groups or beliefs"; third, human remains and objects of sacred significance must be exhibited professionally, and exhibits should take into account, where known, "the interests and beliefs of members of the community, ethnic or religious groups from whom the objects originated"; fourth, requests for the removal of human remains and objects of sacred significance from exhibits "must be addressed expeditiously with respect and sensitivity"; and, finally, museums should not display objects without provenance or of questionable origin so they are not seen as condoning or contributing to the illicit trade in cultural property. The ICOM guidelines are also helpful for new directors and boards to consider because, in addition to highlighting cultural property in exhibits, they also stress two broad themes that are likely to remain a part of the next version of the ICOM Code of Ethics, which are currently being revised: it is important that 1) to ensure an exhibit's integrity, exhibits be closely related to the museum's mission, and 2) to ensure that museums maintain their community's trust, communities be appropriately represented by and involved in exhibits.

Standards and guidelines that outline the nuances that can be encountered when developing and implementing exhibits in certain types of museums are also helpful to review. For example, standards for university museums developed by the Association of Academic Museums and Galleries (2017) stress that, because such museums are typically part of larger, nonmuseum systems, it is important to clarify who funds exhibits. Standards for art museum curators from the Association of Art Museum Curators (2019) outline how art curators should interact with collectors in developing exhibits. Finally, in the "Statement of Professional Standards and Ethics" from the American Association for State and Local History, the need for interpretation in history museums to accurately represent the "breadth of American cultural experiences and perspectives" is emphasized (American Association for State and Local History, 2017).

Guidance on exhibits is also outlined in at least three of the many documents that have been developed by the Association of Art Museum Directors. In "Professional Practices in Art Museums," for example, it is recommended that directors consider involving the board in exhibition loans because of the extent to which many art museums rely on loans for exhibitions (Association

of Art Museum Directors, 2011), whereas, in "Managing the Relationship Between Art Museums and Corporate Sponsors," museum directors and boards are told that they have the responsibility to determine if a proposed sponsorship is an attempt to "exert undue influence" over the exhibit because exhibits in art museums can be sponsored by corporations (Association of Art Museum Directors, 2007a). As another example, in "Art Museums, Private Collectors, and the Public Benefit," because museums may want to borrow artwork from collectors (some of whom may be board members), it is recommended that museum directors, in consultation with boards, weigh questions such as "Does the work reflect the interests of museum constituencies?"; "Is the collector an individual with a reputation?"; and "Are the collector's motives transparent and acceptable to the museum?" (Association of Art Museum Directors, 2007b).

Standards that can be used to orient board members about the nature of exhibits in specific kinds of museums include those from the Association of Children's Museums (2012), The School for Advanced Research (2023) (for museums with Native American collections), the Heritage Rail Alliance (2019) (for railway museums), the American Historical Association's "Standards for Museum Exhibits Dealing with Historical Subjects" (2017), and several others.

The standards for exhibits and programs provided by the Association of Children's Museums emphasize that children's museums focus on interactive exhibits that address community needs, such as public health, early learning, diversity, and the understanding of science; that to best serve the needs of diverse communities, children's museums must center broad community-based relationships and networks with groups such as social service agencies in exhibit development and evaluation; and that board members must have a deep commitment to the values of children's museums, which emphasize "community and audience engagement, dialogue, collaboration and participation" (Association of Children's Museums, 2012, 6).

The standards and recommendations for museums with Native American collections, developed in collaboration with Native American groups by the School for Advanced Research (2023), emphasize that the development of culturally appropriate exhibits is based on educating the museum's governing board and staff with "community informed cultural competency and sensitivity workshops" (2023, 10) and board orientation about the need to connect Native American collections "with originating communities for more meaningful, relevant, and culturally appropriate interpretation" (2023, 11).

The "Recommended Practices for Railway Museums" are designed to guide the transition of railway museums "from inward-oriented preservation organizations to outward-oriented educational and public service institutions" (Heritage Rail Alliance, 2019, 5). The extensive and thoughtful set of recommended practices outlined here include many that relate to exhibits, including when board members with knowledge of technical aspects of railways are

involved in exhibit development and interpretation because staff does not possess such knowledge, or when a range of issues related to restoring collections for active use in exhibits must be addressed by policy, such as when it's necessary to obtain replacement parts for locomotives to ensure that they can run, to borrow components from other railway cars to restore railway cars for use in exhibits, or to ensure that exhibits that use such objects offer authentic experiences.

Lastly, the American Historical Association's "Standards for Museum Exhibits Dealing with Historical Subjects" (2017) outline that history museums and their boards should be "mindful of their public trust" in approaching exhibits; they should discharge their duties by observing that exhibits should be "grounded in scholarship [and] marked by intellectual integrity"; they should engage stakeholders at the outset of exhibit development and consider including them in the planning process; they, as publicly funded organizations, should be "keenly aware" of the diversity within their communities; and they "should acknowledge competing points of view" when an exhibit addresses a controversial topic.

Standards are valuable to new museum directors because they can provide a framework for boards to engage with policy, either through approving proposed policies outright or by developing policy in consultation with the museum's staff. Indeed, as outlined below, the impact of exhibition-related standards on policy in museums can be observed in three areas: in collections management policies, in institutional codes of ethics, and in stand-alone exhibition policies.

First, exhibit standards are often addressed in collections management policies, especially in sections on incoming loans, which outline the circumstances under which objects may be borrowed. Museums ranging from the Newark Museum of Art (2020), to the Asian Art Museum in San Francisco (2011), and the University of Colorado at Boulder Art Museum (2020), for example, have collections management policies with such sections on incoming loans, detailing whether loans from private lenders are permitted and how objects for exhibits are selected. Some collections management policies also include information about how specific kinds of objects can be borrowed for exhibits. For example, the Metropolitan Museum of Art, which has been criticized for borrowing and exhibiting possibly looted antiquities (Bowley and Mashberg, 2023), outlines two kinds of incoming loans in its latest collections management policy, those for the short-term exhibition of objects and those for long-term display (Metropolitan Museum of Art, 2023). The museum's policy on loans for long-term display includes a section on antiquities that states that it will "thoroughly research" the ownership history of any ancient art prior to its loan, "including making a rigorous effort to obtain accurate written documentation with respect to its history, including import and export documents" and undertaking "its own independent research of the work's

ownership history" and, further, that, "if any concerns are raised during this research, the loan will be declined" (Metropolitan Museum of Art 2023, 18).

Museums can also address standards relating to exhibits in their institutional codes of ethics. For example, the Code of Ethics of the Arizona Historical Society (2021) begins with a set of principles that staff and those who serve on boards must commit themselves to in the area of exhibits: first, the "most knowledgeable experts available, especially representatives of related cultural groups," will be involved in the planning and implementation of exhibitions (2021, 2); second, if board members lend objects for an exhibition, they should lend them anonymously; third, any such items should be credited anonymously in museum publications and exhibitions; and, fourth, because "loaned objects can be considerably enhanced in value by being exhibited . . . the sole consideration of the Society in asking for and accepting such loans or gifts shall be the prospective benefit to the public" (2021, 5). Finally, the Arizona Historical Society's Code of Ethics has a lengthy statement that concerns board members as collectors and that is relevant to when objects are loaned for exhibitions: board members may neither "take advantage of, nor enable others to take advantage of, privileged information obtained as a result of their position for furthering personal interest or gain," and board members who are collectors "should exercise extraordinary discretion to assure that no conflict of interest arises between them and the concerns of the Society" (2021, 5).

The impact of standards can also be seen in the existence of a stand-alone exhibition policy, which, although uncommon in the United States because American museums often include statements about exhibits in their collections management policies, can outline how a museum reviews and approves potentially controversial exhibits, as is the case for American University Museum (2018). A stand-alone exhibition policy also can describe the principles that guide the museum's exhibits, as is the case for the Haggerty Museum of Art (2024). Some museums, including the Penn Museum (2023) and the American Museum of Natural History (2023), have also developed separate policies or statements concerning human remains that outline the circumstances under which they are displayed or have been removed from exhibitions. Moreover, even though standards vary from country to country, a review of the exhibit and display policies from outside the United States can supply insights into why establishing such stand-alone exhibition policies can be useful. The Exhibits and Displays Policy from the United Kingdom's National Portrait Gallery (2022), for example, outlines the criteria by which exhibits are decided, how and when museum trustees are updated about exhibits, and the goals and ambitions of the museum's exhibition program. A second example is the Exhibitions Policy of the National Museum of Ireland (2023), which describes that "intellectual rigour and transparency shall underpin the exhibitions development process," that the "planning, design, evaluation, and where appropriate, research and delivery of exhibitions" must be centered on "the

needs, interests, expectations and motivations of audiences," and that all new exhibitions will conform to the museum's Irish Language Policy. A third example is the Oliewenhuis Art Museum, which is part of the National Museum of South Africa and holds a "historical and contemporary art collection on behalf of the people of South Africa." It has an "Exhibition Policy and Structure" that outlines the aims, objectives, and structures for the museum's exhibits, including that the museum's exhibits will "redress the imbalances created by our history and by Eurocentric attitudes and approaches, and . . . participate in the writing and rewriting of South African history and art history" (Oliewenhuis Art Museum, 2024).

Overall, the museum community's guidance about exhibits suggests that, when museum exhibits fall short of established standards because museums have not understood or consulted with their audiences, when they include objects that are not relevant to the exhibit's themes, when they do not warn visitors of material that may upset them, or when they do not consider competing points of view, as in the vignette outlined above, museums can expect reactions from the public. When museums also involve lenders in ways that suggest the lenders have shaped exhibit content or appear to be using the museum to inflate the value of objects that they have loaned to the museum to enrich themselves, or when museums have perceived conflicts of interest with board members and lenders concerning the funding of exhibits, as also seen in the vignette, museums fail to meet well-established standards. For the museum director, a poorly received or inadequately formulated exhibit also means that boards may exercise their oversight responsibilities for museum programs by closely examining the effectiveness of the museum's exhibits, by revisiting any relevant policy, and perhaps by even asking the director to review the museum's process for developing exhibits.

CONTROVERSIAL EXHIBITS AND THE BOARD

The number of museums that have opened exhibits the public has considered to be controversial is too numerous to mention, but noteworthy examples include the reactions to the proposed text leading up to the Smithsonian's Enola Gay exhibit in 1995 (Wright, 2020), the "Sensation: Young British Artists from the Saatchi Collection" exhibit at the Brooklyn Museum in 1999 (Barry and Vogel, 1999), the Jewish Museum's "Mirroring Evil: Nazi Imagery/Recent Art" exhibit in 2002 (Stewart, 2002), and "Perfect Moment," the touring exhibit involving the work of Robert Mapplethorpe, whose cancellation by the Corcoran Gallery of Art in 1989 generated much concern about censorship; "Perfect Moment" later appeared in the Cincinnati Contemporary Arts Center, which was charged with and acquitted of obscenity charges (Gamarekian, 1989; Wilkerson, 1990). More recent, high-profile controversial exhibits include the "Scaffold" installation at the Walker Art Center in Minnesota

(Sawyer, 2017), the painting of Emmett Till at the Whitney Biennial in New York (Kennedy, 2017), and the removal of several pieces of art because of references to abortion from an exhibit called "Unconditional Care" at a public college in Idaho (Kinsella, 2023).

Many of the museums in the examples above did not set out to engage with controversy, underestimated how the public or their governing authorities would respond, and reacted to rather than anticipated controversy. Such exhibits can be characterized by several common themes: the scope of consultation with communities likely to be directly affected by the exhibit's content; how governing authorities express their real or perceived oversight responsibilities; how knowledgeable exhibit developers are about audience attitudes, cultural sensitivities, or expectations about the exhibit's topic; whether board members have been made aware that a controversial exhibit is being planned; how museum directors, senior staff, curators, and board members respond to the controversy; the accuracy of information about the exhibit, its objects, or artists that appears in the media; the role of public funding in supporting the exhibit or the museum; reactions by key community groups to the exhibit; how claims of censorship and calls for freedom of expression are addressed by the museum; the communication strategy in place to address the controversy and who from the museum staff and/or board is included in discussions with the media and the public; and the awareness of boards of institutional codes of ethics and policies concerning collections and exhibitions before, during, or after a controversial exhibit opens.

A detailed study of controversial exhibits examined specifically such exhibits in campus art museums and galleries (Werbel, 2023a). In this study, which involved surveys and interviews of almost one hundred museum directors and curators, Werbel found that such controversies usually involved "works whose subject matter includes sexuality, nudity, racial stereotypes, politics, violence, painful historical subjects, and the U.S. flag" (2023a). Respondents indicated that they were interested in displaying this kind of art "as long as they felt supported to take risks and exercise their professional expertise in shaping programs and interpretive programming" (Werbel, 2023a). More than three-fourths of respondents to Werbel's survey responded that freedom of artistic expression in their organizations was "essential" and that, because of their location on the campus of an institution that values the exchange of ideas, they were more able to address topics that might be considered controversial. At the same time, Werbel also found that only about one-fourth of survey respondents knew who had the authority to decide, on the basis of content or viewpoint, what may be exhibited on campus; only around one-third of respondents worked in museums or galleries that had a plan in place to deal with controversial exhibits; roughly two-thirds of respondents had never received relevant professional development; and, while many respondents reported that they had never or very rarely had constraints placed on what art they had selected

to exhibit, they needed to strategize about how to frame conversations with senior campus administrators to avoid being challenged or overridden when it came to exhibiting controversial art (Werbel, 2023b).

Although Werbel's study focuses on the campus environment, it raises important questions for the broader museum community about how museum directors work with governing authorities and boards in situations that involve controversial exhibits, whether a museum has adequate policies and plans in place to address responses to such cases, and what resources are available to museum directors to navigate the issues relating to controversial exhibits. The study also challenges museum directors to assess how they manage board member responses to controversial content, which can impact how the exhibit, or the museum, is perceived by the public or legislators, and how directors navigate attempts by governing authorities to influence or alter controversial exhibits.

Helpfully, however, new museum directors can work with their staff and boards to be prepared for exhibits that generate intense public reaction by referring to "Museum Best Practices for Managing Controversy" (2024a), which were developed by the National Coalition Against Censorship (NCAC) in response to the controversy surrounding the 2011 exhibit at the National Portrait Gallery titled "Hide/Seek: Difference and Desire in American Portraiture," in which "Fire in My Belly," a work of video art involving a crucifix, was pulled after pressure from politicians (Ulaby, 2011). The NCAC practices, which were developed in association with several major museum professional associations, including the AAM, the Association of Art Museum Curators, and the Association of Academic Museums and Galleries, outline how museums under outside pressure can prevent the removal of works from exhibits and are designed to support "provocative, potentially controversial exhibits" and to help museums "manage controversial content and transform controversy into a learning moment about the nature of diverse opinions and an institution's ability to address them" (NCAC, 2024a, 2024b).

The NCAC practices comprise a preamble, an introduction, and a template for a suggested freedom-of-speech commitment; suggest guidelines to prepare in advance of upcoming programs and potential controversy; and provide procedures for addressing the press or responding to complaints from the public after an exhibition opens.

The preamble highlights that the guidelines are designed to help institutions of any size that are "concerned or confronted with accusations of inappropriate, objectionable, or offensive content" and are "caught in the frantic environment of controversy" (NCAC, 2024a). The associated strategies can "calm the waters, open space for conversation and learning, and prevent or defuse a potentially volatile situation through deliberate steps to create meaningful dialogue" (NCAC, 2024a). The preamble also stresses that such an approach "may prevent an over-cautious, self-punishing reaction by

institutions caught up in controversy" and address an area that is certainly related to the board's work, helping the museum to fulfil its mission "as a forum for the exploration of diverse ideas" (NCAC, 2024a).

The introduction notes that the guidance is based on an analysis of many sources, including a review of how controversial situations were handled in the past by organizations and assessments of the governance documents of institutions. In addition, the introduction names strategies museums can use "to resist pressure and assure their curatorial autonomy": a freedom-of-speech statement, preparing in advance for potential controversies, and developing procedures for addressing the press or public complaints once an exhibit opens. The introduction also emphasizes that the guidance will help institutions respond to criticism, improve relationships with the public, support the right of the public to access material, be transparent, and orient board members.

In the freedom-of-speech template that follows, institutions are encouraged to develop a statement that stresses that 1) freedom of speech is a "foundation of the nation"; 2) the ability of the museum to exhibit works some may consider unsettling and even offensive is a privilege of living in a country where experiencing such material is a constitutional right; and 3) including such material in an exhibit does not mean that the museum endorses the "vision, ideas, and opinions of the artist. . . . It is to uphold the right of all to experience diverse visions and views" (NCAC, 2024a). The statement should also note that, when controversies do arise from an exhibit, the museum welcomes public discussion and debate and that it will not censor exhibitions "in response to political or ideological pressure" (NCAC, 2024a).

The section on guidelines to prepare in advance of upcoming programs and potential controversy encompasses several actions institutions should take. Although all the recommended actions will be of interest to a new director, only one explicitly mentions the museum's board, providing that the museum director and the curator should inform the board about future exhibits that may be considered controversial and should be prepared to respond to any questions about the exhibit from the board. The remaining recommended actions consist of specifying clear curatorial selection procedures for the exhibit because they can help the institution respond to complaints; developing a framework for education and public engagement for the exhibit before it opens in order to support community dialogue, engagement, and the identification of target audiences with whom the museum can elicit genuine input, acknowledge sensitive areas, and develop trust; proactively developing a communications plan that includes presenting the museum's position on the exhibit and that acknowledges support from funders and community groups; using signage that may include written warnings or disclaimers and producing relevant educational material; and, finally, reviewing the overall plan and consulting with legal counsel.

The guidance about complaints from the public emphasizes that it is helpful to have a policy in place for responding to such complaints and that museums should not alter the exhibit but, rather, should establish that there will be a period of review and discussion and that learning opportunities for thoughtful discussion among stakeholders will be created. There are also several specific recommendations about how to address complaints from the public: alerting staff and general counsel about the complaints; notifying artists and funders of the complaints; ascertaining who is complaining and if the criticism is sincere or politically opportunistic; creating a crisis plan; engaging supporters and developing talking points; scheduling additional programming; and considering whether public officials, such as legislators, should be contacted.

Finally, in the area of how the museum should address the press about exhibit controversies, key recommendations include establishing one spokesperson to talk to the public and media; ensuring that all board members defer to the spokesperson and "otherwise refrain from all comments in public places or circumstances"; emphasizing the museum's mission, not the details of the exhibit, in any responses; avoiding an approach that "empowers the opposition"; refining the communications plan for the exhibit by involving the staff and board; and considering obtaining an expert opinion from a public relations firm.

Although indispensable, the NCAC's "Museum Best Practices for Managing Controversy" focus on what a range of staff members should do in such situations when, in reality, much of the responsibility for managing the controversy rests on the shoulders of the museum's director. The director will need to work with the board in the areas that the best practices specify, such as in developing policy, reviewing communications strategies, and informing the board about upcoming exhibits with possible controversial content. Moreover, the director would be wise to consider involving the board chair when statements about freedom of expression are being developed, as well as when legal counsel is consulted about matters involving controversial exhibits, such as the removal of artwork, which could impact the reputation of the museum. The director will also need to use his or her discretion in deciding if and when to involve the board in several situations: when board members stray from crisis communication plans; when museum policy on borrowing objects from board members is vague; when boards do not support a director's efforts to address controversial exhibits before they open; when board members do not have enough information about the content of an exhibit or about freedom of expression to make informed decisions about making alterations to an exhibit; when board members do not adequately understand the museum's governance, especially when it is part of a nonmuseum parent organization; or when, in the guise of supplying oversight for exhibits, boards inappropriately interfere in exhibit development.

Because exhibits that generate controversy will undoubtedly continue to be developed and museums vary in how well their boards function, there is no

substitute for new directors being prepared with the best possible guidance from the field about how to navigate controversial exhibits. They should also understand the helpful, and sometimes unhelpful, role that boards can play in these situations.

PROFESSIONAL AND ACADEMIC RESOURCES ON EXHIBITS

Although some museum boards do have exhibit committees, much of the museum professional and academic literature concerning exhibits does not discuss boards. This reflects a broad consensus that boards are generally not supposed to be involved in the details of the exhibit development process because this kind of operational activity should be delegated to the staff. As noted above, however, boards nevertheless find themselves involved in exhibits, especially when conflicts of interest arise, high-profile exhibits are developed, or controversy erupts and gains the attention of the public. Therefore, new museum directors need to be familiar with relevant literature so that they can brief, educate, and update their boards about the issues, challenges, and trends facing museums in the area of exhibits. They also need to be prepared for cases when boards do insert themselves into the exhibit development process, when boards create ethical challenges, or when broad feedback about the museum's exhibits would indeed be useful.

Museum directors are likely aware that comprehensive resources are available on exhibit development, implementation, and evaluation, but having them gathered in one place is helpful. *General resources on exhibits* include those by Bogle (2013), Dean (1994), Klobe (2012), McKenna-Cress (2013), Piacente (2022), and the Smithsonian Institute (2024c). *Specialized resources that emphasize developing exhibits in certain content areas*, such as in science or history, include those by Chicone and Kissel (2013), Emberling and Petit (2018), and Summers (2018). *Specialized resources that supply guidance for certain kinds of museums*, such as small museums or natural history museums, include those by Caulton (1998), Dillenburg and Klein (2013), and Parman et al. (2017). *Other helpful resources focus on specific parts of developing exhibits*, such as engaging audiences (McRainey and Russick, 2010); writing interpretive text (Leftridge, 2006; Wallace, 2014); evaluation (Diamond, Luke, and Uttal, 2009); creating environmentally friendly or "green" exhibits (Green Exhibits, 2024; Sutton and Wylie, 2008); or discussing elements of exhibit design, such as lighting, accessibility, determining the best size and placement of labels and panels, or eliciting and maintaining visitor interest (Dernie, 2006; Hughes, 2015; McNeil, 2023; Smithsonian, 2024d).

For any museum that exhibits cultural items associated with Native Americans, the Final Rule for the Native American Graves Protection and Repatriation Act (NAGPRA, 2023) requires consultation and consent to exhibit Native American cultural items (Department of the Interior, 2023). Consequently,

museum directors will likely want to educate their board chairs about these latest requirements and to outline what additional resources might be needed to implement them. Directors may also want to discuss revisions to policy with their boards and to examine the impact of the Final Rule on the broader museum community, such as the decisions made by several museums, including the American Museum of Natural History, the Field Museum, and others, to temporarily or permanently close some of their galleries that display Native American objects (Jacobs and Small, 2024).

Another set of resources draw upon museum history, theory, or practice to examine the function and role of museum exhibits: works by Bennett (2007), Kirshenblatt-Gimblett (1998), and McClean (1999) and two interrelated volumes by Karp, Karp, and Lavine (1991) and Karp et al. (2006). Other important literature examines museum exhibitions as a locus of activism (Janes and Sandell, 2019a) or supplies practical guidance, grounded in a knowledge of history, for museums developing interpretative material for exhibits on topics such as LGBT history (Ferentinos, 2015), American Jewish history (Decter, 2014), slavery (Gallas and Perry, 2014), and religion (Buggein and Franco, 2018). It is also helpful to examine studies of exhibits, such as Dubin's analysis of public responses to controversial exhibits, which he characterizes as either "defensive, trying to hold back the tides of change, or offensive, assertively demanding change" (1999, 4), or Pedretti and Navas Iannini's examination of science museum exhibits that seek to generate controversy on topics such as health, race, or climate change, and in which they argue that "it is the responsibility of science museums to engage with topics that are sensitive, complex, and messy" (2020, 70). Important professional and academic journals pertaining to museum exhibits include *Exhibition* (2024), which emphasizes self-reflective practice; *Curator: The Museum Journal* (2024), which often includes papers on exhibit development and evaluation; and more theoretical pieces in journals such as *Museum Worlds* (2024), *Museum Anthropology* (2024), and *Museums and Society* (2024), which examine the role of exhibits in broader society.

Much scholarly work about museum exhibits involves examining *representation*, which can be defined as who is included in or excluded from the stories that exhibits are telling, such as those about Blackness (Cooks, 2011), social and political issues (Henderson and Kaeppler, 1997), science and technology (McDonald, 1998), disability (Sandall, Dodd, and Garland-Thomson, 2010), indigenous groups (Onciul, 2015; Simpson, 2001), or source communities, the groups from whom museum collections have been acquired (Brown and Peers, 2003). In the United States, for example, literature on the topic of representation has been consequential for how museums develop exhibits that involve Native Americans, including how exhibits are presented; the communities that are involved in their planning and implementation; and in recognizing the biases and assumptions incorporated into exhibits. In particular, the work of Amy Lonetree, which examines the "hard truths of colonization in exhibits as

an effort to move toward healing and understanding" (2021, 21), has had a major impact on how museums engage with Native American communities to develop or modify exhibits; indeed, the direct influence of Lonetree's work can be seen in museums ranging from the Museum of Us (2024) in San Diego, the Abbe Museum (2024) in Maine, and History Colorado (Goff et al., 2019), to the Denver Museum of Nature and Science (2024), and the High Desert Museum (2024) in Oregon.

Significantly, *the majority of these resources do not discuss the board's role in exhibits*, though some, such as Dean (1994), mention that board members, along with staff, visitors, and community groups, can sometimes be a source of ideas for exhibits and that, in generally smaller museums, board members can play a more active role in developing or implementing exhibits or in proposing and approving topics for exhibits, such as through an exhibit committee (Dillenburg and Klein, 2013). Museums with board exhibit committees include the Martha Vineyard's Museum (2020), whose programming and exhibits and program committee identifies and evaluates potential exhibit ideas and offers "feedback to staff"; Minnesota's Great River Children's Museum (2021), whose exhibits committee is "tasked with taking initial exhibit ideas and concepts of the board, further conceptualizing them, and readying the concepts to present to exhibit design professionals"; and the Knoxville Museum of Art (2016), whose collections and exhibitions committee reviews the "actions and plans of the museum regarding collection development, exhibitions, and loans from the permanent collection." Examples of museums with exhibits committees in which board members can serve along with staff include Michigan's Holland Museum (2024), whose exhibits committee "works with the professional staff to develop and execute new exhibitions," and Michigan's Tri-Cities Historical Museum (2024), whose exhibitions committee assesses exhibit proposals and works to ensure that the museum's exhibitions include a diverse range of topics.

SUMMARY

Although the day-to-day work of exhibits should be in the hands of the museum's staff, museum boards play an important role in exhibits, either in their initial formulation, in reviewing plans for future exhibits, or in considering and possibly even approving loans of significant objects. Museum boards can also be involved in exhibits when board members lend the objects they own, when they work to ensure that exhibits are consistent with the museum's mission, or when they develop or revise policy that outlines if and how the museum works or consults with audiences and key communities. Furthermore, boards can be involved in exhibits when they consider how to respond to emerging exhibit-related issues, such as changes in regulations or ethical codes, when they address exhibit controversies by issuing supportive statements that

speak with a single voice and that emphasize the freedom of expression, or when they consistently support efforts to develop exhibits that, by design, are intellectually stimulating and aesthetically pleasing and offer transformative experiences.

Although the appropriateness of any exhibit-related board activities will depend on the governance of the museum, directors should be aware of when boards are actively challenging boundaries, are unintentionally undermining standards, or are not knowledgeable about why their museums will or will not display certain objects. As directors work with board chairs, review relevant standards and professional literature related to exhibits, and come to understand the implications of their museum's own governance structure for board oversight of museum operations, they can harness the board's compelling interest in exhibits to ensure that the museum has the resources it needs to present successful exhibitions, to anticipate and prepare for controversy, to promote the museum's exhibits to the public as part of the board's advocacy responsibilities, and, finally, to stress the integrity of the museum's exhibition activities through their link to the museum's mission.

9

Whose Job Is It, Really? Fundraising in Museums

BOARDS AND FUNDRAISING: A VIGNETTE

A museum that focuses on an early-twentieth-century award-winning novelist and playwright is situated in what was once a rural area but is now surrounded by the wealthy suburbs of a thriving metropolitan area. Located up a narrow winding road on top of a hill, the museum has stunning views and a series of outdoor courtyards interspersed with well-maintained gardens. The centerpiece of the museum is the novelist's home, which was designed by a nationally known architect, is considered a classic example of her work, and is listed on local and state registers of significant historic properties.

In the late 1970s, one of the outbuildings on the property, which was first used as a barn during the time before the house was built, was thoughtfully converted into an exhibition gallery, and a permanent exhibit on the author's life and impact on American culture was installed in it by the museum's small staff. Additional outbuildings were renovated over time so that, today, a small complex of buildings surrounds the historic house and exhibit gallery; buildings include a meeting hall for events, an amphitheater to host outdoor programs and performances, and an administrative building with offices, restrooms, a kitchen, and a small collections storage area.

The novelist, whose works deal compellingly with the consequences of poverty in American society, was also an avid collector of modern and decorative art. Indeed, the architect designed the house with the idea that some of the most important pieces in the novelist's collection would be displayed in the structure. When the novelist died in 1952, the house and its contents were in excellent condition, but, over the next fifteen years, as the novelist's wife aged, artwork in the house was intermittently loaned to museums for exhibits, structures on the property were no longer maintained properly, and the furnishings

inside the home began to degrade. The widow, who had no surviving family, was advised by friends to donate the property to a local history museum so that it could be preserved in perpetuity and to ensure that the author's legacy would continue to be recognized in the future. When the wife died in 1968, the property was transferred to the history museum, which quickly spun it off into a private, nonprofit because of the special emphasis of the property on one person and the history museum's assessment that it did not have the capacity to manage the structures, the collections, or the land properly.

In 1970, with the house as its core, the museum was incorporated with a mission that focused on the house as it appeared in 1950, when the author began to live there. He continued to live there until his death, and there he wrote his final and most famous play about a family's battle with poverty and alcoholism. Over the next decades, the funds left by the widow were used to renovate the house; to restore structures; to hire a small staff; to catalog the house's furnishings and artwork; to develop the permanent exhibit; to create a membership program and to hold special events to raise funds for the museum; and to run public programs that generated enough fees to cover their costs. Some of the most successful programs included hosting outdoor performances of the playwright's work, organizing field trips by high schools when the novelist's work was taught as part of high-school curriculum, and developing docent-led tours of the house, although the museum's physical location—high on a hillside—and its limited parking consistently posed logistical problems for operating programs and events.

In the last few years, however, the museum had depleted much of the funds it had received from the estate of the author and his wife, field trips diminished as the novelist's work fell out of favor in school curriculum, and fewer visitors in the area's suburban bedroom community were willing to navigate the limited parking at the site or take the bus that stopped nearby, at the bottom of the hill. The museum entered a phase in which it was offering the same programs it always had; attendance dropped; the permanent exhibit in the gallery and the docent tour had not been updated, despite important information about the author being revealed in biographies and in academic studies; and the surrounding community's increasingly diverse community did not see itself represented in any of the programs, collections, or exhibits that the museum was offering. The museum's membership, which in the past had supplied a reliable stream of funding to the museum, dipped precipitously after the museum closed for two years to reinforce the house's foundation, which was found to have serious cracks that posed a threat to the stability of the house. The closure of the house meant that most of the collections inside had to be relocated and that the signature draw for many of the museum's programs and special events, the house itself, was inaccessible.

The board consists of twenty members, almost all of whom are from the wealthy community surrounding the museum, are primarily over the age of

sixty, and are not representative of the area's diversity. Aside from one retired teacher from the high school in town and the young owner of a new wine bar in town that is known for offering craft cocktails, the board members work for corporations that either have their headquarters in nearby business parks or are located in the region's major urban center, which is thirty miles away. The board's chair is well liked, gregarious, and in his second four-year term. While knowledgeable about the museum's mission and well connected to the local community, the board chair has not addressed the low attendance rate of most board members, has not worked to diversify the age, life experience, occupation, or genders of the board, and has delegated much of the board's work in policy development, education, and fundraising to the museum's longtime director.

Despite the closure of the author's house, the board understood the necessity of continuing to fund payment of the museum's five staff members during the period of construction. In addition to the director, staff members include a facilities manager, who is responsible for maintaining the physical footprint of the museum; an education manager, who manages all programming, develops curriculum, and supervises field trips; a collections manager, who is responsible for the museum's wide-ranging collections, including the house itself, its contents, and those in the gallery; and a development assistant, who is in charge of membership, coordinates special events, and supervises outreach. Staff members, except for the development assistant, have been employed for many years; the development assistant position has been held by four different people in the past six years.

The museum's longtime director has had a good relationship with three different board chairs over the years, which allowed her to support the board's work to update the museum's mission four years ago from one that focused on the story of the author in his home in 1950 to one that emphasizes the relevance of the author's work to contemporary issues. The revision of the museum's mission supported efforts in the past two years to begin expanding board membership beyond the immediate local community, to reinvigorate relationships with secondary schools in the region by supplying them with updated curriculum to encourage field trips, and to diversify the museum's visitors and membership by highlighting core parts of the author's work that emphasize pluralism and cultural respect in new programming.

With construction on the foundation completed and the house about to reopen, the director has plans to reposition the museum in the community by completely updating the exhibit in the gallery and by reconfiguring the largest room in the house so that it can support public programming that engages with a broader range of topics, including controversial aspects of the author's work. For example, the museum's educator is planning a series of actor-led readings from the author's most famous novel, which is about a poor young immigrant mother's struggle to provide for her family in a 1930s urban slum;

has invited contemporary playwrights to discuss the author's legacy; and has asked the writers of a television adaption of one of the author's plays to screen the program at the museum, with the screening to be followed by a remote videoconference discussion session.

In the past several months, however, the director's relationship with the current board chair began to deteriorate when the chair informed the director that she, the director, would need to organize and run a capital campaign to raise funds to operate the museum. The director had spent much of the past few years planning and overseeing the foundation rehabilitation project, ensuring that the museum's budget was balanced, and developing a plan to update the permanent exhibit, which has involved carefully managing resources to support consultation with the community through surveys and focus groups and working with experienced guest curators and exhibit designers.

The director reacted with alarm to being told that, because all the funds from the author's estate had been spent down by the board over the past five years, primarily for the foundation rehabilitation project, the director would need to raise the bulk of the funds for the museum moving forward and that board members were not motivated to give to the museum because they felt "tapped out," though it was unclear to the director who on the board had actually given to the museum recently.

The board chair also shared that a large portion of the funds from the estate had been invested in stock associated with a board member's biotech company, but that, disappointingly, most of the investment had been lost; that the board chair fully expected that funds to update the permanent exhibit could be raised by the director on her own from major corporations "with a quick application or two"; that the board expected that the development unit would expand by hiring staff who would be paid based on a percentage of funds they raised; and that the board chair had just been notified by a lawyer that the museum must accept a gift, left to the museum in the will of a former board member, of a valuable collection of quilts with no connection to the author.

Finally, the board chair also shared that he had received numerous complaints from board members about the various development assistants employed by the museum over the past three years. Complaints included that the development assistants would not help with requests for free admission or parking passes for their friends who were members; that they produced newsletters irregularly; that they neglected to thank board members for donations, including when a board member had made a large contribution in honor of her recently deceased mother; that they would not give board members tax advice about potential donations of objects to the museum; that they were consistently telling board members that the membership program was "seriously under resourced"; and that they had asked board members to invite their friends to museum events "persistently."

The director recognized that she was not experienced with or knowledgeable about several of these issues, especially capital campaigns, and that, in having this new task added to her portfolio without consultation when she was already feeling overwhelmed with the house reopening, the overhaul of the permanent exhibit, and new programming, she was inching closer to burnout. When three new major issues emerged over the course of the next several weeks, however, it became clear to the director that it was time for her to leave.

First, the board chair told the director that, while board members were "more than happy" to be part of events to thank donors for their contributions, they would "rather not" ask their friends and acquaintances to attend museum events and "were not comfortable" asking anyone for donations. When pressed, the board chair admitted that only half of the board members had made contributions to the museum this year, that some members of the fundraising committee were only interested in working on issues that involved the preservation of the author's house, and that, in general, board members felt that they were "just too busy" with their work on other board committees to devote much time to fundraising. The board chair told the director that, when requested to participate in fundraising, more than one board member responded by asking, "What is the staff for anyway?"

Second, the board chair informed that director that a board member was willing to make a major contribution to update the permanent exhibit, but only under a few conditions: one, the museum must accept the gift of a painting that is owned by the board member about one of the artist's plays and that the painting must remain on display at all times; two, the permanent exhibit hall must be renamed after the board member's high-tech company, which sells facial-recognition software to governments around the world to monitor their citizens' activities, and the name of the company must appear atop the name of the museum on the entrance to the exhibit gallery; and three, the museum must sell one of its most valuable pieces of art because it has been on loan to another museum for some time, and the resulting funds would cover the museum's operating budget for some time.

Finally, without consulting the director, the board chair quickly approved an event proposed by the fundraising committee, which was to be hosted by the board member who is the owner of the wine bar and the purpose of which was to let the public know "who the heck the author is," to help "get the word out in the community" about the reopening of the author's house, and to begin generating funds to formally establish "some kind of endowment for the museum" so that it "would never again run through all its money." The board member also pressured the museum's new development assistant to share information about potential donors with the wine bar's marketing staff and prevailed upon the development assistant to participate in the event, which was held in the board member's wine bar, to make it an "official museum fundraiser." When the event was held later that same week and media reports

outlined how an inebriated crowd that had been offered "bottomless craft cocktails" named after the author had spilled out of the event onto the street and had begun to disrupt traffic and accost passersby, the director decides that she has had enough and that she needs to turn the museum over to a new director.

At an emergency board meeting held soon after the wine bar event, the chair announced that the director would be leaving her position in three weeks, that the board would need to discuss and approve the appointment of an interim director, and that, effective immediately, the chair has also decided to step down, in light of what he now understands was the fundraising committee's questionable decision-making in approving the event at the wine bar without consulting the director or the board. The new chair of the board will be one of its newest members, a senior communications executive from a diverse background who works in a multinational company based in the region's urban center. With experience in serving on the nonprofit boards of social service and arts organizations in the region, the new board chair is well connected, comfortable asking for large donations and in opening up her professional network for causes she believes in, and is readily able to communicate the unique value of the museum to the public as it works to tell a more complicated story about the author and his pluralistic values. At the meeting, the new board chair makes it clear that, for the board to meet its responsibilities, it will need to clarify its role in fundraising, delineate what annual contributions are expected of board members, and ask for funds according to a well-conceived fundraising plan. The board will also need to thoughtfully diversify its membership so that it is representative of the community and can access resources and support from those in the community who have never been asked to participate before, and, crucially, the board will need to develop a partnership with the director to help the museum secure the resources it needs to ensure that it can operate successfully.

The incoming museum director, with experience as a guest curator and as an exhibit designer, had been consulting with the departing director about updating the permanent exhibit for the past nine months, and, together, they had been working to create a more complicated, relatable, and relevant narrative for the exhibit, one that highlights the author's work on poverty, immigrant rights, and women. When the new board chair asked the departing director for recommendations about who might step into the directorship of the museum, the name of the guest curator and exhibit designer came up. After an interview with the new chair of the board, in which the guest curator's extensive work history in museums was reviewed, including their involvement in fundraising activities, the new board chair offered the position to the guest curator on an interim basis, pending approval by the full board.

Privately, the incoming director wonders what they have stepped into, how the partnership with the new chair of the board will develop, and what they

will need to know about fundraising in museums to be effective. In debriefing meetings about the museum's operations with the departing director, it becomes clear to the incoming director that the departing director was not very knowledgeable about fundraising; did not see fundraising as interesting or as a good use of her time; did not plan for the fact that income from any programs offered in the house would drop once the house was closed for repairs; and did not update the board regularly about fundraising or understand how much the museum was spending on its fundraising activities.

Specifically, the incoming director also begins to comprehend that the departing director did not work with the board to ensure that the museum's membership program was sufficiently resourced, which resulted in the high turnover of staff in the development assistant position because of unrealistic expectations placed upon them; the departing director assumed that the board's management of the museum's funds and their allocation to the construction project would be completed in a way that would leave the museum with adequate resources; the departing director was not able to navigate many of the ethical issues related to fundraising that the board raised because of the fractured relationship the departing director had with the departing chair of the board; and, significantly, the departing director expected the board to do the work of fundraising, while the board expected the director to do the bulk of fundraising for the museum.

In accepting the position, the incoming director realizes that much of their success would hinge on their understanding of fundraising, especially in how the director and staff work with the board to raise funds for the museum. While in past positions, the incoming director has participated in special fundraising events and has given tours of exhibits and collections to donors, they have not yet been exposed to the full range of activities that involve donors in museums, the principles upon which fundraising is based, the range of techniques used to cultivate and steward donors, how to develop a fundraising plan, what the actual work of a fundraiser involves on a daily basis, or how staff involved in fundraising are expected to interact with board members.

The incoming director also realizes that they will need to work with the board chair to educate the board about fundraising and that, to do so, they will need to know more about foundational concepts and core professional resources in fundraising and which of these might be best to share with boards. The incoming director sees that they will need to understand more about how fundraising broadly contributes to museum finances; what motivates donors to give to museums and nonprofits; how board fundraising committees should work; and how the museum establishes when a board member should approach a potential donor about a gift. Moreover, the incoming director perceives that they do not yet know enough about the range of ways in which donors can give to museums, how much emphasis a museum should place on seeking certain kinds of gifts, such as those from individuals versus those

from corporations and foundations, what some of the professional or academic resources in philanthropy are, or how much board members are involved in activities such as capital campaigns.

Finally, to navigate the fundraising-related challenges that have emerged in the past year, including how the board perceives its role in fundraising, what staff should do versus what the board should do in fundraising, and the unhelpful involvement of board members in some of the museum's fundraising activities, the new director will need to learn quickly about relevant codes of ethics, standards, and guidance from professional associations that relate to fundraising. With a new board chair who promises to be a strong and knowledgeable partner, who is a clear communicator, and who understands the need for board education in the museum, and with at least some board members wanting to support the museum but who need their efforts directed in more productive directions, the incoming director is optimistic that they can help chart a pathway forward for the museum if they can access, learn, and share information about fundraising that will support their interactions with the board.

WHY UNDERSTANDING THE BOARD'S ROLE IN FUNDRAISING IS IMPORTANT

Museum directors appreciate that fundraising is a critical part of their responsibilities, yet not all will be familiar with basic resources in the field because much of their knowledge is likely to have been acquired from on-the-job practical experience as they have advanced in their careers in other areas of museum work. While it is certainly possible to possess strong fundraising skills as a result of this kind of informal training, it is equally likely that new directors may *not* have been exposed to many elements of fundraising, including core concepts, standards, or professional and academic resources that will complement some of the fundraising skills they may have acquired in serving in previous positions.

Although fundraising touches on every position in museums today, and fundraisers interact with virtually all other employees to help raise funds, museum staff whose primary position is not in development, such as a curator giving a special tour of the collections to major donors, or an assistant director outlining why a particular object should be purchased by the board on behalf of the museum, may have only experienced a small part of the museum's overall approach to fundraising. At the same time, while many nonprofit resources on fundraising exist, fewer focus exclusively on museums; staff with little or no formal training in fundraising or museum experience are commonly hired by many museums to work in development; there is a sense among museum professionals that fundraising staff have the highest turnover rate of all positions in museums; museum professional training programs only began to offer coursework in development in the past twenty years, and, even then, it

is seldom a major emphasis of study; and, despite its clear importance to the financial health and sustainability of almost all museums, fundraising is perhaps the least studied area of museums today.

In the vignette above, the new director will want to build on the skills and knowledge of the new board chair to educate the board about its responsibility to ensure that the museum has the financial resources it needs to advance its mission. The director's understanding of how museums are funded, why donors might decide to give to the museum, the ways in which they can give, and what areas of fundraising require or benefit from board participation will be important in developing a plan that generates a reliable source of funding for the museum. The director's knowledge of ethical codes and standards that relate to fundraising in museums will also be useful in supporting the board's ability to make informed decisions about the resources it supplies to the museum, how individual board members should support the museum, and how the board manages any of the museum's funds it oversees, including any savings and investments.

For example, the new director's knowledge of core concepts in fundraising, such as the what the board's actual responsibility is in fundraising, the director's role in fundraising, and how a case for support is developed will help the board appreciate that it must offer appropriately resourced programs and exhibits that are relevant to the public in order to attract philanthropic support. In addition, the new director's awareness of the importance of developing a fundraising plan will help avoid situations in which requests for funding are perceived to be weak by those who might otherwise give, or cases in which special events have not been integrated into fundraising plans. Furthermore, the director's understanding of what board members are supposed to give of their time or from their professional skill sets will assist the director in managing his or her own efforts and make it clear to everyone what is expected of board members in supporting the museum's financial health.

As another example, the director's familiarity with the ways in which most people contribute to museums, including the relative roles of annual giving, major gifts, and planned giving in nonprofits, and with what resources and skills are required to ensure that programs associated with these methods of giving are successful will undoubtedly support the director's efforts to directly involve board members in such programs, supporting, for example, the director in calling on board members to ask potential donors for major gifts. Moreover, an appreciation of the fact that a well-run membership program can be highly successful in supplying a steady stream of funding for museums as well as in creating a basis for deepening a member's involvement with the organization will allow the director to make the case to the board that it would be wise to strengthen the operation of such programs. New directors who also know that foundations and corporations supply only a small percentage of funding to nonprofits, that museums are not required to accept all gifts and bequests, and

that capital campaigns are highly structured and choreographed efforts that must generally be run in a certain way to be successful will be able to work with board chairs to educate them about why the museum is emphasizing one method of fundraising over another.

As a final example, the director's understanding of ethical codes and standards related to fundraising will support efforts to assist the board's chair in clarifying the kinds of behavior that are acceptable for board members when they are involved in fundraising activities, how fundraising staff should work with board members, whether the museum should accept gifts with restrictions and from whom, and if policies concerning the museum's fundraising activities should be developed. The new museum director might want to consider proposing policy that addresses what kinds of income-generating activities the museum considers appropriate, including those involving the board; why development staff should not be permitted to work on commission; how the museum shares information about its fundraising costs internally and with others outside the museum; how gifts from corporations are scrutinized before being accepted; what museum professional associations state about accepting gifts with restrictions or selling artwork to cover operating costs; and how the museum handles any investments it may have made. In consultation with the board chair, the new director might also want to explore developing guidelines for outlining how special events involving board members are planned and staffed and whether board members or major donors receive special privileges, such as parking passes for friends, anytime they request them as a result of the gifts they have made.

To supply new directors with the information and resources they need to interact with boards successfully, the sections below first outline the context for fundraising in museums, including the common sources of support for nonprofits, board responsibilities for fundraising, the structures in place to support board participation, and the philanthropic landscape within which museums operate. Professional and academic resources on nonprofit and museum fundraising are then reviewed, followed by a discussion of professional ethical codes, standards, and guidelines. The chapter will close with an overview of why it is important for new directors to know about fundraising resources when they interact with boards.

THE CONTEXT OF FUNDRAISING FOR MUSEUMS: SOURCES OF SUPPORT

As new directors may know, sources of support for private nonprofit American museums are supplied by a mix of four revenue streams: *government funding*, which accounts for a relatively low percentage of support in the United States when such funding is compared with governmental funding in many other countries and which has been declining for decades; *earned income*, such as

that derived from programs, gift shops, special exhibitions, admission, and the rental of museum spaces to outside groups for events; *investment income*, which is received in those museums that have endowments or other financial instruments that generate funds; and *charitable income*, which is derived from the philanthropy of individuals, foundations, or corporations from the private sector who make contributions (Center for the Future of Museums, 2020; Institute of Museum Services, 2009).

While there are great variations within the museum sector in the percentage that each of these four areas contributes, on average, government funding makes up around 20 percent of overall support for museums; earned income, about one-third; investments, about 10 percent; and philanthropic giving, another one-third (Center for the Future of Museums, 2020). Interestingly, art museums and multidisciplinary museums derive most of their funding from philanthropic sources (35 and 42 percent, respectively), and, while the percentage for history museums is also relatively high (33 percent), support from earned income for zoos and aquaria, at almost 60 percent, is more than twice the percentage that is derived from philanthropy (Center for the Future of Museums, 2020).

An overview of the sources of support for museums tells new directors several things: First, new directors need strong skills in managing the finances of their museum, which fortunately can be obtained through on-the-job experience and professional training programs or by consulting helpful books and articles (for example, see Alexander, 2023; Genoways, Ireland, and Catlin-Legutko, 2017; Granger, 2011). Second, new directors can expect boards to pay special attention to the sources of support that are particularly important to their museum's own financial health, which, while varying between museums, will almost certainly involve both earned income and philanthropic giving. Third, depending on the museum's combination of income streams, boards searching for new directors may seek candidates who have experience in the primary area of support upon which the museum is most reliant or may seek a director who can increase revenue in a particular area that the board believes is not living up to its potential. Finally, new directors need to understand which of the areas of support require the board's direct involvement, what such involvement means for the director's work, and how new directors are expected to interact with boards when board members participate in efforts to generate support for the museum. Of the four sources of support for museums, new directors should understand that boards participate far more directly in philanthropic giving than they do in all the other income-generating areas combined. While boards can be part of the process of securing government funding through their advocacy efforts, for example, may have developed policy about how to manage the museum's investments, or may be able to offer guidance about the kinds of activities the museum should pursue through its earned-income activities because of the marketplace experience of some

board members, in no other area of support for museums is there more direct participation by boards than in the area of philanthropic giving. Indeed, not only can new directors expect to update boards about fundraising on a regular basis but also they will need to spend a significant amount of their own time working on fundraising activities: in most museums, at least 50 percent of a director's time is spent on fundraising (Miller, 2018), and, in some museums, such as those that focus on art, studies have found that up to 70 percent of a director's time can involve fundraising (Schonfeld and Sweeney, 2019).

THE CONTEXT OF FUNDRAISING FOR MUSEUMS: BOARD RESPONSIBILITIES AND STRUCTURE

No matter what the source of support, one of the board's basic responsibilities is ensuring that the organization has the resources it needs to implement its mission. Because museums rely so heavily on philanthropic income as a source of support, however, museums must have boards that are actively engaged in supporting and guiding fundraising. As a result, board members must participate in fundraising by asking for gifts (referred to as *solicitation*); making their own financial gifts; introducing their friends and professional networks to the organization; being involved in special events; and recognizing that fundraising is a collective responsibility for the entire board, met through participating in outreach and stewardship activities, such as recognizing donors for their contributions (BoardSource, 2024j). To support these activities, it is essential that a "powerful partnership" between the board, the director, and the fundraising staff is built (BoardSource, 2024j).

An important way of building a partnership between the board and the director and staff is establishing a fundraising or development committee on the board, which is the case for most museums (American Alliance of Museums 2017). Directors can expect such committees to develop annual fundraising plans or, more commonly, to review and approve plans created by staff; to make contacts with foundations and corporations on behalf of the museum concerning staff-generated applications for funding; to coordinate efforts with staff about when and whom to ask for a major gift; to take the lead in certain activities, such as in planning for special events, though in consultation with staff; to be the main source of oversight for the museum's fundraising efforts, including monitoring who on the board is participating in fundraising and how they are participating; and, ideally, to ensure that ethical fundraising practices are in place, including on the board, that donors are properly acknowledged, and that fundraising is cost-effective (BoardSource, 2024j).

Despite the need for a partnership to exist between the director and the board, there are serious issues in how museum boards are involved in fundraising in museums. For example, in *Museum Board Leadership 2017*, a national report commissioned by the AAM (2017), both museum directors and board

chairs reported that the most important area in which boards needed to strengthen their performance was fundraising. Museum directors, in particular, reported that the need to strengthen fundraising was *more than twice as important* as any other area surveyed—more important than strengthening their board members' understanding of their roles and responsibilities, building a leadership pipeline, recruitment practices, or its outreach efforts. Moreover, the study found that "board member participation in fundraising is lackluster" (American Alliance of Museums, 2017, 23); that less than one-third of board members were "very comfortable" making a personal monetary contribution or providing the names of friends or acquaintances to be contacted by the museum for fundraising purposes; that more than one-fourth of board members were uncomfortable meeting with potential donors in person; and that more than one-third of board members were uncomfortable asking potential donors directly for money, whether alone or with someone else (American Alliance of Museums, 2017, 23).

THE CONTEXT OF FUNDRAISING FOR MUSEUMS: THE LANDSCAPE OF GIVING

The sobering numbers outlined above about the museum board's work in fundraising underscore the need for museum directors to understand how to work with and educate their boards and to know what information is best shared with them so that board members can appreciate the importance of their efforts. One area that is particularly useful for boards to learn about in this context involves reviewing how much Americans give to charitable causes annually, who gives the most to charities, and what percentage of all charitable donations go to the sector of charities that includes museums. Such an overview places museums in the context of overall philanthropic giving, allows boards to consider what trends in giving suggest about how their museum approaches fundraising, and supports informed decision-making about which specific areas of fundraising boards might want to support.

According to the leading organization that tracks data and trends about annual charitable giving in the United States, Giving USA (Giving USA, 2024), individuals, foundations, and corporations gave around $500 billion to charities in 2022 (Giving USA, 2023). Of this number, 64 percent was given by individuals, 21 percent by foundations, 9 percent by bequest, and 6 percent by corporations. Over the past forty years, individual giving has gradually decreased from a high of 81 percent of all giving, while foundation giving has more than tripled; meanwhile, corporate giving and bequests have remained more or less the same since the early 1980s (Master, 2023).

Charitable giving causes are grouped by Giving USA into nine categories, and, of these nine, the top three categories for receiving donations over the past several years have been either religion, human services, or education

(Giving USA, 2023). In 2022, for example, 27 percent of all giving, or around $143 billion, went to religion; 14 percent, or close to $72 billion, went to human services; and 13 percent, or just over $70 billion, was donated to education (Giving USA, 2023). Notably, just 5 percent of all giving, or approximately $25 billion, was donated to the arts, culture, and humanities, the category that includes most museums. Moreover, while giving to arts, culture, and humanities has remained from around 3 to 5 percent of all giving over the past few decades (Haynes and Theis, 2019; Master, 2023), such giving is known to be particularly sensitive to economic fluctuations; as the Blackbaud Institute notes, "when confronted by a financial crisis, arts organizations often experience a decline as they compete for donations against public and society benefit groups" (Blackbaud Institute, 2022; see also Brownlee and Nelson, 2020).

This snapshot of giving suggests that, while broad changes in philanthropy are underway, individual giving, which still accounts for two-thirds of all giving, remains the primary pathway for giving to nonprofits and, consequently, must be thoroughly understood by new directors and boards, not least because board members can be directly involved in it. For example, organizations should know if their number of smaller donors is decreasing, which has been the case more generally for nonprofits over the past few years (Miller, 2024), or if the number of major gifts, a category that is defined by every organization as a certain level of giving, is increasing, because such information can shape how resources are deployed or when board members are asked to be involved in gift solicitation.

At the same time, increased levels of giving from foundations over recent years means that directors and boards should be aware of foundations that might fund their museum's efforts, understand how foundations solicit and fund proposals, and, if appropriate, be prepared to activate board members to engage with foundations on behalf of the museum. In addition, because museums and other organizations in the arts, culture, and humanities can experience changes in giving when the economy is in flux, these organizations need to pay particular attention to ensuring that their approach to fundraising maximizes the potential of individual giving and that they track trends in donor behavior so that plans to minimize the impacts of economic disruptions can be developed.

Finally, museums and other organizations in the arts, culture, and humanities must recognize the philanthropic environment within which they operate. With so many important needs to fulfill in society, from maintaining religious institutions to fighting hunger, boards and directors of museums need to be able to distinguish themselves from organizations in other categories, such as those in religion and social services, as well as from other organizations in the arts, culture, and humanities, by emphasizing their museum's unique value and its central role in and engagement with the community.

In sum, because so much is at stake for directors in ensuring that the museum has the financial resources it needs to implement its mission and because fundraising is a centerpiece of how most museums support themselves, new museum directors need to be aware of what they can do to help strengthen board fundraising efforts. The best way directors can support board development in this area and help educate boards is to be knowledgeable about the context of fundraising for museums, including how museums are supported, how fundraising is perceived by museum boards, and what the philanthropic landscape means for museums. In addition, as outlined below, directors can support board development in this area by having access to and understanding core concepts in fundraising and key professional and academic resources and being aware of the issues new directors can encounter in working with their board in fundraising, which are typically addressed by professional ethical codes, standards, and guidelines.

PROFESSIONAL RESOURCES IN FUNDRAISING FROM THE NONPROFIT SECTOR

Despite the importance of philanthropy for museums, professional resources specific to museums are more limited than one might expect, likely because museums form such a small part of the philanthropic sector and the existence of an abundance of useful literature from the broader nonprofit world. As a result, although the discussion below will prioritize resources that focus on museums, it will largely refer to information from the more general nonprofit literature that nevertheless can be adapted for use by museum professionals.

A foundational resource in nonprofit fundraising that should be reviewed by new museum directors seeking to fill gaps in their understanding of philanthropy is *Achieving Excellence in Fundraising* (Shaker et al., 2022), which is updated every few years and is a product of the highly regarded Lilly Family School of Philanthropy at Indiana University. Combining core concepts and the latest developments in nonprofit fundraising with how organizations should structure their fundraising operations, the book's many authors apply their considerable professional experience to topics such as engaging the diversity of individual donors, developing annual giving programs, reviewing digital fundraising, outlining the role of special events and capital campaigns, and discussing foundation, corporate, and planned giving, all of which are fundamental components of museum fundraising.

The book's first chapter, "Developing a Personal Philosophy of Fundraising" by Tempel and Nathan, is the single most useful resource in the field for understanding why people should give to nonprofits, the role of philanthropy in society, and how organizations should frame their philanthropic efforts (Tempel and Nathan, 2022). For example, the authors emphasize that "the privilege to ask is made legitimate by the mission, the goals of a nonprofit organization,

and by the contribution the organization makes to the public good. . . . Put another way, the organization has a right to ask because it fulfills a community need, not because the organization has a budget shortfall or 'to keep the lights on'" (Tempel and Nathan, 2022, 9).

Tempel and Nathan stress two additional points that museum boards and new directors sometime fail to consider: first, boards need to accept that philanthropy is a legitimate way to help their organization address a worthy cause and to contribute to the public good, and, because of this, organizations deserve to ask for support confidently; and, second, when a "culture of philanthropy" exists in an organization, in which everyone in the organization, including the board, director, and entire staff—not just the fundraising staff—are all involved in fundraising, fundraising outcomes are improved and fundraisers have higher job satisfaction (Tempel and Nathan, 2022, 9).

Another essential chapter in the book for new museum directors to review is entitled "Engaging the Board in Fundraising," by Brown (2022), which succinctly outlines how to retain and recruit board members and how to ask board members for charitable gifts and support in an organization's fundraising activities. The chapter can used by new directors to help educate their boards and to consider the steps that can be taken to involve board members in fundraising. For example, the chapter stresses that all board members should be expected to donate and that board members should not believe that supplying their time and connections to the organization is a substitute for making a personal financial contribution. As the author compellingly asks, "if those who are closest to the nonprofit do not donate, why expect others to give?" (Brown 2022, 236). Minimum donation levels can also be established so that expectations for giving are clear, though some organizations may want to be flexible because they may discourage individuals with important skills or connections from participating. Such levels should never be used to exclude those with unique qualifications from joining the board if their expected contributions are beyond what they can commit.

To engage board members in fundraising, Brown's chapter also notes that work on the entire range of the board's basic responsibilities, not just those related to fundraising, should be activated to avoid the "misperception that the nonprofit only is interested in the board member's charitable giving" (Brown, 2022, 237). Moreover, board fundraising committees, which review the staff's fundraising plan, recommend it to the full board, and, once it is approved, monitor the progress of its implementation, help involve all board members in fundraising because fundraising committees model engagement; indeed, as Brown notes, boards with fundraising committees have been shown to double board member engagement in fundraising.

Finally, Brown's chapter outlines that board members should assist with cultivation strategies, typically with major gifts from individuals, foundations and corporations, and that this can take time; that they should assist staff with

donor identification and the assessment and ranking of prospective donors; that board members should be trained and prepared to be involved with staff in solicitation; that they can assist with donor stewardship by thanking donors in person; and that board members should be asked by staff for specific help in working with individuals, such as "We need to meet with X. Do you know them? Can you help with this potential donor?" (Brown, 2022, 238).

Throughout *Achieving Excellence in Fundraising*, the ways in which directors and staff should interact and work with boards on fundraising is mentioned repeatedly. One noteworthy chapter, for example, titled "Articulating a Case for Support," includes a review of how organizations should outline their "worthiness for philanthropic support" in what is referred to as a case statement. This review includes what a persuasive case for support should incorporate, how cases for support should be developed and tested, and the roles of staff and leadership in developing a case for support (Seiler, 2022, 141). As the author emphasizes, not only should the ideas of board members be cultivated in developing case statements but also the governance structure of the organization should be emphasized because it is "critical in attracting charitable contributions" as it speaks to "the character and quality of the institution" (Seiler, 2022, 146).

Another example in *Achieving Excellence in Fundraising* of how directors and staff should interact with boards is outlined in the chapter entitled "Fundraising Planning, Management, and Leadership," which focuses on what elements should be included in an organization's fundraising plan, which is a written document that is presented to the board for review and that guides and prioritizes fundraising activities (Stanczykiewicz, 2022, 221). Important elements in fundraising plans include outlining the case for support; describing the overall financial need of the organization and its specific programs; presenting a gift range for achieving the plan's goals; specifying what kinds of gifts are being sought (for example, from individuals, corporations, or foundations) and at what levels; describing the interests of major donors; indicating how certain kinds of gifts will be pursued (for example, through one-on-one meetings or through special events); outlining a specific time frame to accomplish the plan with a budget that details how all the work described will be paid for; and specifying what the board and staff need to do to implement the plan.

While *Achieving Excellence in Fundraising* has many other chapters that new directors will find useful in working with boards on topics such as ethics (Bergeron and Tempel, 2022), diversity (Osilli and Bhetaria, 2022), organizational preparedness (Chu, 2022), high-net-worth donors (Rooney, Yasin, and He, 2022), capital campaigns (Conley, 2022), and corporate and foundation giving (Burlingame and Stanczykiewic, 2022; Janin and Logan, 2022), the "cardinal principles" and other foundational concepts of fundraising that can be shared with boards are helpfully outlined in the more internationally focused *The Fundraising Reader* (Breeze, Lafferty, and Wiepking, 2023), in the classic

volume by James Greenfield, titled *Fund Raising: Evaluating and Managing the Fund Development Process* (Greenfield, 1999), and in *The Complete Guide to Fundraising Management* (Weinstein and Barden, 2017).

These latter publications outline key concepts, which, while already familiar to those who are experienced in fundraising, are presented in such a way that new directors can adapt them to make them accessible to board members. Such concepts include the *donor pyramid*, which is a graphic representation of the proportionality of giving levels that are typically present in an organization or that are required in successful campaign (such as a large number of small gifts at the bottom of the pyramid, a lesser number of major gifts in the middle, and a very small number of large gifts at the top of the pyramid), with the goal of attracting donors, engaging them, and moving them up the pyramid to higher levels of giving; the *donor cycle*, or, broadly speaking, how organizations manage potential donors by the process of first identifying them and finding ways to get them involved in the organization (acquisition), followed by engaging them in the nonprofit's mission (cultivation), followed by asking them for funds (solicitation), followed by thanking them and showing them the value of their donation (stewardship), and, finally, once again asking them for funds, typically at a higher level; the *LAI principle*, or identifying potential donors based on their linkage (L) to the organization, their ability (A) to give, and their interest (I) in the organization; and the *"80/20" rule*, in which 80 percent of the funds raised for a campaign will come from no more than 20 percent of the donors.

Several other books that focus on the broader nonprofit sector include helpful chapters that outline how to counter donor fatigue and how to develop successful fundraising boards (Grace, 2005) and how to address fundraising in the face of financial trouble, anxiety about the organization, or when donors are somehow tainted ("dirty money") (Klein and Yogi, 2022). They also include discussions of the skill set required for directors to be fundraising leaders in their organizations (Williams, 2013).

Finally, resources from the broader nonprofit sector that are helpful for new directors in understanding museum fundraising include the websites of organizations concerned with board development, including the website of BoardSource (2024j), which outlines how the board can support individual giving, special events, and fundraising communication; the websites of consulting groups such as Alexander Haas (2024), which seek to work with nonprofits and are often involved in advising boards and staff about capital campaigns; and those of professional associations, such as that of the Association of Fundraising Professionals (2024a), which offers resource guides on fundraising that discuss boards, or that of the National Council of Nonprofits (2024a), which supplies information about the regulatory environment for nonprofits. Also helpful are the websites of publications and organizations such as Independent Sector (2024), Giving USA (2024), *Forbes* (2023), and *The NonProfit*

Times (2024), which track charitable giving and trends. In addition, publications such the *Chronicle of Philanthropy* (2024a) and the *Nonprofit Quarterly* (2024), which provide news, statistics, and analyses of nonprofit fundraising, and professional development or training, such as the certification programs of the Association of Fundraising Professionals (2024b), webinars from the *Chronicle of Philanthropy* (2024b), and courses, seminars, and certification programs from the Fundraising School at Indiana University (Lilly Family School of Philanthropy 2024) are all helpful resources.

PROFESSIONAL RESOURCES IN FUNDRAISING FOR MUSEUMS

In the museum sector itself, one of the most useful overviews of fundraising is by Genoways, Ireland, and Catlin-Legutko (2017), who, echoing the broader nonprofit literature, note that fundraising is about building relationships with people and individuals "who make the decision to become a member, attend a special event, contribute to a campaign, or write a will" as well as with those groups of people in foundations and corporations who decide whether to fund a grant (2017, 96). The authors note that, while fundraising is about money, it is "really about sharing a story you are passionate about with someone with similar interests" (Genoways, Ireland, and Catlin-Legutko, 2017, 96), an approach to fundraising that new directors should be certain their boards understand.

Genoways, Ireland, and Catlin-Legutko (2017) stress the need to develop a *fundraising plan* every year to guide the museum's fundraising activities. Because fundraising plans outline areas where board participation is required and are reviewed and approved by boards and because fundraising plans may adapt or deepen elements of fundraising plans that board members may have seen in other nonprofits, it is important that new directors work with boards who understand the purpose and structure of such plans in the museum context, as outlined below.

As Genoways, Ireland, and Catlin-Legutko (2017) outline, museum fundraising plans should address *membership*, the cornerstone of annual giving in museums, by establishing how new members will be acquired, when such acquisition efforts will take place, any changes in the membership program, what the benefits of membership are at different levels, and how contact about membership renewals will be managed. Fundraising plans also should include how appeals for the *annual fund* will be organized, identify which donors will be asked to contribute in addition to any contributions they may make for membership, and discuss the *major gifts* program, including how research on potential donors will be conducted and what constitutes a major gift. Each museum defines what constitutes a major gift, and, depending on the size of the museum, it can be anywhere from $500 to $10,000 or more.

Fundraising plans should also include information about *stewardship*, or how the museum expresses its gratitude (for example, via personal calls, notes, or email); should specify the museum's *grant writing* projects; and should outline if the museum is engaged in a *capital campaign*, which in museums tend to focus on building projects (though they can be used to build endowments) and which always require proper planning, timing, and research to be successful. Moreover, a fundraising plan should integrate any information about *endowments*, which function like a long-term savings account, and, once built, generate interest that the museum can use for operations; should specify any *special events* to be held, which must have clear purposes related to the overall plan because they tend to be very time consuming and can be costly; and should outline how information about the museum's *planned giving* strategy will be shared with donors to generate bequests or gifts from charitable trusts. Finally, a fundraising plan should describe a *communications* strategy that outlines how the museum will keep donors informed of its activities and should include procedures to *monitor* the fundraising plan, so that it can be modified if it is not succeeding, or celebrated if it is.

As important as fundraising plans are, Genoways, Ireland, and Catlin-Legutko (2017) emphasize that boards must be the "vanguard" of those supporting the museum and that there must be "100 percent participation" from board members in fundraising; furthermore, each board member must contribute to giving programs at the highest level they can afford (2017). The authors also note the tendency of museums with fundraising committees on their boards to shunt the responsibility for raising money to this group and observe that sometimes such committees can "get stuck or overstep boundaries." To avoid these issues, the authors suggest that fundraising committees should have clear charges and members and staff who understand their roles and responsibilities (Genoways, Ireland, and Catlin-Legutko, 2017, 192). Finally, the authors emphasize that the museum's director and senior staff should regularly update boards about the status of the plan, that the museum should communicate how the plan is unfolding through newsletters and press releases to the community, and that the oversight responsibility of boards for fundraising can be exercised through such monitoring efforts.

Another very helpful resource that focuses on museum-based fundraising is by Cillela (2011). Although it emphasizes fundraising in small museums, Cillela's book is useful for directors of museums of all sizes to review because it interprets the broader nonprofit literature for a museum professional audience on topics such as what motivates people to give, the different ways that museums and visitors view the value of membership, and how museums of all sizes can best steward their donors. Cillela's book is particularly useful for those directors who find that they need to educate boards about how board members are involved in capital campaigns or in asking for major gifts.

Citing a commonly quoted description of capital campaigns as "an effort to raise a specific amount of money, for a specific purpose, over a specified period of time," Cillela (2011) describes how remarkably successful such campaigns can be for museums when the need is clear and the campaign is board driven (Cillela, 213, 135). Capital campaigns also succeed if the organization has the capacity to mount the campaign; if the campaign is well planned; if the museum knows that there is the potential to raise the amount of money needed from the community; if the public image of the museum is not negative; if the case for support is well articulated; if staff and board are properly trained in solicitation and board members can "lead the way" in asking for donations; and, especially, if leadership is "courageous," comes from the board chair, and the board has the trust and confidence of the donor community (Cillela, 2013, 145).

Cillela's (2011) discussion of membership is also very helpful: the author notes that there is a range of ways that museums define memberships; that, in larger institutions, museums need to recognize that membership can be viewed by members as an "economic proposition," given high admission costs; and that membership programs need to carefully consider how they will attract members, serve them, and fulfill member needs with services or benefits cost-efficiently. Cillela also emphasizes that membership programs must be very well run and deliver the services that have been promised and that they must maintain their records in a "pristine manner" (2011, 120). Critically, so that they can ensure membership renewal, Cillela also stresses that museum membership programs must be devoid of "bureaucratic dysfunction" and "outmoded policies" (2011, 120).

Several other resources in fundraising are helpful for new museum directors to be aware of. First, Catlin-Legutko's (2013a) chapter in one of the *Small Museum Toolkit* volumes is especially useful for understanding how to run membership programs, which the author notes not only comprise the basis for support for many museums but also provide "the first connection to an individual and an opening for sharing the museum's story and goals." As Catlin-Legutko (2013a) notes, directors and staff should work with the board's development committee to generate creative ideas about how to attract new members and offer membership benefits "with minimal cost impact" for the organization, and, in small organizations, board members can even be deployed to recruit new members (Catlin-Legutko, 2013a).

New directors can also consult Matthew (2022) for a model for organizing fundraising activities that centers the impact that museums, libraries, and archives have on communities; Brueggemann and McGinnis (2024) for a discussion of what museums need to do to make the best possible case for funding; and Simek (2018) for succinctly outlining fundraising basics for local history organizations. Books or articles that helpfully examine more specialized areas of museum fundraising include those by Rich and Hines (2006) and Rich, Hines, and Siemer (2015) on membership; Hamm (2015) on capital campaigns;

Beaulieu (2022) on endowments; Wolf (2018) on marketing; Sutton (2018) on grant writing; and Hartz (2015) on fundraising in academic museums.

Finally, three additional sources of information can be very useful for new directors to be aware of when working with their boards on fundraising: first, news about and guidance on all facets of museum fundraising from the AAM (2024o); second, reports from foundations, such as the Henry Luce Foundation (2024), the Mellon Foundation (2023), and the Hearst Foundations (2024), that outline their philanthropic giving to museums and to museum-related projects; and, third, studies by nonprofit groups, such as Americans for the Arts (2024), or groups associated with them, such as Ithaka S+R (2024a).

To highlight the utility of these sources, one example will be discussed here, the research group Ithaka S+R, which advises museums about strategic issues and has produced a range of insightful reports on subjects such as diversity in art museums. In a study of the characteristics, roles, and experience of Black trustees in art museums, which combined surveys and interviews, for instance, Ithaka S+R researchers Sweeny et al. (2022b) found that, when Black trustees were asked why they were nominated to the museum board, Black trustees "frequently reported that they believed they were selected in order to diversify the museum board and bring improved community engagement to the museum," while "White trustees commonly cited their philanthropic work or professional experience." Sweeny et al. (2022b) also examined which board committees Black trustees served on in art museums and found that Black trustees were least likely to serve on what were characterized as the board's most influential committees, the collections/acquisition and finance committees, and most likely to serve on the DEAI and governance committees; members of the fundraising/development committees were also more likely to be White. These numbers suggest that, as directors work with their boards to diversity them and to support their fundraising efforts, the philanthropic capacity of Black trustees is underappreciated both in seeking new board members and in tapping into their philanthropic skill sets once they join the board.

ACADEMIC RESEARCH AND MUSEUM FUNDRAISING

Given the importance of philanthropy to American museums, scholarly research on museum fundraising is surprisingly limited. Much of what museum fundraisers do is based on practice that has worked before or adaptations of traditional techniques to address new challenges, such as moving certain kinds of solicitation from direct mail to email or some stewardship to social media. Without research playing a role in much of how museums think about fundraising, however, museums can overlook information from fields such as psychology, marketing, technology, audience research, or museology, resulting in some practices that can become static, ineffective, or inadvertently exclusionary. This is an issue for museum directors because they cannot readily use

the results of academic studies to help guide their decisions about fundraising work with boards or to support recommendations that they might want to make to boards about key aspects of the museum's fundraising plan.

To demonstrate the value of conducting academic studies of museum fundraising, three areas in which studies have been conducted will be discussed in some detail below: membership, particularly in understanding the motivations of members for joining or renewing their membership; diversity and philanthropy, including whether museums are engaging with the full range of cultural groups in fundraising; and the analysis of big datasets, using powerful computational tools to study giving to the arts. All three areas provide valuable information about fundraising, which could be useful for directors to share with boards to help them with their oversight efforts or to support board decision-making in prioritizing how much of their time should be allocated to fundraising activities.

The first area of research on museum fundraising is on membership, which, as mentioned above, forms a core part of giving for many museums. For example, building on earlier work and based on a review of museum practice and research from behavioral economics, Siemer (2020) found that museum members fall into two categories: "transactional" members, who are motivated by the "value that membership offers" and who make membership decisions based on a cost-benefit assessment; and "philanthropic" members, who belong because of their commitment to the museum's mission and who are "more likely to renew [and] join at higher levels" (Siemer, 2020, 82). Siemer (2020) argues that understanding this distinction is critical in acquiring and renewing members, in maximizing revenue from membership programs, and in meeting the needs of members. Siemer concludes that innovation is lagging in museum membership and that, given the place of museums in a crowded leisure marketplace, museums need to dramatically change how they approach and operate membership programs because "old solutions are regularly prescribed to address new problems," resulting in wasted resources and programs that do not meet the expectations of modern consumers (2020, xviii).

In another example of research on museum membership, a study by Reavey, Howley Jr., and Korschun (2013) found that members of large urban art museums who did not renew their memberships often did not because of other demands on their time and attention, not because of any service failures on the part of the museum. As a result, to enhance renewal rates, the authors quite logically argue that any communications that museums plan to send about renewals to lapsed members should directly address this concern. Interestingly, earlier studies on membership that focused on renewal found that museum members who were also part of a special interest group that was central to the mission of the organization had a lower rate of lapsing (Bhattacharya, 1998). Membership studies such as these can be of particular interest to new directors in developing fundraising plans if they find that a

small amount of additional financial resources might significantly strengthen an underperforming area.

Another area of research on museum fundraising about which there has been increasing interest among scholars is diversity in giving. For example, Yuha (2015) argues that the lack of scholarship in this area has had particular consequences for how museums engage with culturally diverse donors and that the "traditional fundraising strategy in the arts of focusing on wealthy and mostly White patrons" is proving to be "less reliable" in light of major demographic changes underway in the United States (2015, 255). Based on a review of the museum fundraising literature and theoretical models about inclusion, Yuha theorizes that, when art museums are mainly funded by small group of nondiverse, powerful people in the community who are not representative of the local community, access to works of art becomes limited, and most community members do not have arts experiences. Yuha concludes that museums must modify their approach to fundraising so that they can build relationships with the diverse public and that this will require "internal changes in diversifying fundraising professionals and board members, understanding different giving patterns of diverse communities, and adopting alternative methods to building relationships and raising funds" (2015, 265).

In another study that examines diversity in fundraising, Banks (2019) investigates how race and identity complicate earlier findings that board members and other volunteer leaders involved in museums primarily pursue their upper-class interests (most notably, as seen in the work of Ostrower 1999, 2002). For example, in examining views of trustee participation in African American museums, Banks found that board members who were Black professionals working in the private sector thought that the ideal person to succeed them as a trustee would be someone else from their firm, because of the professional skill sets and connections they would provide to the museum, while other Black trustees were instead "especially keen" on ensuring that other members of the Black middle and upper class become members of the board (Banks, 2019, 177). Banks also addresses the concern that, as mainstream museums develop diversity initiatives, there might be a flight of Black trustees and their dollars from African American museums to majority museums and finds that there is evidence to support this concern. Such research helps new directors understand how potential board members from diverse groups weigh the importance of philanthropy in their commitment to board service and appreciate the pressures placed on diverse board members to ensure that members of their group are represented in the governance of the museum, which is the place where real change in how museums relate to diverse communities can take place.

The third area of research in museum fundraising involves the analysis of large datasets and promises to give museum professionals and board members detailed and highly useful characterizations of patterns in philanthropic giving. For example, in a comprehensive analysis of the funding of the arts by

foundations that included a review of a large IRS e-file dataset from nearly fifty thousand foundations over a nearly ten-year period, Shekhtman and Barabasi (2023) found that, of the $36 billion in grants made from foundations to arts organizations, the largest amount, $9.7 billion, or 27 percent, went to the performing arts; followed by museums, a category that included art museums, children's museums, history museums, and science museums, with $8.9 billion, or 25 percent; another $2 billion, or 5 percent, went to historical societies, which, in other analyses, have been sometimes grouped with museums. The authors also found that some foundations gave predictably and considerably more than others; that giving from foundations to the arts was highly localized, with most grants going to organizations in the foundation's home state; that foundations gave to those organizations that they have already funded in the past in very high percentages; and that, for art museums, the more "prestigious" an institution, the more likely it was that funding flowed to the organization, with notable exceptions involving museums with "unique and captive" donor bases, such as museums associated with culturally specific communities.

Interestingly, Shekhtman and Barabasi (2023) also found that relatively fewer museums received most of the funds when compared with funding for performing arts institutions and that almost half of arts funding was made by foundations whose main focus was not art. Moreover, in a sophisticated statistical analysis of more than six hundred art museums, using measures of prestige, the authors found that institutional prestige clearly affected philanthropic support, with the number and amount of grants received by museums being a clear function of prestige. Information is of this kind is of great use to new directors in helping them shape how their boards work through their professional networks to advocate for funding from foundations, in supporting boards to make informed decisions about from which foundations it might be best to seek funding, and in framing board expectations about outcomes when requests for funding have been submitted to foundations.

As these studies demonstrate, research on museum fundraising has the potential to enhance museum practice and to help new museum directors educate their boards about key issues affecting their museums. Because few studies of museums and philanthropy have been completed, large areas of museum practice in fundraising, including the effectiveness of capital campaigns or special events in different kinds of museums and the effectiveness of how museums manage their endowments, are ripe for analysis and would likely result in information that new directors could share with their boards to develop more reflective approaches to philanthropy in their organizations.

ETHICAL CODES, STANDARDS, AND STATEMENTS

Many nonprofit scandals over the past thirty years have involved fraud, especially the misuse of funds, and, when such scandals emerge, consequences

include damage to the organization's reputation and credibility and to public trust in the organization (Chapman et al., 2023). When scandals are handled poorly by a nonprofit, donations can drop or the organization can struggle financially, though research shows that a public response to the scandal that acknowledges the issue, apologizes, and works to rebuild trust can mitigate negative consequences in some cases (Chapman et al., 2023).

Museums are not immune from situations in which boards and their directors are involved in the misuse of funds. Prominent cases include those at the Missouri History Museum (Hartman, 2012) and the Independence Seaport Museum (Fiorillo, 2018), but museum scandals have also involved the public questioning of sources of funding from donors or trustees with ties to companies that made their profits from pharmaceuticals, oil, or weapons (often referred to as "dirty money" or "tainted gifts") (Harris, 2023); naming rights for buildings or galleries (Kazinka 2021); donor exhibitions of artwork (Dafoe, 2022); corporate giving (Merritt, 2019a); donors who gifted funds or collections who are later discovered to have behaved unethically or illegally (Frank, 2022); questionable financial arrangements between board members and museum employees (Holson, 2016); the use of proceeds from sales of deaccessioned items to fund operational costs and real or perceived violations of the original donor's intent (Florino, 2023; Kennedy, 2014); commissions to staff, board members, or collectors from exhibited artwork that may be later sold (Luscombe, 2023); blockbuster exhibits that increase visitation in the short term but that undermine membership in the long term (Rega, 2011); and the acceptance of restricted gifts (Halperin, 2015).

Fortunately, to help guide new directors through the thicket of ethical issues that can develop in fundraising, a range of ethical codes, standards, and guidelines about nonprofit and museums fundraising exists. Because museums regularly ask for public support in the form of funds, receive and manage large amounts of money, and are scrutinized by regulators and the media when they fall short in their financial and fundraising practices, such information is particularly important for directors to be aware of (Merritt, 2008).

For example, the nonprofit Charity Navigator (Charity Navigator, 2024a), a watchdog group that rates charities on a scale of zero to four stars, where four stars means "great . . . exceeds or meets best practices and industry standards across almost all areas . . . [and] likely to be a highly-effective charity," and where zero stars means "very poor . . . performs below industry standards and well underperforms nearly all charities," has rated nearly fourteen hundred museums (Charity Navigator, 2024b). Although Charity Navigator's methodology has been criticized, millions of people visit its website annually (Lindsay, 2023), and its measures assess areas that donors pay attention to, such as organizational transparency, fundraising efficiency, and overhead costs (Charity Navigator, 2024a). Of the 1,356 museums rated by Charity Navigator, more than 15 percent have no stars or just a single star, which, at

the very minimum suggests that the directors and boards of these organizations are not monitoring the reputation of their museums sufficiently but also that the ethical codes and standards in place for museums are not shaping the behavior of some museums. Notably, because of many recent changes they have made in the wake of the scandals mentioned above, both the Missouri History Museum and the Independence Seaport Museum are both now rated as four-star charities.

From the broader nonprofit world, ethical fundraising standards, resources, and common issues are helpfully outlined by the National Council of Nonprofits (2024b), including the need for transparency about donors, board membership, and fundraising costs; why fundraisers should never be paid a commission on contributions; the importance of timely and appropriate gift acknowledgments to donors; and the wisdom of saying no to restricted gifts. The Better Business Bureau, though its Standards for Charity Accountability, also lists twenty standards that are useful to consider, including those relating to donor privacy, fundraising expenses (for example, no more than 35 percent of related contributions should be spent on fundraising), and conflicts of interest (for example, board or staff members are not to be involved in any transactions in which they have material conflicting interests resulting from any relationship or business affiliation) (Better Business Bureau, 2024).

The Association for Fundraising Professionals provides guidance and outlines standards in its Donor Bill of Rights and its Code of Ethics that are well worth the time of new museum directors to review. To ensure that donors trust and have full confidence in nonprofit organizations, for example, the Donor Bill of Rights specifies ten areas in which the rights of donors must be recognized, many of which focus on sharing information with donors. Topics include how organizations use the resources that have been donated to them, how organizations obtain donations (if they use hired solicitors, for instance), and exactly who is on the museum's governing board (Association for Fundraising Professionals, 2024c). In particular, the Donor Bill of Rights emphasizes that gifts should be used for their intended purposes to implement the organization's mission, that confidentiality about donations is to be respected, and that boards are expected to exercise "prudent judgement" in meeting their stewardship responsibilities, especially responsibilities relating to donors (Association for Fundraising Professionals, 2024c).

The Association for Fundraising Professionals also outlines a set of standards in its Code of Ethical Standards for professional fundraisers to which many new museum directors or board members may not have been exposed but which outline a set of expected behaviors that are useful in guiding the interactions of directors and board members with one another and with donors. The standards focus on four areas: public trust, transparency, and conflicts of interest; solicitation and stewardship of philanthropic funds; treatment of confidential and proprietary information; and compensation, bonuses, and

finder's fees (Association for Fundraising Professionals, 2024d). Some of the standards outlined in the four areas that are relevant to museum fundraising are not engaging in activities that harm the organization or that conflict with fiduciary, legal, and ethical obligations; disclosing potential or real conflicts of interest; not exploiting relationships for the benefit of the individual or the organization; and ensuring that donors receive accurate advice about the value and tax implications of donations. Other parts of the standards relevant to museum fundraising include ensuring that donations are used according to donor intentions; that information about donors and giving is not disclosed to unauthorized parties; that compensation based on a percentage of contributions is not accepted; and that special considerations are not offered in order to influence the selection of a service.

The Association for Fundraising Professionals also has a supplementary document entitled "Frequently Asked Questions (FAQ's) about Fundraising Ethics" (Association for Fundraising Professionals, 2016) that discusses some of the standards in more depth. For example, of particular use to new museum directors is how to procced when the organization is considering removing the name of a donor from a building if the donor has been convicted of a crime, why changing the purposes of a restricted gift is a violation of the code of ethics, and under what circumstances it is appropriate for staff to share confidential information, such as donor names, with the board chair or board members.

Among the most important ethical codes and standards related to fundraising for new directors to review from the museum sector include those from the AAM (2024b), the International Council of Museums (2020), the American Association of State and Local History (2018), and the Association of Art Museum Directors (2022). In addition to providing ethical codes and standards, these organizations also outline key fundraising issues that museums should address, such as the types of gifts museums should accept, how donors should be recognized, and the conditions under which anonymous gifts will be accepted (see Merritt, 2008), or offer specialized guidance about museum fundraising, such as how history museums can use the proceeds from any collections that have been deaccessioned and sold (American Association of State and Local History, 2024), how art museums should manage their relationship with corporate sponsors (Association of Art Museum Directors, 2007a), and what museums should consider when working with private art collectors when donations of art are being made (Association of Art Museum Directors, 2007b). Combined with information from leading professional publications, such as those by Malaro (1994), Malaro and DeAngelis (2012), and Theobald (2021), about the acceptance of restricted gifts, considerations in accepting corporate gifts, the tax consequences of giving, and the overall process of donating objects to museums, new directors also have information from the museum sector to draw upon as they seek to educate their board members about museum fundraising or to navigate related challenges.

Because of their general applicability to a range of museums, only the ethical codes and standards from the AAM (Merritt, 2008) and the International Council of Museums (2020) related to fundraising will be reviewed below; the reader is referred to the references above for more discipline-specific standards or for detailed information about restricted gifts, corporate giving, taxes, or object donations.

American Alliance of Museums, Code of Ethics

The Code of Ethics from the American Alliance of Museums (2024b) (the AAM Code) does not focus explicitly on fundraising because the subject is discussed in more detail in the AAM's National Standards and Best Practices (Merritt, 2008) and in guidance titled "Developing and Managing Business and Individual Donor Support" (American Alliance of Museums, 2024p). Nevertheless, the AAM Code provides a foundation for understanding how fundraising should be framed by museums through its emphasis on how museum financial resources must be managed to promote the public good rather than to seek individual financial gain; that the museum's financial resources must be protected, maintained, and developed; and that board members must act corporately, and not individually, in exercising their responsibilities.

As mentioned in earlier chapters, the AAM Code emphasizes governance, collections, and programs, and, in the area of collections, the AAM Code touches on two fundraising issues: first, it states that proceeds from the sale of collections are never to be used for "anything other than acquisition or direct care of collections," which stresses that museums cannot cover operational costs with funds from the sale of deaccessioned items; and, second, it states that collections-related activities must not promote individual gain over the public good, which speaks to concerns that involve board member activities, such as donating funds to sponsor exhibits, loaning objects that later may be sold for exhibits, and forging links with foundations or corporations to enrich themselves rather than to benefit the museum.

American Alliance of Museums, National Standards and Best Practices

The AAM's National Standards and Best Practices (Merritt, 2008) present standards related to fundraising in the context of financial stability, but they do so only briefly, because, as Merritt notes, "museums are mostly concerned that: (1) they have enough money; (2) it was raised in an appropriate way; and (3) it is spent in accordance with the mission" (Merritt, 2008, 63). Although this approach minimizes the ethical issues that can be encountered in museum fundraising, it is a useful framing device to engage readers in a topic that some museum professionals believe is not relevant to their daily work.

Specifically, two standards relevant to fundraising are outlined in the National Standards: first, a museum's financial resources should be acquired,

managed, and allocated responsibly, legally, and ethically, in order to advance the museum's mission; and, second, museums should operate in a way that promotes their long-term sustainability and is fiscally responsible. Related to the standard of advancing the museum's mission, the important issue of executive compensation is discussed; museums are advised to be circumspect in offering excessively large salaries to directors, especially to those coming from the private sector who may expect such levels of renumeration, because the press and public can become outraged when they perceive that the museum is spending funds that they believe are more appropriately devoted to implementing the museum's mission (Merritt, 2008).

American Alliance of Museums, Donor Support

Based on the AAM's Code and the National Standards and Best Practices, the AAM has also created a detailed and very useful set of guidelines titled "Developing and Managing Business and Individual Donor Support" that highlight the "intricate nature" of museum-donor relationships and note that museums have "benefited from the business sector and the generosity of individual donors . . . [and] businesses and individual donors also have benefited from their relationships with the museum community" (American Alliance of Museums, 2024p).

The donor support guidelines recommend that museums create policies for developing and managing support and outline several areas that such policies should address, such as how decisions about support are made by the board and staff; how conflicts of interest are addressed when a board or staff member has an interest in a business or individual donor who intends to donate; who on the staff or board is authorized to make agreements with donors; what level of information about finances, tax, or law the museum will supply to donors; and the types of support the museum will accept or exclude from businesses and individuals.

A museum should also consider how it recognizes donors, based on the level of support received, including the "use, placement, size of names and signage"; how it controls access to and handling of donor information; the circumstances under which the museum will accept anonymous gifts (being sure to avoid agreeing to requests that conceal a conflict of interest or ethical concerns); when it enforces the pledge of a gift legally; how it should respond to inquiries about allegations of unethical behavior; how its business partners can use the museum's name and logo; how the relationship between the museum is promoted by the business; and how relationships between the museum and its vendors should be managed.

Much of the guidance outlined in "Developing and Managing Business and Individual Donor Support" involves creating policies that will have a significant impact on the museum's fundraising operations and reputation and on the behavior of board members. The document setting forth such policies

is essential for new directors to become familiar with as they work with their boards on fundraising.

International Council of Museums

The Standards on Fundraising of the International Council of Museums (the ICOM Standards) (2020) are designed to build on the principles of the ICOM Code for museums in the area of the development of financial resources and were developed in recognition that the global "environment for raising financial support is becoming more challenging and competitive." Similar to the American ones, the ICOM Standards focus on four areas: ethical principles; fundraising policy; considerations when developing and managing financial support; and considerations after accepting funds.

In the area of ethical principles, the ICOM Standards first outline that museums must have sufficient funds to carry out and develop their activities, that all funds must be accounted for in a professional way, and that a policy should be in place about income-generating activities in which it is made clear that these activities do not compromise institutional standards.

The next area of the standards focuses wholly on policy and emphasizes that a fundraising policy, approved by the museum's governing authorities, must be in place. The specific components of the fundraising policy are then outlined in detail, and among the issues that the policy must address is identifying who on the governing body and staff is involved in the decision-making process about the acceptance of financial support.

The third area of the ICOM Standards suggest that the museum develop and manage financial support, whether from individuals or businesses, "in a way that is consistent with their mission and values"; be transparent to potential donors; ensure that a given donation will not result in a perceived or real conflict of interest for the staff or board; create a process for how the museum should decide whether or not it should accept donations, including from businesses; should not allow itself to be influenced by donors who seek to shape programs, exhibitions, and activities; must document financial support in written agreements; and must steward funds responsibly and provide reports to the public that protect confidentiality, if it has been requested.

Finally, the fourth area of the ICOM Standards outlines what museums should consider once they have accepted funds and recommends, when the reputation of a donor is called into question, that museums assess whether the situation will affect the museum's credibility or have a negative impact on the museum, that museum governing authorities be involved in the process, and that communication on the matter be clear and open.

Taken together, the ethical codes, standards, guidance, and related professional resources available for museum fundraising create a strong framework for new directors to navigate the myriad ethical issues that can arise. However,

it is best to have considered this information before it needs to be deployed, so that, if a director does indeed need to address a fundraising issue that involves the museum's board, he or she has ready access to the tools that will help successful navigation of the situation.

OVERVIEW: BOARDS AND FUNDRAISING

Museums are among the most successful nonprofit fundraising organizations in the country. For new directors, this means that, even though they may not understand the technical details of some of the more sophisticated ways of raising money, they need to appreciate the role that different kinds of giving play in their museum because fundraising operations need to be sufficiently funded by boards to be successful. At the same time, in perhaps no other area of museums are board members more directly involved in museum activities than in fundraising. Consequently, new directors not only must understand the role boards play in developing such areas as fundraising plans and policies but also must be prepared to work closely with boards in ways unlike what they do in most any other core area of museum operations.

However, not all new directors understand the framework that exists for raising funds in either the nonprofit or the museum sector, realize that boards require training to actively participate in fundraising (often provided by the museum's director in some way), or know that creating a "culture of philanthropy" in a museum will support its success. Moreover, not all new directors are aware of the professional and academic resources that can support the development of strong fundraising plans or have taken the time to review the ethical codes, standards, and guidance from professional associations that underpin ethical approaches to philanthropy and that can help avert crises or scandals.

Finally, when new directors know that they possess the skills to assess a board's approach to fundraising, they can develop a road map to strengthening the weaker areas of the board's fundraising efforts, thereby supporting the entire organization in implementing its mission. For, in answering the question, "Whose job is it to fundraise for the museum anyway?" new directors can call upon their training and knowledge to explain that there is perhaps no more important and rewarding partnership that exists in a museum than the one between a director and board members who are working together to successfully raise funds for a museum.

10

Strategic Planning, Directors, and Boards

THE WAY AHEAD

STRATEGIC PLANNING AND BOARDS: A VIGNETTE

A private nonprofit children's museum in a large, growing city that is home to well-known banks, highly regarded institutions of higher learning, and successful life science and biotech companies is struggling to keep its audiences engaged in its programming, even though many young families have moved into the region recently because of the area's strong economic growth and continued affordability for raising families. Founded in the early 1980s, the museum has long emphasized arts education for children, but, in a sudden shift two years ago, after five years of declining attendance, the museum's board told the museum's rather new director that he needed to shift the museum's emphasis to STEM learning—science, technology, engineering, and math—to appeal more to the interests of the families who have recently moved into the region.

The museum, which relies on the proceeds from admissions, programming, and membership for the bulk of its annual operating budget, has as its mission "to support learning, creativity, and inspiration through art" and offers a range of programs in its "Everyone Can Paint" studio, the "Kid's Draw Comics" center, and in the "You-Can-Make-Art-From Anything" lab. The museum also has two galleries for special exhibits, "The Children's Space," which exhibits art that has been created in the museum's programs, and a second gallery called the "Artist's Workshop," which features hands-on contemporary art developed on site by professional artists. In particular, attendance for programs in the "Artist's Workshop" has been low, and, over time, the museum sought fewer and fewer artists to work in the space, so that programming became stagnant, much to the dismay of the staff.

The museum's director was hired four years ago with great excitement because he was working as professional teaching artist in a major art museum nearby, where he ran a widely admired teen program that engaged youth in art making to build community. During the interviews for the position, the director was particularly effusive about the potential he saw to strengthen the "Artist's Workshop" as a vehicle for an artist's residency program. He argued persuasively that, by opening up his network of contemporary artists to the museum, the organization's profile would be enhanced, and new audiences and funders would be attracted to the museum. Indeed, the director's passionate remarks about how art was critical to the development of imagination and creativity in children and the central role the museum should be playing in the community in the face of the elimination of art from the curriculum of many public schools deeply resonated with the board, and he was offered the directorship.

Once hired, the director began to pour a great deal of time and effort into the area of the museum's work he felt he knew best, the Artist's Workshop. After he enticed regionally known artists to participate in programming and worked closely with the museum's staff to enact his vision for the space, the Artist's Workshop was announced to the public with great fanfare. Associated programming began, and the museum's rejuvenated efforts in this area received glowing praise from the artistic community. Unfortunately, however, the museum's target audience, children and their families, did not attend programs linked to the Artist's Workshop, despite a major investment of time and funding, and the museum's overall attendance continued to decline.

The museum's sixteen-member board is composed principally of business leaders from finance, along with lawyers, teachers, and an artist, and, over the past two years, members from life science and biotech companies have joined the board. Board members are notably diverse, female, and under the age of fifty. None of the board members has been involved in organizations that focus on arts education, and, for almost all board members, this is their first experience in serving on a nonprofit board. The board's chair is a very busy vice president of human resources in a well-known financial services company, has placed most of her efforts into ensuring that the museum's finances are in order and in obtaining board approval of the museum's annual budget, and, until recently, had not discussed the future direction of the museum with the board. In addition, the board chair and the museum's director meet infrequently due to their busy schedules; have had a cordial working relationship that consists almost entirely of the director briefing the board chair about upcoming programs; and have not worked together to discuss board education, recent changes in the museum's external environment, or the sustainability of the museum's finances.

The museum's director erupted with anger when he was told in a board meeting that, because revenue generated from admissions, programs, and membership had declined dramatically over the past eighteen months, the

museum's executive board had decided that the museum needed to shift its mission and programming to STEM to attract new visitors. The director interrupted the board chair, raised his voice, and shouted that the board's actions were a "sellout" to corporate interests, a "betrayal" of the artistic community, and "unfaithful" to the vision of the founders of the museum. The director's comments shocked, dismayed, and silenced board members; once the director paused in speaking for a moment, the board chair stepped in and said that it was time for a break.

During the break, the board chair spoke privately with the director, urged him to remain calm for the remainder of the meeting, and emphasized that, although the board valued his service, the museum's projected financial situation was precarious, and this had compelled the board to make significant changes. The board chair outlined that the meeting being held now was intended to begin the consultation process with the director and staff about how to shift the museum's programming and outreach, but that expensive and sparsely attended programs, including the Artist's Workshop, would have to be reformulated completely or eliminated. The board chair hoped that the director would remain in his position so that they could continue to work together but stressed that, if the director planned to return to the meeting, he would need to be prepared to engage in discussion "professionally."

When the meeting resumed, the director, realizing that he had put his job in jeopardy, apologized for losing his temper. Although still deeply troubled and simmering with resentment, he listened quietly to board members for the remainder of the meeting as they discussed the reasoning behind the decision to shift the museum's emphasis. Factors influencing their reasoning, in addition to the museum's finances, included the changing composition of the area's population, informal feedback from local school leaders that the museum would be wise to integrate science into its activities, and communications from volunteers who said they were worried because there had been a noticeable decrease in attendance.

Soon thereafter, in meetings with staff, the director dispassionately outlined the need for the museum to alter its programming, outlined the board's reasoning behind the move, and encouraged staff to develop STEM-based activities. In the ensuing weeks, it became clear that the director had absented himself from any leadership, oversight, or daily involvement in implementing any of the changes related to the shift in programming, that the staff would be left on its own to develop new activities, and that the director was likely searching for a new position.

The museum has a staff of three full-time educators, including the unit's head of education, whose career started in another children's museum that emphasized play and learning. In this prior position, the educator had developed interactive learning experiences for children that integrated art with science. Projects included creating a sculpture lab, establishing a 3D printing

center, and designing and using model vehicles. With this background and experience, the unit's head of education embraced the museum's change in emphasis and, after brainstorming with staff, proposed to the museum's director that, rather than emphasizing STEM learning, the museum focus on STEAM—hands-on programs that integrate science, technology, engineering, *arts*, and mathematics—to build creative problem-solving skills, collaboration, and critical thinking in children.

After writing a brief plan explaining STEAM learning, telling how STEAM programming would serve visitors, and outlining three possible programs that could be introduced sequentially over the next year, the head of education met with the museum's director to review the document and discuss whether the director thought the board might be interested in building on the strengths of what the museum already does well in art. Without commentary, the director said that he would share the plan with the board and report back to the head of education.

After reviewing the plan, the board asked to meet directly with the head of education. In the meeting with the board, the head of education outlined the basics of STEAM learning; stated why, in her professional assessment, programming related to it was a good fit for the museum; explained how STEAM-related programming could be implemented in a way that was both cost-effective and would build long-term connections with community; and discussed three possible programs that could be rolled out successively over the next year if sufficient resources were available. Convinced, the board decided to shift the emphasis of the museum to STEAM-based learning, said it would identify the resources to support the effort, and asked the head of education if she would implement their plan.

By the time the first STEAM program—tracing the life cycle of commonly recycled materials and how they are broken down for reuse—opened six months later in the "You-Can-Make-Art-From Anything" lab, the museum's director had left. When the next STEAM program, which engaged glassblowing artists in the "Artist's Workshop," opened to much interest three months later, was lauded by local educators, and was very well attended, the new chair of the board, who was a senior manager in a life sciences company and had board experience with a nonprofit focused on physical and mental health in children, asked the head of education if she would be interested in becoming the museum's next director.

Although concerned about how the board had decided to shift what was, in effect, the museum's mission, and after being extremely busy developing programs that had opened over the past several months, the head of education gladly accepted the offer. In assessing the board's actions over the past few years, which included allowing the now-departed director to focus almost exclusively on the area he was most interested in and not intervening when he withdrew from day-to-day management of the museum when he was informed

about the shift in the museum's emphasis, the incoming director realized that success would mean having to reset the board-director relationship and to remind the board of its oversight responsibilities.

With the nonprofit experience of the new board chair to draw upon to address these issues, the new director believed that a productive partnership could be established but remained worried about the long-term development of the museum. How was the museum's new mission formulated, had it been formalized yet by the board in any of the museum's foundational documentation, and were all board members in agreement about changing the museum's emphasis? What were the goals for the museum over the next few years? How had the board worked to integrate the needs of audiences and feedback from the community into its next steps, and had the board considered if the available resources would be sufficient to enact the changes? And was there a document that could be used to guide everyone, and, if not, shouldn't there be a process in place to develop one?

As an experienced museum educator, during her career, including at her last position, the new director has developed many projects that received grant funding, possessed clearly delineated goals, had time-based benchmarks for monitoring project implementation, and were closely tied to the museum's mission and long-term plans. While the new director appreciated that she had successfully helped her current museum move in a new direction, her experience and training told her there was a fundamental weakness in this approach: the foundation that the new director had just built was fragile because basic issues about what the museum intended to do moving forward had not yet been formally agreed upon and established.

As she begins her directorship of the museum, the new director realizes that she will need to understand how the museum, with everyone working together toward the same goal, can change from the organization that it is today to the museum that it is seeking to be. The director also wonders what her role is in shaping and managing the future of the museum, how the board understands what its own activities should be in this area, and how she can encourage the full board both to consider the external trends facing the museum more thoughtfully and to formally agree on how to address them.

The new director was exposed to strategic planning in her professional training program in graduate school but did not think at the time that it would apply to her career so did not engage with the material meaningfully. Now, however, the director realizes that the key to moving the museum forward will involve engaging the board in strategic planning. With a board that is clearly open to change and a board chair who is experienced in working with other nonprofits, the new director is hopeful that, by reconsidering her own understanding of strategic planning and working closely with the board, a comprehensive plan can be created that identifies and assesses the issues the museum is facing; that formally establishes the museum's new mission;

and that develops an agreed-upon set of steps to be implemented, so that the museum can be a leading educational destination for the local community, a creatively driven place of learning, and an organization that is highly responsive to the educational needs of children.

WHY UNDERSTANDING THE BOARD'S ROLE IN STRATEGIC PLANNING IS IMPORTANT

A director has a compelling interest in understanding that the major undertakings that will shape his or her museum, such as updating its mission, developing new initiatives, responding to external challenges, and rebuilding the museum's physical footprint, must be handled thoughtfully and in partnership with the museum's board through the process of strategic planning. Consequently, new directors need to understand who is involved in strategic planning, what its core components are, and how strategic plans are written, evaluated, and assessed.

In the vignette above, the absence of a strategic planning process meant that the board reacted with haste even though it correctly intuited that audience needs were changing and that changes in the region's economy were affecting attendance of the museum's programming. At the same time, rather than engaging in a deliberative process of planning that would have provided a framework for discussion about why the museum exists and what audiences it is seeking to serve, the board's unilateral decision to shift programming impeded any organization-wide discussion of the fundamental purposes of the museum and made any efforts to shift the museum's programming that much more difficult. If the museum's board members and former director had known more about why museums engage in strategic planning before the board decided to shift the museum's programming in a new direction, they would have seen that strategic planning can serve as a vehicle for clarifying the mission of a museum, for examining what the museum hopes to achieve, for identifying how the museum might need to change its approach to be sustainable, and for mapping out how the museum plans to move forward.

The absence of a strategic planning process in the museum also meant that, when the board decided to shift the museum's purpose and programming, the museum's former director was not a partner in the decision, which not only reflected the tendency of the board and the director to work separately but also irrevocably damaged their trust in one another. If the former director had known that strategic planning often tests the board-director relationship, he could have been prepared to use the planning process as a way to reestablish trust with the board and to reset and strengthen this partnership, which would have benefited the overall board-director relationship.

Moreover, had the former director known that strategic planning provides a road map for making organizational change, he may have been able to guide

his board toward understanding that, while the board believed that it needed to act quickly to address the museum's underlying fiscal issues, it also needed a framework within which it could address the many challenges the museum faced. Indeed, had the former director understood that strategic plans are developed to determine the best possible future for a museum and then to chart a way forward, he may have been able to guide the board in seeing that it first needed to ask broad questions about the museum's purpose and how the museum differs from other museums like it. And, if the former director had realized how strategic plans are organized, that they are time based, cover all areas of museum operations, identify the resources needed to carry out the proposed changes, involve assessing how well the museum is currently serving its audiences, specify goals, and require considerable political skill and time on the part of directors in working with their boards, he might have been able to engage the board in planning *before* it made the decision to change the museum's emphasis and perhaps even learned why STEAM learning might be a good fit for the museum.

As for the new director, although she may have created a foundation for success by shifting some of the museum's programs to STEAM learning, this foundation is fundamentally weak because it has not been established that the changes were arrived at through a deliberative process, that they will be sustainable in the long term, or that they are linked to a clear set of goals that will guide the museum over the next few years. The new director also wonders how best to introduce to the board to the need for strategic planning to take place, even if it seems likely that STEAM learning may be the best route forward for the museum, and whether to engage a consultant to facilitate the process. The new director wants to learn more about her role in the strategic planning process, so that a productive partnership with the board can be established from the outset; is curious about how long after a new director has been hired strategic planning should commence; and knows she has not paid much attention to what professional standards might outline about strategic planning, including what measures should be in place to determine if the museum's embrace of STEAM will be considered successful and what role the community should formally play in the planning process.

Most importantly, the new director recognizes that the pathway forward for the museum runs through her understanding of strategic planning—why it is initiated, who is involved, how such plans are structured and implemented— so that she can decide how to share this information with the board. Such an understanding will give the director the tools needed to address the inevitable challenges that will arise as the museum's environment changes, will define what areas in a strategic plan she can actually help shape, and will give her the confidence to lead the museum in partnership with the board.

To assist new directors in understanding the importance of strategic planning in their work, the sections below will first describe the context of strategic

planning in museums and then discuss professional resources, including a review of standards and professional practices from the AAM and guidance outlined in *The Manual of Strategic Planning for Cultural Organizations* (Lord and Markert, 2017), the most useful book on the topic. The limited academic resources on strategic planning in museums will then be discussed, and the chapter will conclude with a summary that highlights why it is so important for new museum directors to understand how they will work and interact with boards in the strategic planning process.

THE CONTEXT OF STRATEGIC PLANNING IN MUSEUMS

Museum Board Leadership 2017, the most recently available report on museum boards produced by the AAM, supplies important context for understanding how strategic planning is carried out in museums and helps identify some of the challenges directors face in working with boards on strategic planning (American Alliance of Museums, 2017). The report is based on surveys of museum directors and board chairs in nearly nine hundred museums of all types and sizes.

First, among the more than a dozen areas of board performance that were assigned a grade by museum directors and chairs of the board in the *Museum Board Leadership 2017* report, both museum directors and board chairs assigned themselves a grade of "B minus" in how their organizations adopted and followed a strategic plan, which ranked in the middle of all areas of board performance (American Alliance of Museums, 2017). While museum directors reported that boards were best in "understanding mission," with a grade of "B plus," they reported that boards were worst, with a grade of "C minus," at "monitoring performance against goals and objectives," which is an element of many strategic plans.

Second, the survey found that only around half of museums regularly monitored the organization's specific progress against the goals of the strategic plan and that this was the least-conducted practice reported from a list of more than a dozen common museum policies and practices. Almost one-fifth of museum directors also assigned their boards a "D" or an "F" in strategic planning, with another quarter assigning a "C" grade. And, while directors gave several other museum policies and practices a lower grade than they gave to strategic planning, virtually all of these lower-graded policies and practices involved the *external* focus of the museum in areas such as fundraising and community-building and outreach, rather than those with more of an *internal* organizational focus, such as strategic planning.

Finally, the survey reported that only about one-third of the time of an average board meeting was focused on "future, strategic, or generative work" (American Alliance of Museums, 2017). While roughly three-fourths of museums had written strategic plans in place, more than 80 percent of museum

directors also reported that board meetings never, or only to a small extent, focused on strategy and policy rather than on operations. In addition, both museum directors and board chairs reported that one of the weakest areas for board members was furthering their own learning and growth about the organization, though board chairs believed they were much stronger in this area than did museum directors.

Given the very high percentage of museums that have strategic plans in place, the results of the *Museum Board Leadership 2017* report suggest that, while museums are successful at developing and adopting strategic plans, they are much less successful in monitoring their implementation. At the same time, although the report demonstrates that museums do indeed develop strategic plans, the board's work on them may be perceived to be perfunctory rather than enthusiastic, which is likely reflected in why so many museum directors reported that their boards performed poorly or only satisfactorily in strategic planning. Furthermore, the report's findings also suggest that directors face twin challenges in working with their boards on strategic planning: first, board members are not concentrating on future-oriented work enough during board meetings, and, second, they are not as interested as they should be in deepening their own learning about the organization.

These results underscore important concerns for directors to be aware of when engaging in strategic planning. Not only will the director need to work closely with the board chair to stress the importance of strategic planning for mapping out the future for the museum, but the director and the board chair should be prepared to address the likelihood that they will need to encourage the board's full participation in the strategic planning process. Engagement in the strategic planning process could be accomplished by taking steps to support education and training about the planning process itself at board meetings or special retreats; by suggesting that the organization work with reputable consultants who can help bring attention to the need for the museum to plan for its future or who can link the museum's internal work to its external efforts; or by adding more time at board meetings to discuss the museum's current and potential impact on the community. None of these actions was taken by the former director in the vignette. Finally, knowing that the interest of many board members in the strategic plan may wane once its implementation begins, the director, with the board's chair, may need to develop ways to demonstrate why monitoring the plan will make it more effective.

PROFESSIONAL AND ACADEMIC RESOURCES ON STRATEGIC PLANNING

Several resources are available to new directors who need to learn or be reminded about the core principles of strategic planning. These resources include manuals, books, and a few academic studies, but, unquestionably, the two most useful works and the emphasis of the discussion here are the

standards and professional practices promulgated by the AAM and *The Manual of Strategic Planning for Cultural Organizations* by consultants and museum professionals Gail Dexter Lord and Kate Markert (2017), as outlined below.

American Alliance of Museums

The AAM offers a well-regarded accreditation program that is based on adherence to a set of *standards* and provides museums with a "high-profile, peer-based validation" of the museum's impact and operations to increase a "museum's credibility and value to funders, policy makers . . . community and peers" (American Alliance of Museums, 2024q). A key component of these standards is strategic planning. Indeed, the most important elements of the standards have been distilled into five "core" documents that demonstrate "fundamental professional museum operations and embody core museum values and practices" (American Alliance of Museums, 2024r); notably, a strategic plan (along with a mission statement, a code of ethics, a disaster preparedness/emergency response plan, and a collections management policy) is one of these five core documents. Interestingly, according to the most recently available information, the main reason applications for accreditation are "tabled," meaning that when one or more specific concerns create barriers to the museum meeting accreditation requirements, is because there is an issue with the museum's strategic plan (Merritt and Garvin, 2007; Lorentzen, 2013).

The standards concerning strategic planning, which are outlined in the section on mission and planning, include a series of clear statements: strategic planning "produces a mutually agreed upon vision of where the museum is going and what it wants to achieve"; this vision must meet the needs of the museum's audiences and communities; the strategic plan must identify how the resources to fulfill the vision will be secured and allocated in ways that advance the museum's mission and maintain its financial viability; and strategic planning must involve gathering information from stakeholders, including the board, staff, volunteers, members, and community groups, to guide the museum's actions, so that it makes "sound decisions in response to changes in its operating environment" (American Alliance of Museums, 2024s).

The standards also outline the required elements of a strategic plan as follows: that it is up to date; is multiyear; is aligned with the museum's mission; includes a summary of the planning process itself; specifies a vision, goals, and action steps; discusses relevant areas of museum operations; identifies the resources required to carry out the plan; assigns responsibilities, identifying who will complete each action step; outlines evaluative measures; and is formally approved by the museum's governing authority (American Alliance of Museums, 2024s, 2024t). Museums with nonmuseum parent organizations are also expected to develop strategic plans that are linked to the parent organization's planning efforts, and, in turn, the parent organization's plan should

reflect support for the museum's mission and ensure that the museum's goals can be achieved (American Alliance of Museums, 2024s).

The AAM also offers guidance about developing and implementing strategic plans (American Alliance of Museums, 2024t), which are sometimes called institutional or long-range plans (American Alliance of Museums, 2018b) and emphasizes that, while each museum's plan may look different, every plan should cover multiple years, be consistent with the museum's mission, and include measurable goals and methods to evaluate success (American Alliance of Museums, 2024t). Strong strategic plans, according to the AAM, incorporate prioritized action steps and timelines, assign responsibilities, outline resources required to implement the plan, and can be accompanied by related plans that detail how decisions are put into practice on a day-to-day basis, for instance, when a strategic plan outlines a major shift that will especially impact the operation of specific areas of the museum, such as educational programming, exhibitions, or collections care.

In the *National Standards and Best Practices for U.S. Museums*, which provide an overview of "things all good museums should do" (Merritt, 2008, 1), the section on strategic planning discusses the purpose, importance, implementation, and documentation required for strategic planning and lists the reasons why museums must engage in it, among which is a key question: "How do you know you are doing a great job if you have not decided as a group (board, staff, stakeholders) what that job is?" (Merritt, 2008, 37). Merritt stresses that, if the decision about what the museum's job is is not written down and approved, everyone may not have the same understanding of what the museum intends to do and how it will get there. In such cases, Merritt asks what happens if the museum's director leaves and the incoming director does not have a strategic plan to refer to, and Merritt notes that museums without viable strategic plans undermine their efforts to convince funders that their support is warranted.

Merritt emphasizes that the primary value of a strategic plan is the process of creating it. Strategic plans that are developed with the participation of a diverse group of stakeholders, such as staff, board members, and important supporters, are more likely to be successful and realistic, because a broader range of possibilities for the museum's future will have been considered and the groups that the museum serves, which know best if the museum is serving them well, will have been involved in the process (Merritt, 2008). Moreover, the strategic plan is more likely to be supported and well implemented if those affected by the plan have been consulted in its development (Merritt, 2008).

The AAM has also produced a brief practical guide called "Developing A Strategic Institutional Plan" (American Alliance of Museum, 2018b) that integrates discussions of the *National Standards* with another useful reference on the subject, titled *Secrets of Institutional Planning* (Merritt and Garvin, 2007). Eight steps involved in the development of a strategic institutional plan are outlined: first, assembling a *planning team* and establishing its responsibility, its authority,

and a timeline; second, considering who the *audience* is for the plan; third, gathering *feedback* from internal and external stakeholders; fourth, assessing *current performance* using internal information, such as financial or attendance information, or external information, such as regional demographics; fifth, developing the *vision, goals, and action steps* of the plan by assessing the information gathered above; sixth, creating *timelines*, analyzing the *resources* that are required to meet the plan's goals, and assigning *responsibility* for action steps; seventh, *reviewing and editing* the draft plan; and, finally, *celebrating, implementing, and continuously evaluating* the final plan (American Alliance of Museum, 2018b).

Another valuable aspect of "Developing A Strategic Institutional Plan" is a template that outlines the basic elements of a written strategic plan as follows: an *introduction,* in which the background of the museum and its mission, vision, and values are supplied so that everyone has an understanding of the museum today and in the past; an *overview of operations, programs, and staffing*, to ensure that the goals that are specified reflect the capacity of the museum and that resources are allocated realistically to relevant areas of the museum; an *overview of the planning process*, to give context to the decisions made in the plan and to the action steps that are included; *other planning documents/information*, such as collections plans, that may be referenced or integrated into the strategic plan; *goals, strategies, and action steps*, the lengthiest part of the document, in which the museum's goals, the steps that will be taken to achieve them, who is assigned to do what, a time frame, costs, and funding are outlined; and an *evaluation and update plan*, in which the frequency of evaluation is delineated so that any necessary changes can be made in the plan and it is considered a "living document" that is not "put on the shelf" for several years but, instead, is part of "a culture of constant planning and evaluation" (American Alliance of Museum, 2018b).

Each museum will decide for itself the extent to which the museum's director is immersed in the specific areas of strategic planning, but directors will be involved in all of them in one way or another, which means directors who understand the strategic planning process *before* it commences can help shape their own involvement in it. Directors may find that they are co-leading the entire planning process, coordinating specific steps on their own or with the board, or perhaps even working on specific activities themselves, such as soliciting feedback from staff or writing drafts of plans. Although the depth of participation in some areas of strategic planning can therefore vary depending on the individual museum, new directors will unquestionably be occupied with strategic planning during their tenure, so it is vital that they understand the standards and professional practices that underpin the process.

The Manual of Strategic Planning for Cultural Organizations

The focus of the highly useful book *The Manual of Strategic Planning for Cultural Organizations* by Lord and Markert (2017), which integrates much of the

material included in the earlier *Manual of Strategic Planning for Museums* (Lord and Markert, 2007), is on strategic planning across the cultural sector, defined as museums, historic sites, libraries, gardens, and performing arts groups. This broader framework highlights what is distinctive about museums in the strategic planning process—for example, building a high-profile new building designed by a famous architect often dramatically alters a museum's long-term direction—while also emphasizing that all cultural organizations today must grapple with how to recognize, assess, and respond to change. Although the book includes many details about how directors are involved in coordinating the activities of *staff* who are involved in the strategic planning process, the discussion below emphasizes points of contact between the *director and the board*.

The *Manual of Strategic Planning for Cultural Organizations* outlines *why* it is necessary to conduct a strategic plan, such as when competition for the public's scarce leisure time erodes attendance, when pressing social issues such as diversity need to be addressed, or when ethical and legal concerns become critical; *when* it is necessary to conduct one, such as when museums create a new building or redesign or expand an existing one; the *structure* of strategic planning, including a ten-step process for developing strategic plans; how organizations *engage* with staff, funders, stakeholders, and audiences in strategic planning; and the need to *think broadly and strategically*, instead of anecdotally or episodically, about the challenges the organization faces.

The authors also discuss the importance of *retreats* in the strategic planning process; how *action plans*, in which goals are translated into objectives and tasks and then assigned to groups who implement and complete them according to a schedule and a time frame, are formulated; how strategic plans are *implemented* to achieve the agreed-upon goals; and how strategic plans are *updated and evaluated*, including through assessments of strengths, weaknesses, opportunities, and threats; and how the planning process and the plans themselves are *communicated* to the public, such as by posting plans on a museum's website.

Significantly, museum directors can be involved in all areas of strategic planning, and some of the more common challenges they may encounter include a lack of time; board chairs who do not want to participate in strategic planning; plans that are not being used by organizations; managing community expectations; obtaining a variety of views of the organization from the community; and initial board goals that are unrealistic, too detailed, or too narrow (Lord and Markert, 2017). As the authors note, gathering the information for a writing a strategic plan can take from six to twelve months, while a strategic plan is implemented over the course of three to five years; importantly, directors will need to participate in the process during this entire span of time.

Although new directors therefore need to be aware of the full scope of what is involved in strategic planning, three examples of when the director's involvement in strategic planning is salient are highlighted below.

First, the hiring of a new director may prompt the development of a strategic plan so that the search process yields candidates that are a good fit with the organization and because new directors typically come to organizations with fresh perspectives. Although Lord and Markert (2017) argue that it is valuable to have a strategic plan in place *before* the search for a new director begins, a strategic plan can also be updated as part of the search process. They also advise that, once a new director is in place, it is best to wait twelve to twenty-four months before initiating a new strategic plan so that the director can learn more fully about the organization. Accordingly, candidates being interviewed for directorial positions should pay particular attention to the status of strategic planning in the museums they are seeking to lead because such information will reveal much about the board's understanding of planning and may provide insights into how the museum can best move forward if the strategic plan has not been updated for some time.

Second, strategic planning is one of a few areas of joint responsibility between the board and the director and senior staff. Because the director and board will work together in strategic planning in ways that they otherwise do not, directors should realize that strategic planning can be "difficult and dangerous": "difficult" because formal communication in museums should take place through the director; and "dangerous" because the process itself brings staff and board members together in novel ways to discuss issues, challenges, and goals that some individuals may be unprepared, resistant, or reluctant to engage in. Consequently, strategic planning requires a "great deal of care" to ensure that the director's interactions with the board are appropriate (Lord and Markert, 2017).

Third, throughout the planning process, directors must have the confidence of the board and must demonstrate strong leadership (Lord and Markert, 2017). Such leadership involves the ability to engage outside groups, including working with communities who support the museum as well as those who are directly associated with the museum, such as strategic planning committees, and discerning if and when it might be time to involve a professional consultant in the process. Jointly with the chair of the board, the director also needs to ensure participants that the confidentiality of the planning process will be respected, that it is based on integrity and accountability, and that the process includes a range of perspectives. Finally, directors need to actively participate in strategic planning retreats, which are often the best way for organizations to focus on the topic, and they must regularly report to the board on the progress and challenges that have been encountered in implementing the approved strategic plan.

In sum, in concert with the board, directors are typically involved in initiating the strategic planning process, in critically examining the resources that need to be expended in the plan, and in implementing and assessing the plan, though from different perspectives. This interdependence highlights the complexity of the relationship between the director and the board and the need for directors to be prepared to navigate the challenges that can emerge so that they know when they must take the lead, when they should defer to the board, or when they should gather more information to assess the situation. Directors who are aware of these dynamics are better positioned to address them by understanding that it may be best to work to educate the board or to strengthen the board-director partnership *before* the strategic planning process begins, as the new director in the vignette already intuits, or they may find that the museum is indeed well positioned to embark on the strategic planning process.

Other Professional Resources

The most useful summary of strategic planning for museum directors to review, which draws on the broader nonprofit literature and perspectives of museum leaders, is presented in *Museum Administration 2.0* (Genoways, Ireland, and Catlin-Legutko, 2017). Also exceptionally helpful is a leading resource for strategic planning in small museums, "DIY Strategic Planning" by Catlin-Legutko (2013b), which is based on a well-known earlier version of the work (2008). Guidance for museums updating their mission statements is provided by Anderson (2019).

Helpful resources from the broader nonprofit literature include "The Strategy Change Cycle" (Bryson, 2016); *Creating Your Strategic Plan: A Workbook for Public and Nonprofit Organizations* (Bryson and Alston, 2011); *Strategic Planning: Understanding the Process* (BoardSource, 2011); and *Strategic Planning for Public and Nonprofit Organizations: A Guide to Strengthening and Sustaining Organizational Achievement* (Bryson, 2018).

Museum directors can benefit from reviewing actual strategic plans, which museums sometimes post on their websites, but, because they are an end product aimed at a more general public, they do not provide particular insight into the role of the director in the strategic planning process or of the director's relationship with the board. While it useful to compare the suggested templates of strategic plans from the literature and to see how individual plans reflect standards and professional practices, an easier access point is reviewing the case studies in *The Manual of Strategic Planning for Cultural Organizations*, which, most helpfully, makes the connections directly for the reader (Lord and Markert, 2017).

Academic Studies

Despite the shift of the missions of many museums from an emphasis on collections to an increased focus on engaged learning and service to the community and despite the need for museums to grapple with a host of external changes, such as the changing demographic profile of the United States, few studies have examined the process of strategic planning, which is the primary way that museums address change. Most of these studies take a case study approach, which supplies insight into the particular issues that can be encountered in the strategic planning process but does not offer a sector-wide perspective on strategic planning or an assessment of common obstacles.

Among the most thoughtful discussions that touch on strategic planning in museums from a research perspective include those by Sandell and Janes (2007), Kotler et al. (2008), Lorentzen (2013), Decker (2015), and Janes (2016). For example, in a national survey of museums, Lorentzen (2013) found that roughly half of respondents did not work with a key stakeholder group, the community, as part of the strategic planning process and, furthermore, that the museum's staff members were not involved in the development of about one-third of strategic plans. Interestingly, Lorentzen also found that more than half of museums worked with independent consultants and that, in many cases, these consultants ran the strategic planning process, which contradicts professional recommendations that the planning process remain in the hands of the board and director. Finally, Lorentzen found that a crucial component of strategic planning, specifying the human and financial resources required, was not included in roughly half of the plans; that nearly one-fifth of museums were not meeting their plan's benchmarks, primarily due to funding issues; that only 10 percent of directors had inherited a previously developed strategic plan, which suggests that one of the key tasks for a new director will involve working on a strategic plan; and that roughly three-fourths of museums did not post their plans on their websites, which Lorentzen suggests may be related to the lack of community involvement in the strategic planning process that she also found, as mentioned above.

Overall, however, little is known from academic research about what is the most effective way to conduct strategic plans in museums, what are the primary factors when the planning process languishes or breaks down, which are the areas in which the director's influence is most important, and if some of the information, such as attendance figures and the results of audience research, and some of the practices, such as working with trained consultants, used in strategic planning are demonstrably more important in strategic planning than in other areas. Until research answers these questions, the practiced guidance of those who have successfully moved museums through the strategic planning process will remain the touchstone for understanding strategic planning in museums.

SUMMARY

At some point in their careers, museum directors will be involved in strategic planning, which allows museums to envision their future, to set institutional priorities collaboratively, and to create a pathway that anticipates and manages change. The director will coordinate and participate with the board in many aspects of the process in a way that is dependent on the quality of their partnership, the knowledge of both parties about the strategic planning process itself, and their ability to navigate challenges, such as deciding who is involved, identifying who does what, balancing envisioning "what the museum might be" with accepting what is realistic, and recognizing that gaps exist between standards and the realities of conducting strategic planning on the ground.

Consequently, aspiring museum directors should immerse themselves in the literature about strategic planning to learn about their role as a leader in the process, a role that will draw on their flexibility, discipline, and ability to listen, learn, and engage productively in critical issues with others. In particular, directors who do not recognize how their museum's external environment is changing or that the quality of their relationship with the board affects the museum's ability to address change will find that they may experience many difficulties, as seen in the vignette. New directors should appreciate the fact that strategic planning puts them in contact with the board in a way that will be unique for them, for they will work directly to shape a board responsibility: setting the long-term direction of the museum. The constellation of information that new directors must be aware of to support the strategic planning process has at its center one clarifying truth: the director's training, skills, and knowledge of how to work with boards will be critical in moving the museum forward.

11

The Board and Key Issues Facing Museums Today

THE BOARD AND KEY ISSUES: A VIGNETTE

A multidisciplinary private nonprofit museum is located at the edge of a city in a bustling neighborhood of shops, restaurants, small private colleges, and a minor-league baseball stadium. The museum's new director was hired two years ago to "make the museum more interesting" by the museum's board of twenty, all of whom live within five miles of the museum, range in age from thirty-five to seventy, and represent the ethnic diversity of the area. The city is renowned for its natural beauty, many parks, low cost of living, and its association with long-established companies that were involved in technologies that supported the development of film and cameras. The region also has one of the largest populations of Deaf and Hard-of-Hearing people in the United States, many of whom moved to the city in the past two decades because of its vibrant Deaf and Hard-of-Hearing community; the presence of American Sign Language (ASL) interpreters in many medical centers, businesses, and at baseball games; and the existence of a university in the city with a large, nationally renowned program specifically designed to support and mainstream Deaf and Hard-of-Hearing students in their academic studies.

The museum has a range of collections, including those associated with art, history, and natural history, and two main exhibition galleries, a permanent one with an exhibit about the history of the city, and a large gallery for temporary exhibits that includes space for lectures, programs, and meetings. The museum's mission is to collect, preserve, and display objects related to the city's history. It has a staff of twelve, including a curator, a development team, educators, an events manager, a security and facilities team, collections managers, and exhibit designers and preparators; and is financially sound, with

well-attended exhibits and programs, strong membership levels, and a positive public image.

The museum's director is creative, engaged, steeped in professional standards, and well liked by both the board and staff. The board is very content to let the director lead the museum and has traditionally limited its oversight to finances; this approach has deepened as the board recognizes and defers to the director's professionalism, deep understanding of museum practice, and evident support from the museum's staff. The museum's director, who recognizes the board's passivity but sees how it is also is allowing her to get her job done, is also satisfied with the state of her relationship with the board and is fond of saying to the staff that she sees the true mission of the museum as "compellingly telling untold stories," an approach that resonates with staff, who she manages well, mentors, listens to, and learns from.

The director was hired just as an exhibit for the temporary gallery on the technologies that had developed in the city to support the use of motion-picture and mass-use cameras was nearing the end of its development. This exhibit displayed some of the museum's most important objects. The director helped to shape the final form of the exhibit, including adding one of its most popular elements, a carefully edited loop of recorded statements that community members had recorded on their smartphones and submitted. The loop, which was refreshed regularly, described the impact of the technology displayed in the exhibit on their lives. Also well liked was a place in the exhibit for visitors to take images of themselves or others in their group, using instant cameras, and to post comments and audio files about the images that could be easily accessed by others visiting the exhibit. The subsequent exhibit, on the history of the city's association with its minor-league baseball team, was well reviewed and well attended, displayed historic items associated with baseball from the museum's collection, and will soon close to make way for an exhibit that the director and the museum's staff are deeply passionate about, one about the history of and the profound impact of the Deaf and Hard-of-Hearing population on the city.

As the museum began to develop the new exhibit many months ago, it reached out to leaders in the Deaf and Hard-of-Hearing community to create an advisory group to guide the exhibit's development but was surprised when invitations to work with the museum on the exhibit were repeatedly rebuffed. More than one leader told the museum that, along with members of other disabled groups, that members of the Deaf and Hard-of-Hearing community did not feel welcome at the museum, that they were not served well there, and that it was especially galling to be asked to provide their input when the museum had done nothing to make either of the previous two temporary exhibits accessible to members of the Deaf and Hard-of-Hearing community, no matter how important the story to be told in the exhibit under development was. "Where were the assisted listening devices, transcripts of audio files, and captions for

video in the camera exhibit?" and "Where were the docents who could lead tours with American Sign Language for the baseball exhibit?" the leaders asked with wearied disappointment, given this echoed their experiences with many other museums.

One of the leaders noted that visitors who were Deaf or Hard-of-Hearing were especially put off by the baseball exhibit because they expected it would be accessible to them, but word had quickly spread in the community that this was far from the case. The leader emphasized that many from the Deaf and Hard-of-Hearing community attend baseball games because the local team has demonstrated its commitment to them by taking such actions as installing a closed captioning board at the stadium and employing interpreters who interpret live on the field for all home games. Because of higher poverty levels in the disabled community, the team also offered special events focusing on Deaf culture, which included discounted admission tickets for visitors. With evident frustration, the leader asked the museum's staff how the museum could either be totally unaware of these developments or, worse, aware of them and unwilling to develop ways to support visitors who are Deaf or Hard-of-Hearing.

The realization that the museum was not serving the Deaf and Hard-of-Hearing community and had, in fact, alienated its members by not recognizing them as an audience was devastating to the museum staff. Over the next many months, the staff worked assiduously to repair the relationship with the goal of creating a meaningful long-term relationship with the Deaf and Hard-of-Hearing community, one that would not only involve developing the exhibit together but also would change museum practices in how the museum served this community and would introduce new policies about exhibit development, visitor services, museum programming, and even what the museum collected, because so little of its collection related directly to what the museum now understood was a key community.

While the staff was consumed with meetings concerning how the museum's practices and policies would shift in all areas of museum operations to serve the Deaf and Hard-of-Hearing community, the museum's board continued with its traditional approach to oversight: it informally delegated most of its authority to the museum's highly competent director. As the director became deeply engaged in self-assessment activities with the staff about the museum's failure to serve the Deaf and Hard-of-Hearing community, board meetings continued to be poorly attended, few members spoke at meetings, and the director participated in them mostly by responding to questions about museum finances or by providing perfunctory overviews of museum programming until, during one recent meeting, the board's newest member spoke.

The newest board member is a senior executive who works in one of the multinational companies that helped to develop the camera technology that is now ubiquitous across the world. The board member supported the museum's

exhibits on camera technology and baseball, though she expressed the view several times at board meetings that these exhibits were not "academic enough" in their presentation, that the exhibits could have used the space that was devoted to "participatory" activities (such as those with Post-it Notes) to display more of the museum's objects, and that museum staff were beginning to veer into areas that they should not, such as including a panel in the baseball exhibit that examined past racism on the city's baseball team. The newest board member argued that these and other exhibit elements undermined the museum's mission to collect and preserve, a statement that was repeated over several meetings but was not meaningfully addressed by the board chair, the director, or other board members.

A few weeks before the exhibit on the city's Deaf and Hard-of-Hearing population is set to open, the board meets, and the newest board member insists that the director update board members about the exhibit because she has been learning about it from colleagues at her company and is gravely concerned that the exhibit has taken on an "advocacy stance" that she argues is completely inconsistent with the museum's mission. The director, who has been very busy supporting the development of the exhibit and its programming by working with leaders in the Deaf and Hard-of-Hearing community and in drafting new policy in several areas, is shocked by this statement. The chair and the rest of the board members, who appear to be embarrassed by the new board member's words and worried that they might have respond to them, are waiting for the meeting to end.

The director regroups and begins to passionately outline her reasons for developing the exhibit, which include the museum profession's commitment to urgently engage with groups who have been marginalized; the need for museums to respond to the major issues of the times, such as social justice, inequality, and climate change, which she announces will be the topic for the museum's next exhibit; the view that museums must not be quiet any longer about the serious issues that affect their communities; and to demonstrate to groups that historically have not been welcomed by museums that they have a place in museums. She emphasizes that such groups, especially the disabled, make up just around 5 percent of visitors at museums, even though more than one-fifth of the American population is disabled.

The director continues, saying that the staff is completely supportive of the exhibit; the museum will be borrowing objects from the community to supplement the few items that the museum cares for that are relevant to the exhibit's themes; and the staff has been drafting policy to codify how the museum works with community groups. The director also notes that, in presenting the exhibit, the museum is seeking to demonstrate that it can serve the Deaf and Hard-of-Hearing community and not just be focused on attracting more people to the museum to enhance its financial standing, especially because the museum's financial position is good; and that, to be transparent,

the exhibit will include a panel that outlines the fraught nature of early interactions between the museum and the Deaf and Hard-of-Hearing community and that the panel will include an apology for the way the museum has treated the community in the past. The director also states that the next staff search will prioritize hiring someone from the Deaf and Hard-of-Hearing community to serve as a liaison with the community.

The director concludes her comments by arguing that the museum needs to be both a site for safe and open discussion about issues such as marginalization and a place to bring about social and political change and that this approach implements what the staff consider the museum's core purpose to be, which is to tell untold stories compellingly.

The board has never seen the director speak so passionately about museum activities before. While many are visibly moved by the director's fervor and commitment, the newest board member is incensed about what she hears and quickly shares her reaction: she considers these statements to be moralizing, patronizing, and to describe actions that are clearly beyond the scope of what any museum, let alone their museum, should be doing today; she believes that the exhibit is guaranteed to alienate visitors who do not think the museum should apologize for its actions in the past; and she finds that the comments the director has made about prioritizing areas other than the museum's finances are naive and somewhat insulting.

The board chair calls an end to the meeting but first states that the exhibit will open as planned because it the director's job to manage the museum and the exhibit is set to open soon. At the same time, the board chair comments that the discussion has raised many questions in her mind about the true mission of the museum and, in particular, why the staff has such a different view of the museum's reason for existing—is it to preserve and display objects or to tell untold stories? The board chair adds that the comments at the meeting underscore the need for the board to know more about some of the major issues facing museums today, especially those about how missions change, inclusion, and accessibility, and if the museum is even allowed to advocate for social and political change.

When the exhibit opens, everyone is relieved when it is greeted favorably by the Deaf and Hard-of-Hearing community, especially because of the easy availability of ASL interpreters for tours of the exhibit and the presence of transcripts and streamlined text, as recommended by the advisory group. The exhibit is also well attended and receives enthusiastic reviews in the local media. However, a sense of unease and even distrust has developed between the board and the staff.

The director recognizes that her role in moving the museum forward will be critical because she is the communication link between the board and the staff, but she also sees that the board and the staff have starkly different views of the museum's mission and wonders what resources she might review about

how missions shift over time and can be updated. Moreover, the director sees a pressing need to educate the board about some of the major issues facing museums today, such as the demographic changes underway in the United States, whether the broader museum community is becoming more engaged in activism, and what this means for the perceived neutrality of museums, but she realizes that she first needs to review what she already knows about these issues. What are the key issues facing museums that boards should know about and that apply to her museum at this time, she asks herself, and what resources can a director share or use as a basis for learning more about or communicating these issues to a board?

WHY IT IS IMPORTANT FOR BOARDS TO UNDERSTAND KEY ISSUES FACING MUSEUMS TODAY

Because new directors have a unique opportunity to shape how their boards are educated, directors should evaluate how much their boards know about the key issues facing museums today; in addition, they should assess whether their boards understand their core responsibilities. Boards may not appreciate that their museum is part of a broader community of museums that is grappling with a range of challenging issues, including creating equitable workplaces; the partisan divide in society; repatriation; the continual change in digital technologies; shifting donor behavior; financial sustainability; bringing in new audiences while keeping traditional audiences engaged; deteriorating infrastructure; green collections care practices; decolonization; the future of blockbuster exhibits; the threat of societal collapse; corporate giving, and many others (see, for example, American Alliance of Museums, 2023b; Anderson, 2019; Biraglia and Gerrath, 2021; Halperin, 2024; Janes, 2024; Jurčišinová, et al., 2011; Merritt, 2019b).

Some of these are familiar and long-standing issues that have taken on new urgency because perspectives about them have recently changed (restitution), whereas others are underappreciated or inherently difficult to address (poor governance), and still others are ones that museums are now beginning to recognize that they can confront (climate change).

To provide insight about some of these issues and how they might impact or be addressed by the museum, new directors can share with boards their assessments of why certain of these issues are relevant, how they developed, and how the broader museum community is addressing them. Directors must also be able to identify and prioritize the issues that they believe would best provide perspective for better board decision-making in their own museum because, on a very practical level, most boards meet once a month for a few hours and therefore can be made aware of only a few of the major issues facing museums.

If this approach is applied to the vignette, the director could have shared information with the board about three important issues facing museums

today: *mission drift*, which can occur when the programs of a museum gradually became disassociated from the reason the museum exists; the *impact of changing communities*, which involves understanding the responsibility of museums to serve an increasingly diverse America; and *the role of museums as places of activism*, which explores whether museums should embrace advocating for social and political change.

For example, in their attempts to align the museum's programming with professional standards and best practices, the museum staff in the vignette informally began to shift the mission of the museum. At the same time, the board quite legitimately assumed that the mission they had approved at some point in the past would be implemented through the museum's programming, such that a misunderstanding between the director and the board about the mission of the museum threatened to undermine the organization's stability and shared sense of purpose. If the board had known that delegating its responsibilities to a director can sometimes result in a situation in which, over time, the museum's programming no longer strictly reflects the museum's mission because staff are attempting to comply with professional standards, the board could have taken steps to ensure that it regularly communicated with the director and learned about these standards. Furthermore, if the board had known that it has discretion in deciding how its mission is to be accomplished, it may have more easily discerned that the museum's current and planned programming is relevant enough to the museum's mission at this time, while also concluding that it needed to work with the director to reevaluate the museum's mission and to perhaps redevelop it.

As another example, if the board in the vignette had understood how America's changing demographics are affecting museums, it could have learned that the city the museum is located in has one of the highest proportions of residents who are Deaf or Hard-of-Hearing in the nation, examined how the museum was serving this and other historically marginalized groups, and considered how this might have shaped museum activities and policies *before* becoming aware of the contents of the exhibit. If the board had also known that the programming changes were not driven by the staff's own interests but, rather, reflected a close reading of professional standards, ethical codes, and recent initiatives in diversity, equity, accessibility, and inclusion, the board might have ensured that the exhibit was just one of many efforts to make the museum more inclusive.

Finally, if the board had been aware of the discussions taking place in the field regarding the role of museums as places of activism, it would have known that museums can indeed advocate for social and political change if their missions are reflective of this purpose. Consequently, the board and the director would have been able to discuss the strengths and shortcomings of shifting the museum's mission to a more explicitly activist approach, decide whether the museum's current mission was broad enough to encompass the kinds of

socially engaged programming the director had been developing, and perceive why the staff had been making the museum's activities more inclusive, accessible, and relevant to certain communities. At the same time, if the director had shared information about how other museums have enacted mission-based programming about museum activism, summarized some of the scholarship that underpins museum activism, and explored how advocating for social and political change might impact the museum's activities and policies, the director may not have been put in the position to defend the exhibit in a way that exacerbated underlying tensions about who should be in charge of revising the mission of the museum.

In this chapter, the three issues identified in the vignette—mission drift, the impact of changing communities, and the role of museums as places of activism—will be discussed to model how a new museum director might go about determining which of the many issues museums face today to focus on in educating the board. Rather than examining the full range of issues facing museums today, the sections below emphasize the kinds of information that new directors might share with their boards about the three specific issues identified in the vignette to illustrate how a board's education can be strengthened before a crisis develops. While the three issues are specific to the museum in the vignette, they also speak to the universal concerns of museums today: why they exist, whom they should serve, and what role they should play in society.

MISSION DRIFT

A mission statement formally states what a museum does, for whom, and why (American Alliance of Museums, 2024w). A mission statement "explains why the museum exists [and] how it makes a difference in the lives of others. . . . It is the heart of the institution and the grounding force that guides all the museum does and inspires the people who work there" (Anderson, 2019, 2). Both the wording of a mission statement and the process by which it was developed are central to the success of a museum because creating a mission statement is "the most important thing the organization will ever do"; consequently, the process must not be rushed, so that boards have ample time for discussion and to "listen to the views of staff and key stakeholders and to engage them in conversation" (Skramstad and Skramstad, 2013, 67). Mission statements are especially important when museums are making systemic changes because these statements provide clarity to everyone about why the museum exists, what it does, and who it serves (Anderson, 2019). Although the basics of what mission statements are, how they are developed, and why they are important are generally well known to museum professionals, new museum directors can benefit from reviewing some core resources, as outlined below.

The purpose of mission statements and the areas they must address are outlined in the Ethics, Standards, and Professional Practices of the AAM (2024u), in the Core Standards for Mission and Planning (American Alliance of Museums, 2024w), and in the *National Standards and Best Practices for U.S. Museums* (Merritt, 2008). Helpful guidance on developing mission statements is provided by the AAM (American Alliance of Museums, 2012b; Anderson, 1998). The importance of mission statements, their relationship to strategic plans and vision statements, and the board's role in how the mission is implemented and how implementation is monitored is discussed by Skramstad and Skramstad (2013). Common issues with mission statements, such as consistency, realism, and alignment with those of the parent organization, are summarized by Merritt (2008). Genoways, Ireland, and Catlin-Legutko (2017) summarize the importance of mission statements, noting that the responsibility for developing a museum's mission is shared between the board and the director, but that the board has final approval. Malaro and DeAngelis (2012) discuss the fact that a museum's board has discretion in deciding how its mission is to be accomplished, though it must select its goals carefully and ensure that these goals are relevant to the museum's mission. Furthermore, why museum mission statements matter, the qualities of impactful mission statements, how museums can align internal operations with the external landscape, examples of how museum mission statements are developed, and some of the issues encountered in their development are outlined in the essential *Mission Matters: Relevance and Museums in the 21ˢᵗ Century* (Anderson, 2019).

In addition to reviewing the resources outlined above and then deciding which might be useful to share with the board, the director in the vignette might have provided details about mission drift once she began to tell staff and colleagues about her view of the mission. For example, the new director could have outlined that mission drift, which is sometimes called mission creep, can take place when museums develop activities in their day-to-day operations that gradually move them away from their stated missions. As nonprofit expert Grace (2009) defines the phenomena, mission drift is either a long-term or temporary condition in which "an organization becomes so consumed by its (internal) institutional issues that it loses sight of its mission" (Grace, 2009, 30). In *National Standards and Best Practices for U.S. Museums*, Merritt notes that the development of substantively different views in a museum about what it should be doing or who it serves is "extremely serious" (2008, 34) and that it likely reflects "a broader failure to review plans and policies comprehensively to make sure they are all working toward the same goal" (2008, 34).

While the new director in the vignette could have observed that mission drift has been discussed as uniformly negative in the practice-based literature, the director might have also noted that recent discussions in the museum sector are reframing "mission creep" as the result of artificially narrow missions, such as those limited to the concepts of "collect, preserve, and interpret,"

which minimize or exclude serving communities in ways that matter to museums (Le, 2021; see Merritt, 2022). At the same time, an understanding of mission drift is clearly stymied by a lack of academic studies of mission drift in nonprofits (see Gooding, 2012), so that the reasons for its occurrence in museums, aside from practice-based insights, have not been scrutinized.

Finally, the ability of the new director in the vignette to share her knowledge with the board about mission statements, including their role and why and how they are developed, and what is known about mission drift, may have spurred the board to consider the ways the museum's newer programming was serving its community in beneficial ways. This assessment may have opened up discussions so that everyone in the museum agreed that the museum should move in this direction, which, in turn, would have initiated the process of revising the mission statement in ways that were productive and resulted in the staff and board understanding their respective roles in approving mission statements. Fortunately, by working closely with the chair of the board and sharing key information on mission statements, the new director, like many others, can rely on her training to access useful resources to navigate mission drift as one of many important though often underappreciated issues facing museums today.

THE IMPACT OF CHANGING COMMUNITIES

New museum directors will already know that there is a tremendous range of resources that can be shared with boards about the changing demographics of American communities and what this means for museums, what ethical codes and standards state about the importance of serving communities as a core purpose of museums, and what the many professional and academic resources suggest about working with communities.

For example, directors can share information with their boards about the dramatic change over the past forty years in the composition of the American population—which is now at least one-third minority and is rapidly on its way to having a majority of the population be composed of minority groups—and can also inform their boards about the striking underrepresentation of minority visitors to museums and on museum boards (American Alliance of Museums, 2018a; Farrell and Medvedeva, 2010). Similarly, directors can share that more than one-fourth of Americans have some type of disability, that anyone can join the ranks of the disabled at any time, that 6 percent of adult Americans are Deaf or have serious difficulty hearing, and that the poverty rate for disabled adult Americans under the age of sixty-five living in the community is more than twice that of those who are not disabled (Annual Disability Statistics Compendium, 2023; Centers for Disease Control, 2023).

New directors might also convey to their boards surveys that outline how boards view their work with communities and what ethical codes and

standards recommend about *how* museums should work with communities. For example, in the most recent national survey of museum board leadership conducted by the AAM (2017), which showed that almost half of museum boards were all-White, the board actions related to diversity and inclusion that boards ranked as most important to the organization were advancing board diversity and incorporating diversity into the organization's core values. At the same time, only around one-fifth of museums had modified their organizational policies and procedures to be more inclusive. These numbers undoubtedly have increased in the past few years as the disparity between the composition of museums' boards and staffs, compared with that of the broader American population, has become more widely known. These survey findings are valuable for educating boards in areas where they are likely to be deficient.

In the area of ethical codes and standards, it can be helpful for new directors to recall that the AAM Code stresses that all museums have a commitment of service to the public, that public service is a paramount concern for museums, that they must be responsive to represent the interests of society, and that a museum's programs must encourage participation by the widest possible audience and must respect pluralist values (American Alliance of Museums, 2024b). The more extensive ICOM Code also refers to museums' commitment to public service but frames these responsibilities in terms of how museums are expected to interact with communities, especially in the context of collections and education. As the ICOM Code states, museums must work in close collaboration with and have an important duty to attract wider audiences from the communities they serve (International Council of Museums, 2024a). Significantly, the ICOM's recently approved definition of a museum emphasizes that museums are accessible, are inclusive, foster diversity and sustainability, and operate with the participation of communities (International Council of Museums, 2024e). Finally, AAM Standards emphasize that museums must identify the communities they serve, decide how to serve them, strive to be inclusive and offer opportunities for diverse participation, assert their public service role, and place education at the center of that role (American Alliance of Museums, 2024v).

Professional resources a new director might review in the area of community include "Facing Change: Insights from the American Alliance of Museums' Diversity, Equity, Accessibility and Inclusion Group" (American Alliance of Museums, 2018a), as well as resources on the AAM's web page, including those on diversity, equity, accessibility, and inclusion (American Alliance of Museums, 2024x), community engagement (American Alliance of Museums 2024y), and diversifying museum boards, which have been designed for board members *and* staff who work directly with the board (American Alliance of Museums, 2023a). The Western Museums Association also has comprehensive information about diversity, equity, accessibility, and inclusion in museums (Western Museums Association, 2024). Other helpful information includes

the *Museum and Community Partnerships Collaboration Guide* (McCarthy and Herring, 2015), which outlines what is required to create successful partnerships; resources from the "Museums Foster Belonging" initiative (American Alliance of Museums, 2024z); "Guidelines for Collaboration," which were designed to be a resource for museums conducting collaborative work (Indian Arts Research Center, 2019); and the book *Museums Involving Communities: Authentic Connections* (Kadoyama, 2018), which provides a helpful framework for connecting with communities.

In the area of accessibility, new museum directors will likely be familiar with the phrase "Nothing About Us Without Us," which stresses "the importance of centering the participation of disability community members in any work an organization does to better serve them" (Association of Science and Technology Centers, 2024), as well as with professional resources, such as those by Pressman and Schulz (2021), Ciaccheri (2022), the Association of Science and Technology Centers (2024), the Museum Education Institute at Art Beyond Sight (2024b), the Museum, Arts and Culture Access Consortium (2024), and the Smithsonian Institution (2024e). The participation of disabled people can be centered by hiring staff and recruiting volunteers and board members with disabilities, by forming advisory groups, and by working with disability organizations; most importantly, feedback from the disabled community must be addressed appropriately (Association of Science and Technology Centers, 2024). As emphasized by the Association of Science and Technology Centers, since museums have made mistakes in the past in the area of accessibility, in order to develop trust-based, meaningful relationships with members of this marginalized community, hard conversations must be entered into humbly by museum staff (Association of Science and Technology Centers, 2024).

Insightful academic studies that address issues of how museums work with their communities can be used to help new directors identify, assess, and navigate issues with their boards. Many of these studies focus on the history of museum-community interactions, the challenges of working with communities, if and how museums can share authority with communities in the stewardship of collections and the development of exhibits, how communities, especially marginalized ones, are represented in museums, and how communities have come together to change museums (Allison, 2020; Brown and Peers, 2003; Crooke, 2007; Golding and Modest, 2013; Sandell, Dodd, and Garland-Thomson, 2010; Sandell, 2019; Silverman, 2015; Watson, 2007). An important caveat is that few studies examine the role governing authorities can play in supporting or maintaining partnerships on an institutional level (but see Butts, 2002; Horwood, 2019; McCarthy et al., 2013; and Scott and Luby, 2007).

The director in the vignette was busy doing the work of connecting with the Deaf and Hard-of-Hearing community in ways that reflected the changing demographics of American communities. The director had consulted ethical codes and standards about how museums should interact with communities,

as well as professional and academic resources about working with communities. If selected information about museums and their communities that supported the director's efforts had been shared with the board well before the exhibit opened, the director's efforts to shift the museum's mission would have been more productive, the Deaf and Hard-of-Hearing community would have been supported by the entire organization, and the road ahead for the director would likely be easier. Specifically, the information and timeline, along with board training and ability to change course, would enable the director to work with the board to outline why the museum's efforts with the Deaf and Hard-of-Hearing community should be supported and integrated into the museum's mission.

THE ROLE OF MUSEUMS AS PLACES OF ACTIVISM

New museum directors are most certainly familiar with the burgeoning discussion of the role museums can play in advocating for social and political change and of the movement among many museum professionals to recognize and explore the implications of arguments that "museums are not neutral." From its theoretical roots in academic studies of museums to being embraced more recently by all kinds of museum professionals, the idea that museums are not impartial interpreters and presenters of objects and information and that they have an obligation to address the pressing social, political, and environmental issues of our time through activism continues to profoundly affect museums. Museum boards, however, are much less likely to be aware of the resources that provide a foundation for museum activism, may not be cognizant of just how pervasive the concern is about the lack of neutrality in museums, and may be unaware of the desire of staff to influence public policy. Consequently, boards may justifiably worry about the implications for museums of presenting programming that embraces such an approach when they do not yet understand it.

New museum directors may therefore wish to review some of the work that provides context for understanding the recent "museums are not neutral" movement, which arose in around 2017 (Autry and Murawski, 2018; 2019), including publications by Cameron (1971) and Weil (2002), who use the history of museums as a prism through which to examine how contemporary museums shape society; Duncan (1995), who examines how art museums present a defined set of values and beliefs to the public; Ames (1999) and Peers and Brown (2003), who use analyses of interactions with Indigenous groups to underscore inherent biases in how museums develop exhibits and manage collections; Marstine (2011), who uses new museology to disentangle the value systems encoded in museums; and Janes (2013) and Fleming (2016, 2019), who refute the idea that museums can somehow be neutral. As Fleming argues, "no museum is actually 'neutral,' ever. . . . It is to the discredit of

museums that many still like to portray themselves as without bias, as apolitical. They are the opposite—all museums are full of bias, and all museums are political" (Fleming 2016, 74–75).

New museum directors are likely familiar with the "museums are not neutral" initiative and its well-known efforts to advocate for change in how museums operate internally and externally through the recognition of systemic biases (Autry, 2017; Murawski, 2017), but reviewing *Museums As Agents of Change: A Guide to Becoming a Changemaker* (Murawski, 2021) will help directors understand how the initiative developed, how it relates to museums working with communities, and what it means for leadership, the organization of museums, and the work of museum professionals. Related work by the grassroots organization Mass Action (Museum as Sites of Social Action, 2024) stresses that internal changes are needed to support equity and inclusion as part of efforts to engage communities in meaningful ways, including critically examining the historical legacies that continue to resonate in institutions.

New museum directors know that, although museum ethical codes and standards are silent on museum neutrality and do not yet speak directly to the issue of museum activism, they nonetheless provide an important foundation that supports museums in addressing social and political issues internally and externally, by stressing service to the public and the need to maintain public confidence and to be responsive to the needs of community and by encouraging access and participation by the widest possible audience (American Alliance of Museums, 2024b; International Council of Museums, 2024a; Merritt, 2008). Many professional resources produced by the AAM on diversity, equity, accessibility, and inclusion, which were referenced in the section above, are also relevant to understanding why museums are engaging in social and political advocacy (for example, see American Alliance of Museums, 2024x).

The leading academic work, titled *Museum Activism*, by Janes and Sandell (2019a), defines museum activism, makes arguments for why museums need to engage in social and political advocacy, explores the "myth of neutrality" of museums, and presents case studies of museum activism. According to the authors, "with a variety of notable exceptions, the museum community is not responding to the world, be it climate change, species extinction, or social justice issues such as poverty and homelessness. . . . As crises mount, museums are alarmingly invisible—reluctant to disturb or assert" (Janes and Sandell, 2019b, 18).

In the vignette, the director might have shared some case studies in *Museum Activism* with the board to supply context for the museum's work with the Deaf and Hard-of-Hearing community and the reasons behind developing the exhibit. For example, Kudlick and Luby's (2019) article on what happens when the disabled community is placed at the center of the exhibition development process could have been used as a basis for briefing the board, because,

"when it comes to serving, representing, and hiring people with disabilities, many institutions are not fulfilling their potential to demonstrate leadership. . . . Museums' capacity to impact both the lives of people with disabilities and to support broader changes in the way in which disability is perceived is significant and largely untapped" (Kudlick and Luby, 2019, 58).

Currently, museum activism and neutrality are not addressed in museum ethical codes and standards, making it especially important that museum directors who wish to engage in activities related to these areas take proactive steps to ensure their boards are familiar with what important professional academic resources have to say on these topics. Fortunately for the director in the vignette, reviewing the "museums are not neutral" initiative as well as professional resources on diversity, equity, accessibility, and inclusion and academic resources on museum activism will support her efforts to have the board understand whether the museum's exhibit can be encompassed by a broader interpretation of the museum's mission or if discussions about updating the museum's mission need to commence immediately.

SUMMARY

The museum community faces a host of challenging issues that museum directors are well equipped to understand through their professional training and experience and by referring to ethical codes, standards, and professional and academic resources for guidance and insights. Indeed, an unwritten part of a museum director's job is keeping up with professional and academic literature to be familiar with these issues and determine their relevance to the museum. If museum directors can determine which major issues facing museums today are likely to affect their museum in the long term, new directors are well positioned to identify the resources that are most pertinent to their museum and that also can be absorbed by boards and to ascertain how and when to deliver this information to boards.

This chapter explored *why* directors need to be able to discern how the major issues facing museums today can be expressed in their museum, *what* directors need to know about some of these issues, and *how* directors might address these issues with their boards. The specific issues identified in the vignette—mission drift, the impact of changing communities, and the role of museums as places of activism—are just three of the many major issues facing museums today.

The stakes are high in educating boards about issues before they become too difficult to manage easily. For the director in the vignette, the issues the museum must grapple with strike not only at what she hopes the museum will accomplish in the community but also at the very heart of her job. Fortunately, with appropriate resources and the knowledge that board members, to guide

their decision-making, need the right information shared with them at the right time, the director in the vignette is positioned to guide her museum through a discussion of why it exists, for whom it exists, and how it can best serve its community, especially such groups within its community, such as the disabled, who have long felt that museums do not exist for them.

12

Bringing It All Together

MUSEUM DIRECTORS AND BOARDS: A FINAL VIGNETTE

A museum, located in a city that is the cultural and economic hub of a region that, over the past thirty years, experienced a dramatic influx of people from around the world, revised its mission two years ago to emphasize the use of its large cultural collection of global art to explore humanity's interconnect-edness. The museum has just hired a highly skilled, enthusiastic, and hard-working new director, who comes to the position with experience, professional training, and an awareness of the major issues facing museums today. The new director is stepping into the place of a well-regarded former director. In a press release announcing the director's departure, the chair of the board described her as "a visionary and exceptional leader who partnered with the board from day one and helped us to understand how we could connect our activities to our region's diverse communities. . . . We congratulate our departing director as she leaves to take on the leadership of one of America's most important museums." The press release goes on to "welcome our new director, who comes to us with years of professional experience and knowledge as a division head in our city's outstanding public art museum, and who is poised to con-tinue to advance our mission and to deepen our relationship with the much-valued communities of our region."

The museum offers highly regarded educational programming, including a well-known summer day camp that explores the culture of the city's diverse communities and that is funded in part by a long-established and effective friends group. The museum also presents exhibits that are developed in con-sultation with advisory groups, one of which is composed of people from the disabled community, so that exhibits are designed accessibly from the outset, and another that is composed of representatives from diverse communities, to ensure that exhibits are reflective of the communities they represent. Exhibits tackle pressing issues ranging from the impact of climate change on the area to

the history of constructing interstate highways in the poorest neighborhoods in the city. The museum's staff is diverse, representative of the community, and growing, and, in the past year, the departing director and the board worked together to increase compensation levels for all entry- and mid-level employees. The museum's budget is stable; the museum has strong attendance, especially when it offers cultural festivals and events related to exhibits that feature diverse communities; and it is successful at raising funds from both board members and wealthy donors from across the region.

The museum's collections are well cared for and stewarded in a state-of-the-art facility. Staff support the cultural care practices of the communities associated with the objects through a comprehensive and regularly updated collections management policy, which also outlines how decisions are made to display culturally sensitive objects. The museum has a collections plan that supports deaccessioning, as well as a process for acquiring new objects that have been recommended by the museum's advisory groups. In an action that had the director and staff working closely with the board, the museum also recently repatriated several objects for the first time to a community in South America when it learned through staff outreach activities that the objects were sacred and were needed to revive some of the community's most important ceremonies. The repatriation was closely tracked by the media, the board chair spoke eloquently about it to the press, and the board decided that it would discuss updating relevant policy to reflect what had been learned during the process once the new director was in place.

The museum board is diverse and is representative of the region. The board has term limits in place for its members, regularly cycles members on and off the board, and is composed of members who work well together and deeply understand their responsibilities and duties. The board does not interfere in museum activities that are under the purview of the director and staff, including exhibition development, educational programing, and the management of support groups; regularly meets with the director and a rotating set of staff at board meetings to learn about museum operations and so staff can learn about board functions; participates in fundraising activities, such as special events and the solicitation of major donors; and is knowledgeable about its bylaws, the charges of its committees, and the need for group decision-making. The board also understands the nature of trusteeship; has been exposed to key museum standards and guidelines; is aware of the need to avoid conflicts of interest; consistently behaves ethically; is concerned with the public image of the museum; and values the trust the public places in the museum. Finally, the board has worked to ensure that the museum's collections have the necessary resources for their care; fully participates in and embraces strategic planning; and understands the need for continued education about the role of the board, including about the major issues facing museums today.

Although the new director sees work ahead, she is confident that, with her extensive training and work experience, she has the skills and knowledge to lead the museum to its next stage of development. Significantly, this confidence rests not only on her mastery of museum management principals and the expertise that she has acquired during her career but also on an assessment of the museum's board and governance structure. By reviewing core museum documentation, such as bylaws, plans, and policies, during the interview process, by evaluating public statements of the board chair, and by hearing about the reputation of the museum in the media, the new museum director was able to understand how the board viewed its responsibilities and how the partnership between the chair of the board and the former director had unfolded over time and to learn if the board intervened in the museum's day-to-day activities.

Consequently, instead of relying solely upon an assessment of how she would *manage* the museum, the new director was also able to consider what kind of relationship she would likely have with the board and to evaluate how the museum's *governing authorities* functioned. This allowed her to assess the board's role in the museum—which is something many aspiring directors are either unaware of or may minimize in terms of the challenges involved—and make an *informed* decision about whether to accept the position. Indeed, the new director's prior knowledge of how much time directors needed to devote to working with boards, what the role of the board is with respect to the director's job, and what the board's core responsibilities should consist of played a key role in the new director's ability to determine which areas of its work the board already understood and which areas needed strengthening.

At the same time, the board discovered during the interview process that the new director was the only applicant who sought to understand how the board interpreted the museum's governance structure, how the board perceived its responsibilities, and how the board's chair and committees planned to work with its next director. The board learned quickly that the new director understood how boards are supposed to operate, the crucial nature of the board chair–director partnership, the importance of board orientation and training efforts, and the board's role in policy development, fundraising, and strategic planning. Conversations about these areas told the board members that the new director was prepared to work with them and that, although some applicants had more management experience, the new director had skills that were indispensable in working with boards, skills that other candidates lacked or had not highlighted in their applications.

Finally, the new director noticed that several areas of the museum's management could be improved. She saw opportunities to expand the museum's successful day camps and cultural festivals as a source of earned income and to expand community interactions; believed that the museum could broaden its educational programming and partner with school districts by seeking

funding from local foundations; and perceived that the museum could do more to engage donors from diverse communities. The new director also saw how the museum's approach to cultural property and outreach to cultural communities for exhibitions and collections care might be enhanced and supported by the development of more-nuanced policies that formalized the role of communities in museum activities. When the new director was subsequently hired, she immediately began planning which of these areas might require input from staff, which would require additional board training, and which should take priority over other activities involving the board.

WHY UNDERSTANDING BOARDS IS IMPORTANT FOR NEW DIRECTORS

In the vignette above, the ability to assess the museum's governance structure and its board gave the new director information that was instrumental in deciding whether to accept the position. This information strongly suggested that the board and staff understood how the museum was organized and operated, that the infrastructure to build a trust-based and enduring partnership with the board chair was in place, and that, all told, the museum had good governance. Just as importantly, the new director's assessment also provided a road map for understanding how she would work with the board once she began to work in the position and what she could do to strengthen several areas of museum operations that involved the board.

The new director's understanding of how the board is structured and operates, how she will interact with the board, and what areas she will work on with the board will be essential to her success as a leader of the museum. Equally as important will be the new director's knowledge of who is on the board, how often and for what reasons she needs to meet with the board chair, and her ability to identify and navigate many of the common challenges that arise in working with boards.

As part of her career development, the new director learned about museum management and how to be a leader but also sought to obtain the skills and knowledge required to work with boards, which will now be instrumental to her work as a museum director. Unlike many aspiring directors today, who find it challenging to access relevant resources about working with boards, who are not exposed to important information about boards or governance, or who do not receive training in an organized manner about their interactions with boards, the new director is prepared for her position.

Significantly, after years of training and hard work, not all museum professionals have the luxury of declining a directorship when it is offered to them because they may have just relocated, a pathway to the directorship at their current museum is not available to them, or they may need a higher salary. New museum directors may therefore have accepted positions in museums

with less-than-ideal governance, with boards that are not engaged in exercising their oversight responsibilities, or with boards that do not support the museum in the many ways that are needed. Under such circumstances, there are three main reasons why new museum directors who can assess their museum's governance structure and who know how to interact with boards will have a distinct advantage over those who do not: first, they will have realistic expectations of the work ahead; second, they will have accepted positions with knowledge about the challenges ahead; and, third, they can use their skills and knowledge to help their museums move toward better governance.

CONCLUSIONS

In a time when museums are under more pressure than ever—financially, legally, and ethically—yet are some of the few remaining institutions that the public trusts, the stakes are high for a new director, who must understand how to interact with the museum's board in order to advance the mission of the museum as a place of collections stewardship, learning, and community. The museum sector's efforts to prepare new directors for this work have been insufficient.

The "burnout rate" for museum directors is "fairly high," and, with the average length of service for directors being less than four years, such turnover can result in considerable instability for museums (Genoways, Ireland, and Catlin-Legutko, 2017, 22). There are few studies of why museum directors leave their positions, but not being prepared for working with boards is surely a contributing factor—possibly the most important one. Therefore, to close the gap between what new museum directors *expect* they will do in their positions and what they will *actually* do, today's conscientious and engaged museum directors must understand how much of their time, effort, and interpersonal skills will be required to interact with boards. Rather than continuing the timeworn tradition of blaming boards for a lack of engagement or decrying a governance model that show no signs of changing, directors need to embrace all the tools available to them and recognize that knowledge about how they interact with boards is just as important as understanding museum administration, managing the finances of the museum, or deploying any of the numerous day-to-day management skills required to lead a museum today.

All directors hope that they will assume the directorship in a museum that already has good governance, but the troubling reality is that most do not. With so many people, from the staff and volunteers to visitors and community members, dependent on the acumen of a museum director, the museum director must have the knowledge and skills to make the most of his or her museum's governance structure and must take proactive steps to help the board function

better than it did when the new director arrived. Museum professionals need to recognize that boards truly do matter to their success and that, the more they understand about how they will interact with boards and the challenges that can arise in these interactions, the better off they, their museums, and their communities will be.

Bibliography

Abbe Museum. 2024. "Strategic Plan: What is Decolonization?" https://abbemuseum.wordpress.com/about-us/decolonization/

Ackerson, Anne W., and Joan H. Baldwin. 2019. *Leadership Matters: Leading Museums in an Age of Discord*. Lanham, MD: Rowman & Littlefield.

Akers, Torey. 2023. "California Museum Returns Nearly 1300 Pre-Columbian Artefacts to Mexico." *The Art Newspaper*, September 23, 2023.

Alexander, Brian. 2023. *Museum Finance: Issues, Challenges, and Successes*. Lanham, MD: Rowman & Littlefield.

Alexander Haas. 2024. "Home page." https://fundraisingcounsel.com/

Allison, David B. 2020. *Engaging Communities in Museums: Sharing Vision, Creation and Development*. London: Routledge/Taylor & Francis Group.

American Alliance of Museums. 2009. "A Code of Ethics for Curators." https://www.aam-us.org/wp-content/uploads/2018/01/curcomethics.pdf

American Alliance of Museums. 2012a. "Developing a Collections Management Policy." https://www.aam-us.org/wp-content/uploads/2018/01/developing-a-cmp-final.pdf

American Alliance of Museums. 2012b. "Standards for Museum Exhibitions and Indicators of Excellence." https://static1.squarespace.com/static/58fa260 a725e25c4f30020f3/t/58ff73ed3e00bea8e746d4ce/1493136367751 /2012+Standards+for+Museum++Exhibitions+and+Indicators+of +Excellence.pdf

American Alliance of Museums. 2017. "Museum Board Leadership 2017: A National Report." https://www.aam-us.org/wp-content/uploads/2018/01 /eyizzp-download-the-report.pdf

American Alliance of Museums. 2018a. "Facing Change." https://www.aam-us.org/wp-content/uploads/2018/04/AAM-DEAI-Working-Group-Full-Report-2018.pdf

American Alliance of Museums 2018b. "Developing a Strategic Institutional Plan." https://www.aam-us.org/wp-content/uploads/2017/12/Developing-a-Strategic-Institutional-Plan-2018.pdf

American Alliance of Museums. 2021a. "Museums and Trust 2021." https://www.aam-us.org/2021/09/30/museums-and-trust-2021/

American Alliance of Museums. 2021b. "Code of Ethics and Professional Practices for Collections Professionals." https://www.aam-us.org/wp -content/uploads/2021/03/Code_Ethics_Collections_Professionals_2021 _02_24.pdf

American Alliance of Museums. 2022a. "Remarks from Benin Bronzes Repatriation Ceremony." Posted November 18, 2022. https://www.aam -us.org/2022/11/18/remarks-from-benin-bronzes-repatriation-ceremony/

American Alliance of Museums. 2023a. "Diversifying Museum Boards." https://www.aam-us.org/2023/03/24/diversify-museum-boards/

American Alliance of Museums. 2023b. "TrendsWatch 2023b." https://www .aam-us.org/programs/center-for-the-future-of-museums/trendswatch/ ?gad_source=1&gclid=Cj0KCQjw2PSvBhDjARIsAKc2cgN3e_yqkcj0LtNfN v7KWxqAq6JX_w2wzf8CNze4dQHOwAw2Ot3EiNwaAhwJEALw_wcB

American Alliance of Museums. 2024a. "Directory of Museum Studies and Related Programs." http://ww2.aam-us.org/resources/careers/museum -studies-programs

American Alliance of Museums. 2024b. "Code of Ethics." https://www .aam-us.org/programs/ethics-standards-and-professional-practices/code -of-ethics-for-museums/?gclid=CjwKCAjw69moBhBgEiwAUFCx2BIrv3C hevLpO8UMvRHX3n5vyf5-qVbV9ga2jGirtHxF-Vi5FGF2hBoCHZoQAvD _BwE

American Alliance of Museums. 2024c. "Ethics, Standards, and Accountability: Institutional Code of Ethics." https://www.aam-us.org/programs/ethics -standards-and-professional-practices/institutional-code-of-ethics/

American Alliance of Museums. 2024d. "Governance and Leadership." https:// www.aam-us.org/topic/governance-and-leadership/#all-resources

American Alliance of Museums. 2024e. "Starting a Museum." http://ww2. aam-us.org/docs/default-source/about-museums/starting-a-museum- final.pdf?sfvrsn=6

American Alliance of Museums. 2024f. "Accreditation and Excellence in DEAI." https://www.aam-us.org/programs/accreditation-excellence-programs/ accreditation-and-excellence-in-deai/

American Alliance of Museums. AAM 2024g. "Board Recruitment." https:// www.aam-us.org/programs/resource-library/governance-and-support -organizations-resources/board-recruitment/

American Alliance of Museums. AAM 2024h. "Board Orientation and Training." https://www.aam-us.org/programs/resource-library/governance-and- support-organizations-resources/board-orientation-and-training/

American Alliance of Museums. 2024i. "Leadership and Organizational Structure Standards." https://www.aam-us.org/programs/ethics-standards-and- professional-practices/leadership-and-organizational-structure-standards/

American Alliance of Museums. 2024j. "Board Meetings and Retreats." https://www.aam-us.org/programs/resource-library/governance-and -support-organizations-resources/board-meetings-and-retreats/

American Alliance of Museums. 2024k. "Ethics, Standards, and Professional Practice: Collections Management Policy." https://www .aam-us.org/programs/ethics-standards-and-professional-practices /collections-management-policy/?gclid=CjwKCAiApuCrBhAuEiw A8VJ6Jqoed-7NS60K9WF1e_fQ4Fs12-Ph5OsL4hzPQFQ9V-gUA -Ht1Pi5ZxoCLGEQAvD_BwE%20s:

American Alliance of Museums. 2024l. "Ethics, Standards, and Professional Practice: Collections Stewardship Standards." https://www.aam-us.org /programs/ethics-standards-and-professional-practices/collections -stewardship-standards/?gclid=CjwKCAiA-bmsBhAGEiwAoaQNmlST 255zdbflP6bD0C-ACgUjKoHnZAYi_NwneXKcZF7KwKLzgCxsvhoC C3UQAvD_BwE

American Alliance of Museums. 2024m. "Collections Stewardship Resources: Cultural Property." https://www.aam-us.org/programs/resource-library/ collections-stewardship-resources/cultural-property/

American Alliance of Museums. 2024n. "Ethics, Standards, and Professional Practices: Education and Interpretation Standards." https://www.aam -us.org/programs/ethics-standards-and-professional-practices/education -and-interpretation/

American Alliance of Museums. 2024o. "Development and Fundraising." https://www.aam-us.org/category/development-and-fundraising/?gad _source=1&gclid=CjwKCAiArfauBhApEiwAeoB7qDRJHRXRwzj5uOlcW4 -3DKWVVZrTnlpbdzGFwOEdPyMFW4igSvDi0RoCjW0QAvD_BwE

American Alliance of Museums. 2024p. "Developing and Managing Business and Individual Donor Support." https://www.aam-us.org/programs/ ethics-standards-and-professional-practices/developing-and-managing -business-and-individual-donor-support/

American Alliance of Museums. 2024q. "Accreditation." https://www.aam-us .org/programs/accreditation-excellence-programs/accreditation/

American Alliance of Museums. 2024r. "Core Documents." https://www .aam-us.org/programs/ethics-standards-and-professional-practices/core -documents/?gad_source=1&gclid=CjwKCAjw48-vBhBbEiwAzqrZVH Nd4POK-OJflu2mpYXKQQrKtl9Zk173AtJiVCx8ZdAdKk2fTpVopRoC 3OMQAvD_BwE

American Alliance of Museums. 2024s. "Mission and Planning Standards. Professional Practices: Institutional Planning." https://www.aam-us.org/ programs/ethics-standards-and-professional-practices/mission-and- planning-standards/

American Alliance of Museums. 2024t. "Strategic Institutional Plan." https://www.aam-us.org/programs/ethics-standards-and-professional-practices/strategic-institutional-plan/

American Alliance of Museums. 2024u. "Ethics, Standards, and Professional Practices: Mission Statement." https://www.aam-us.org/programs/ethics-standards-and-professional-practices/mission-statement/#:~:text=The%20American%20Alliance%20of%20Museums'%20mission%20is%20to%20champion%20equitable,community%2C%20and%20nurturing%20museum%20excellence

American Alliance of Museums. 2024v. "Public Trust and Accountability Standards." https://www.aam-us.org/programs/ethics-standards-and-professional-practices/public-trust-and-accountability-standards/

American Alliance of Museums. 2024w. "Core Standards for Mission and Planning." https://www.aam-us.org/programs/ethics-standards-and-professional-practices/mission-and-planning-standards/

American Alliance of Museums. 2024x. "Diversity, Equity, Accessibility, and Inclusion." https://www.aam-us.org/category/diversity-equity-inclusion-accessibility/

American Alliance of Museums. 2024y. "Community Engagement." https://www.aam-us.org/topic/community-engagement/

American Alliance of Museums. 2024z. "Museums Foster Belonging Resources." https://www.aam-us.org/programs/museums-fostering-belonging/fostering-belonging-resources/

American Association of Art Museum Directors. 2007a. "Managing the Relationship between Art Museums and Corporate Sponsors." https://aamd.org/sites/default/files/document/Corporate%20Sponsors_clean%2006-2007.pdf

American Association of Art Museum Directors. 2007b. "Art Museums, Private Collectors, and the Public Benefit." https://aamd.org/sites/default/files/document/PrivateCollectors3.pdf

American Association of Art Museum Directors. 2011. "Professional Practice in Art Museums." https://aamd.org/sites/default/files/document/Professional%20Practices%202011%20rev%202.2.23_0.pdf

American Association of Art Museum Directors. 2022. "Professional Practice in Art Museums." https://aamd.org/sites/default/files/document/Professional%20Practices%202011%20rev%202.2.23.pdf

American Association of State and Local History. 2017. "Statement of Professional Standards and Ethics." https://d221a1e908576484595f-1f424f9e28cc684c8a6264aa2ad33a9d.ssl.cf2.rackcdn.com/aaslh_f3b127c7bc6e406a8ae1829095a08c49.pdf

American Association of State and Local History. 2018. "Statement of Standards and Ethics." http://download.aaslh.org/AASLH+Statement+of+Standards+and+Ethics+-+Revised+2018.pdf

American Association of State and Local History. 2020. "Valuing History Collections." http://download.aaslh.org/AASLH+Valuing+History+Collections+Position+Paper+May+2020.pdf

American Association of State and Local History. 2024. "Deaccessioning and Capitalization of Collections." https://aaslh.org/deaccessioning-capitalization-collections/

American Historical Association. 2017. "Standards for Museum Exhibits Dealing with Historical Subjects." https://www.historians.org/jobs-and-professional-development/statements-standards-and-guidelines-of-the-discipline/standards-for-museum-exhibits-dealing-with-historical-subjects

American Institute for Conservation. 2024. "For Collections Care Professionals." https://learning.culturalheritage.org/collections-care

American Museum of Natural History. 2023. "Human Remains Stewardship." https://www.amnh.org/about/human-remains-stewardship

American University Museum. 2018. "American University Museum Exhibition and Program Policy." https://www.american.edu/policies/upload/museum-exhibition-and-program-policy.pdf

Americans for the Arts. 2024. "ArtsU." https://artsu.americansforthearts.org/read

Ames, Michael M. 1999. "How to Decorate a House: The Re-Negotiation of Cultural Representations at the University of British Columbia Museum of Anthropology." *Museum Anthropology* 22 (3): 41–51.

Anderson, Gail. 1998. *Museum Mission Statements: Building a Distinct Identity*. Washington, DC: American Association of Museums.

Anderson, Gail. 2012. *Reinventing the Museum: The Evolving Conversation on the Paradigm Shift*, 2nd edition. Lanham, MD: AltaMira Press.

Anderson, Gail. 2019. *Mission Matters: Relevance and Museums in the 21st Century*. Lanham, MD: Rowman & Littlefield.

Anderson, Jane L., and Haidy Geismar. 2017. *The Routledge Companion to Cultural Property*. London: Routledge.

Andy Warhol Museum. 2024. "Our Advisory Board." https://www.warhol.org/museum/the-warhol-board/

Annual Disability Statistics Compendium. 2023. "Annual Disability Statistics Compendium for 2023." https://disabilitycompendium.org/compendium/2023-annual-disability-statistics-compendium?page=11

Antiquities Coalition. 2024. https://theantiquitiescoalition.org/

Arizona Historical Society. 2021. "Code of Ethics." https://arizonahistoricalsociety.org/wp-content/uploads/2021/03/OPR21-002-AHS-Code-of-Ethics_fillable-1.pdf

Art Beyond Sight. 2024a. "Developing an Advisory Board: Practical Considerations." https://www.artbeyondsight.org/handbook/advisory-prac1.shtml

Art Beyond Sight. 2024b. "Museum Education Institute." https://www.artbeyondsight.org/mei/

Asian Art Museum. 2011. "Ethical Stewardship and Collections Management Policy." https://about.asianart.org/wp-content/uploads/sites/2/2020/09/Collections-Management-Policy.pdf

Asian Art Museum. 2024. "Governance Boards." https://about.asianart.org/about-the-asian-art-museum/governance/governance-boards/?gad_source=1&gclid=CjwKCAiA9dGqBhAqEiwAmRpTC0y7yVA3znITsoj3HQnqo_Lvq9UnD7pz_ginTkHezlqRUYlvQYQWLRoCDEYQAvD_BwE

Association of Academic Museums and Galleries. 2014. "Jule Collins Smith Museum of Fine Art at Auburn University Advisory Board Handbook." https://www.aamg-us.org/wp/wp-content/uploads/2015/01/AUBURN_ADVISORY.pdf

Association of Academic Museums and Galleries. 2017. "Professional Practices for Academic Museums and Galleries." https://www.aamg-us.org/best-practices/

Association of Art Museum Curators. 2019. "Professional Practices for Art Curators in Nonprofits." https://www.artcurators.org/page/ProfPractices

Association of Art Museum Directors. 2011. "Professional Practices for Art Museum Curators." https://aamd.org/sites/default/files/document/Professional%20Practices%202011%20rev%202.2.23.pdf

Association of Art Museum Directors. 2013. "Guidelines on the Acquisition of Archaeological Material and Ancient Art." https://aamd.org/sites/default/files/document/AAMD%20Guidelines%202013.pdf

Association of Art Museum Directors. 2022. "Guidance on Art from Colonized Areas." https://aamd.org/sites/default/files/document/AAMD%20Guidance%20on%20Art%20from%20Colonized%20Areas%20%281%29.pdf

Association of Children's Museums. 2012. "Standards for Professional Practice in Children's Museums." https://childrensmuseums.org/wp-content/uploads/2022/01/StandardsforProfessionalPracticeinChildrensMuseums.pdf

Association of Fundraising Professionals. 2016. "Frequently Asked Questions (FAQs) About Fundraising Ethics." https://afpglobal.org/ethicsmain/frequently-asked-questions-faqs-about-fundraising-ethics

Association of Fundraising Professionals. 2024a. "Resource Guides." https://afpglobal.org/resource-guides

Association of Fundraising Professionals. 2024b. "Professional Development." https://afpglobal.org/professional-development

Association of Fundraising Professionals. 2024c. "Donor Bill of Rights." https://afpglobal.org/donor-bill-rights

Association of Fundraising Professionals. 2024d. "Code of Ethical Standards." https://afpglobal.org/ethicsmain/code-ethical-standards?gad_source=1

&gclid=CjwKCAiAloavBhBOEiwAbtAJO08Epu9I9_Xnx_mZXgpFtPUan
WdTX2wXsYrGHtGBuChBOC67ELwKIRoCVCIQAvD_BwE

Association of Registrars and Collections Specialists. 2016. "Code of Ethics."
https://www.arcsinfo.org/about/code-of-ethics#:~:text=It%20generally
%20includes%20standards%20for,that%20the%20registrar%20and
%20collections

Association of Science and Technology Centers. 2024. "Accessibility Toolkit
for Digital Engagement, Accessibility 101: Basics for Science Centers and
Museums." https://www.astc.org/digital-accessibility-toolkit/accessibility
-101-basics-for-science-centers-and-museums/

Aton, Francesca. 2023. "The Carnegie Museum of Natural History in
Pittsburgh Changes Display Policy on Human Remains." *ARTnews*,
October 5, 2023.

Autry, La Tanya. 2017. "Museums Are Not Neutral." https://artstuffmatters
.wordpress.com/museums-are-not-neutral/

Autry, LaTanya S., and Mike Murawski. 2018. "Museopunks Episode 27:
#MuseumsAreNotNeutral." American Alliance of Museums. https://
www.aam-us.org/2018/06/28/museopunks-episode-27-museumsaren
otneutral/

Autry, LaTanya S., and Mike Murawski. 2019. "Museums Are Not Neutral: We
Are Stronger Together." *Panorama: Journal of the Association of Historians of
American Art* 5, no. 2. https://doi.org/10.24926/24716839.2277

Axelrod, Nancy R. 1998. *The Advisory Committee.* Washington, DC: National
Center for Nonprofit Boards.

Axelrod, Nancy R. 2004. *Advisory Councils: Book Five of the BoardSource
Committee Series.* Washington, DC: BoardSource.

Bandelli, Andrea, Elly A. Konijn, and Jaap W. Willems. 2009. "The Need
for Public Participation in the Governance of Science Centers." *Museum
Management and Curatorship* 24 (2): 89–104.

Banks, Patricia Ann. 2019. *Diversity and Philanthropy at African American
Museums: Black Renaissance.* Abingdon, Oxon, UK: Routledge.

Barry, Dan, and Carol Vogel. 1999. "Giuliani Vows To Cut Subsidy Over 'Sick'
Art." *New York Times*, September 23, 1999.

Beaulieu, Rebekah. 2022. *Endowment Essentials for Museums.* Lanham, MD:
Rowman & Littlefield.

Bench, Raney. 2014. *Interpreting Native American History and Culture at Museums
and Historic Sites.* Lanham, MD: Rowman & Littlefield.

Bennett, Tony. 2007. *The Birth of the Museum: History Theory Politics.* London:
Routledge.

Benzine, Vittoria. 2022. "The Orlando Museum of Art has Created a 'Task
Force' to Help Recover Trust After the FBI's Raid of a Contested Basquiat
Show." *Artnet*, August 23, 2022.

Bergeron, Anne, and Eugene R. Tempel. 2022. "A Commitment to Ethical Fundraising." In *Achieving Excellence in Fundraising*, edited by Genevieve G. Shaker, Eugene R. Tempel, Sarah K. Nathan, and Bill Stanczykiewic, 13–22. Hoboken, NJ: John Wiley & Sons.

Berlinger, Gabrielle A. 2018. "Balancing Memory and Material at the Lower East Side Tenement Museum." *Museum Anthropology Review* 12 (1): 15–29.

Better Business Bureau. 2024. "BBB Standards for Charity Accountability." https://give.org/donor-landing-page/bbb-standards-for-charity-accountability

Bhattacharya, C. B. 1998. "When Customers Are Members: Customer Retention in Paid Membership Contexts." *Journal of the Academy of Marketing Science* 26 (1): 31–44.

Bieber, Mike. 2002. "Governing Independent Museums." In *The Governance of Public and Non-Profit Organizations: What Do Boards Do?* edited by Chris Cornforth, 164–84. London: Taylor & Francis Group.

Biraglia, Alessandro, and Maximillian HEE Gerrath. 2021. "Corporate Sponsorship for Museums in Times of Crisis." *Annals of Tourism Research* (May) 88: 103056.

Blackbaud Institute. 2022. "The State of the Arts and Culture Subsector." https://institute.blackbaud.com/the-state-of-the-arts-and-culture-subsector/

BoardSource. 2005. *The Source: Twelve Principles of Governance That Power Exceptional Boards*. Washington, DC: BoardSource.

BoardSource. 2011. *Strategic Planning: Understanding the Process*. Washington, DC: BoardSource.

BoardSource. 2012. *The Nonprofit Board Answer Book: A Practical Guide for Board Members and Chief Executives*. San Francisco: Jossey-Bass.

BoardSource. 2015. "Leading with Intent: A National Index of Nonprofit Board Practices." https://leadingwithintent.org/wp-content/uploads/2017/09/LWI2015-Report.pdf?hsCtaTracking=bb3fa3b0-26f5-42d8-b6a5-d938c064193a%7C45248f56-2de0-4c54-a5ca-684e9bb95b91

BoardSource. 2016. "Recommended Governance Practices." https://boardsource.org/wp-content/uploads/2016/10/Recommended-Gov-Practices.pdf?hsCtaTracking=0b9b1f34-4dc4-49b5-bdc2-9a4a6560454b%7Ca3aa7356-5ee3-4ada-bf05-e37ebebf1cae%20BoardSource%20.2023x

BoardSource. 2017. "Leading with Intent: A National Index of Nonprofit Board Practices" Washington, DC: BoardSource. https://leadingwithintent.org/previous-reports/?utm_referrer=https%3A%2F%2Fleadingwithintent.org%2F

BoardSource. 2021. "Leading with Intent: A National Index of Nonprofit Board Practices." Washington, DC: BoardSource. https://leadingwithintent.org/

previous-reports/?utm_referrer=https%3A%2F%2Fleadingwithintent.org%2F

BoardSource. 2024a. https://boardsource.org/

BoardSource. 2024b. "The Guide to Board Member Roles and Responsibilities." https://boardsource.org/fundamental-topics-of-nonprofit-board-service/roles-responsibilities/

BoardSource. 2024c. "Board Composition and Recruitment." https://boardsource.org/fundamental-topics-of-nonprofit-board-service/composition-recruitment/

BoardSource. 2024d. "Strategic Board Composition Matrix." https://boardsource.org/board-recruitment-matrix/

BoardSource. 2024e. "Board Orientation." https://boardsource.org/resources/board-orientation/

BoardSource. 2024f. "Nonprofit Board Education and Orientation." https://boardsource.org/fundamental-topics-of-nonprofit-board-service/nonprofit-education/

BoardSource. 2024g. "Structuring Board Committees." https://boardsource.org/resources/structuring-board-committees/

BoardSource. 2024h. "Board Meetings: FAQs." https://boardsource.org/resources/board-meetings-faqs/

BoardSource. 2024i. "Board Meetings: Virtual Meetings." https://boardsource.org/board-meeting/virtual-meetings/

BoardSource. 2024j. "Fundraising for Nonprofits." https://boardsource.org/fundamental-topics-of-nonprofit-board-service/fundraising/

Bogle, Elizabeth. 2013. *Museum Exhibition Planning and Design*. Lanham, MD: AltaMira Press.

Bowley, Graham. 2022. "For U.S. Museums With Looted Art, the Indiana Jones Era Is Over." *New York Times*, December 13, 2022.

Bowley, Graham, and Tom Mashberg. 2023. "At the Met, She Holds Court. At Home, She Held 71 Looted Antiquities." *New York Times*, July 17, 2023.

Boylan, Patrick C. 2006. "Current Trends in Governance and Management of Museums in Europe." In *Museum Philosophy for the Twenty-First Century*, edited by Hugh H. Genoways, 201–19. Lanham, MD: AltaMira Press.

Breeze, Beth, Donna Day Lafferty, and Pamala Wiepking. 2023. *The Fundraising Reader*. Abingdon, Oxon, UK: Routledge.

Brown, Alison K., and Laura Peers. 2003. *Museums and Source Communities: A Routledge Reader*. London: Taylor & Francis Group.

Brown, Anne, Melissa Callahan, Trisha Shively, Patty Stringfellow, and Jennifer Walter. 2001. "Friends of the Indiana Public Library, Indiana Origins and Outlook." *Indiana Libraries* 20 (1): 21–25.

Brown, M. Gasby. 2022. "Engaging the Board for Fundraising." In *Achieving Excellence in Fundraising*, edited by Genevieve G. Shaker, Eugene R. Tempel,

Sarah K. Nathan, and Bill Stanczykiewic, 229–42. Hoboken, NJ: John Wiley & Sons.

Brownlee, David, and Eric Nelson. 2020. "COVID-19 Sector Benchmark: Insight Report October 2020." *TRG Arts and Purple Seven.* https://trgarts.com/blog/insights-report-oct-2020.html

Brueggemann, Kate, and Donna McGinnis. 2024. *Fundraising Management in a Changing Museum World.* Abingdon, Oxon, UK: Routledge.

Bryson, John M. 2016. "Strategic Planning and the Strategy Change Cycle." In *The Jossey-Bass Handbook of Nonprofit Leadership and Management*, edited by David O. Renz, 240–73. John Wiley & Sons.

Bryson, John M. 2018. *Strategic Planning for Public and Nonprofit Organizations: A Guide to Strengthening and Sustaining Organizational Achievement.* Hoboken, NJ: John Wiley & Sons.

Bryson, John M., and Alston K. Farnum. 2011. *Creating Your Strategic Plan: A Workbook for Public and Nonprofit Organizations.* San Francisco, CA: Jossey-Bass.

Buck, Rebecca A., and Jean Allman Gilmore. 2007. *Collection Conundrums: Solving Collections Management Mysteries.* Washington, DC: American Association of Museums.

Buggein, Gretchen Townsend, and Barbara Franco. 2018. *Interpreting Religion at Museums and Historic Sites.* Lanham, MD: Rowman & Littlefield.

Burlingame, Dwight F., and Bill Stanczykiewic. 2022. "Business Sector Fundraising." In *Achieving Excellence in Fundraising*, edited by Genevieve G. Shaker, Eugene R. Tempel, Sarah K. Nathan, and Bill Stanczykiewic, 453–64. Hoboken, NJ: John Wiley & Sons.

Butts, David J. 2002. "Maori and Museums: The Politics of Indigenous Recognition." In *Museums, Society, Inequality*, edited by Richard Sandell, 225–43. Abingdon, Oxon, UK: Taylor & Francis Group.

California Secretary of State. 2024. "California Business Search." https://bizfileonline.sos.ca.gov/search/business

Cameron, Duncan F. 1971. "The Museum: The Temple or the Forum." *Curator: The Museum Journal* 14 (1): 11–24.

Carver, John. 2002. *John Carver on Board Leadership: Selected Writings from the Creator of the World's Most Provocative and Systematic Governance Model.* San Francisco: Jossey-Bass and Wiley.

Catlin-Legutko, Cinnamon. 2008. *DIY Strategic Planning for Small Museums.* American Association for State and Local History, Technical Leaflet #242. Nashville, TN: American Association for State and Local History.

Catlin-Legutko, Cinnamon. 2013a. "Fearless Fundraising: A Road Map for Kick-Starting Your Development Program." In *Financial Resource Development and Management, Small Museum Toolkit, Volume 2*, edited by Cinnamon Catlin-Legutko and Stacy Klingler. Lanham, MD: AltaMira Press.

Catlin-Legutko, Cinnamon. 2013b. "DIY Strategic Planning." In *Leadership, Mission, and Governance, Small Museum Toolkit, Volume 1*, edited by Cinnamon Catlin-Legutko and Stacy Klingler, 77–93. Lanham, MD: AltaMira Press.

Catlin-Legutko, Cinnamon, Chris James Taylor, and American Alliance of Museums. 2021. *The Inclusive Museum Leader*. Lanham, MD: Rowman & Littlefield.

Caulton, Tim. 1998. *Hands-On Exhibitions: Managing Interactive Museums and Science Centres*. London: Taylor & Francis Group.

Center for the Future of Museums. 2020. *Trends Watch 2020: The Future of Financial Sustainability*. Washington, DC: American Alliance of Museums.

Centers for Disease Control. 2023. "Disability Impacts All of Us." https://www.cdc.gov/ncbddd/disabilityandhealth/infographic-disability-impacts-all.html

Chapman, C. M., M. J. Hornsey, N. Gillespie, and S. Lockey. 2023. "Nonprofit Scandals: A Systematic Review and Conceptual Framework." *Nonprofit and Voluntary Sector Quarterly* 52 (1_suppl), 278S-312S.

Chari, Sangita, and Jamie M. N. Lavallee. 2013. *Accomplishing NAGPRA: Perspectives on the Intent Impact and Future of the Native American Graves Protection and Repatriation Act*. Corvallis: Oregon State University Press.

Charity Navigator. 2024a. "How We Rate Charities." https://www.charitynavigator.org/about-us/our-methodology/ratings/#accordion-0f1da9ef58-item-57920c7dce

Charity Navigator. 2024b. "Search for 'Museums,' '501 (c)(3) organizations' and 'no ratings and above.'" https://www.charitynavigator.org/search?causes=Museums&c3=true&sort=rating

Chicone, Sarah J., and Richard A. Kissel. 2013. *Dinosaurs and Dioramas: Creating Natural History Exhibitions*. Walnut Creek, CA: Taylor & Francis Group.

Chronicle of Philanthropy. 2024a. "Home page." https://www.philanthropy.com/?sra=true

Chronicle of Philanthropy. 2024b. "Webinars." https://www.philanthropy.com/webinars

Chu, Jane. 2022. "Preparing the Organization for Fundraising." In *Achieving Excellence in Fundraising*, edited by Genevieve G. Shaker, Eugene R. Tempel, Sarah K. Nathan, and Bill Stanczykiewic, 115–26. Hoboken, NJ: John Wiley & Sons.

Ciaccheri, Maria Chiara. 2022. *Museum Accessibility by Design: A Systemic Approach to Organizational Change*. Lanham, MD: Rowman & Littlefield.

Cilella, Salvatore G. 2011. *Fundraising for Small Museums: In Good Times and Bad*. Lanham, MD: AltaMira Press.

Claims Conference. 2024. "World Jewish Restitution Organization Art and Cultural Property Initiative." https://art.claimscon.org/

Clarke, Julia. 2013. "Do We Really Want That Bust of Jesus, and What Should We Do with the Pump Organ in the Other Room? Or, Why You Want

A Good Collections Management Policy." In *Stewardship: Collections and Historic Preservation: Collections and Historic Preservation, Small Museum Toolkit, Volume 6*, edited by Cinnamon Catlin-Legutko and Stacy Klingler, 86–107. Lanham, MD: AltaMira Press.

Collections: A Journal for Museum and Archives Professionals. 2024. https://journals.sagepub.com/home/cjx

College Art Association. 2016. "Standards and Guidelines, CAA Guidelines: Statement Concerning the Acquisition of Cultural Properties Originating from Abroad, from Indigenous Cultures, and from Private Collections During the Nazi Era." https://www.collegeart.org/standards-and-guidelines/guidelines/cultural-properties

Conley, Anne. 2022. "Campaign Essentials." In *Achieving Excellence in Fundraising*, edited by Genevieve G. Shaker, Eugene R. Tempel, Sarah K. Nathan, and Bill Stanczykiewic, 404–18. Hoboken, NJ: John Wiley & Sons.

Connecting to Collections. 2024a. "Conservation Center for Art & Historic Artifacts Collections Management Policy Toolkit." https://connectingtocollections.org/ccaha_cmpt_toolkit/

Connecting to Collections. 2024b. "Resources." https://connectingtocollections.org/resources/

Cooks, Bridget R. 2011. *Exhibiting Blackness: African Americans and the American Art Museum*. Amherst, MA: University of Massachusetts Press.

Corning Museum of Glass. 2024. "Leadership Team, Board of Trustees, and Fellows." https://info.cmog.org/trustees-fellows

Counts, Alex. 2020. "Spotting and Fixing Dysfunctional Nonprofit Boards." *Stanford Social Innovation Review*. https://doi.org/10.48558/Z03W-8089.

Crooke, Elizabeth M. 2008. *Museums and Community: Ideas, Issues, and Challenges*. London: Routledge.

Cuno, James B. 2008. *Who Owns Antiquity? Museums and the Battle Over Our Ancient Heritage*. Princeton, NJ: Princeton University Press.

Cuno, James B. 2012. *Whose Culture: The Promise of Museums and the Debate over Antiquities*. Princeton, NJ: Princeton University Press.

Curator: The Museum Journal. 2024. https://onlinelibrary.wiley.com/journal/21516952

DaFoe, Taylor. 2022. "A University Museum Has Come Under Fire for Displaying the 'Terrible' Art of a Self-Help Author and Major Donor." *Artnet*, June 14, 2022.

DeAngelis, Ildiko Pogány. 2002. "Museums and the Nonprofit Sector." In *Foundations of Museum Governance for Private, Non-profit Museums*, edited by Roxana Adams. Washington, DC: American Association of Museums.

Dean, David. 1994. *Museum Exhibition: Theory and Practice*. London: Routledge.

Decker, Juilee. 2015. *Fundraising and Strategic Planning: Innovative Approaches for Museums*. Lanham, MD: Rowman & Littlefield.

Decter, Avi Y. 2016. *Interpreting American Jewish History at Museums and Historic Sites*. Lanham, MD: Rowman & Littlefield.

Denver Museum of Nature and Science. 2023. "Collections Management Policy." https://www.dmns.org/media/3538/collections-management -policy_2023_20230111.pdf

Denver Museum of Nature and Science. 2024. "North American Indian Cultures (Closed): Important Hall Update." https://www.dmns.org/visit/ exhibitions/north-american-indian-cultures/

Department of the Interior. 2023. "Press Release: Interior Department Announces Final Rule for Implementation of the Native American Graves Protection and Repatriation Act. December 6, 2023." https://www.doi.gov /pressreleases/interior-department-announces-final-rule-implementation -native-american-graves

Dernie, David. 2006. *Exhibition Design*. New York: W.W. Norton.

Diamond, Judy, Jessica J. Luke, and David H. Uttal. 2009. *Practical Evaluation Guide: Tool for Museums and Other Informal Educational Settings*. Lanham, MD: AltaMira Press.

Dickenson, Victoria. 1991. "An Inquiry into the Relationship Between Museum Boards and Management." *Curator* 34 (4): 291–303

Dillenburg, Eugene, and Janice Klein. 2013. "Creating Exhibits: From Planning to Building." In *Interpretation: Education, Programs, and Exhibits*, edited by Cinnamon Catlin-Legutko and Stacy Klingler, 72–99. Lanham, MD: AltaMira Press.

Dubin, Steven C. 1999. *Displays of Power: Controversy in the American Museum from the Enola Gay to Sensation*. New York and London: New York University Press.

Duncan, Carol. 1995. *Civilizing Rituals: Inside Public Art Museums*. London: Routledge.

Emberling, Geoff., and Lucas P. Petit. 2018. *Museums and the Ancient Middle East: Curatorial Practice and Audiences*. London: Routledge.

Encyclopedia of Alabama. 2024. "Jule Collins Smith Museum of Fine Art." https://encyclopediaofalabama.org/article/jule-collins-smith-museum-of -fine-art/

Exhibition. 2024. https://www.aam-us.org/programs/exhibition-journal/

Feldman, Ella. 2022. "Was That Painting Stolen by the Nazis? New York Museums Are Now Required to Tell You." *Smithsonian Magazine*, August 16, 2022.

Farrell, Betty, and Maria Medvedeva. 2010. *Demographic Transformation and the Future of Museums*. Washington, DC: American Association of Museums.

Ferentinos, Susan. 2015. *Interpreting LGBT History at Museums and Historic Sites*. Lanham, MD: Rowman & Littlefield.

Fforde, Cressida, C. Timothy McKeown, and Honor Keeler. 2020. *The Routledge Companion to Indigenous Repatriation: Return Reconcile Renew.* Abingdon, Oxon, UK: Routledge.

Field Museum. 2024. "About Us: Board of Trustees." https://www.fieldmuseum .org/board-of-trustees

Fine Arts Museums of San Francisco. 2024. "Board of Trustees." https://sf.gov /departments/fine-arts-museums-board-trustees

Fiorillo, Victor. 2018. "Is Another Scandal Brewing at the Seaport Museum?" *Philadelphia Magazine*, October 5, 2018.

Fitz Gibbon, Kate. 2004. *Who Owns the Past? Cultural Policy, Cultural Property, and the Law.* New Brunswick, NJ: Rutgers University Press.

Flavelle, Christopher. 2021. "Saving History With Sandbags: Climate Change Threatens the Smithsonian." *New York Times*, November 25, 2021.

Fleming, David. 2016. "Do Museums Change Lives? Ninth Stephen Weil Memorial Lecture." *Curator: The Museum Journal* 59 (2): 73–79.

Fleming, David. 2019. "Missions and the 21st Century Museum—A Perspective." In *Mission Matters: Relevance and Museums in the 21st Century*, edited by Gail Anderson. Lanham, MD: Rowman & Littlefield.

Florida Natural History Museum. 2022. "About Us: Code of Ethics." https:// www.floridamuseum.ufl.edu/about/ethics/

Florino, Joanne. 2023. "Donor Intent Watch: A Dispute at the Berkshire Museum Offers Lessons on Donor Intent." Philanthropy Roundtable. https://www.philanthropyroundtable.org/donor-intent-watch-a-dispute -at-the-berkshire-museum-offers-lessons-on-donor-intent/

Flynn, Outi. 2009. *Meeting and Exceeding Expectations: A Guide to Successful Nonprofit Board Meetings.* 2nd ed. Washington, DC: BoardSource.

Forbes. 2023. "America's Top 100 Charities." https://www.forbes.com/lists/ top-charities/?sh=aaa6ebc5f501

Foundation for Advancement in Conservation. 2024. "About Us: Heritage Preservation Programs" https://www.culturalheritage.org/about-us/ foundation/programs/heritage-preservation

Frank, John. 2022. "Denver Art Museum Reckons with Past Ties to Illegal Art Dealers." *Axios*, December 20, 2022.

Gallas, Kris, and James DeWolf Perry. 2015. *Interpreting Slavery at Museums and Historic Sites.* Lanham, MD: Rowman & Littlefield.

Gamarekian, Barbara. 1989. "Corcoran, to Foil Dispute, Drops Mapplethorpe Show." *New York Times*, June 14, 1989.

Gardner, James B., and Elizabeth E. Merritt. 2004. *The AAM Guide to Collections Planning.* Washington, DC: American Association of Museums.

Gardyn, Rebecca. 2006. "How Can I Gain Access to a Charity's Bylaws?" *Chronicle of Philanthropy*, August 17, 2006.

Garthe, Christopher J. 2022. *The Sustainable Museum: How Museums Contribute to the Great Transformation.* London: Routledge.

Genesee Country Museum. 2015. "Collections Management Policy." https:// www.gcv.org/wp-content/uploads/2022/07/COLLECTIONS_POLICY _Amended_March_2015.pdf

Genesee Country Village and Museum. 2024. https://www.gcv.org/

Genoways, Hugh H., Lynne M. Ireland, and Cinnamon Catlin-Legutko. 2017. *Museum Administration 2.0.* Lanham, MD: Rowman & Littlefield.

Gerstenblith, Patty. 2006. "Museum Practice: Legal Issues." *A Companion to Museum Studies,* edited by Sharon Macdonald, 442-56. Malden, MA: Blackwell Publishing.

Gerstenblith, Patty. 2019. *Art Cultural Heritage and the Law: Cases and Materials.* Durham, NC: Carolina Academic Press.

Giving USA. 2023. *Giving USA 2023: The Annual Report on Philanthropy for the Year 2022.* Giving USA Foundation, Indiana University Lilly Family School of Philanthropy.

Giving USA. 2024. https://givingusa.org/

Goff, Sheila, Betsy Chapoose, Elizabeth Cook, and Shannon Voirol. 2019. "Collaborating Beyond Collections: Engaging Tribes in Museum Exhibits." *Advances in Archaeological Practice: A Journal of the Society of American Archaeology* 7 (3): 224-33.

Golding, Vivien, and Wayne Modest. 2013. *Museums and Communities: Curators, Collections and Collaboration.* London: Bloomsbury.

Gooding, Claude Ivan. 2012. "Organizational Mission and the Phenomenon of Mission Drift/Creep: A Perspective from the Nonprofit Sector." PhD thesis, University of Maryland University College.

Grace, Kay Sprinkel. 2005. *Beyond Fundraising: New Strategies for Nonprofit Innovation and Investment.* Hoboken, NJ: John Wiley & Sons.

Grace, Kay Sprinkel. 2009. *The Nonprofit Board's Role in Mission, Planning, and Evaluation.* Washington, DC: BoardSource.

Granger, Brenda. 2011. "The Good, the Best, and the IRS: Museum Financial Management Systems and Recommendations." In *Financial Resource Development and Management, Small Museum Toolkit, Volume 2,* edited by Cinnamon Catlin-Legutko and Stacy Klingler. Lanham, MD: AltaMira Press.

Great Rivers Children's Museum. 2011. "Ready, Set, Exhibits." https:// greatrivercm.org/author/vincent-miles/

Green Exhibits. 2024. https://greenexhibits.org/

Greenfield, James M. 1999. *Fund Raising: Evaluating and Managing the Fund Development Process.* New York: Wiley.

Guidestar. 2024. https://www.guidestar.org/

Haggerty Museum of Art. 2024. "Exhibition Policy." https://www.marquette .edu/haggerty-museum/exhibition-policy.php

Hall, Peter Dobkin. 2003. *A History of Nonprofit Boards in the United States.* Washington, DC: BoardSource.

Halperin, Julia. 2015. "US Museums Accept Gifts With Collectors' Strings Attached." *The Art Newspaper,* July 5, 2015.

Halperin, Julia. 2024. "The Hangover after the Museum Party: Institutions in the US are Facing a Funding Crisis." *The Art Newspaper,* January 19, 2024.

Hamm, Carl G. 2015. "Building for the Future: Converting Capital Campaigns into Sustainable Major Gifts." In *Fundraising and Strategic Planning: Innovative Approaches for Museums,* edited by Juilee Decker, 79–86. Lanham, MD: Rowman & Littlefield.

Harris, Gareth. 2023. "Money Matters—The Problem Museums Have with Philanthropy." *Apollo,* October 20, 2023.

Hartman, Ray. 2013. "Whose Museum Is It, Anyway? Archibald Saga is a History Lesson In Public Accountability." *St. Louis Magazine,* January 31, 2013.

Hartz, Jill. 2015. "Successful Fundraising Strategies for the Academic Museum." In *Fundraising and Strategic Planning: Innovative Approaches for Museums,* edited by Juilee Decker, 87–94. Lanham, MD: Rowman & Littlefield.

Haynes, Emily, and Michael Theis. 2019. "'Gifts to Charity Dropped 1.7 Percent Last Year,' Says Giving USA." *Chronicle of Philanthropy,* June 18, 2019.

Hearst Foundations. 2024. "Funding Priorities in Culture." https://www.hearstfdn.org/culture/funding-priorities

Henderson, Amy, and Adrienne L. Kaeppler. 1997. *Exhibiting Dilemmas: Issues of Representation at the Smithsonian.* Washington, DC: Smithsonian Institution Press.

Henry Luce Foundation. 2024. "News. Going Home: Returning Cultural Materials to Their Rightful Native Communities." https://www.hluce.org/news/articles/going-home-returning-cultural-materials-to-their-rightful-native-communities/

Heritage Health Index. 2005. "A Public Trust at Risk: The Heritage Health Index Report on the State of America's Collections." https://resources.culturalheritage.org/hhi/

Heritage Rail Alliance. 2019. "Toolkit: Recommended Practices for Railway Museums." https://heritagerail.org/wp-content/uploads/2019/10/HRA_Toolkit_April_25_2019_FINAL.pdf

High Desert Museum. 2024. "Exhibit: By Hand through Memory." https://highdesertmuseum.org/by-hand-through-memory-notes/

Hirzy, Ellen Cochran. 2018. *Nonprofit Board Committees.* Washington, DC: BoardSource.

History Leadership Institute. 2024. American Association of State and Local History. https://aaslh.org/professional-development/history-leadership/

Hoffman, Barbara T. 2009. *Art and Cultural Heritage: Law Policy and Practice.* Cambridge: Cambridge University Press.

Holland Museum. 2024. "Committees." https://hollandmuseum.org/volunteer/committees/

Holson, Laura M. 2016. "Dede Wilsey Is the Defiant Socialite." *New York Times*, September 24, 2016.

Horwood, Michelle. 2019. *Sharing Authority in the Museum: Distributed Objects, Reassembled Relationships*. Abingdon, Oxon, UK: Routledge.

Howe, Fischer. 2004. *The Nonprofit Leadership Team: Building the Board-Executive Partnership*. San Francisco: Jossey Bass.

Hughes, Philip. 2015. *Exhibition Design: An Introduction*. London: Laurence King Publishing.

Illinois State Museum. 2023. "Board Meetings, Agendas, and Minutes." https://www.illinoisstatemuseum.org/ism-system-content/ism-board -meetings.html

Indian Arts Research Center. 2019. "Guidelines for Collaboration." Facilitated by Landis Smith, Cynthia Chavez Lamar, and Brian Vallo. Santa Fe, NM: School for Advanced Research. https://guidelinesforcollaboration.info/

Independent Sector. 2023. "Health of the Nonprofit Sector Annual Review." https://independentsector.org/resource/health-of-the-u-s-nonprofit -sector/

Ingram, Richard T. 2015. *Ten Basic Responsibilities of Nonprofit Boards*. Washington, DC: BoardSource.

International Council of Museums. 2020. "Standards on Fundraising of the International Council of Museums." https://icom.museum/wp-content/ uploads/2022/03/Fundraising-Standards_EN.pdf

International Council of Museums. 2021. "Consultations: Museum Definition and Code of Ethics." https://icom.museum/en/news/icom-define -consultation-2-what-should-be-part-of-the-new-museum-definition/

International Council of Museums. 2024a. "ICOM Code of Ethics for Museums." https://icom.museum/en/resources/standards-guidelines/ code-of-ethics/

International Council of Museums. 2024b. "Standards and Guidelines." https://icom.museum/en/resources/standards-guidelines/

International Council of Museums. 2024c. "Red Lists: Cultural Objects at Risk." https://icom.museum/en/red-lists/

International Council of Museums. 2024d. "Code of Ethics." https://icom .museum/wp-content/uploads/2018/07/ICOM-code-En-web.pdf

International Council of Museums. 2024e. "Museum Definition." https://icom .museum/en/resources/standards-guidelines/museum-definition/

International Journal of Cultural Property. 2024. https://www.cambridge.org/ core/journals/international-journal-of-cultural-property

Institute of Museum and Library Services. 2008. "InterConnections: the IMLS National Study on the Use of Museums, Libraries, and the Internet, Conclusions and Summaries." http://interconnectionsreport.org/reports/ ConclusionsSummaryFinalB.pdf

Institute of Museum and Library Services. 2009. "Exhibiting Public Value: Government Funding for Museums in the United States." Washington, DC: Institute of Museum and Library Services. https://www.imls.gov/sites/default/files/publications/documents/museumpublicfinance_0.pdf

Institute of Museum and Library Services. 2019. "Protecting America's Collections: Results from the Heritage Health Information Survey (HHIS)." https://www.imls.gov/data/surveys-data/heritage-health-information-survey-hhis

Institute of Museum and Library Services. 2024a. "Legislation and Budget." https://www.imls.gov/about/mission/legislation-budget

Institute of Museum and Library Services. 2024b. "Mission." https://www.imls.gov/about/mission

Isabella Stewart Gardner Museum. 2023. "Isabella Stewart Gardner Museum Diversity, Equity, Accessibility & Inclusion (DEAI) Update, June 2023." https://www.gardnermuseum.org/sites/default/files/2023-09/ISGM_DEAIReport_8.5x11_June2023.pdf

Ithaka S+R. 2024a. "Home page." https://sr.ithaka.org/

J. Paul Getty Trust. 2017. "Committee Charter: Antiquities Review Committee." https://www.getty.edu/about/governance/pdfs/Charter-Antiquities.pdf

Jacobs, Julia, and Zachary Small. 2024. "Leading Museums Remove Native Displays Amid New Federal Rules." *New York Times*, January 26, 2024.

Janes, Robert R. 2013. *Museums and the Paradox of Change*. New York: Routledge.

Janes, Robert R. 2016. *Museums without Borders: Selected Writings of Robert R. Janes*. Milton Park, Abingdon, Oxon, UK: Routledge.

Janes, Robert R. 2024. *Museums and Societal Collapse: The Museum As Lifeboat*. Abingdon, Oxon, UK: Routledge Taylor & Francis Group.

Janes, Robert R., and Richard Sandell. 2019a. *Museum Activism*. Abingdon, Oxon, UK: Routledge.

Janes, Robert R., and Richard Sandell. 2019b. "Posterity Has Arrived: The Necessary Emergence of Museum Activism." In *Museum Activism*, edited by Robert R. Janes and Richard Sandell, 1–21. London: Routledge.

Janin, Pat Danahey, and Angela Logan. 2022. "Overview of Grantmaking Foundations." In *Achieving Excellence in Fundraising*, edited by Genevieve G. Shaker, Eugene R. Tempel, Sarah K. Nathan, and Bill Stanczykiewic, 441-52. Hoboken, NJ: John Wiley & Sons.

Jule Collins Smith Museum of Fine Art. 2023. "The Jule Year in Review, 2022." https://jcsm.auburn.edu/the-jule-year-in-review-2022/

Jule Collins Smith Museum of Fine Art. 2024. "About Us" https://jcsm.auburn.edu/about/

Kadoyama, Margaret. 2018. *Museums Involving Communities: Authentic Connections*. London: Routledge.

Karp, Ivan, and Stephen Lavine. 1991. *Exhibiting Cultures: The Poetics and Politics of Museum Display.* Washington, DC: Smithsonian Institution Press.

Karp, Ivan, Corinne A. Kratz, Lynn Szwaja, Gustavo Buntinx, Tomas Ybarra-Frausto, Barbara Kirshenblatt-Gimblett, and Ciraj Rassool. 2006. *Museum Frictions: Public Cultures/Global Transformations.* Durham, NC: Duke University Press.

Kazinka, Katya. 2021. "How Naming Rights Became the Art World's Most Controversial Issue." *Town and Country*, June 16, 2021.

Kennedy, Randy. 2014. "'Grand Bargain' Saves the Detroit Institute of Arts." *New York Times*, November 7, 2014.

Kennedy, Randy. 2017. "White Artist's Painting of Emmett Till at Whitney Biennial Draws Protests." *New York Times*, March 21, 2017.

Kinsella, Eileen. 2023. "Artists Decry an Idaho College's 'Alarming' Removal of Artworks Centered on Reproductive Rights From a Group Show on Healthcare." *ArtNet*, March 7, 2023.

Kipp, Angela. 2016. *Managing Previously Unmanaged Collections: A Practical Guide for Museums.* Lanham, MD: Rowman & Littlefield.

Kirshenblatt-Gimblett, Barbara. 1998. *Destination Culture: Tourism, Museums, and Heritage.* Berkeley, CA: University of California Press.

Klein, Kim, and Stan Yogiu. 2022. *Fundraising for Social Change.* 2022. Hoboken, NJ: Wiley.

Klobe, Tom. 2013. *Exhibitions. Concept Planning and Design.* Washington, DC: American Association of Museums.

Knoxville Museum of Art. 2016. "Museum Bylaws." https://knoxart.org/museum-bylaws/

Kotler, Neil G., Philip Kotler, Wendy I. Kotler, and Neil G. Kotler. 2008. *Museum Marketing and Strategy: Designing Missions, Building Audiences, Generating Revenue and Resources.* San Francisco: Jossey-Bass.

Kudlick, Catherine, and Edward M. Luby. 2019. "Access as Activism: Bringing the Museum to the People." In *Museum Activism*, edited by Robert R. Janes and Richard Sandell, 58–68. New York: Routledge.

Kuprecht, Karolina. 2014. *Indigenous Peoples' Cultural Property Claims: Repatriation and Beyond.* New York: Springer.

Kuta, Sarah. 2022. "Field Museum Confronts Its Outdated, Insensitive Native American Exhibition." *Smithsonian Magazine*, May 26, 2022.

Le, Vu. 2021. "We Need to Rethink the Concept of 'Mission Creep.'" Nonprofit AF. https://nonprofitaf.com/2021/08/we-need-to-rethink-the-concept-of-mission-creep/

Leftridge, Alan. 2006. *Interpretive Writing.* Fort Collins, CO: National Association for Interpretation.

Legal Information Institute. 2024. "2 CFR § 3187.3 - Definition of A Museum." https://www.law.cornell.edu/cfr/text/2/3187.3

Lilly Family School of Philanthropy. 2024. "Courses and Seminars." https://philanthropy.iupui.edu/professional-development/courses-seminars/index.html

Lindsay, Drew. 2023. "With 200,000 Nonprofits Rated, the New Charity Navigator Aims High, Falls Short." *Chronicle of Philanthropy*, September 21, 2023.

Lindsay Wildlife Museum. 2016. "Lindsay Wildlife Experience: Bylaws of the Lindsay Wildlife Museum." https://lindsaywildlife.org/wp-content/uploads/2016/03/LWE-BYLAWS-FINAL-032216.pdf

Lomawaima, K. Tsianina, and Janet Cantley. 2018. "Remembering Our Indian School Days: The Boarding School Experience: A Landmark Exhibit at the Heard Museum." *Journal of American Indian Education* 57 (1): 22–29.

Lonetree, Amy. 2012. *Decolonizing Museums: Representing Native America in National and Tribal Museums*. Chapel Hill, NC: University of North Carolina Press.

Lonetree, Amy. 2021. "Decolonizing Museums, Memorials, and Monuments." *The Public Historian* 43 (4): 21–27.

Lord, Barry, and Rina Gerson. 2015. "Governance: Guiding the Museum in Trust." In *The International Handbooks of Museum Studies*, edited by Conal McCarthy, 27–42. Hoboken, NJ: John Wiley & Sons.

Lord, Gail Dexter, and Barry Lord. 2009. *The Manual of Museum Management*. Lanham, MD: AltaMira Press.

Lord, Gail Dexter, and Kate Markert. 2007. *The Manual of Strategic Planning for Museums*. Lanham, MD: AltaMira Press.

Lorentzen, Shelly. 2013. "The State of Institutional Planning in U.S. Museums." MA thesis, San Francisco State University.

Los Angeles County Museum of Art. 2024. "About Us, Articles of Incorporation." https://www.lacma.org/about?tab=corporate-governance#corporate-governance

Louisiana Office of the Lieutenant Governor. 2020. "Department of Culture, Recreation, and Tourism, Office of the State Museum, Program Objectives." https://www.crt.state.la.us/Assets/strategicplan/2020/OSMPlan.pdf

Louisiana State Museums. 2024. https://louisianastatemuseum.org/

Lowry, Glenn D. 1998. "Cultural Property: A Museum Director's Perspective." *International Journal of Cultural Property* 7 (2): 438–45.

Luscombe, Richard. 2023. "Florida Museum Chief Tried to Make Millions From Exhibition of Fake Basquiat Art, Lawsuit Claims." *The Guardian*, August 16, 2023.

McCarthy, Catherine, and Brad Herring. 2015. *Museums and Community Partnerships: Collaboration Guide for Museums Working with Community Youth-Serving Organizations*. NISE Network, Saint Paul, MN. https://www.nisenet.org/collaboration-guide

McCarthy, Conal, Eric Dorfman, Arapata Hakiwai, and Āwhina Twomey. 2013. "Mana Taonga: Connecting Communities with New Zealand Museums through Ancestral Māori Culture." *Museum International* 65: 5–15.

McGlone, Peggy. 2022. "U.S. Museums are Trying to Return Hundreds of Looted Benin Treasures." *Washington Post*, May 12, 2022.

McKenna-Cress, Polly. 2013. *Creating Exhibitions: Collaboration in the Planning, Development, and Design of Innovative Experiences.* Newark, NJ: John Wiley & Sons.

McLean, Kathleen. 1999. "Museum Exhibitions and the Dynamics of Dialogue." *Daedalus* 128 (3): 83–107.

McNeil, Timothy J. 2023. *The Exhibition and Experience Design Handbook.* Lanham, MD: Rowman & Littlefield.

McRainey, D. Lynn, and John Russick. 2010. *Connecting Kids to History with Museum Exhibitions.* Walnut Creek, CA: Left Coast Press.

Macdonald, Sharon. 1998. *The Politics of Display: Museums, Science, Culture.* London: Routledge.

Malaro, Marie C. 1994. *Museum Governance: Mission Ethics Policy.* Washington, DC: Smithsonian Institution Press.

Malaro, Marie C., and Ildiko Pogány DeAngelis. 2012. *A Legal Primer on Managing Museum Collections.* Washington, DC: Smithsonian Books.

Mark Twain House and Museum. 2024. "From Twain to Today: How the Mark Twain House and Museum Came to Be." https://marktwainhouse.org/about/our-history/

Marstine, Janet. 2011. "Introduction: What Is New Museum Theory?" In *New Museum Theory and Practice*, edited by Janet Marstine, 1–36. Malden, MA: Blackwell Publishing.

Martha's Vineyard Museum. 2020. "Board of Directors: Membership Responsibilities." https://mvmuseum.org/wp-content/uploads/2021/09/13.-Board-Member-Responsibilities.pdf

Master, Nancy. 2023. "Giving USA 2023 Report: Four Donor Trends Nonprofit Leaders Need to Know." Giving USA. https://www.sage.com/en-us/blog/giving-usa-2023-report-four-donor-trends-nonprofit-leaders-need-to-know/

Matthew, Kathryn K. 2022. *Fundraising for Impact in Libraries Archives and Museums: Making the Case to Government Foundation Corporate and Individual Funders.* London: Routledge Taylor & Francis Group.

Mellon Foundation. 2023. "Annual Report." https://www.mellon.org/annual-report

Merritt, Elizabeth. 2008. *National Standards and Best Practices for U.S. Museums.* Washington, DC: American Association of Museums.

Merritt, Elizabeth. 2019a. "Toxic Philanthropy. American Alliance of Museums." https://www.aam-us.org/2019/12/11/toxic-philanthropy/

Merritt, Elizabeth. 2019b. "TrendsWatch 2019: Confronting the Past: The Long, Hard Work of Decolonization." https://www.aam-us.org/2019/04/19/trendswatch-2019-confronting-the-past-the-long-hard-work-of-decolonization/

Merritt, Elizabeth. 2022. "In Praise of Mission Creep." Center for the Future of Museums, American Alliance of Museums. https://www.aam-us.org/2022/06/15/in-praise-of-mission-creep/

Merritt, Elizabeth E., and Victoria Garvin. 2007. *Secrets of Institutional Planning.* Washington, DC: American Association of Museums Press.

Merritt, Elizabeth E., and Philip M. Katz. 2009. *2009 Museum Financial Information.* Washington, DC: American Association of Museums.

Merryman, John Henry. 2009. *Thinking About the Elgin Marbles: Critical Essays on Cultural Property Art and Law.* Austin Alphen aan den Rijn, the Netherlands: Kluwer Law International; Frederick, MD: Wolters Kluwer Law and Business.

Messenger, Phyllis Mauch. 1999. *The Ethics of Collecting Cultural Property: Whose Culture? Whose Property?* Albuquerque: University of New Mexico Press.

Metropolitan Museum of Art. 2023. "Collections Management Policy." https://cdn.sanity.io/files/cctd4ker/production/000f5c7763ee42ddeb9f349d97282a8a528f4951.pdf

Metropolitan Museum of Art 2024a. "The Met's Friend's Groups." https://www.metmuseum.org/join-and-give/support/curatorial-friends-groups

Metropolitan Museum of Art 2024b. "Friends of the Met." https://www.metmuseum.org/join-and-give/support/curatorial-friends-groups/friends-of-the-met

Miller, Kevin. 2024. "Recruit New Donors to Turn the Tide for Nonprofits." *Independent Sector*, January 22, 2024.

Miller, Steven. 2018. *The Anatomy of a Museum: An Insider's Text.* Hoboken, NJ: Wiley Blackwell.

Milman, Oliver. 2018. "Museum of Natural History Urged to Cut Ties with 'Anti-Science Propagandist' Rebekah Mercer." *The Guardian*, January 25, 2018.

Montana Historical Society. 2023. "Board of Trustees Meeting Minutes." https://mhs.mt.gov/about/trustees/BOTMtgMinutes

Moore, Kevin. 2006. *Museum Management.* London: Routledge.

Morris, Martha. 2018. *Leading Museums Today: Theory and Practice.* Lanham, MD: Rowman & Littlefield.

Murawski, Mike. 2017. "Museums Are Not Neutral." https://artmuseumteaching.com/2017/08/31/museums-are-not-neutral/

Murawski, Mike. 2021. *Museums As Agents of Change: A Guide to Becoming a Changemaker.* Lanham, MD: Rowman & Littlefield.

Museum Anthropology. 2024. https://anthrosource.onlinelibrary.wiley.com/journal/15481379

Museum, Arts and Culture Access Consortium. 2024. https://macaccess.org/

Museum as Sites of Social Action. 2024. https://www.museumaction.org/

Museum International. 2024. https://onlinelibrary.wiley.com/journal/14680033

Museum Leadership Institute. 2024. "The Museum Leadership Institute at Claremont Graduate University." https://mli.cgu.edu/

Museum Management and Curatorship. 2024. https://www.tandfonline.com/toc/rmmc20/current

Museum of Science, Boston. 2024. "Code of Ethics" https://www.mos.org/ethics#:~:text=Gifts%2C%20Favors%2C%20Discounts%2C%20Dispensations,best%20interests%20of%20the%20Museum

Museum of the City of New York. 2023. "Collections Management Policy." https://www.mcny.org/sites/default/files/2023-12/MCNYCollectionsManagementPolicy2023.pdf

Museum of the City of New York. 2024a. "About the Museum." https://www.mcny.org/about?gclid=CjwKCAiA1-6sBhAoEiwArqIGPnTHK7tQkUatmTHITs3BjXOfL3-CBpUTnviNz3WegC3ERQKOwMS3KRoCXEUQAvD_BwE

Museum of the City of New York. 2024b. "About Us." https://www.mcny.org/about

Museum of Us. 2024. "Decolonizing Initiatives." https://museumofus.org/decolonizing-initiatives

Museum Trustee Association. 2018. "The Board Orientation Handbook, Revisited." https://www.museumtrustee.org/tips-for-trustees/category/board-orientation

Museum Trustee Association. 2024a. https://www.museumtrustee.org/

Museum Trustee Association. 2024b. "About Us." https://www.museumtrustee.org/about-us.html

Museum Trustee Association. 2024c. "Are You Bored at Your Museum Board Meeting?" https://www.museumtrustee.org/tips-for-trustees/are-you-bored-at-your-museum-board-meeting

Museum Worlds. 2024. https://www.berghahnjournals.com/view/journals/museum-worlds/museum-worlds-overview.xml

Museums and Society. 2024. https://journals.le.ac.uk/ojs1/index.php/mas/index

NAGPRA. 2023. "Final Rule: Native American Graves Protection and Repatriation Act Systematic Processes for Disposition or Repatriation of Native American Human Remains, Funerary Objects, Sacred Objects, and Objects of Cultural Patrimony." https://www.federalregister.gov/documents/2023/12/13/2023-27040/native-american-graves-protection-and-repatriation-act-systematic-processes-for-disposition-or#:~:text=SUMMARY%3A,and%20Repatriation%20Act%20of%201990

National Archives. 2024. "Preservation." https://www.archives.gov/preservation

National Center for Nonprofit Boards. 1994. *Nonprofit Governance Case Studies: A Collection of Case Studies from Board Member NCNB's Periodical for Nonprofit Leaders*. Washington, DC: National Center for Nonprofit Boards.

National Coalition Against Censorship. 2024a. "Museum Best Practices for Managing Controversy." https://ncac.org/resource/museum-best -practices-for-managing-controversy

National Coalition Against Censorship. 2024b. "Museum Best Practices: Background." https://ncac.org/resource/museum-best-practices -background

National Council of Nonprofits. 2024a. https://www.councilofnonprofits.org/ running-nonprofit/fundraising-and-resource-development/fundraising

National Council of Nonprofits. 2024b. "Ethical Fundraising." https://www .councilofnonprofits.org/running-nonprofit/fundraising-and-resource -development/ethical-fundraising

National Council of Nonprofits. 2024a. "Finding the Right Board Members for Your Nonprofit." https://www.councilofnonprofits.org/running-nonprofit/ governance-leadership/finding-right-board-members-your-nonprofit

National Council of Nonprofits. 2024b. "Board Orientation." https://www .councilofnonprofits.org/running-nonprofit/governance-leadership/board -orientation

National Council of Nonprofits. 2024c. "Good Governance Policies for Nonprofits." https://www.councilofnonprofits.org/running-nonprofit/ governance-leadership/good-governance-policies-nonprofits

National Council of Nonprofits. 2024d. "Principles and Practices: Best Practices for Nonprofits." https://www.councilofnonprofits.org/running -nonprofit/governance-leadership/principles-practices-best-practices -nonprofits

National Council of Nonprofits. 2024e. "Effective Board Meetings for Good Governance." https://www.councilofnonprofits.org/running-nonprofit/ governance-leadership/effective-board-meetings-good-governance

National Museum of Ireland. 2023. "Exhibition Policy." https://www.museum .ie/en-IE/About/Corporate-Information/Policies-Guidelines/Exhibition -Policy

National Park Service. 2024a. "NPS Museum Handbook." https://www.nps .gov/museum/publications/handbook.html

National Park Service. 2024b. "The Native American Graves Protection and Repatriation Act." https://www.nps.gov/subjects/nagpra/index.htm

National Portrait Gallery. 2022. "Exhibitions and Displays Policy." https://www .npg.org.uk/about/corporate/gallery-policies/exhibitions-and-displays -policy

National World War II Museum New Orleans. 2024. "Board of Trustees." https://www.nationalww2museum.org/about-us/our-team/board -trustees

Natural History Museum of Utah. 2024. "Indigenous Advisory Committee." https://nhmu.utah.edu/museum/about/iac

Newark Museum of Art. 2020. "Collections Management Policy." https://newarkmuseumart.org/wp-content/uploads/2023/02/COLLECTIONS-MANAGEMENT-POLICY-Final.pdf

The Nonprofit Board Answer Book: A Practical Guide for Board Members and Chief Executives. 2012. San Francisco, CA: Jossey-Bass/BoardSource.

Nonprofit Quarterly. 2024. https://nonprofitquarterly.org/

NonProfit Times. 2024. https://thenonprofittimes.com/

North Carolina Museum of Natural Sciences. 2024a. "Friends of the North Carolina Museum of Natural Sciences." https://naturalsciences.org/about/friends

North Carolina Museum of Natural Sciences. 2024b. "Museum Membership." https://naturalsciences.org/calendar/wp-content/uploads/2023/10/Membership-Brochure-2023.pdf

Northeast Document Conservation Center. 2024. "Free Resources." https://www.nedcc.org/free-resources/overview

O'Brien, Timothy. 2021. "Audit Report, Denver Art Museum" https://www.denvergov.org/files/assets/public/v/1/auditor/documents/audit-services/audit-reports/2021/denver-art-museum_january2021.pdf

Offenhartz, Jay. 2018. "What's a Climate Denial Funder Doing on the American Museum of Natural History Board?" *Village Voice*, January 12, 2018.

Oliewenhuis Art Museum. 2024. "Exhibition Policy and Structure: Oliewenhuis Art Museum." https://nasmus.co.za/oliewenhuis-exhibition-policy-and-structure/

Onciul, Bryony. 2015. *Museums, Heritage, and Indigenous Voice: Decolonising Engagement.* Vol. 10. London: Routledge.

Osilli, Una, and Sarah King Bhetaria. 2022. "Philanthropy among Communities of Color." In *Achieving Excellence in Fundraising*, edited by Genevieve G. Shaker, Eugene R. Tempel, Sarah K. Nathan, and Bill Stanczykiewic, 337–46. Hoboken, NJ: John Wiley & Sons.

Oster, Sharon, and William N. Goetzmann. 2003. "Does Governance Matter? The Case of Art Museums." In *The Governance of Not-for-Profit Organizations*, edited by Edward L. Glaeser, 71–100. Chicago: University of Chicago Press.

Ostrower, Francie. 1999. "The Arts as Cultural Capital among Elites: Bourdieu's Theory Revisited." *Poetics* 26: 43–53.

Ostrower, Francie. 2002. *Trustees of Culture: Power, Wealth, and Status on Elite Arts Boards.* Chicago: University of Chicago Press.

Oswald, Margareta von. 2022. *Working Through Colonial Collections: An Ethnography of the Ethnological Museum in Berlin.* Leuven: Leuven University Press.

Parman, Alice, Ann Craig, Lyle Murphy, Liz White, and Lauren Willis. 2017. *Exhibit Makeovers: A Do-It-Yourself Workbook for Small Museums.* Lanham, MD: Rowman & Littlefield.

Pedretti, Erminia, and Ana Maria Navas Iannini. 2020. *Controversy in Science Museums: Re-Imagining Exhibition Spaces and Practice.* Abingdon, Oxon, UK: Routledge.

Penn Museum. 2023. "Penn Museum Human Remains Policy." https://www.penn.museum/img/documents/PM-HRP-full-20230920.pdf

Persson, Ann S. 2012. "From Residence to Relevance: Making an Academic Museum at Hartford Community College." In *A Handbook for Academic Museums: Exhibitions and Education,* edited by Stefanie S. Jandl and Mark S. Gold, 338–59. Edinburgh: MuseumsEtc.

Phelan, Marilyn E. 2014. *Museum Law: A Guide for Officers Directors and Counsel.* Lanham, MD: Rowman & Littlefield.

Piacente, Maria. 2022. *Manual of Museum Exhibitions.* Lanham, MD: Rowman & Littlefield.

Pogrebin, Robin. 2020a. "Trustee Who Funds Climate Change Deniers Leaves Natural History Board." *New York Times,* February 27, 2020.

Pogrebin, Robin. 2020b. "Black Trustees Join Forces to Make Art Museums More Diverse." *New York Times,* October 9, 2020.

Pogrebin, Robin, and Somini Sengupta. 2018. "A Science Denier at the Natural History Museum? Scientists Rebel." *New York Times,* January 25, 2018.

Pogrebin, Robin, Elizabeth A. Harris, and Graham Bowley. 2019. "New Scrutiny of Museum Boards Takes Aim at World of Wealth and Status." *New York Times,* October 2, 2019.

Potter, William Taylor. 2023. "Louisiana's Nine Public Museums are Underfunded and Short-Staffed Audit Shows." *Lafayette Daily Advertiser,* March 15, 2023.

Powell, James, and Michael E. Mann. 2018. "Rebekah Mercer Puts a Museum's Credibility at Risk." *New York Times,* February 5, 2018.

Pressman, Heather, and Danielle Schulz. 2021. *The Art of Access: A Practical Guide for Museum Accessibility.* Lanham, MD: Rowman & Littlefield.

Prott, Lyndel V., and Patrick J. O'Keefe. 1992. "'Cultural Heritage' or 'Cultural Property'?" *International Journal of Cultural Property* 1 (2): 307–20.

Reavey, Brooke, Michael J. Howley Jr., and Daniel Korschun. 2013. "An Exploratory Study of Stalled Relationships among Art Museum Members." *International Journal of Nonprofit and Voluntary Sector Marketing* 18 (2): 90–100.

Reed, Sally Gardner. 2012. *Libraries Need Friends: A Toolkit to Create Friends Groups or to Revitalize the One You Have.* Philadelphia: United for Libraries. http://www.ala.org/united/sites/ala.org.united/files/content/friends/orgtools/libraries-need-friends.pdf

Reed, Victoria S. 2023. "American Museums and Colonial-Era Provenance: A Proposal." *International Journal of Cultural Property* 30 (1): 1–21.

Rega, Julie N. 2011. "Museum Membership Programs: Innovation in a Troubled Economy." MA thesis, Seton Hall University.

Reibel, Daniel B., and Deborah Rose Van Horn. 2018. *Registration Methods for the Small Museum*. Lanham, MD: Rowman & Littlefield.

Rentschler, Ruth 2004. "Four by Two Theory of Non-profit Museum Governance." *Museological Review* 11: 30–41.

Rich, Patricia, and Dana Hines. 2006. *Membership Development: An Action Plan for Results*. Sudbury, MA: Jones and Bartlett.

Rich, Patricia, Dana S. Hines, and Rosie Siemer. 2015. *Membership Marketing in the Digital Age: A Handbook for Museums and Libraries*. Lanham, MD: Rowman & Littlefield.

Robinson, Maureen. 2001. *Nonprofit Boards that Work, The End of One-Size Fits-All Governance*. New York: John Wiley & Sons.

Rooney, Patrick, Kidist Yasin, and Lijun He. 2022. "High Net Worth Household Giving Insights." In *Achieving Excellence in Fundraising*, edited by Genevieve G. Shaker, Eugene R. Tempel, Sarah K. Nathan, and Bill Stanczykiewic, 367–78. Hoboken, NJ: John Wiley & Sons.

San Bernadino County Government. 2023. "Museum Returns Archaeological Objects to Mexico." October 6, 2023. https://main.sbcounty.gov/2023/10/06/museum-returns-archaeological-objects-to-mexico/

San Bernadino County Museum. 2023. "Museum Returns Archaeological Objects to Mexico." September 29, 2023. https://museum.sbcounty.gov/museum-returns-archaeological-objects-to-mexico/

Sandell, Richard. 2019. "Disability: Museums and Our Understandings of Difference." *The Contemporary Museum* 1: 169–84. London: Routledge.

Sandell, Richard, Jocelyn Dodd, and Rosemarie Garland-Thomson. 2010. *Re-Presenting Disability: Activism and Agency in the Museum*. London: Routledge.

Sandell, Richard, and Robert R. Janes. 2007. *Museum Management and Marketing*. London: Routledge.

Sandell, Richard, and Eithne Nightengale. 2012. *Museums, Equality, and Social Justice*. London: Routledge.

Sawyer, Liz. 2017. "After Outcry and Protests, Walker Art Center Will Remove 'Scaffold' Sculpture." *Star Tribune* (Minnesota). May 28, 2017.

Schonfeld, Roger, and Liam Sweeney. 2019. "Organizing the Work of the Art Museum." *Ithaka S+R*. https://doi.org/10.18665/sr.311731

School for Advanced Research. 2023. *Standards for Museums with Native American Collections*. Santa Fe, NM: School for Advanced Research. https://sarweb.org/wp-content/uploads/2023/05/SMNAC-Final-Document.-May-2023.pdf

Science Museum of Minnesota. 2024. "Collections Management Policy." https://new.smm.org/collections/policy

Scott, Elizabeth, and Edward M. Luby. 2007. "Maintaining Relationships with Native Communities: The Role of Museum Management and Governance." *Museum Management and Curatorship* 22 (3): 265–85.

Seiler, Timothy L. 2022. "Articulating a Case for Support." In *Achieving Excellence in Fundraising*, edited by Genevieve G. Shaker, Eugene R. Tempel, Sarah K. Nathan, and Bill Stanczykiewic, 141–52. Hoboken, NJ: John Wiley & Sons.

Sentell, Will. 2023a. "Louisiana State Museum System Has No Oversight, Low Employee Morale, Audit Finds." *The Times-Picayune/The New Orleans Advocate*, March 13, 2023.

Sentell, Will. 2023b. "Audit Finds La. State Museum System Has No Oversight, Low Employee Morale." *KTBS News*, March 14, 2023.

Shaker, Genevieve G., Eugene R. Tempel, Sarah K. Nathan, and Bill Stanczykiewic. 2022. *Achieving Excellence in Fundraising*. Hoboken, NJ: John Wiley & Sons.

Sharp, Kathleen. 2023. "Is the Metropolitan Museum of Art Displaying Objects that Belong to Native American Tribes?" *ProPublica*, April 25, 2023.

Shekhtman, L. M., and A. L. Barabási. 2023. "Philanthropy in Art: Locality, Donor Retention, and Prestige." *Scientific Reports (Nature)* 13: 12157.

Shortell, David. 2023. "Stone by Stone, Mexico Recovers Its Lost Treasures." *New York Times*, October 23, 2023.

Siemer, Rosie. 2020. *Museum Membership Innovation Unlocking Ideas for Audience Engagement and Sustainable Revenue*. Lanham, MD: Rowman & Littlefield.

Silverman, Raymond A. 2015. *Museum as Process: Translating Local and Global Knowledges*. London: Routledge.

Simek, Jaime. 2018. *Fundraising Basics for Local History Organizations*. American Association for State and Local History Technical Leaflet #283. Nashville, TN: American Association for State and Local History.

Simmons, John E. 2018. *Things Great and Small: Collections Management Policies*. Lanham, MD: Rowman & Littlefield.

Simmons, John E., and Toni M. Kiser. 2020. *MRM6: Museum Registration Methods*. Lanham, MD: Rowman & Littlefield.

Simpson, Moira. 2001. *Making Representations: Museums in the Post-Colonial Era*. London: Routledge.

Skramstad, Harold, and Susan Skramstad. 2013. "Mission and Vision: What's the Big Deal?" In *Leadership, Mission, and Governance, Small Museum Toolkit, Volume 1*, edited by Cinnamon Catlin-Legutko and Stacy Klingler, 62–77. Lanham, MD: AltaMira Press.

Smithsonian Institution. 2007. "Statement of Values and Code of Ethics." https://www.si.edu/content/governance/pdf/Statement_of_Values_and_Code_of_Ethics.pdf

Smithsonian Institution. 2021. "Climate Change Action Plan." https://www
.sustainability.gov/pdfs/si-2021-cap.pdf

Smithsonian Institution. 2022. "Shared Stewardship and Ethical Returns
Policy." https://ncp.si.edu/sites/default/files/files/Ethical%20Return
%20Docs/shared-stewardship-ethical-returns-policy_4.29.2022.pdf

Smithsonian Institution. 2024a. "Our Organization." https://www.si.edu/
about/administration

Smithsonian Institution. 2024b. "Advisory Boards." https://www.si.edu/
support/advancement-leadership/advisory-boards

Smithsonian Institution. 2024c. "A Guide to Exhibit Development." https://
exhibits.si.edu/wp-content/uploads/2018/04/Guide-to-Exhibit
-Development.pdf

Smithsonian Institution. 2024d. "Smithsonian Guidelines for Accessible
Exhibition Design." https://www.sifacilities.si.edu/sites/default/files/Files
/Accessibility/accessible-exhibition-design1.pdf

Smithsonian Institution. 2024e. "Accessibility Resources for Museum
Professionals." https://access.si.edu/museum-professionals

Society for Nonprofits. 2024. https://www.snpo.org/?gclid=CjOKCQjwtJK
qBhCaARIsAN_yS_kPaNcbo29vs3ZinANgQe5Bay7lqEINGjjoNDR9y
GvcezE-IvUud4saAsOVEALw_wcB

Society for the Preservation of Natural History Collections. 2024. https://
spnhc.org/

Southard, Alexandra Elaine. 2015. "Creating Community Engagement: The
Role of Community Advisory Councils in Museums." MA thesis, San
Francisco State University.

Spears, Loren, and Amanda Thompson. 2022. "As We Have Always Done":
Decolonizing the Tomaquag Museum's Collections Management Policy."
Collections 18 (1): 31–41.

Stanczykiewic, Bill. 2022. "Fundraising Planning, Management, and Leadership."
In *Achieving Excellence in Fundraising*, edited by Genevieve G. Shaker, Eugene
R. Tempel, Sarah K. Nathan, and Bill Stanczykiewic, 217–28. Hoboken, NJ:
John Wiley & Sons.

Stewart, Barbara. 2002. "Jewish Museum to Add Warning Label on Its Show."
New York Times, March 3, 2002.

Summers, John. 2018. *Creating Exhibits That Engage: A Manual for Museums and
Historical Organizations.* Lanham, MD: Rowman & Littlefield.

Sutton, Sarah. 2018. *Is Your Museum Grant-Ready?* Lanham, MD: Rowman &
Littlefield.

Sutton, Sarah, and Elizabeth Wylie. 2008. *The Green Museum: A Primer on
Environmental Practice.* Lanham, MD: AltaMira Press.

Sweeney, Liam, Deirdre Harkins, and Joanna Dressel. 2022a. "Art Museum
Staff Demographic Survey 2022." *Ithaka S+R.* Last modified November 16,
2022. https://doi.org/10.18665/sr.317927

Sweeney, Liam, Deirdre Harkins, Celeste Watkins-Hayes, and Dominique Adams-Santos. 2022b. "The BTA 2022 Art Museum Trustee Survey: The Characteristics, Roles, and Experiences of Black Trustees." *Ithaka S+R.* Last modified November 16, 2022. https://doi.org/10.18665/sr.317881

Taberner, Aimée L. 2011. *Cultural Property Acquisitions: Navigating the Shifting Landscape.* Walnut Creek, CA: Left Coast Press.

Tempel, Eugene R., and Sarah K. Nathan. 2022. "Developing a Personal Philosophy of Fundraising." In *Achieving Excellence in Fundraising*, edited by Genevieve G. Shaker, Eugene R. Tempel, Sarah K. Nathan, and Bill Stanczykiewic, 3–12. Hoboken, NJ: John Wiley & Sons.

Theobald, Sharon Smith. 2021. *To Give and to Receive: A Handbook on Collection Gifts and Donations for Museums and Donors.* Lanham, MD: Rowman & Littlefield.

Tri-Cities Historical Museum. 2024. "Exhibits." https://www.tri-citiesmuseum .org/exhibits

Trimbach, David J. 2016. "Thank You for Being a Friends Group: An Assessment of Friends Group Characteristics and Best Practices." *The Journal of Nonprofit Education and Leadership* 6 (2): 115+.

Trower, Cathy A. 2012. *The Practitioner's Guide to Governance As Leadership: Building High-Performing Nonprofit Boards.* Newark, NJ: John Wiley & Sons.

True, Megan. 2019. "Toward a Shared Native American/Western Heritage: A Case Study of the Eiteljorg Museum of American Indians and Western Art." *The International Journal of The Inclusive Museum* 12 (3): 15–31.

Ulaby, Neda. 2011. "As 'Hide/Seek' Ends, A Step Back To Look For Lessons." *National Public Radio*, February 11, 2011.

UNESCO. 2024. "Legal Affairs: Convention on the Means of Prohibiting and Preventing the Illicit Import, Export and Transfer of Ownership of Cultural Property, 1970." https://www.unesco.org/en/legal-affairs/convention -means-prohibiting-and-preventing-illicit-import-export-and-transfer -ownership-cultural

University of Colorado at Boulder Art Museum. 2020. "Collections Management Policy and Procedures: Loans." https://www.colorado.edu/cuartmuseum /about/strategic-guiding-documents/collection-management-policy-and -procedures

Van Horn, Deborah Rose, Corrinne Midgett, and Heather Culligan. 2022. *Basic Condition Reporting: A Handbook.* Lanham, MD: Rowman & Littlefield.

Vanderwarf, Sandra, and Bethany Romanowski. 2022. *Inventorying Cultural Heritage Collections: A Guide for Museums and Historical Societies.* Lanham, MD: Rowman & Littlefield.

Vaughn, Jacqueline, and Hanna J. Cortner. 2013. *Philanthropy and the National Park Service.* New York: Palgrave Macmillan.

Vetter, Kara. 2023. "Decolonizing in Collections Care." Connecting to Collections. https://connectingtocollections.org/decolonizing_in_collections_care/

Virginia Law. 2024. "Code of Virginia, Article 5, Science Museum of Virginia." https://law.lis.virginia.gov/vacodefull/title23.1/chapter32/article5/

Vrdoljak, Ana Filipa. 2008. *International Law Museums and the Return of Cultural Objects.* Cambridge: Cambridge University Press.

Waguespack, Michael J. 2023. "Office of State Museum, Department of Culture, Recreation, and Tourism, Performance Audit Services." https://app.lla.state.la.us/publicreports.nsf/0/7137ddf3e71a75958625896c006cd504/$file/00000ef0a.pdf?openelement&.7773098

Wallace, Margot A. 2014. *Writing for Museums.* Lanham, MD: Rowman & Littlefield.

Wallace, Nicole. 2019. "$4 Million Grant Will Promote Board Diversity at Museums." *Chronicle of Philanthropy*, January 15, 2019.

Walt Disney Museum. 2024. "Advisory Committee." https://www.waltdisney.org/about/advisory-committee

Walters Art Museum. 2021a. "Bylaws of the Walters Art Museum." https://thewalters.org/wp-content/uploads/policy-by-laws_walters-art-museum.pdf

Walters Art Museum. 2021b. "Collections Management Policy." https://thewalters.org/wp-content/uploads/2021/09/policy_collections-management.pdf

Warner, Mark S., and Terry S. Childs. 2019. *Using and Curating Archaeological Collections.* Washington, DC: The Society for American Archaeology.

Watson, Sheila E. R. 2007. *Museums and Their Communities.* London: Routledge.

Weil, Stephen E. 1995. "A Brief Meditation on Museums and the Metaphor of Institutional Growth." In *A Cabinet of Curiosities: Inquiries into Museums and their Prospects*, edited by Stephen E. Weil, 39–46. Washington, DC: Smithsonian Institution Press.

Weil, Stephen E. 2002. "The Museum and the Public." In *Making Museums Matter*, 195–213. Washington, DC: Smithsonian Institution Press.

Weinstein, Stanley, and Pamela Barden. 2017. *The Complete Guide to Fundraising Management.* Newark, NJ: John Wiley & Sons.

Werbel, Amy. 2023a. "The Fragile Future of Artistic Expression on Campus." *Inside Higher Ed.* March 29, 2023. https://www.insidehighered.com/views/2023/03/30/campus-art-museum-leaders-feel-heat-opinion

Werbel, Amy. 2023b. "A Study of Freedom of Artistic Expression in Academic Art Museums and Galleries." University of California National Center for Free Speech and Civic Engagement. https://freespeechcenter.universityofcalifornia.edu/fellows-21-22/werbel-research/

Western Museums Association. 2024. "DEAI Resources." https://westmuse.org/diversity-and-inclusion-resources

Wheeler, Ryan, Jaime Arsenault, and Marla Taylor. 2022. "Beyond NAGPRA/Not NAGPRA." *Collections*, 18 (1) 8–17.

Widmer, Candace Hestwood, and Susan Houchin. 2000. *The Art of Trusteeship: The Nonprofit Board Member's Guide to Effective Governance*. San Francisco: Jossey-Bass.

Wilkerson, Isabelle. 1990. "Cincinnati Jury Acquits Museum In Mapplethorpe Obscenity Case." *New York Times*, October 6, 1990.

Williams, Karla A. 2013. *Leading the Fundraising Charge: The Role of the Nonprofit Executive*. Hoboken, NJ: John Wiley & Sons.

Williams, Sherill K., and Kathleen A. McGinnis. 2011. *Building The Governance Partnership: The Chief Executive's Guide To Getting The Best From The Board*. Washington, DC: BoardSource.

Wisconsin Historical Society. 2024. "How To Stop Bad Behavior on Your Nonprofit Board." https://www.wisconsinhistory.org/Records/Article/CS3843

Wolf, Sheldon. 2018. *A Practical Guide to Fundraising for Small Museums: Maximizing the Marketing-Development Connection*. Lanham, MD: Rowman & Littlefield.

Wright, Jennifer. 2020. "Exhibiting the Enola Gay." Smithsonian Institution Archives. https://siarchives.si.edu/blog/exhibiting-enola-gay

Yuha, Jung. 2015. "Diversity Matters: Theoretical Understanding of and Suggestions for the Current Fundraising Practices of Nonprofit Art Museums." *The Journal of Arts Management, Law, and Society* 45 (4): 255-68.

Zoo Atlanta. 2024. "Leadership and Board." https://zooatlanta.org/about/leadership-board/

Index

professional training. advisory committees and, 87, 89–91, 93–95; board orientation and, 127–28; on board performance, 182–83; burnout of, 147–48, 213; day-to-day work of, xvii, 34; ethical codes and, 4–10; executive compensation and, 172; exhibitions and, 119–27, 131, 135–40; friends groups and, 77–85; fundraising and, 146–65, 170–74; governance and, 35, 213; interim, 42, 148; marginalization addressed by, 196–97; museum self-assessment activities by, 181, 195, 198–202; in the press, xv, 209; professional training for, xvi, 207; responsibilities, xv–xvi, 13–15, 43–44, 131, 138, 150, 188, 201; retiring of, 121–23; search and hiring process for, 15–16, 30, 42–44, 78–79, 153, 188; strategic planning and, 179–91; turnover of, 42, 80, 98, 147–48, 178–79, 185, 213

disabilities, disabled community and, 140, 193–97, 199, 202, 204–8

disaster response, crisis plans and, 8, 27, 100–101, 111–12, 138

discrimination, 120, 196

diversity, 54–55; in advisory committees, 90–91; board, 58, 62–65, 67, 94, 144–45, 148, 164, 176, 203, 210; in giving, 157, 159, 165–66

diversity, equity, accessibility, and inclusion (DEAI), 72–73

division of labor, director-board, 33–34, 43, 90

"DIY Strategic Planning" (Catlin-Legutko), 189

documentation, museum, 8–9, 55, 57–61, 95, 101, 116, 179, 211. See also specific documents

Donor Bill of Rights, Association of Fundraising Professionals, 169

donors, 149–50, 198, 211–12; donor fatigue, 160; financial gifts from, xv–xvi, 146–47; individual giving and, 3, 155–56, 158–60, 173; major, xv, 150, 152, 159, 210; philanthropic giving and, 152–59, 164–67, 174; public trust and, 3; stewardship of, 159, 162, 164, 169; transparency about, 169–70

Dubin, Steven C., 140

Duncan, Carol, 205

earned income, 152–54, 211–12

education, charitable giving to, 155–56

educational programming, 23, 29–31, 119–20, 185, 209, 211–12; by friends groups, 78; missions and, 33, 49, 93

"Education and Interpretation Standards," AAM, 129

emergency management plans, 8, 27, 100–101, 111–12, 138

employees, museum, xvi, xviii, 12, 210. See also staff, museum

employment contracts, written, 30, 32

endowments, 121, 147; fundraising and, 153, 162–64, 167

"Engaging the Board in Fundraising" (Brown), 158–59

Enola Gay exhibit, Smithsonian, 134

environmental controls for collections, 111–12

ethical codes, xvi, xviii, 1–2, 4–16, 120, 199. See also organizations; specific codes. on accessibility, 10, 203–4; changing demographics and, 202–5; collections stewardship and, 100; exhibitions and, 125, 127–35, 141–42; fundraising and, 150–52, 167–74; museum neutrality and, 206–7

About the Author

Edward M. Luby is professor emeritus of museum studies at San Francisco State University, where he was director of the museum studies program and founding director and chief curator of the Global Museum, a campus-based museum at San Francisco State University. He was formerly associate director of the Berkeley Natural History Museums at the University of California, Berkeley, served as special assistant to the Vice Chancellor of Research, also at Berkeley, and was director of the Repatriation Unit at the Phoebe A. Hearst Museum of Anthropology. He has received numerous museum-based grants and has published articles in journals ranging from *Museum Management and Curatorship* and *American Indian Culture and Research Journal* to *Exhibition* and *Collections: A Journal for Museum and Archives Professionals.*